DESIGN REIMAGINED

Rizzoli
NEW YORK

New York Paris London Milan

DESIGN REIMAGINED
COREY DAMEN JENKINS

FOREWORD BY AMY ASTLEY
written with KYLE HOEPNER
principal photography by ANDREW FRASZ

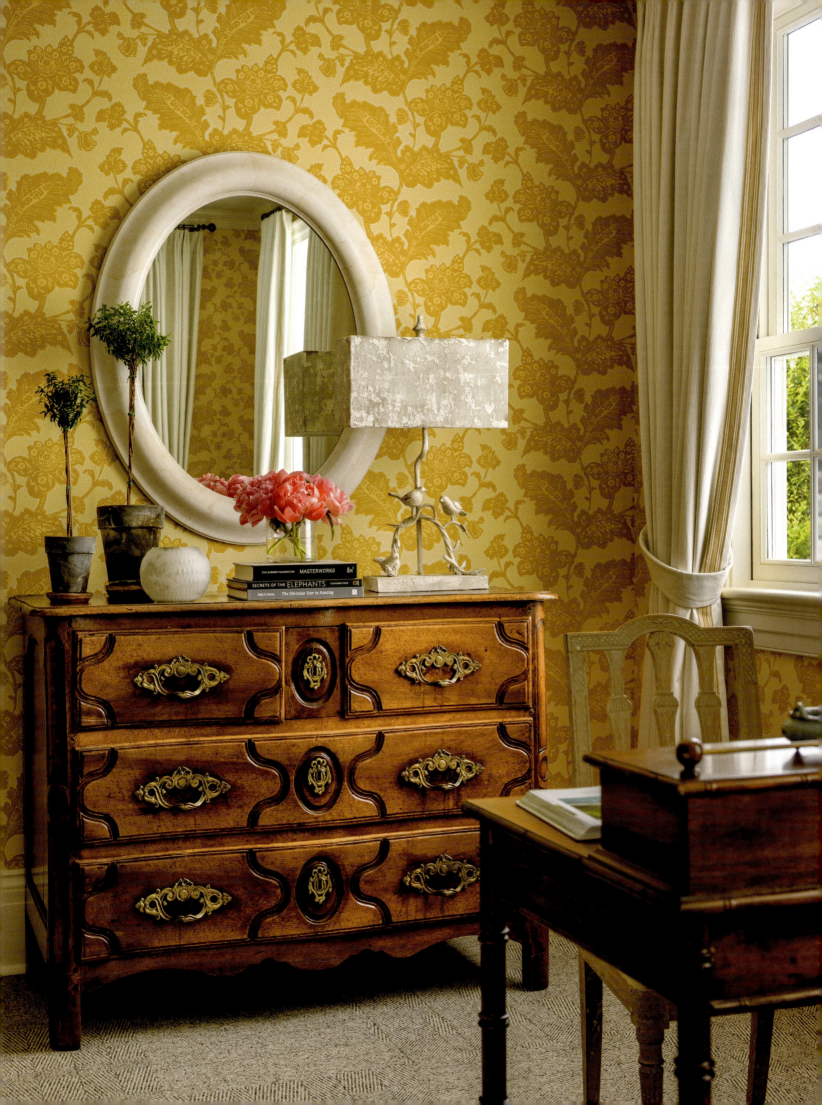

To Ann and Bill, for graciously opening the 779th door.

To Adam, for being the wind beneath my wings.

And to all the creative people out there courageously breaking through the chains of fear, doubt, and impostor syndrome: always remember that broken crayons still color, and delays do not mean denial.

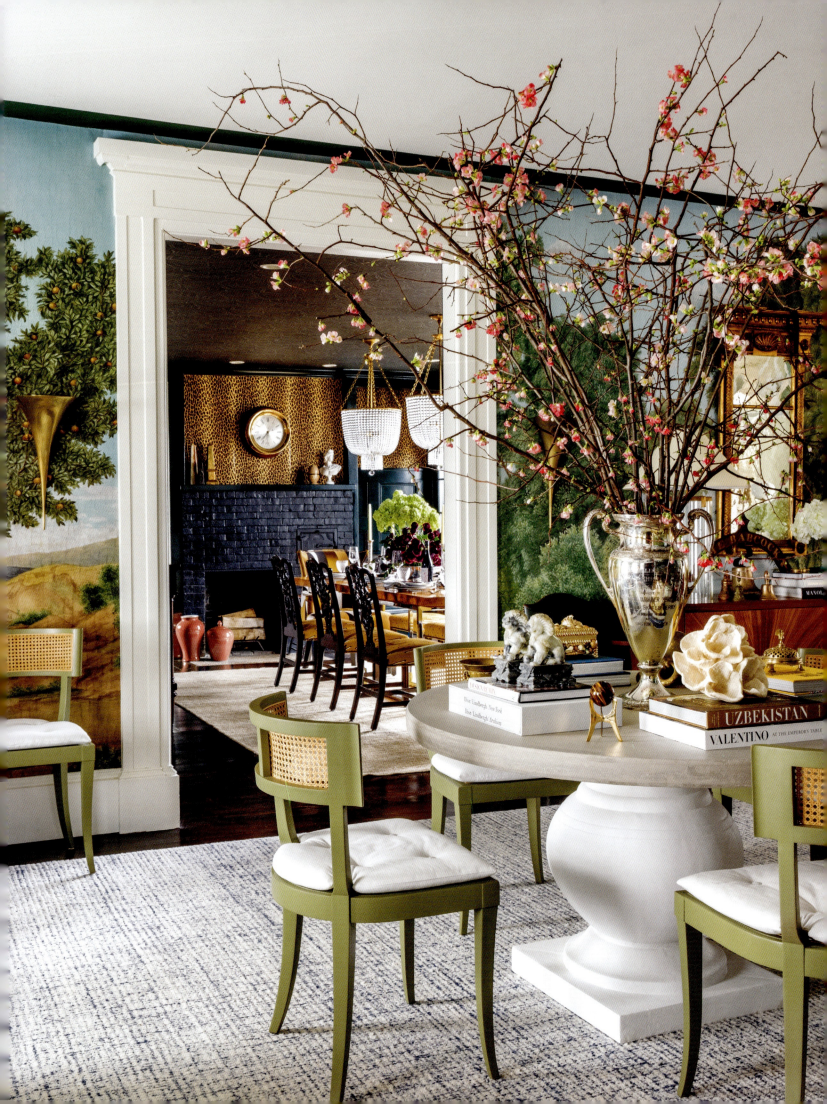

Contents

Foreword by Amy Astley *8*
Introduction *10*

A New Beginning *16*

Coastal Cosmopolitan *46*

An Elegant Domain *78*

Gwendolyn's Pied-à-Terre *114*

Lions and Tigers and Chairs *128*

Sanctuary by the Sea *158*

A Diplomatic Mission *176*

Balancing Act *200*

Executive Order *220*

Design Democracy *226*

Resources *268*
Acknowledgments *270*
Credits *272*

Foreword
Amy Astley

He had me at Detroit.

I first met Corey Damen Jenkins years ago at a design industry dinner in Manhattan, where he immediately impressed me as an authentic soul. His broad, friendly smile, gracious manner, and direct eye contact (no scanning the room while speaking to you!) were refreshing, and when we discovered that we are both Michigan natives . . . well, it was a done deal. Midwesterners are not overrepresented in either New York City or the design industry, and I was determined that *AD* would play a role in sharing Corey's formidable creative gifts with a wider audience.

In his second book, Corey once again proves himself a natural communicator, that rare designer who is fluent both visually *and* verbally. Communication might even be at the core of his success. Corey repeatedly emphasizes the "designer as diplomat" and unfailingly speaks of his clients with great care and respect. Most of them seem to become both repeat business and close friends—I met more than a few such folks at his wedding to his partner. I have often observed this quality in designers with real longevity—their relationships stand the same test of time that their rooms do. The entire endeavor, from house to inhabitants, is built with love and meant to last.

Corey conceived this book, just like the environments he creates, to be both inspirational and practical. It features ten projects and loads of luscious photos, but also a wealth of tips, pro tricks, and frank accounts of his personal challenges on the path to achieving success and becoming a leader in the design community's educational and philanthropic activities. But ultimately, Corey's rooms speak for themselves. His work skews traditional and classic but never, ever boring or predictable. His spaces are always comfortable, vibrant, fearlessly bursting with color and pattern, and they never fail to exude an irrepressible sense of energy and optimism. These are words I associate with Corey himself, and his refined eye and joyful voice permeate every single page of this captivating volume.

Introduction

"Life imitates art far more than art imitates life." This Oscar Wilde quote has deeply resonated with me in the time since I wrote my first book, *Design Remix*. When considering a title for this second tome, *Design Reimagined* felt right, because, in the interim, my own life has undergone a major renovation of sorts, a transformation that followed the same stages that are typically involved in my art of designing interiors and architecture: a degree of upheaval and chaos, as we either demolish old spaces or build a new home from scratch, followed by a period when tough decisions must be made, and, in the end, the reshaping of the messiness into something lovely and useful that hadn't been there before.

Life has been more eventful and unpredictable over the past few years than I would ever have anticipated. To begin with, there was the onslaught of the global pandemic, and the many ripples of change that washed over our society. For me, the crisis also forced some difficult personal choices, the most consequential being the decision to close my company's flagship Michigan studio and expand our New York City atelier to make it our primary location (see page 220 for more about that).

I was once convinced that I'd stay in Michigan forever. But then I fell in love with someone special, and the experience of the pandemic's lockdowns helped crystallize our desire to build a life together in Manhattan. There were growing demands on my firm: the size and scope of our mission was changing, and we were designing projects throughout the United States and beyond. I had wrapped up

the filming of my educational series for MasterClass and was giving talks on interior design for audiences near and far—from Washington, DC, and Los Angeles to Paris and Bangkok. In addition, I was in the throes of producing several licensed collections for furniture and textile manufacturers. Becoming a full-time New Yorker was a logical next step, and it would allow me to get more involved with charities I cared about, such as the Kips Bay Boys & Girls Club (where I now serve on the Board of Trustees). In the end, it was a whirlwind of opportunities and commitments that eventually dictated the big move.

While the relocation may have looked glamorous in the press and on social media, I can assure you, dear reader, that I was ambivalent while taking the leap. Like Dorothy Gale being flung from Kansas to the Land of Oz, I could barely catch my breath. I felt excited, overwhelmed, and—to be honest—a little scared. The mixed feelings brought a sense of déjà vu from the big breakthrough that began my career. In *Design Remix* I shared my story about determinedly knocking on 779 household doors—in the dead of winter during the Great Recession—to find my company's first client. Twelve years later, I thought I was done with rapping on doors, but it turned out that I had new ones to knock on now, in different places and at a different level. Once again, at a time of great global upheaval, I was reimagining my career, starting a new chapter, and knocking on new proverbial doors of opportunity.

So, *Design Reimagined* charts the story of how I, along with my fantastic team, have thrived on the East Coast. The projects featured here are some of our favorites from the past three years; they're multifaceted in their scope, varied in their locations (from the Hamptons to California), and they showcase a huge range of styles (though always, I hope, with the eclectic exuberance our brand is known for).

"Reimagined" is fitting, as well, because the ten projects in this book are all

renovations of spaces that already existed. While I adore new construction, I have a special affinity for working on historic properties. I believe there's little to talk about if everything in a house is brand-new, whereas antiquity and storied elements give a home its soul and pedigree.

As you'll see, many of my clients own historic houses. And, to their credit, they have a deep appreciation for the timeless refinement of those structures. They want to honor, rather than tear out, the buildings' remarkable architectural details. Some of the homeowners are also the lucky beneficiaries of family heirlooms—even if they aren't always sure exactly what to *do* with their bounty. I relish the challenge of giving inherited pieces a rebirth through our design process.

We must evolve past the idea that everything has to be shiny and immaculate to be appreciated. Antiques and vintage pieces proudly show evidence of their prior lives, which accounts for much of their appeal. Like diamonds, they're "perfectly imperfect," and they retain their attractiveness and worth despite their flaws. Mixing and matching gorgeously disparate things has become an essential part of my design ethos.

To produce this kind of creative synthesis calls for openness and flexibility. You must be willing not only to think about how you're going to arrange items in your home but also periodically reevaluate your opinions about what truly defines "beauty" to you. The best design aesthetic may be one that you absorb from others. There's nothing wrong with being informed by the taste and knowledge of those who came before you and blending their worldview with your own—as long as you continue developing your own eye with independence and authenticity. This is why I always say I don't *follow* the trends—I set them. And you can set the trends for what is beautiful in your home, too!

Adapting to New York City life hasn't always been easy for me. The hectic pace and public manners (or lack thereof—ahem!) are unlike the Midwest, and expectations are very high. Perhaps it was a touch of impostor syndrome, but at first, I didn't feel like I fit in. What helped me find my footing was applying the same resilience to my life situation that works in interior design: you evaluate the lay of the land and use your imagination to get to the next goal. If someone unexpectedly buys that vintage chandelier your client desperately wanted, for example, then you go back to the drawing board and rework the design around another light fixture. If demolition in a penthouse uncovers a structural girder overhead that can't be shifted, then you devise a coffered ceiling detail to conceal it. Interior design—much like life in general—is similar to navigating a boat on the ocean. Our Earth is curved, and winds and currents are changeable, so it's impossible to sail in an entirely straight line. You will naturally find yourself pivoting and adjusting constantly to get to your destination. There's rarely a direct shot toward success—and that's OK. Changing course doesn't mean you've lost your rudder.

Since making the move to Manhattan, our firm has partnered with many wonderful clients who have encouraged us to produce bold and ambitious work (some of which you'll experience in the pages that follow). I'm deeply grateful for the public accolades that have resulted, but I'll never forget that these were all acts of reimagining, achieved by embracing opportunities as they appeared, despite any initial fear or doubt. And, finally, I've learned that knocking on doors—some daunting, some thrilling—is a process that never stops. Those doors are, after all, the portals that will take you to your future!

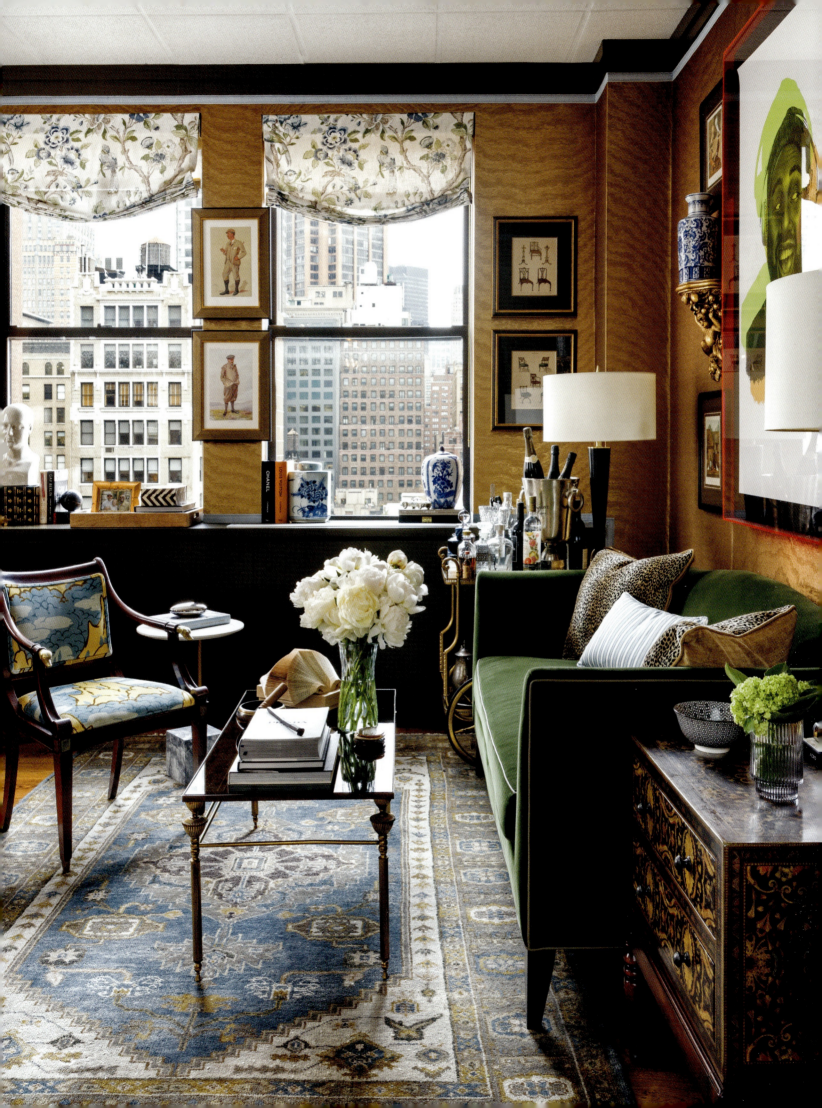

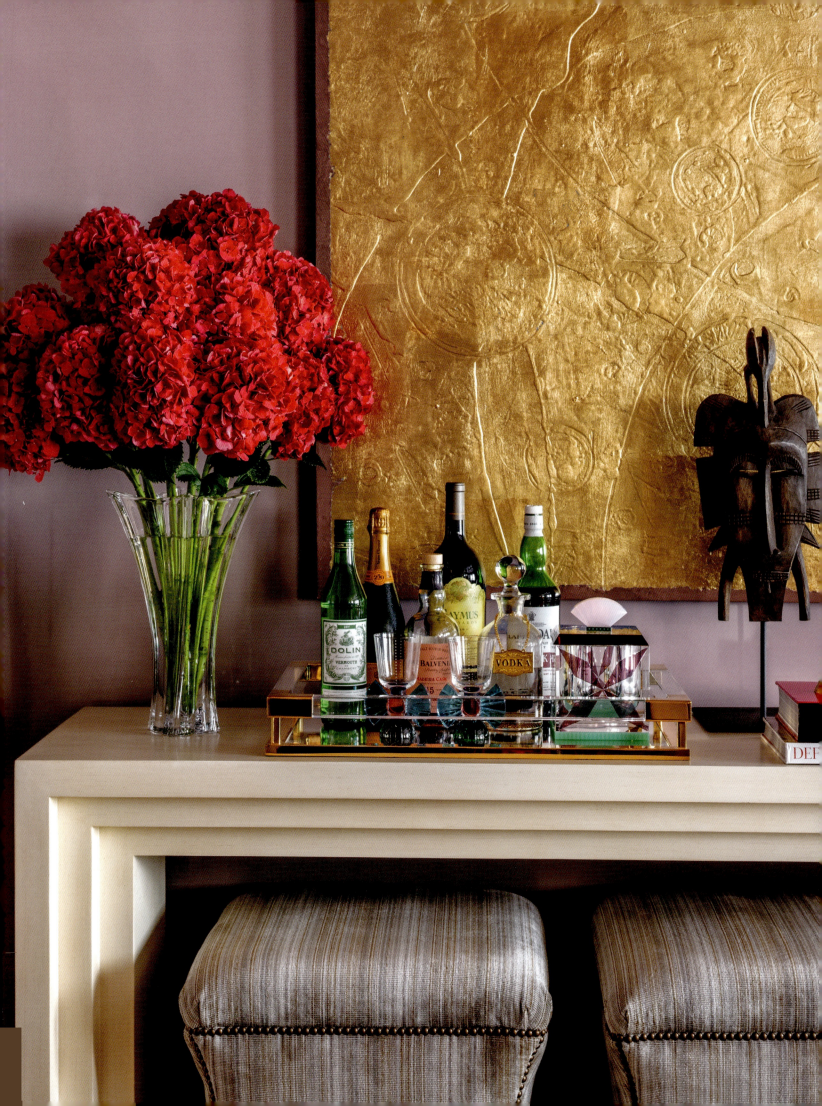

A New Beginning

———•———

One of the most special connections a designer can have with a client is that of shared life experiences. When this homeowner—a sophisticated woman with two young daughters—contacted my firm, she was undergoing a major life pivot: a move from out of state to New York's Upper East Side. Since I had also moved into the neighborhood a few years earlier, she and I quickly bonded as we embarked on this very special project.

My client had just purchased a high-rise luxury apartment in one of the stately prewar buildings along Fifth Avenue's "Museum Mile." Her unit offered real advantages: tall ceilings, plenty of large windows, amazing views across Central Park. But, while the building's facade and grand lobby had survived the decades with their historic character and lovely Beaux-Arts ornamentation largely intact, this particular apartment hadn't been quite as lucky.

It was, in fact, two apartments that had been combined into one, with a lot of corners cut in the process. There were no frills or flourishes, the materials used were subpar, and more than a few of the architectural decisions made were,

A corner of the dining room encapsulates several important qualities of my design for this residence: it's sleek (like the white-lacquered console), it's rich (like the *Constellations* piece rendered in gold leaf by artist Karen Tomkins), and it's practical (like the upholstered stools that can be pulled out for extra seating).

well, *unfortunate* is the most diplomatic word I can come up with. For example, what remained of the original herringbone wood floors no longer matched the rooms' layout; their decorative edge inlay would simply disappear beneath a baseboard, only to emerge again in a different space on the other side of the wall. Ceiling soffits and awkward bump-outs in rooms served no real purpose, or contained mystery plumbing connected to nothing.

The homeowner optimistically hoped to get the makeover done in only six months. I assured her that, given the immense scale of the gut renovation, this project simply could not be done that fast. "It will be greater later" was my constant mantra, and, thankfully, she had the patience of a saint.

To expand the space that would become her family room, we took out a wall that had partitioned off a very narrow maid's room next to it. The need to conceal a structural beam that had run through the wall guided the vision for our ceiling treatment: a grid of coffers, their inner edges lined with tambour. Even though we had to lower the ceiling slightly to accommodate wiring for a row of milk-glass chandeliers, the coffers make the room feel tall and airy. The tiered effect of the coffers themselves and the vertical grooves in the tambour draw the eye up toward dramatic expanses of an emerald-hued silk grass cloth we installed overhead.

The grass cloth was originally intended for the walls, and the room's spectacular wall covering was a last-minute addition. One evening, well after the grass cloth had been purchased and much of the room's furniture was already in production, the client sent me a text expressing worry that the family room's design wasn't bold enough. I was more than happy to go bolder with the

OPPOSITE: We wanted this front hall to feel like a verdant jewel box. To add glamour and height, the ceiling is covered in mirrored tiles, each one applied by hand. FOLLOWING SPREAD, LEFT: The de Gournay chinoiserie mural is hand-embroidered in silk. The single peacock symbolizes the homeowner; a pair of peacocks elsewhere in the room represents her daughters. FOLLOWING SPREAD, RIGHT: The home's interior architecture and millwork were designed by us.

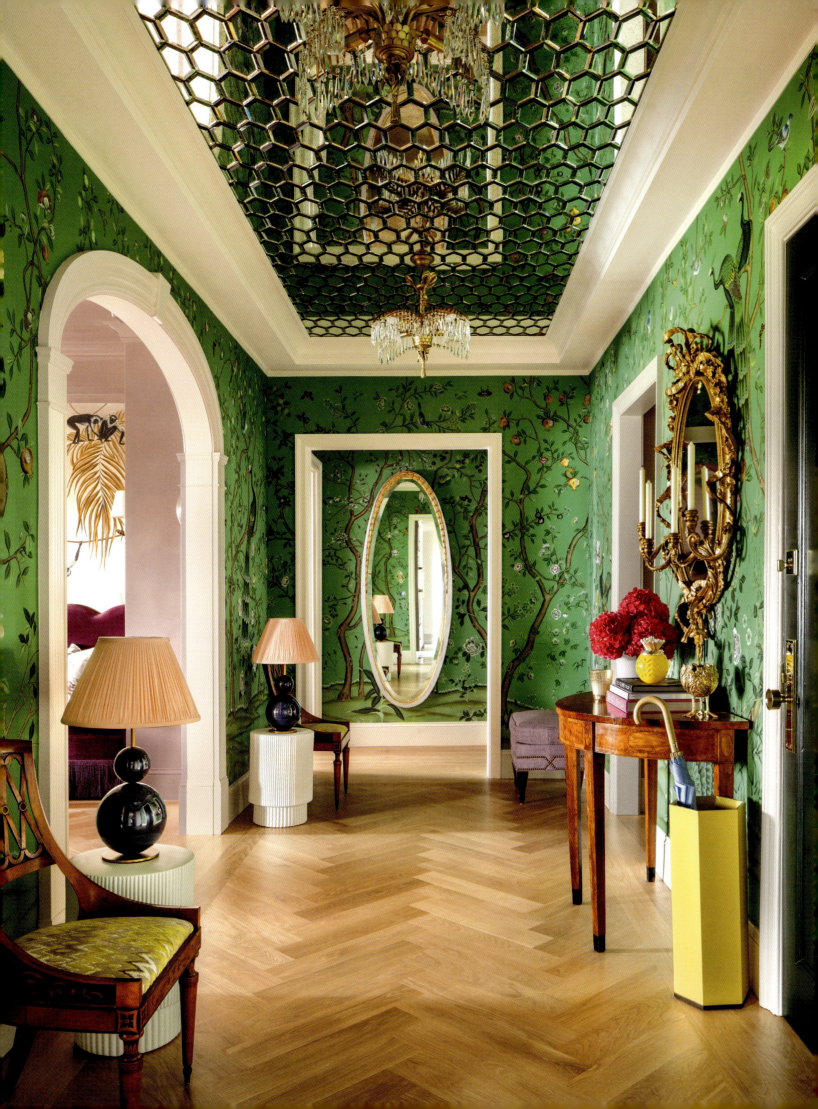

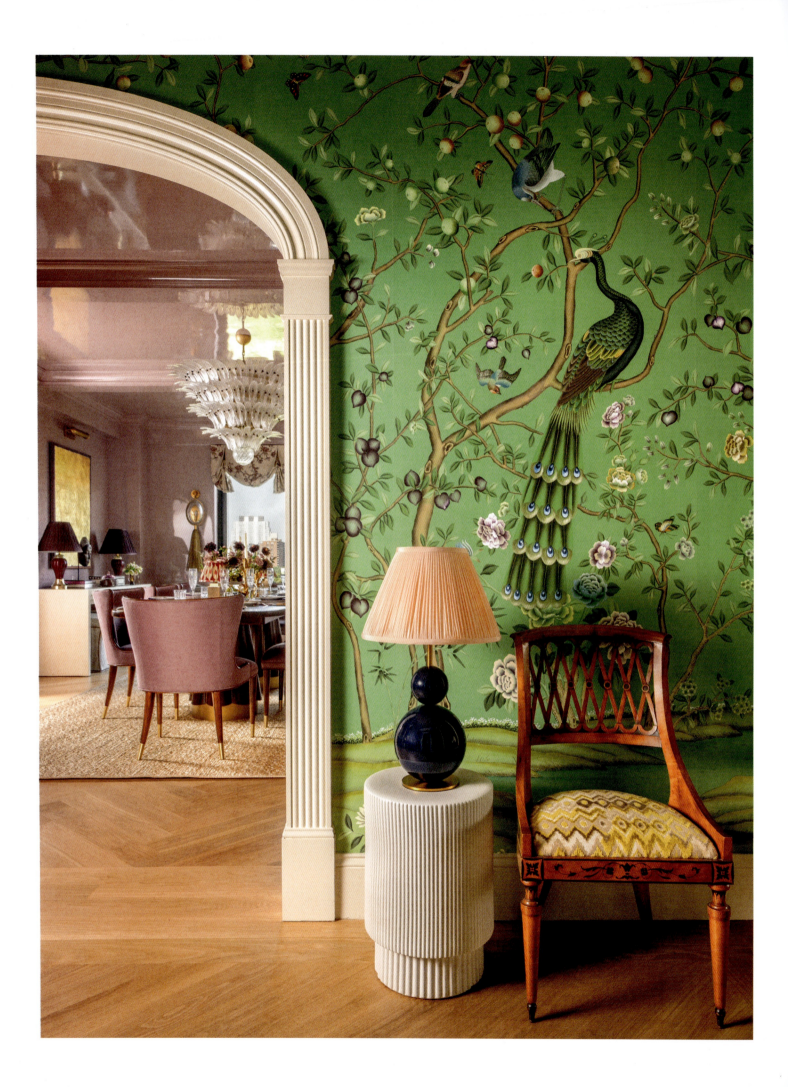

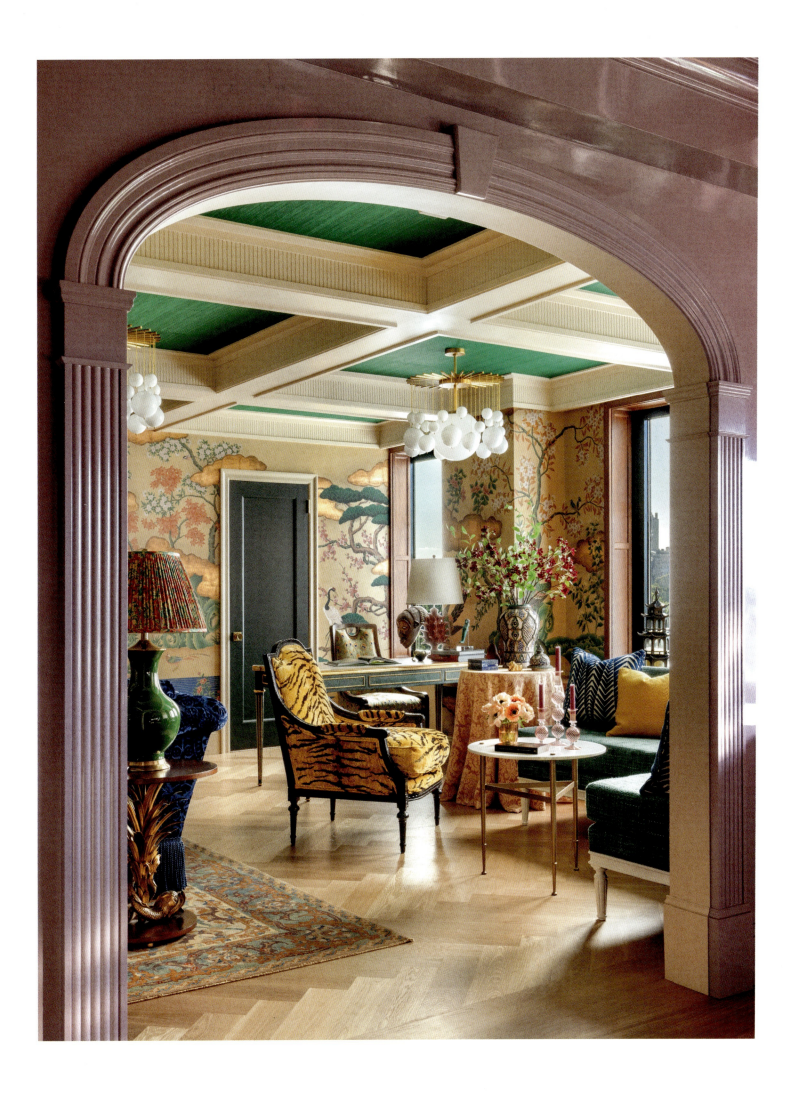

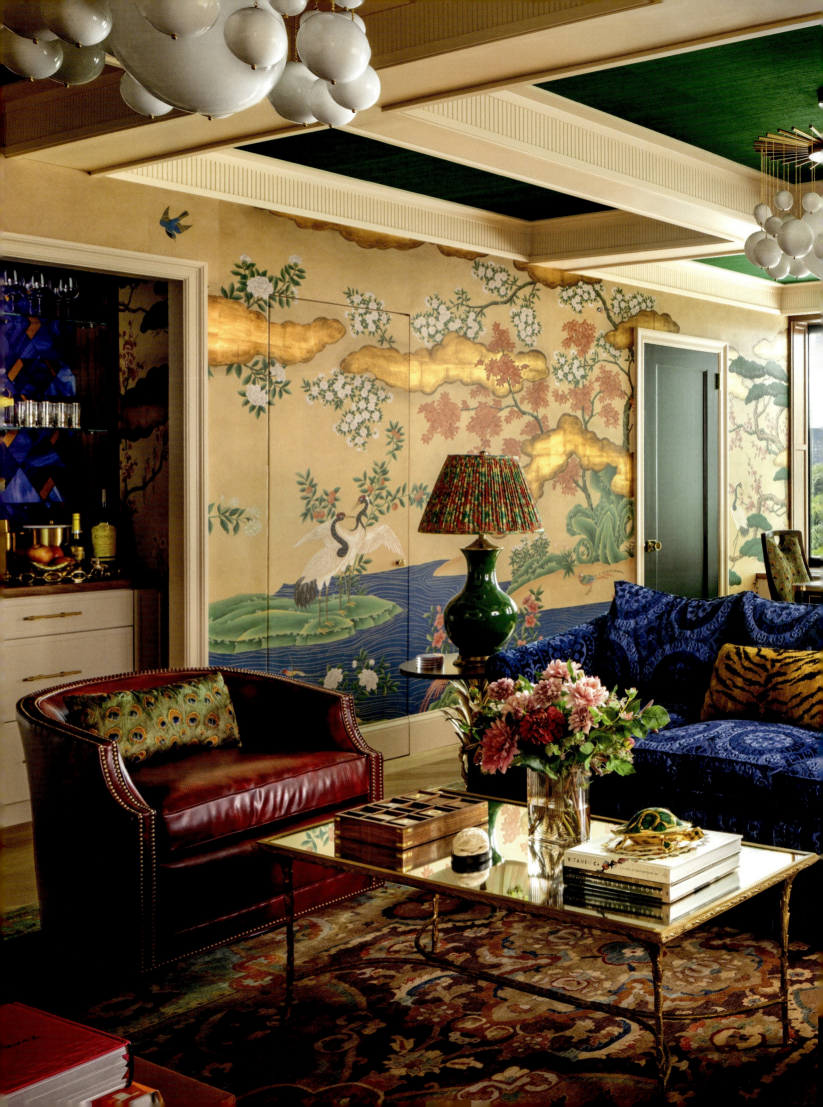

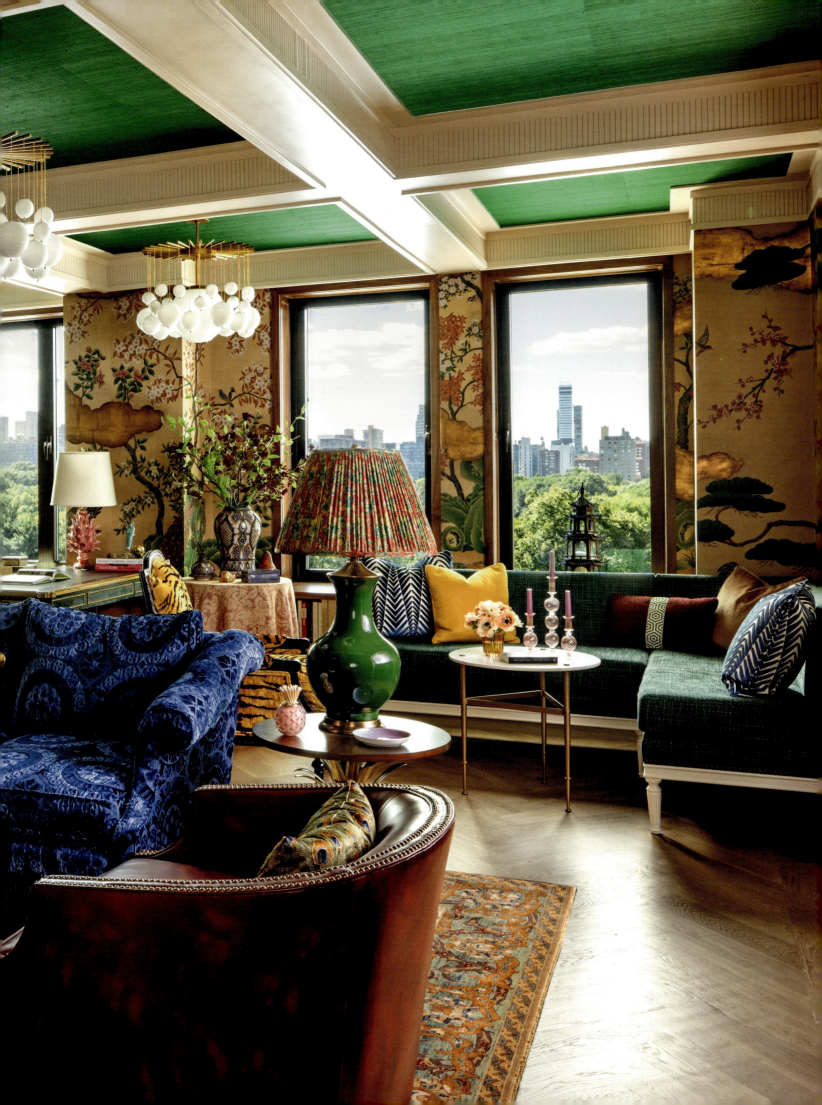

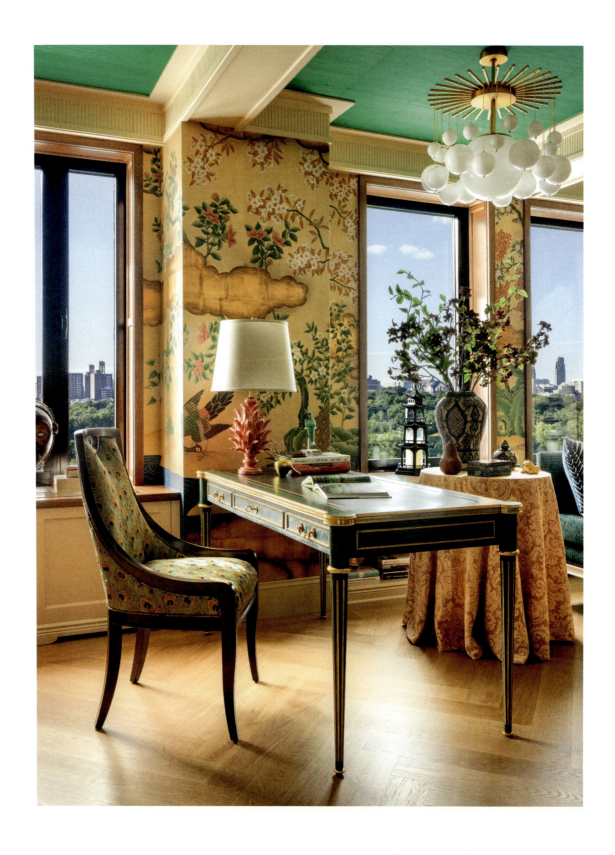

PRECEDING SPREAD: Three chandeliers hover like miniature solar systems above the family room. The hand-painted Gracie wall mural's landscape blends almost seamlessly with the spectacular views of Central Park outside. ABOVE: The window insets are paneled with walnut-stained wood for a more finished look. OPPOSITE: Cobalt and gold-leaf geometric tiles in a built-in bar take their color cue from the suzani-patterned velvet sofa.

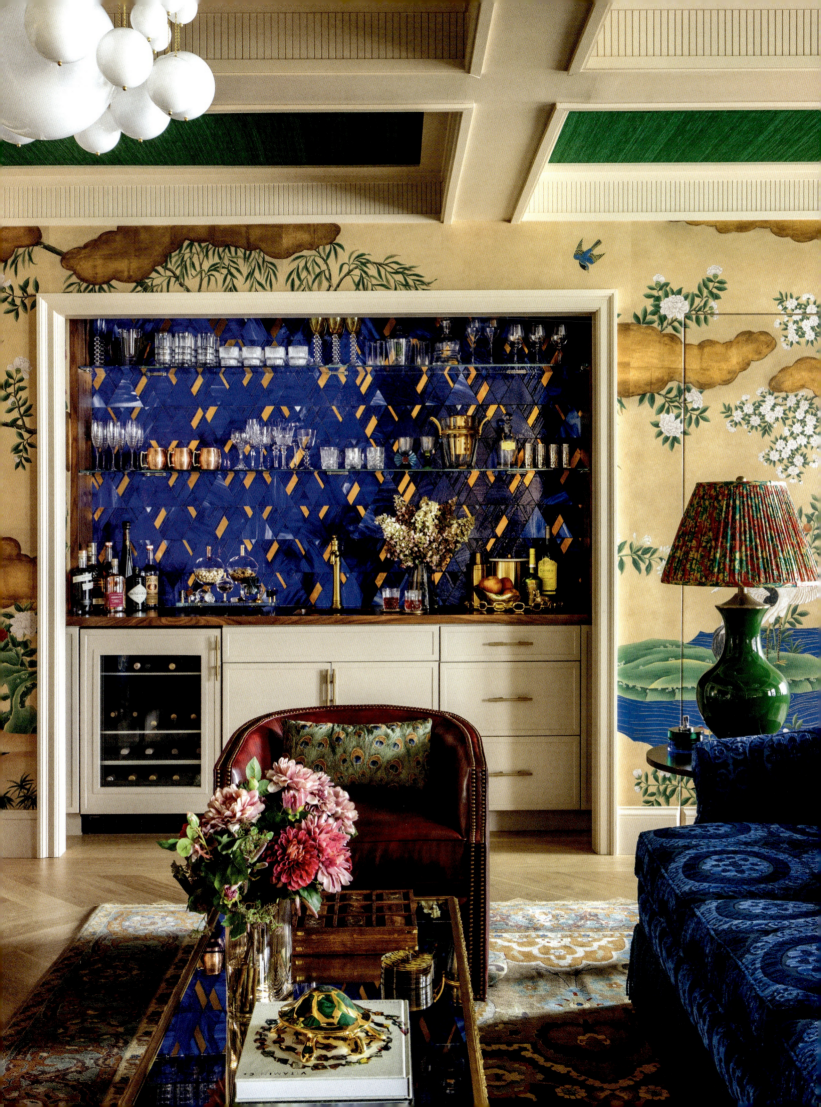

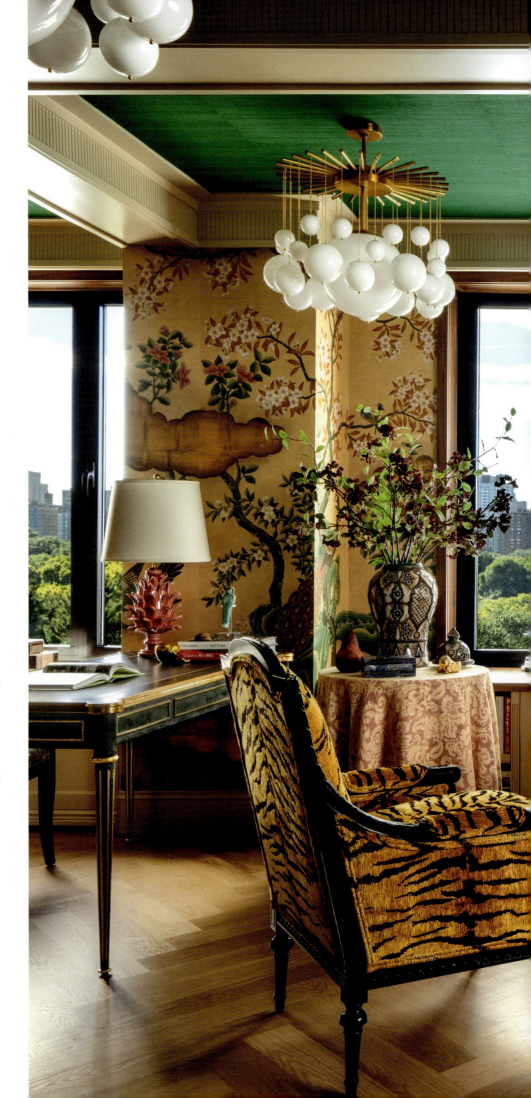

One corner of the family room becomes an additional conversation area when kitted out with what we call a "soquette"—a combined sofa-banquette—and a tiger-striped bergère. The rouge-colored porcelain lamp on the desk at left was custom-made for us by an artist in France. The large figured vase on the skirted table, an antique piece we sourced from Morocco, looks absolutely magical filled with blossoms and branches.

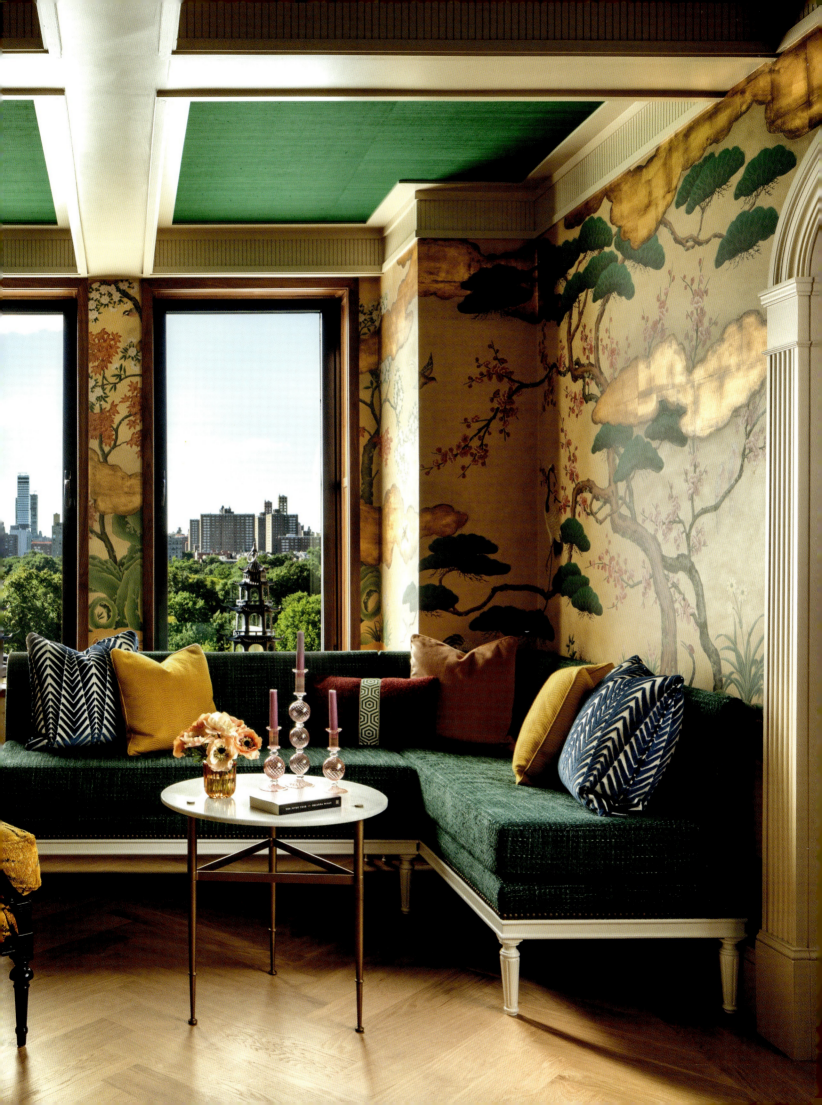

aesthetic—*naturally!*—but didn't want to throw away money that had already been spent. Changing the grass cloth's destination solved one part of the problem, and ordering a custom-colored wall mural to match the palette of the furniture took care of the rest. As they say, waste not, want not—and we ended up making one of the most dynamic statements in the project as a result.

The primary suite presented a special challenge. We composed it from two smaller bedrooms and their surrounding cluster of tiny closets and bathrooms. The puzzle of where we could run pipes and drains—New York City building regulations are notoriously strict on that score—called for an especially imaginative solution: instead of one primary bathroom, our client now has a trio of spaces dedicated to beauty and self-care. The principal bath has a sink, vanity, toilet, and shower. The second we dubbed the "glam chamber"; it's a place for hair and makeup, and features another sink, a dressing table, and plenty of storage for cosmetics, perfumes, and linens. Finally, there is a hidden spa room tucked behind a discreet pocket door in the walk-in closet, perfect for long, relaxing soaks in its luxurious nickel-clad tub.

One of the most important qualities a designer can have is flexibility: coming up with clever ways to compensate when life throws up barriers that prevent you from doing what you initially wanted. During our work on this project, we had to be nimble and pivot several times to reach our goals from different directions. By the time all was said and done, our Fifth Avenue metamorphosis took eighteen months to complete, but now this mother and her two daughters have a setting for their new lives that's elegant, distinguished, and totally feminine.

In the dining room, silver leafed de Gournay panels feature monkeys cavorting amid palm branches. The walls and ceiling are entirely coated in a plum lacquer from Fine Paints of Europe. Niches flanking the fireplace are filled with scallop-backed custom banquettes. A Baker dining table and chairs introduce a streamlined, modern note; The circa-1920s palmette chandelier took more than eight hours to assemble.

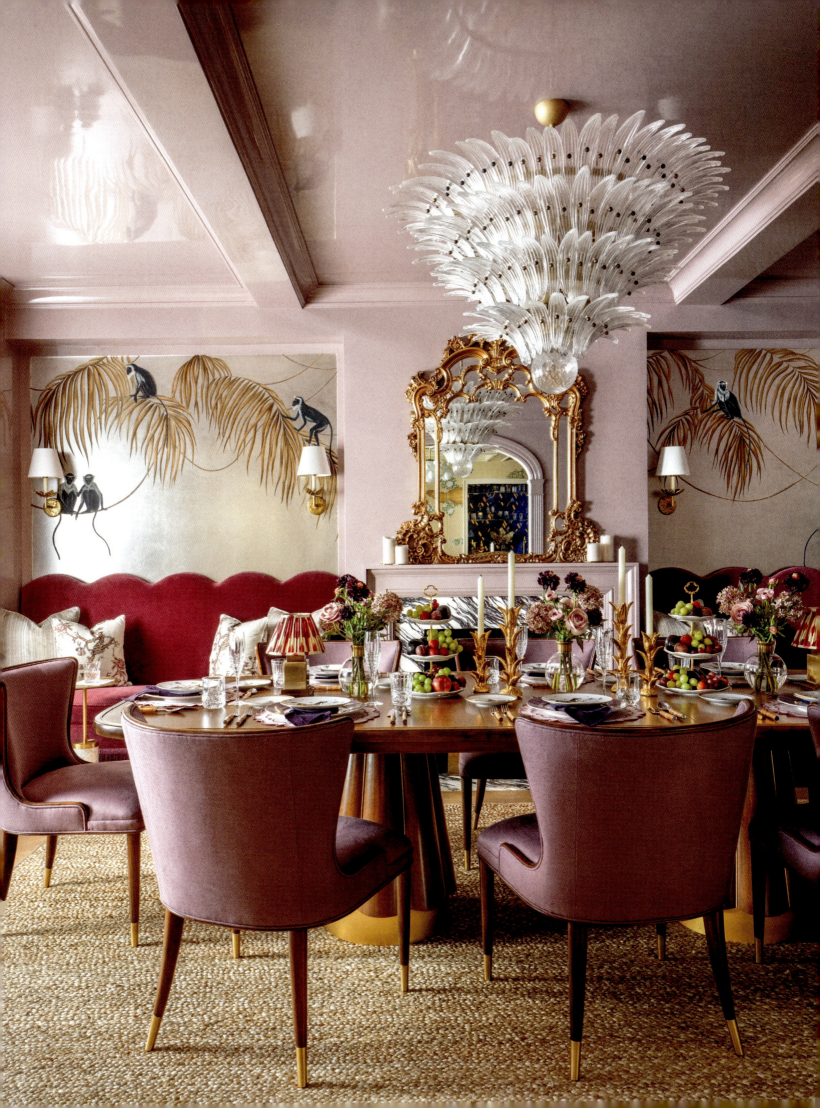

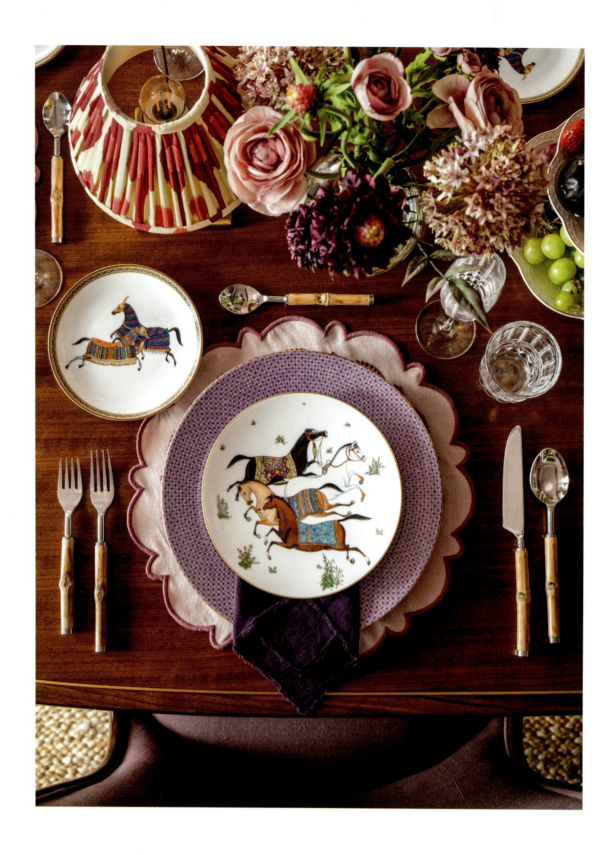

ABOVE: These place settings pull from four different services owned by the client. It's fun to mix and match when entertaining. The Hermès horses, with their colorful blankets, feel right at home in an apartment that's full of animal motifs. OPPOSITE: The dining room's banquettes are accompanied by small tables, making them multifunctional: people can sit there for a meal or plug in their devices for studying and work.

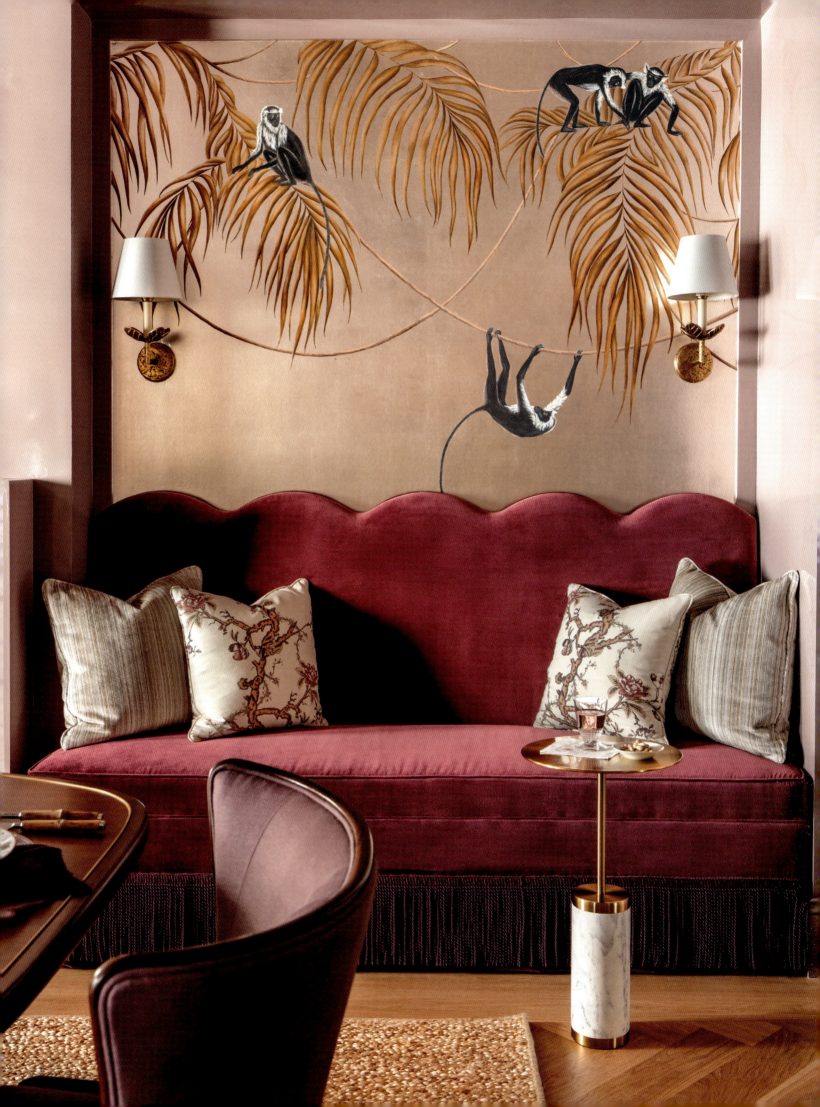

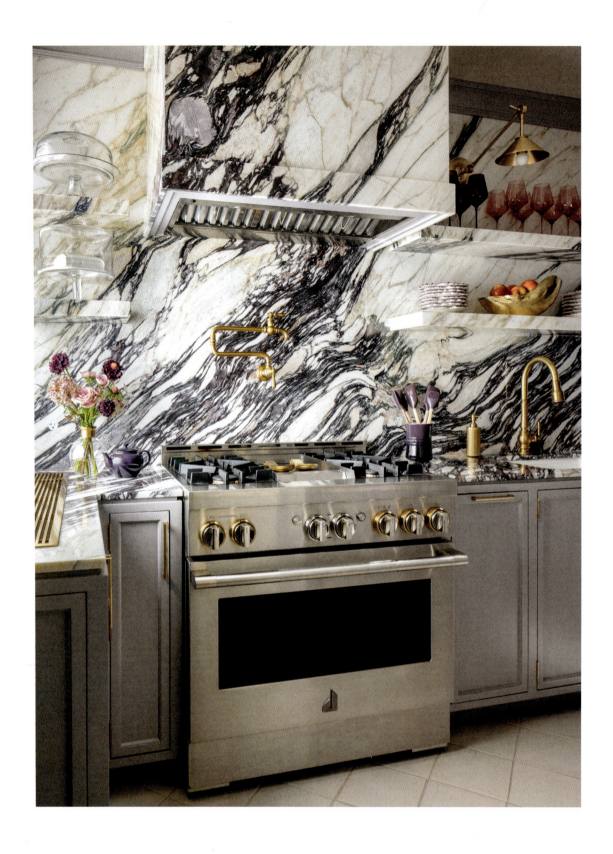

ABOVE AND OPPOSITE: We wrapped the relatively compact kitchen in this incredible calacatta viola marble, which looks like vanilla ice cream with some sort of berry jam mixed in. To make it a completely sculptural statement, we also had floating shelves—and even the range hood's casing—fabricated from the same wonderful stone. Small but mighty!

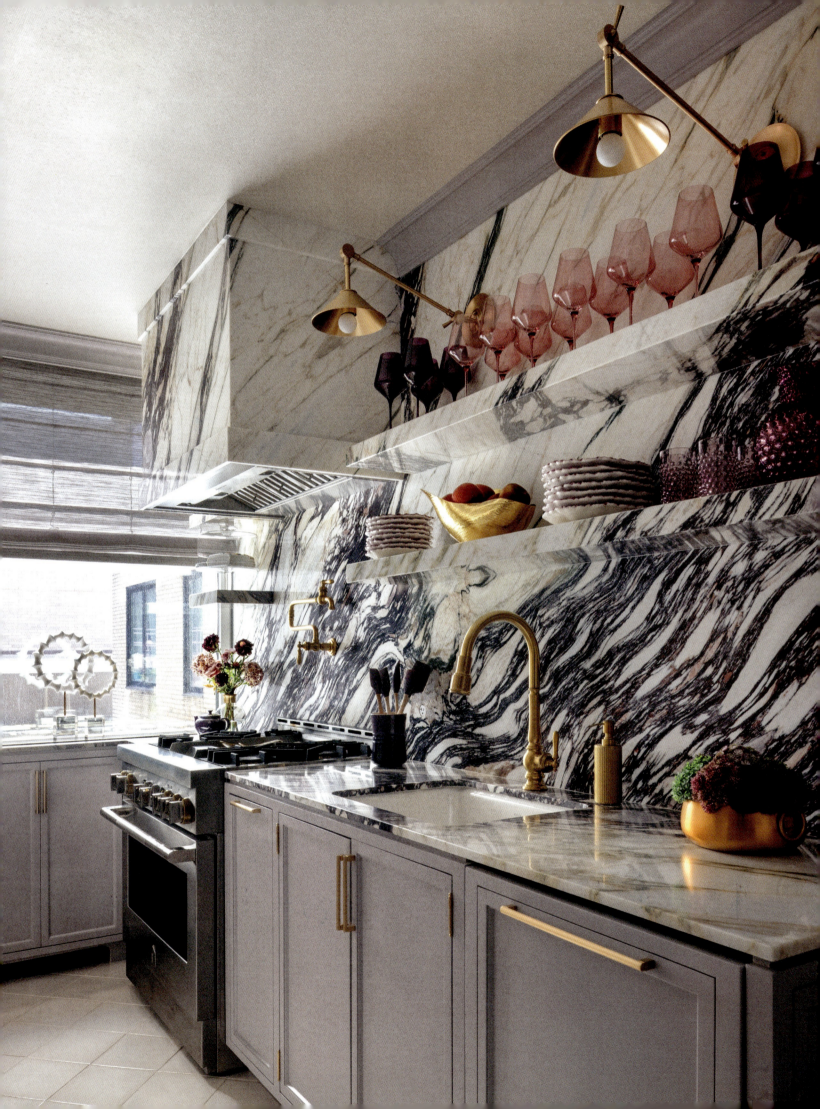

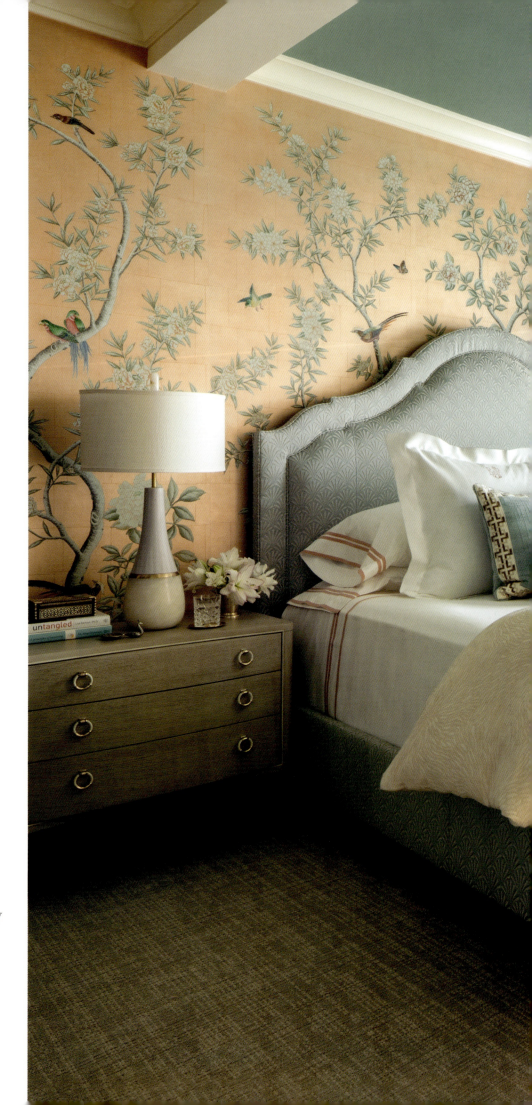

The owner wanted her bedroom to be super-feminine, so we chose to celebrate shades of blush pink, cornflower blue, and celadon. I designed the upholstered bed and had it covered in a deco-patterned fabric. Acrylic legs on the nightstands and a mid-century Lucite ribbon chandelier inject a bit of modernity.

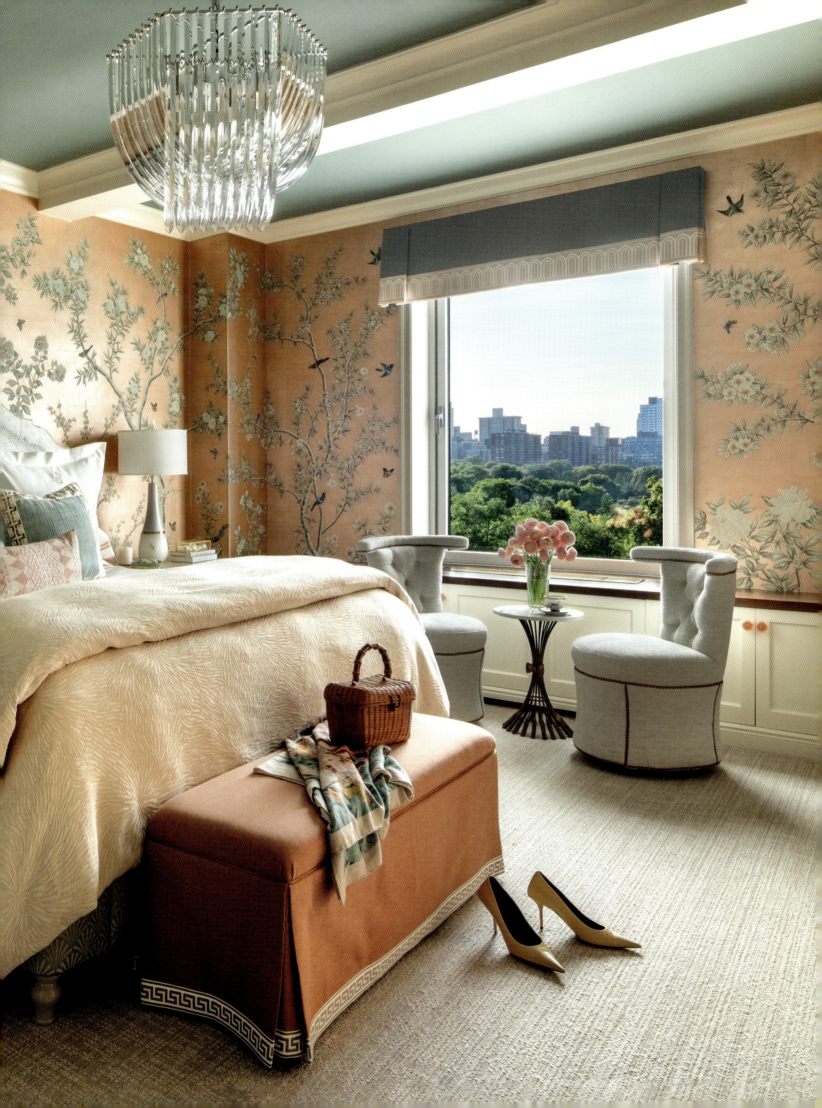

ABOVE: The owner's bath has a silver and gold theme, with the fluted legs of the Ann Sacks vanity, for example, counterpointing a brass strip framing the marble tile floor. The mirror lifts up like a garage door to reveal a medicine cabinet. OPPOSITE: Subtle figuration in the headboard, bedding, and a tweed-like carpet offsets the gorgeously florid Gracie wall mural.

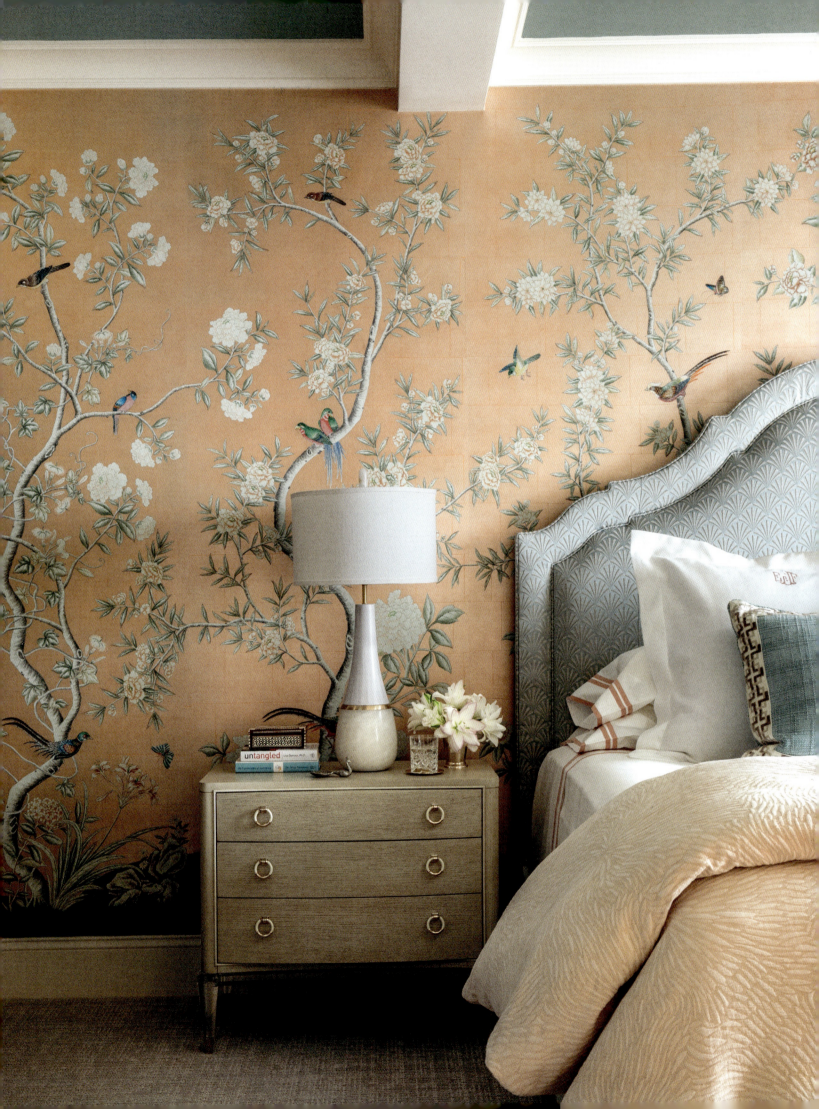

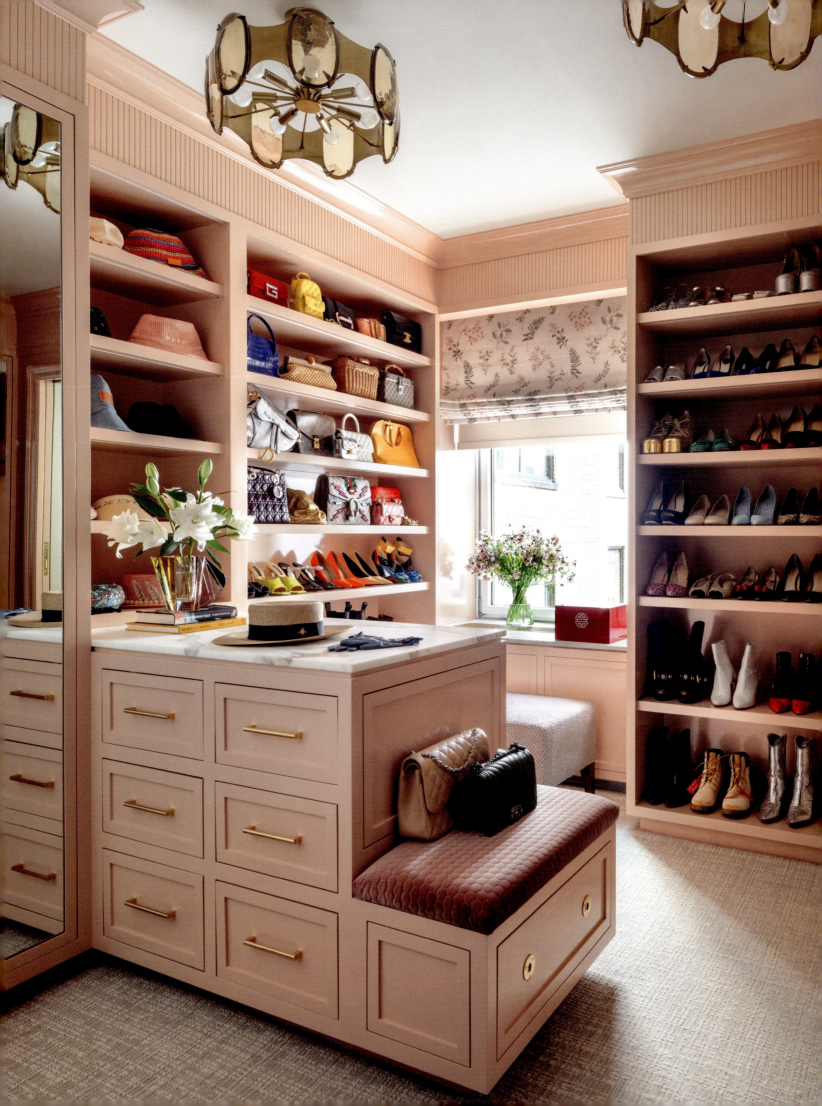

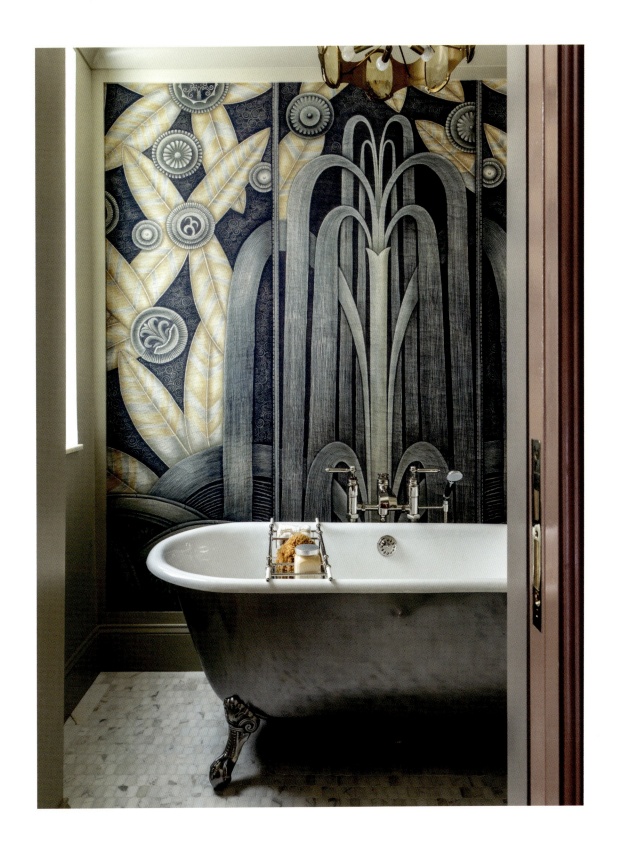

OPPOSITE: A tambour frieze and built-in shelves in the blush-pink dressing room are arranged to disguise some awkward ceiling soffits and ductwork that couldn't be moved. ABOVE: The spa room, with its enticing Drummonds soaking tub, is reached via a concealed panel in the dressing room's cabinetry. A stylized fountain in the hand-painted wall mural almost seems to be spouting from inside the tub itself.

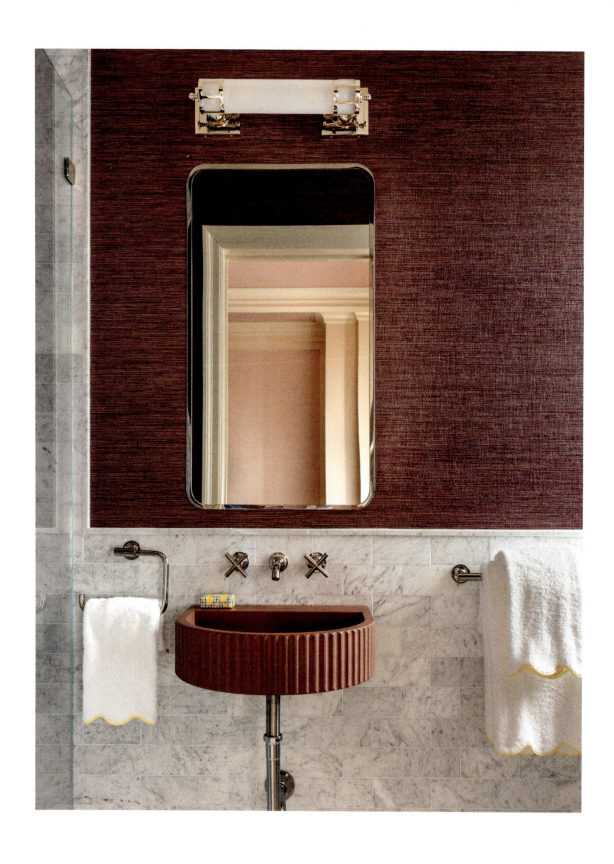

ABOVE: A petite guest bath gains playful character from a colorful Kast concrete basin and a matching textured grass cloth. OPPOSITE: A media and homework space for the client's two daughters has walls covered in suede with an imprinted design in gold leaf. The Anthony Akinbola art piece above the sofa is a collage made from durags. The large-loop carpet injects a note of fun.

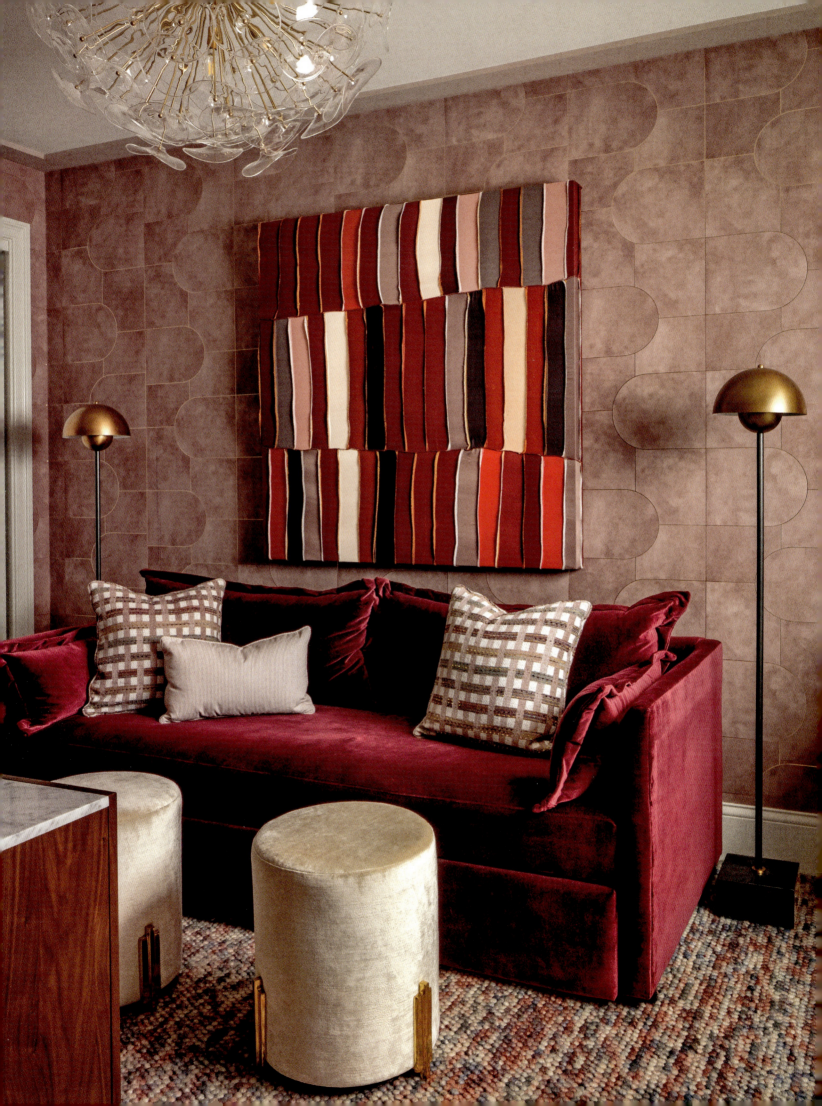

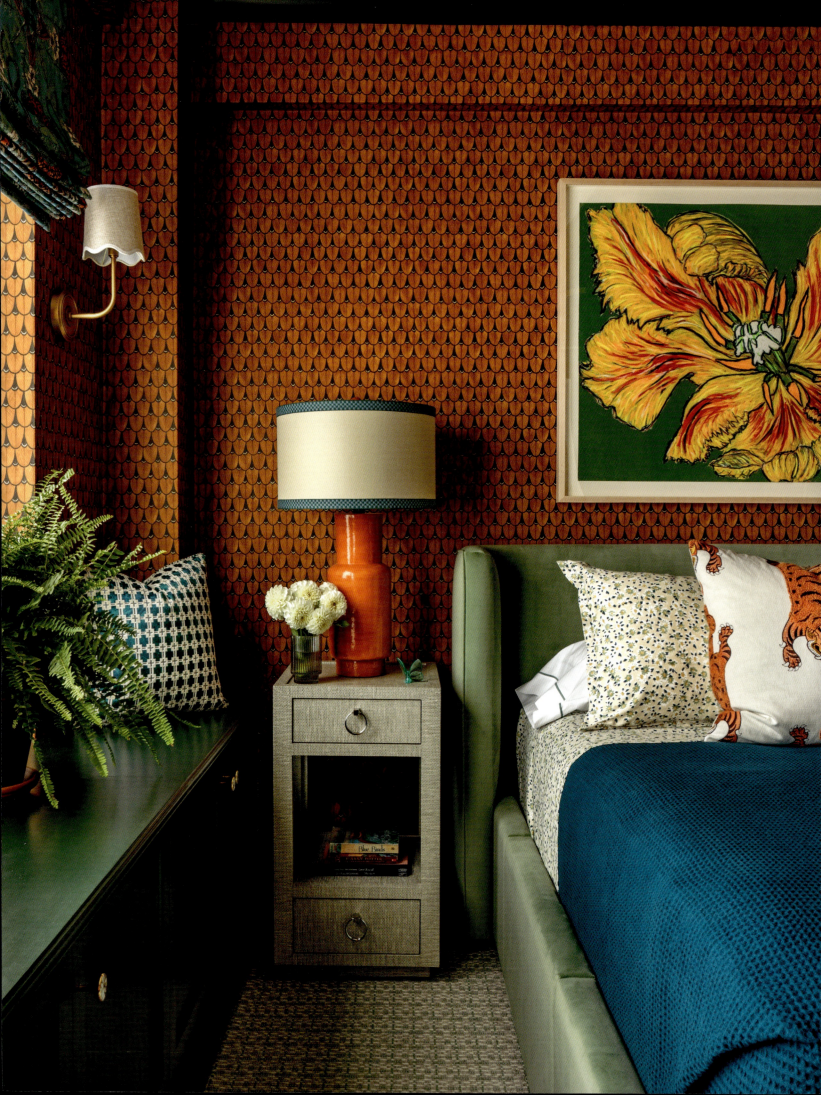

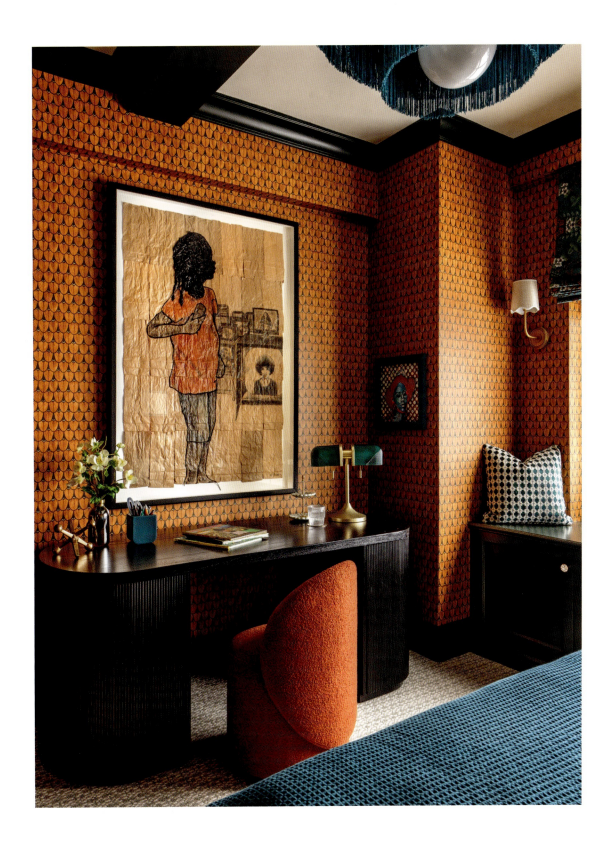

OPPOSITE AND ABOVE: My client's younger daughter originally asked for her bedroom to be black. We compromised with shades of teal and dark green, combined with a saturated saffron wall covering. The chandelier, with its deep turquoise tassels, was a big win with the young lady—and contemporary artworks by Christian Brechneff (opposite), Nathaniel Donnett (above left) and Dionne Simpson (above right) will continue to suit her as she grows up.

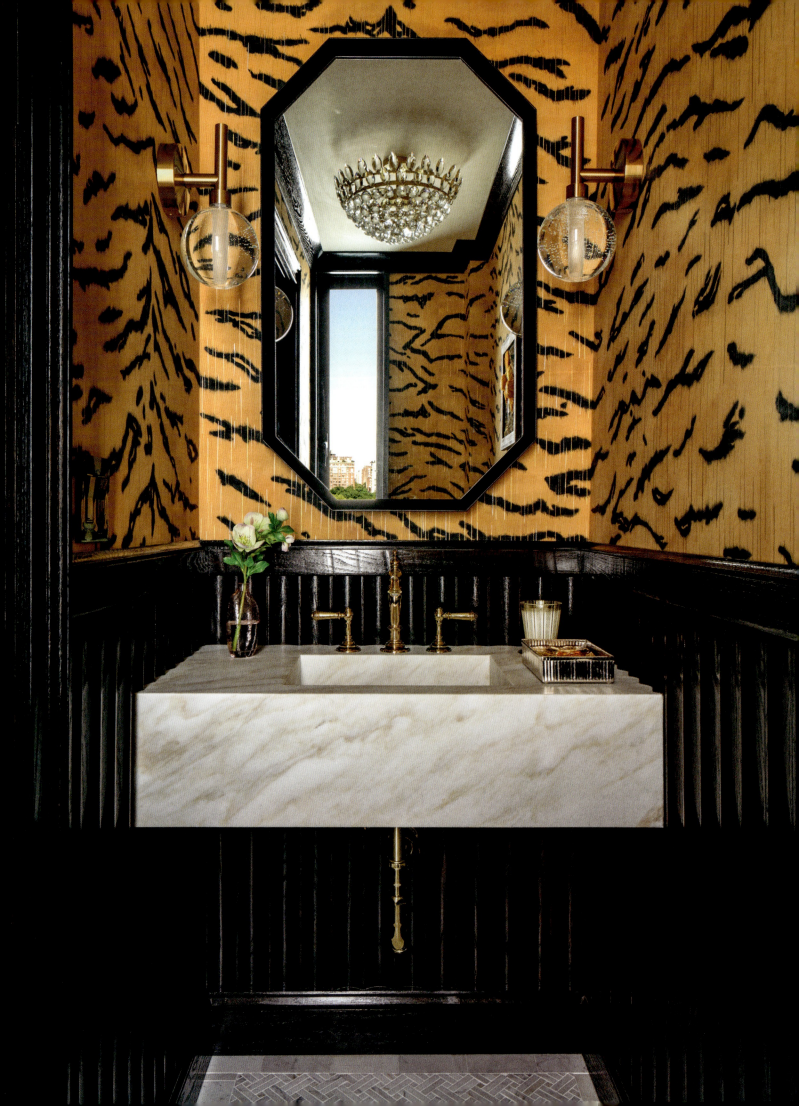

APPLIED EXPERTISE
Powder Rooms

In my professional opinion, small spaces like powder rooms are an opportunity to go big and bold in terms of personality. Every surface, every fixture, every fitting is a chance to show off what you can do. Always remember that your powder room deserves as much design consideration as any other key public space—when you have guests over, it will be their refuge when they need to get away for a bit.

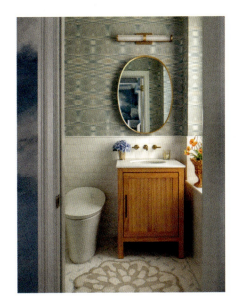

WALL COVERINGS
When it comes to dressing up the walls, you can go big with pattern, you can go big with color, and you can be super-moody, if you want. Don't be afraid to splurge with a more expensive wall covering, because you'll only need a tiny amount of it. It can give you the wow factor you desire, in a place where everyone can really enjoy it, and it can still fall within a reasonable budget.

DECORATIVE LIGHTING
Are you dreaming of a dramatic crystal chandelier in your powder room? Go for it! (And if there isn't enough ceiling height, a striking flush-mount fixture will certainly do.) Pendants and sconces are great, too—especially over a vanity—to throw a warm glow on your guests' faces. Be careful about placement, however: sconces flanking the mirror should be set back far enough over the vanity that people won't bump into them. And avoid light bulbs that will cast a blinding glare in people's eyes. Frosted bulbs are a nice touch.

WAINSCOTING
Are you in love with a fabulous wallpaper that is not damp-rated? If so, be mindful of the splash factor around the sink and toilet. Installing wainscoting of some sort, whether stone, wood, or painted drywall, creates a protective perimeter around the room. Wainscoting also adds another layer of visual interest and extra dimension—making it a feature that's beautiful and practical at the same time.

MIRRORS
Use reflections to make a statement. An oversize mirror above the vanity can make a narrow space appear deeper. A mirrored ceiling can make a small room feel larger. Even reflective vanity accoutrements—a polished-nickel soap dispenser or a brass tray for towels—will gleam, glint, and bounce light around, creating a brighter, airier feeling.

STORAGE
I know how sleek and glamorous pedestal sinks can be, but if you don't have adequate space for necessities, this may be an area where form must cede to function. Alternatively, consider adding a small what-not or simple glass shelf beneath the vanity mirror.

OPPOSITE: This tiny powder room makes an unforgettable impression from top to bottom, with its Gracie tiger-stripe wallpaper, ebony-stained wainscoting, marble-block sink, and basket-weave tile floor. The globe sconces are filled with water. ABOVE: Another small bath has a similar diversity of elements but in quieter colors.

Coastal Cosmopolitan

The New York City–based owners of this second home in Bridgehampton, on the South Fork of Long Island, discovered my work while watching my MasterClass streaming series *Corey Damen Jenkins Teaches Interior Design*. After viewing the twelve-part curriculum together, they were convinced that I would "get" their style and help them reimagine their new abode outside the city.

The wife had been attracted to the residence's large, mostly white spaces and wanted to maintain a traditional "Hamptons coastal" vibe. The husband desired something more metropolitan, like a swanky Manhattan hotel—complete with a dash of glitz and glamour. My firm was tasked with overseeing the complete renovation of the home's three stories and creating a look that celebrated the tension point where city and shore meet.

I've never subscribed to the mentality that everything from a client's previous existence must go simply so I can make my own statement as a designer. I believe in design democracy: in other words, every project should be a joint undertaking between myself and the client, and everyone gets a vote. The best way to make a house become a genuine home is to bring elements of the owners' lives forward

Glints of brass and masculine textiles, such as plaids and pinstripes, rub shoulders in the husband's office. The room's walls are clad in what appear to be polished slabs of agate.

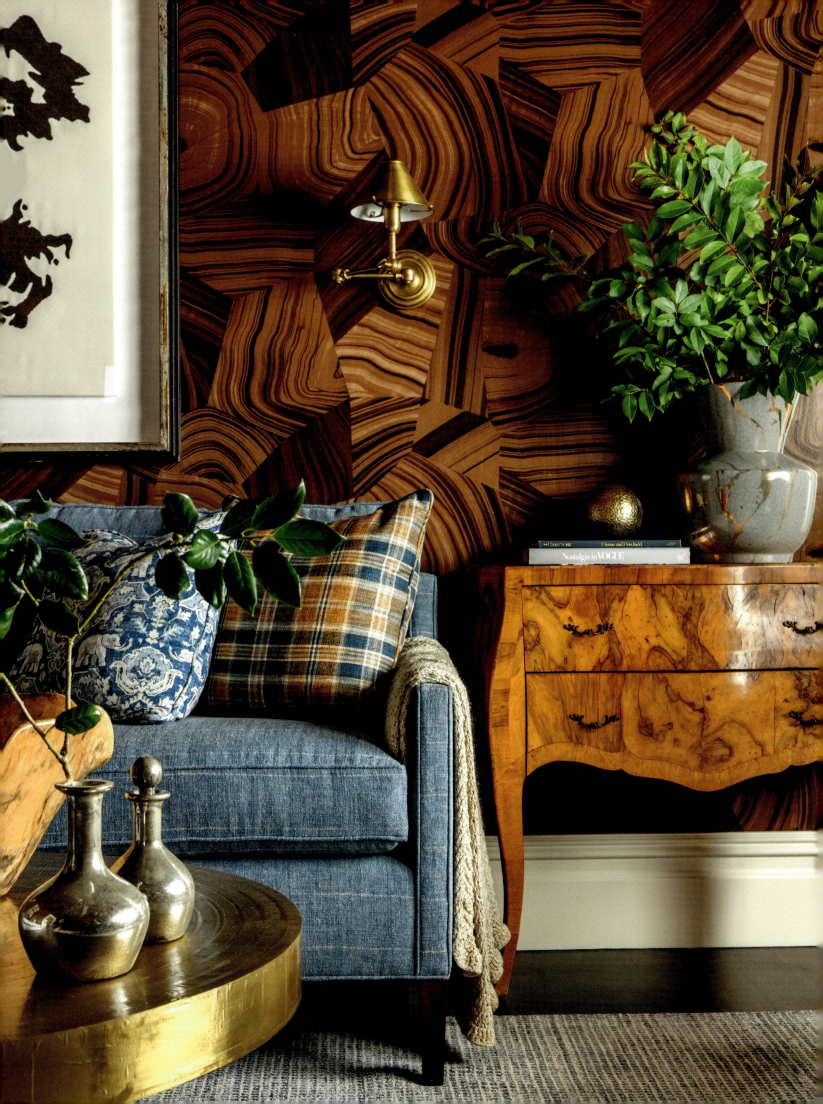

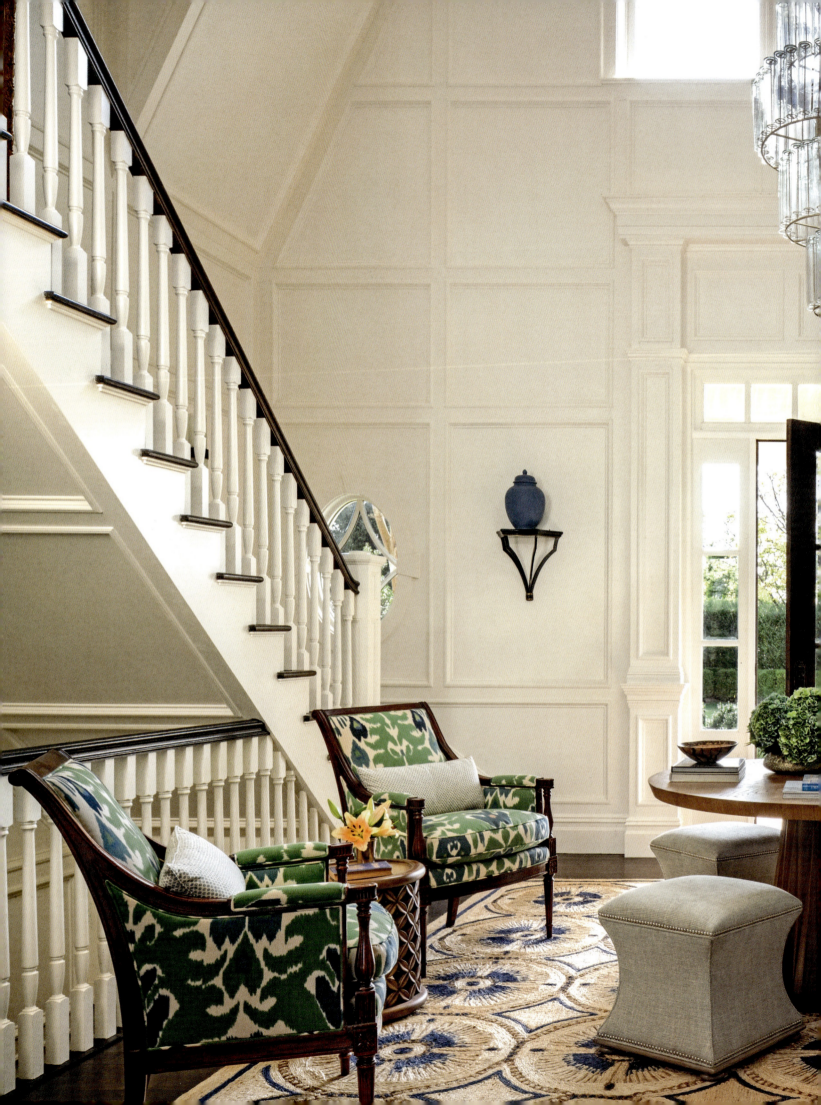

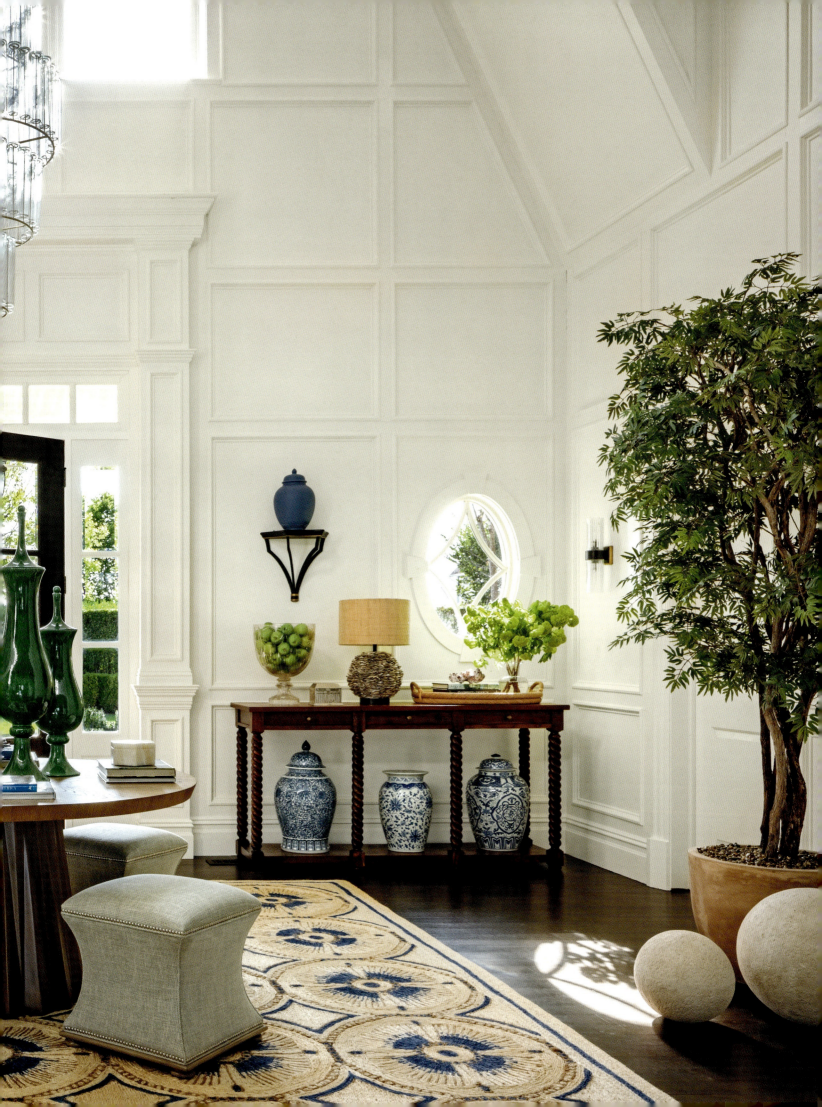

into its new design and wholeheartedly embrace certain items the clients may already own. This house had been purchased fully furnished, so we conducted a careful edit of the inventory and kept a small selection of pieces that we reupholstered in fresh new fabrics. Next, we added meaningful items from the family's Manhattan home. Finally, we layered in numerous custom designs, new furnishings, and fine art to complete each room.

Since the home's existing architectural envelope was quite traditional, we took a big first step toward modernity by rethinking the decorative lighting choices. A lot of the previous fixtures had been as traditional as the millwork—and we replaced them with art deco and Hollywood Regency motifs. To honor the community the house stands in, we added natural materials and finishes that allude to the beachy side of Hamptons life: jute rugs, cane and rattan, wicker baskets, warm woods, grass cloth. We chose fabrics in easygoing stripes, checks, and colorful ikat patterns. Direct references to the sea are sprinkled throughout, from seashell-encrusted boxes and lamps to a brass crab and a model sailboat—a family heirloom that we had refurbished to occupy a place of honor in the living room.

There's also a deliberate thread of 1960s and 1970s retro nostalgia running through the spaces, which is especially noticeable in the family lounge. Crisp white wainscoting and trim help keep the home's interiors airy, while brightly hued ceilings and patterned wall coverings ensure that the rooms, as big as many of them are, never come off as cold or cavernous. A limited palette of accent colors, variously blue, green, caramel, or chocolate, adds just enough vibrance.

The juxtaposition of contemporary chic and classic comfort continues in every part of the residence, playing out differently each time. The grand entryway's paneled walls form a decorous backdrop for a showstopping

PRECEDING SPREAD AND OPPOSITE: The home's entryway is very large, so one goal was to give it some warmth and make it feel cozy. A dynamic abaca rug and four custom tweed-covered ottomans add texture; the ikat-clad armchairs contribute bold color and pattern.

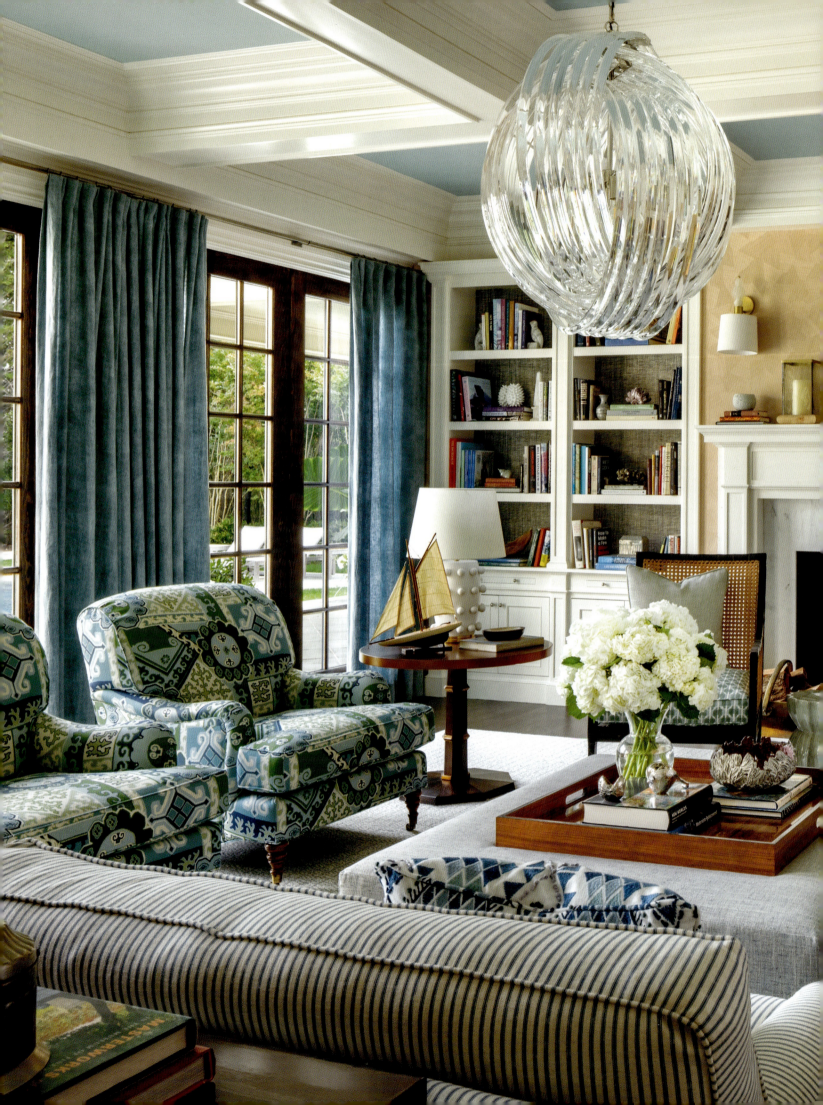

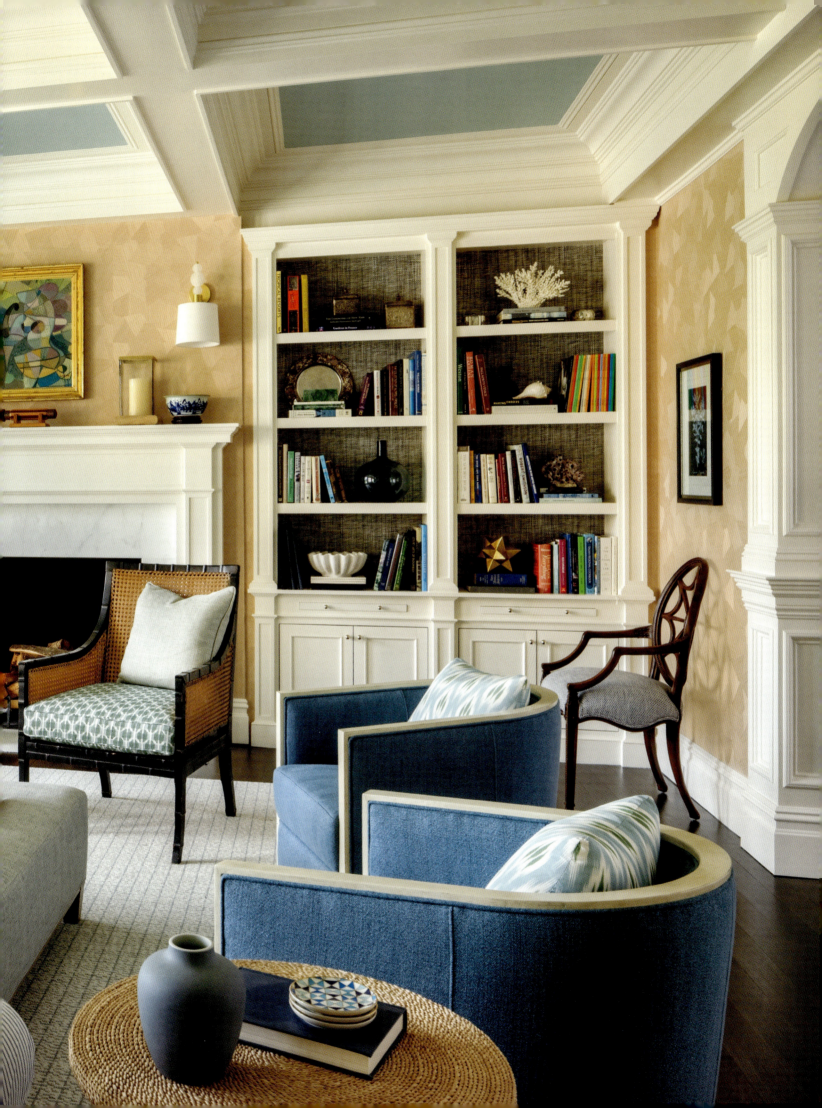

PRECEDING SPREAD: The living room neatly walks the line between urban chic and coastal casual. The walls are covered in an irregular geometric wood veneer, surrounding a comfortably "collected" assortment of furniture. The open display shelves are backed with a contrasting grass cloth. The painting above the fireplace is by Lucia Lopez. RIGHT: Caned armchairs, woven side tables, and a charming wicker pagoda supply warmth amid an overall palette of blues, whites, and apple greens.

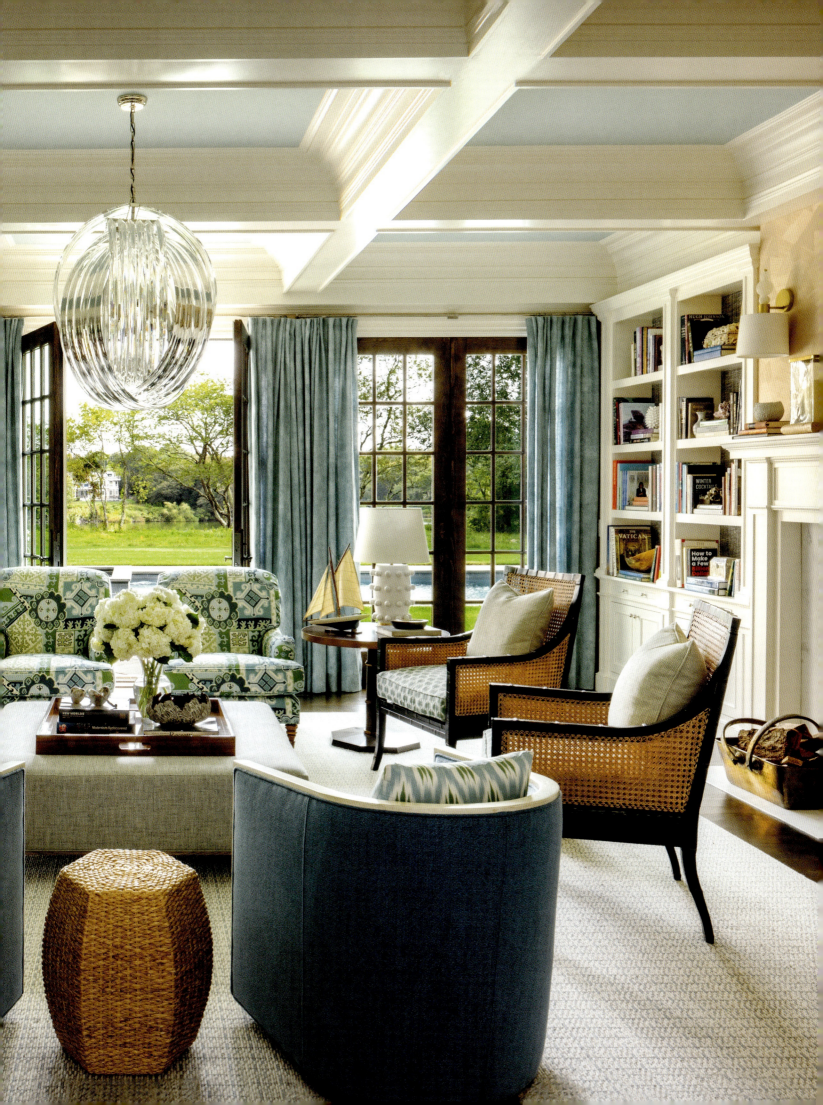

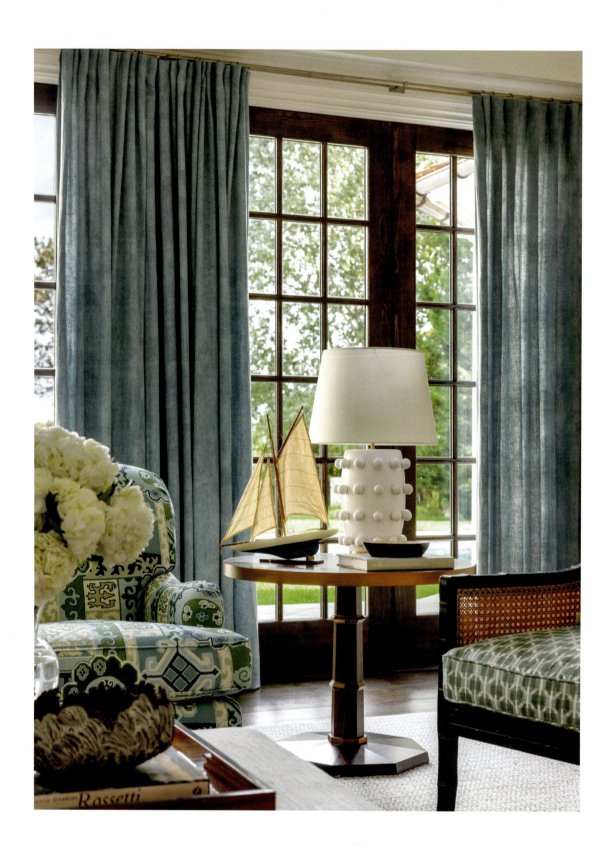

ABOVE: The model sailboat is an antique that has been in the family for quite some time; we had it repaired and refurbished to serve as a focal point here. The chair fabrics have a funky retro feel. OPPOSITE: The lacquered-walnut console table that backs up to the sofa adds a layer of modernity to the room.

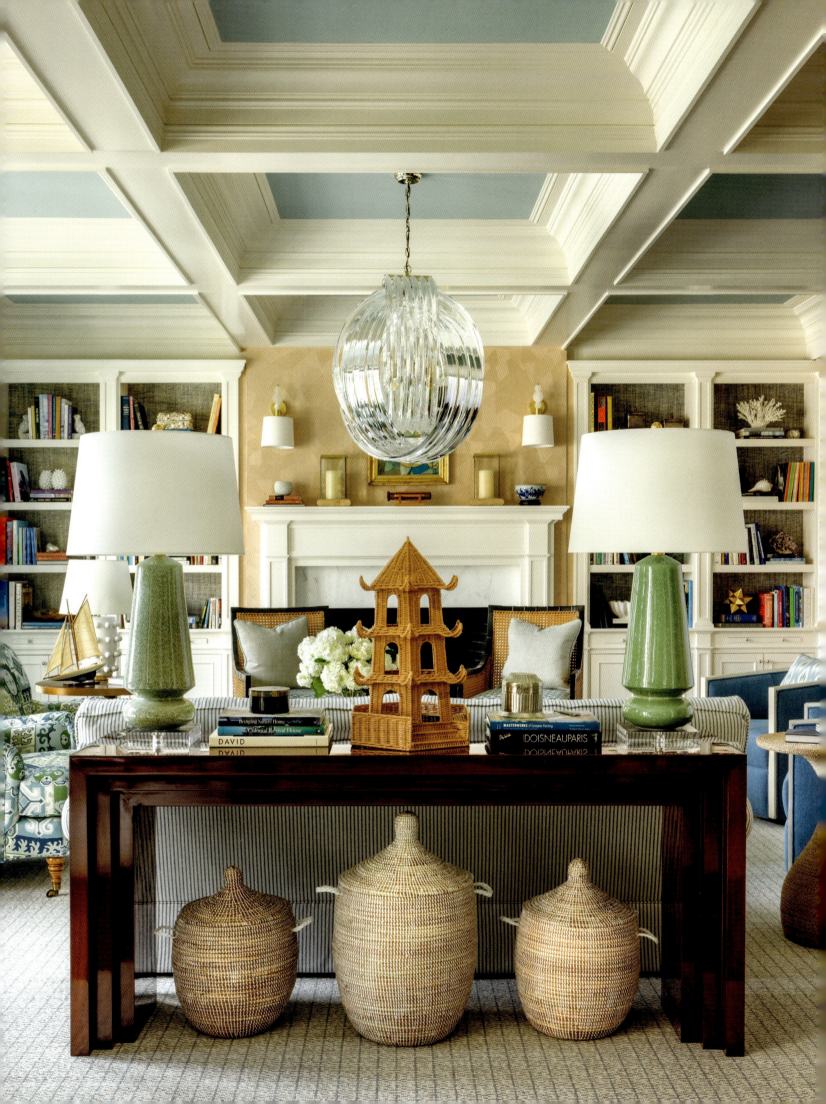

Moroccan-flavored abaca rug. A sculptural center table speaks to the husband's love of lacquered sleekness; a nearby pair of reupholstered armchairs reflects the wife's affinity for jewel-tone color combinations. In the living room, a clean-lined console table backs up to a skirted sofa wrapped in navy-and-white-striped cotton, while an eye-catching chandelier of interlocking acrylic loops floats overhead.

Whenever a designer repurposes a client's personal possessions, it's important to handle such matters with care and empathy. As we installed the wife's office—a haven of feminine elegance, although even here the desk skews modern with its minimalist construction of satiny book-matched wood—I discovered four framed artworks that had been stored out of sight for years. Each drawing featured a floral bouquet with a date written beneath it. I didn't know that the dates had any particular significance, but I saw that the pieces would be a perfect match for her room. So, I had them hung together on one wall. When we unveiled the space the next day, the wife immediately spotted the drawings and was moved to tears. It turned out that the four pieces commemorated important milestones in her family's history, and she was deeply touched to see them prominently displayed in her private space.

Overall, it's the mingling of the refined with the informal that gives this project its fusion of energy and relaxed appeal, and that keeps the house from taking itself too seriously. We achieved the synthesis the clients were hoping for—one foot planted in town and the other set squarely at the shore—as a series of imaginative and beautiful variations on a consistent theme. And we did it in a way that authentically embodies the owners' individual pasts as well as their lives together.

OPPOSITE AND FOLLOWING SPREAD: The dining room's walls were upholstered in a floral chintz, and we had ice-blue drapes made to complement them. The ceiling was painted in the same hue for more architectural definition. The jute rug provides a soft foundation for the furnishings.

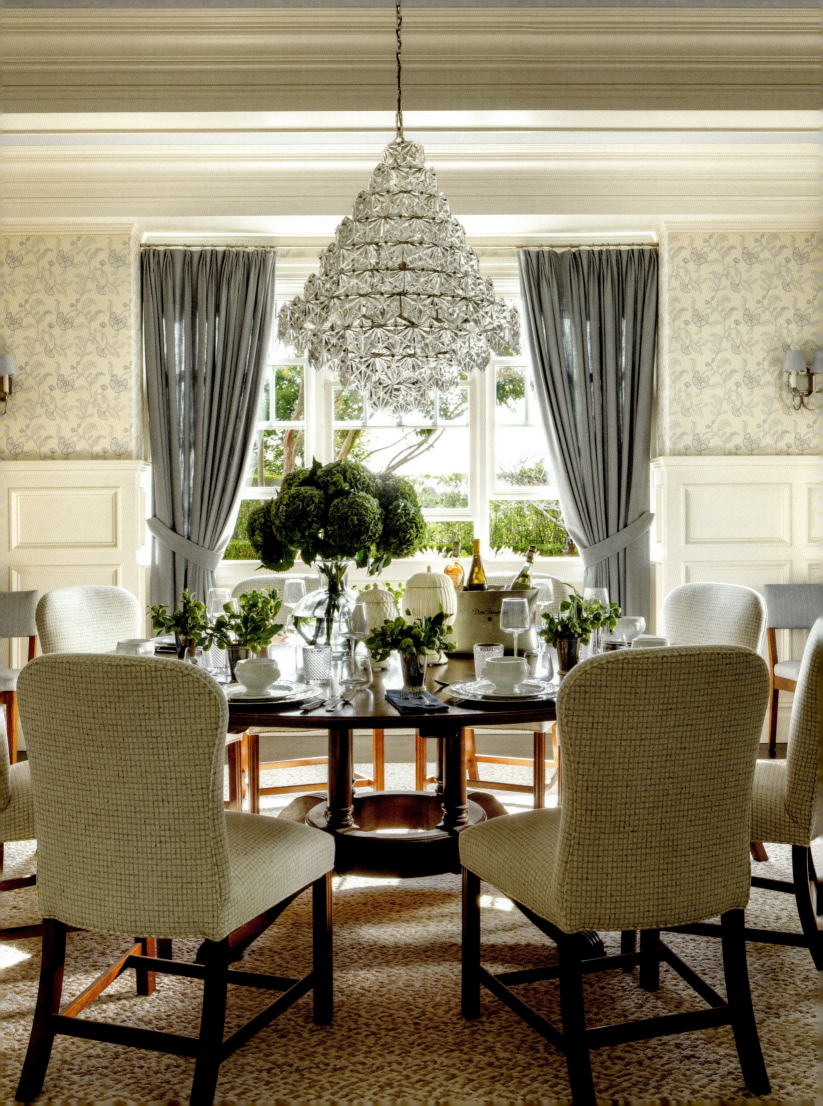

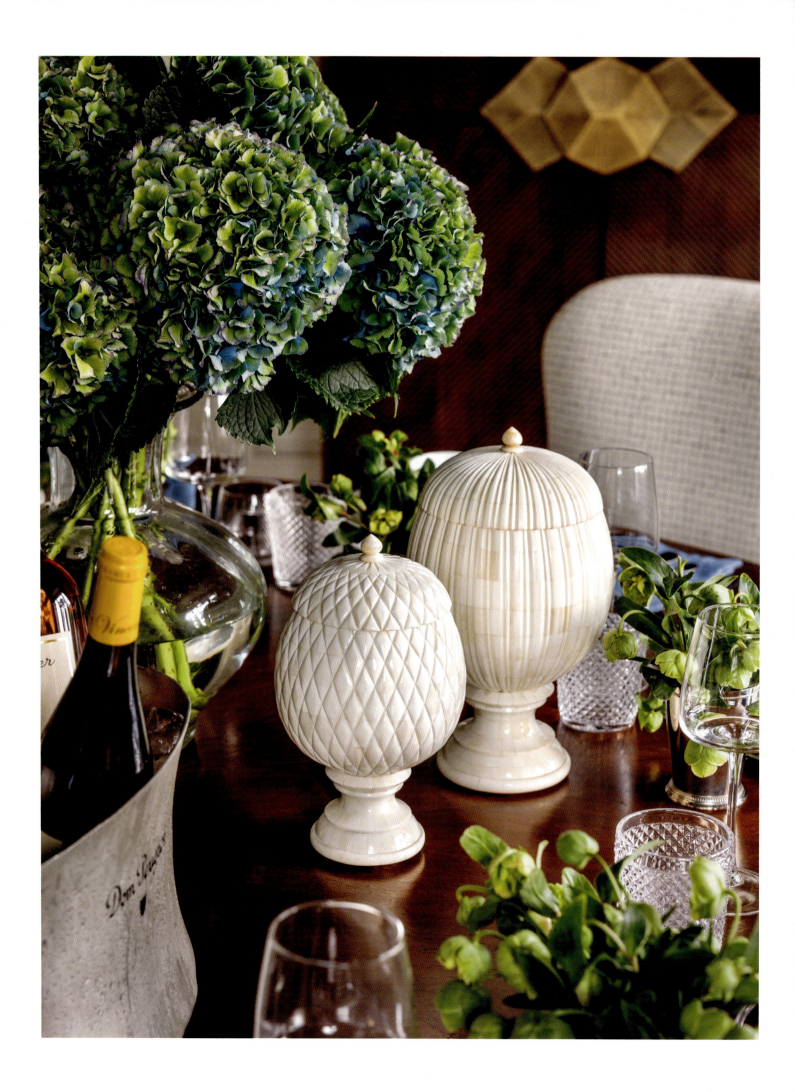

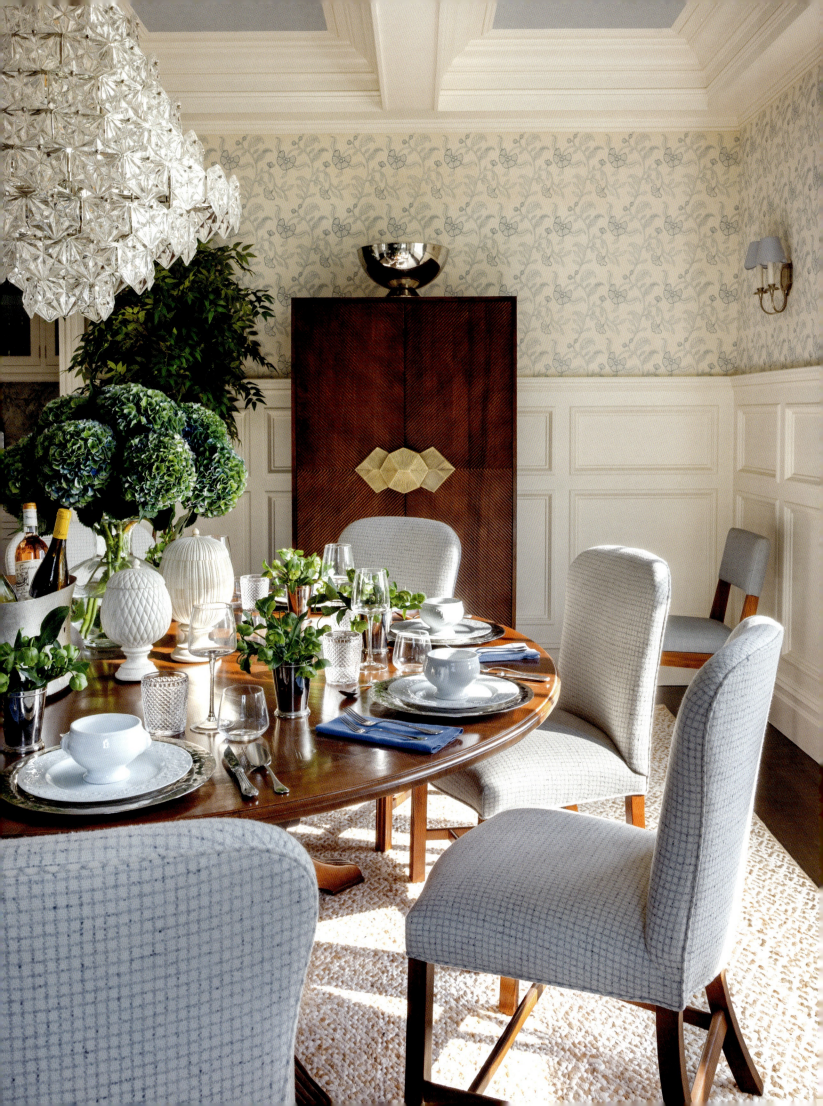

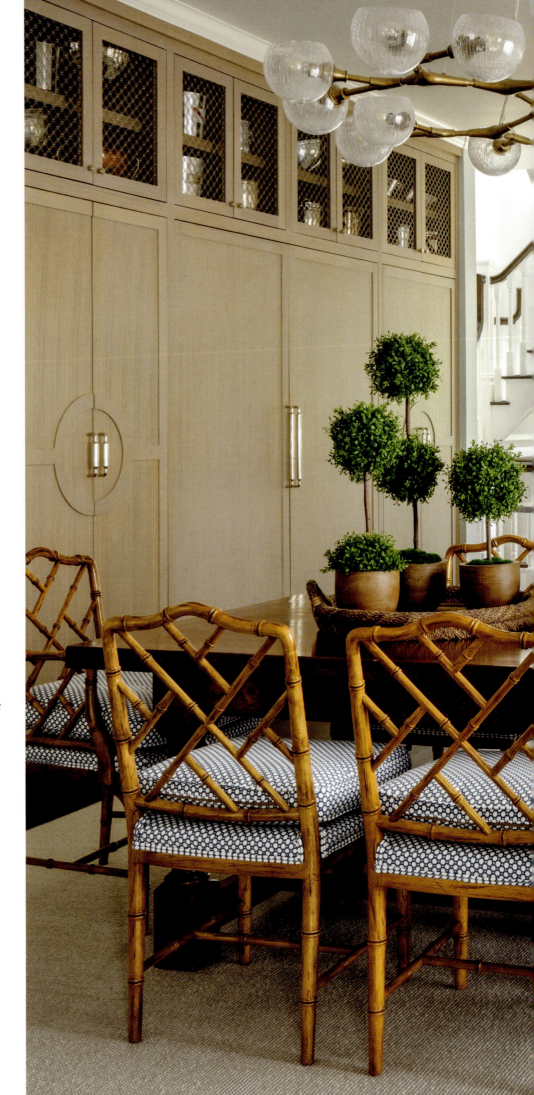

The kitchen's breakfast area features a chunky English table surrounded by fretwork chairs. Giving the classic "all-white kitchen" concept a twist, we designed the pecan-stained storage wall on the left to conceal the refrigerator, coffee maker, and other appliances. Two organically shaped chandeliers are juxtaposed against Shaker-style cabinetry and a dramatically figured marble used for the counters and backsplash.

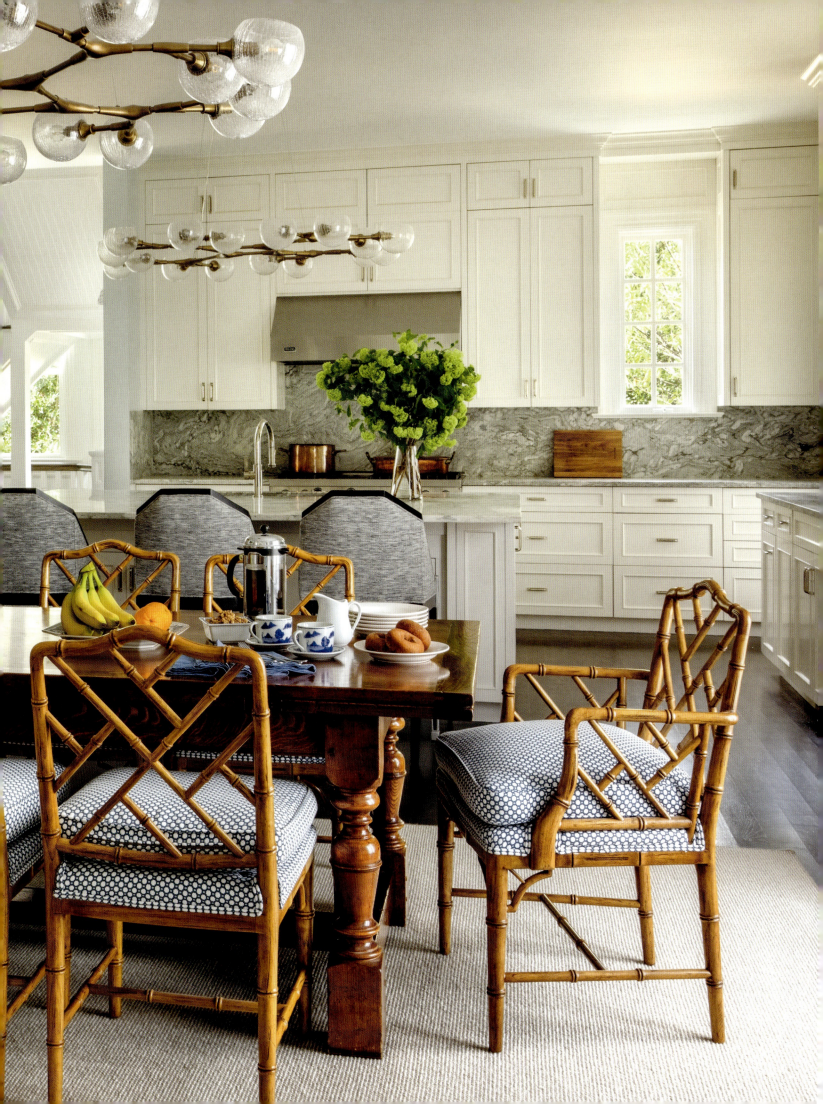

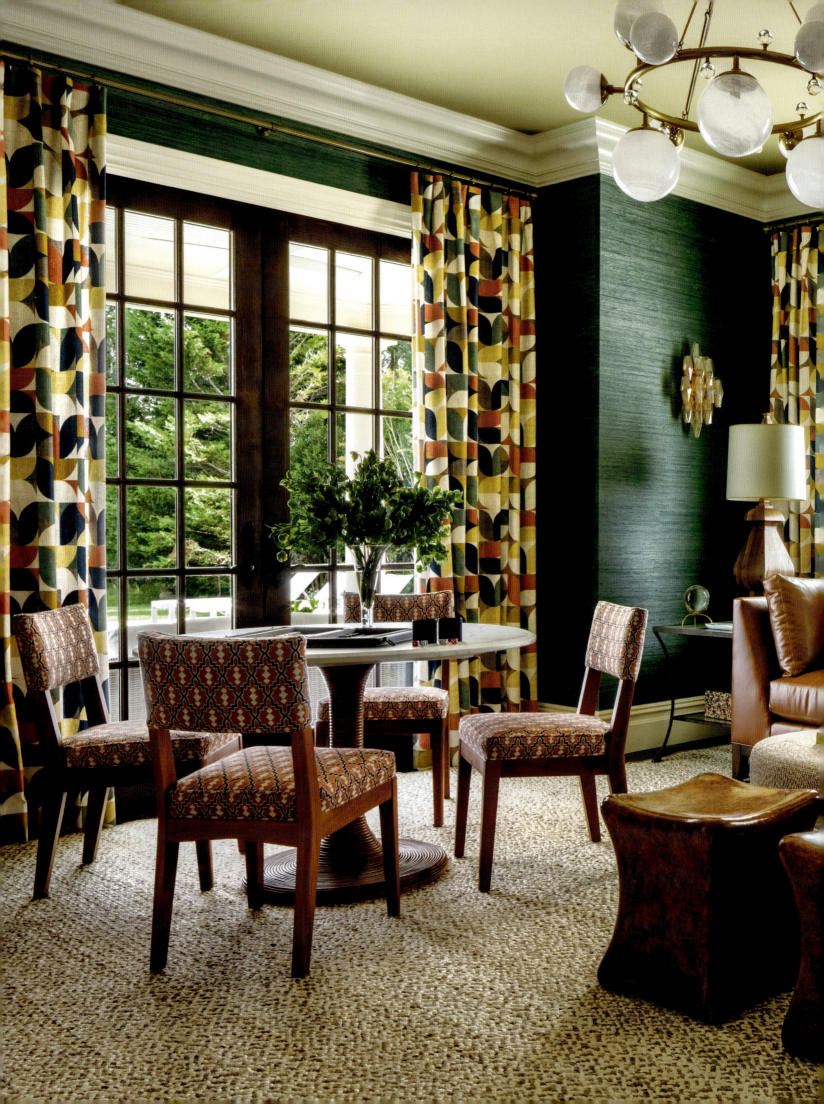

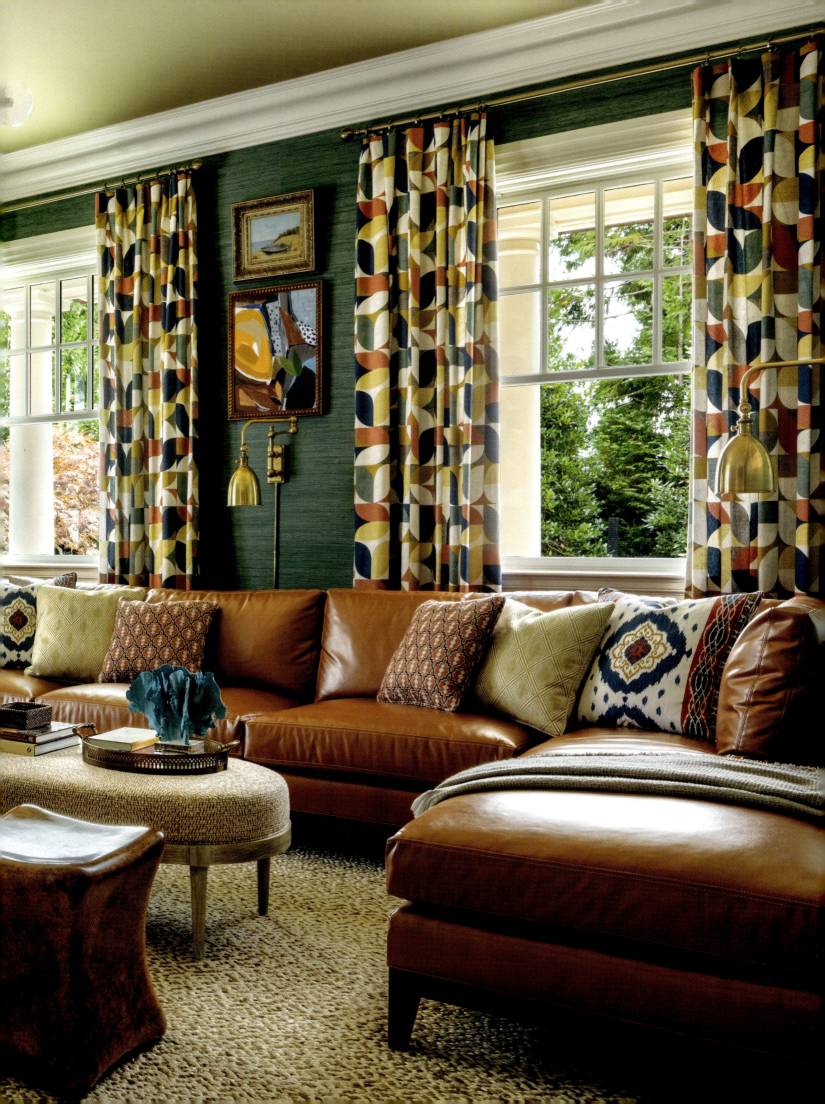

PRECEDING SPREAD: Nods to 1960s and 1970s fashion styles are strongest in the media room, where the family gathers to watch movies and play games. The big sectional sofa, upholstered in caramel-colored vegan leather, is great for lounging, and a pair of burl wood ottomans can be pulled over to wherever seating is needed. RIGHT: The cathedral-ceilinged principal bedroom is meant to be a place of respite for the owners, with its calm, monochromatic palette and walls adorned by tropical leaves and flowers.

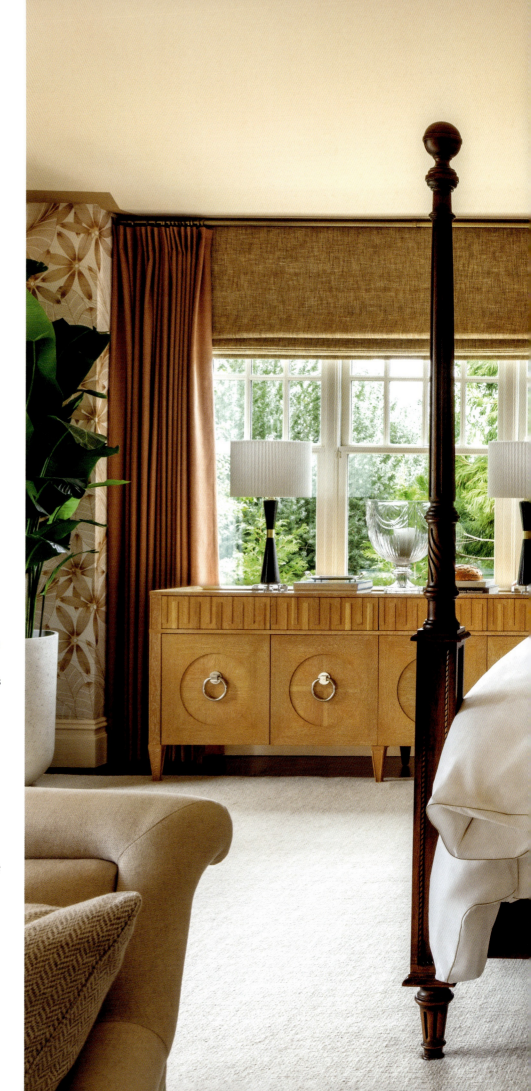

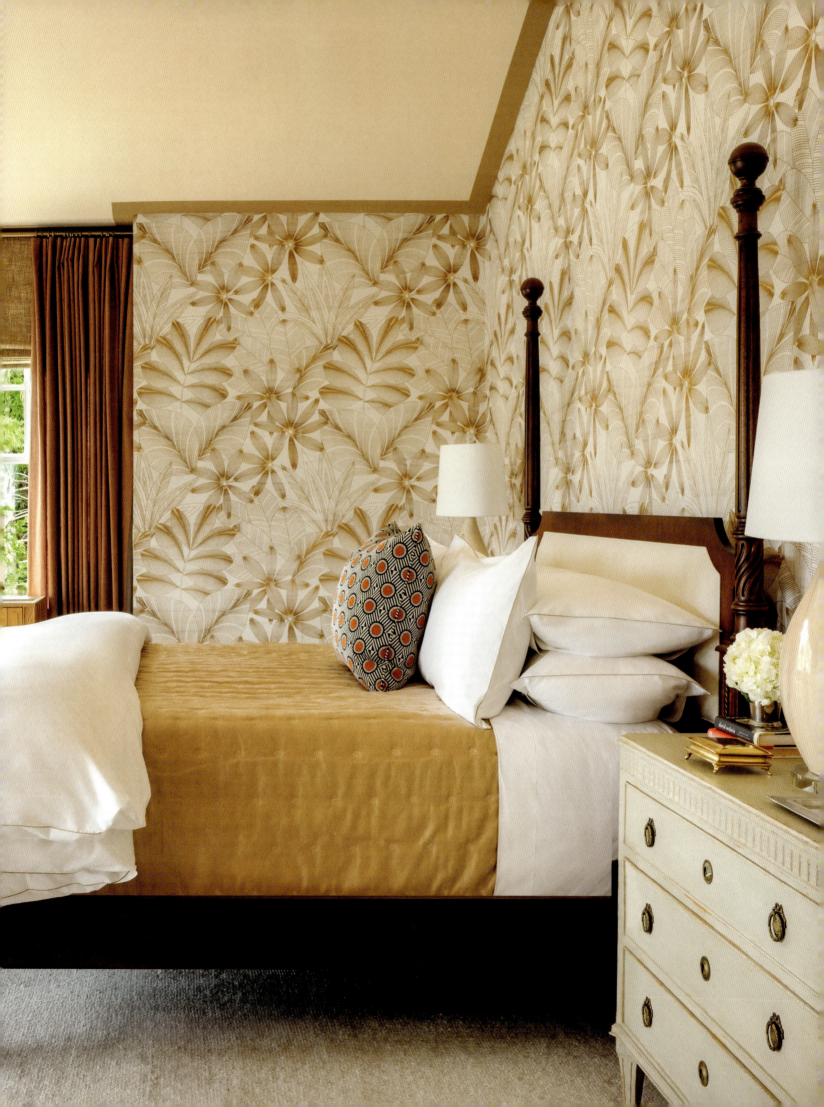

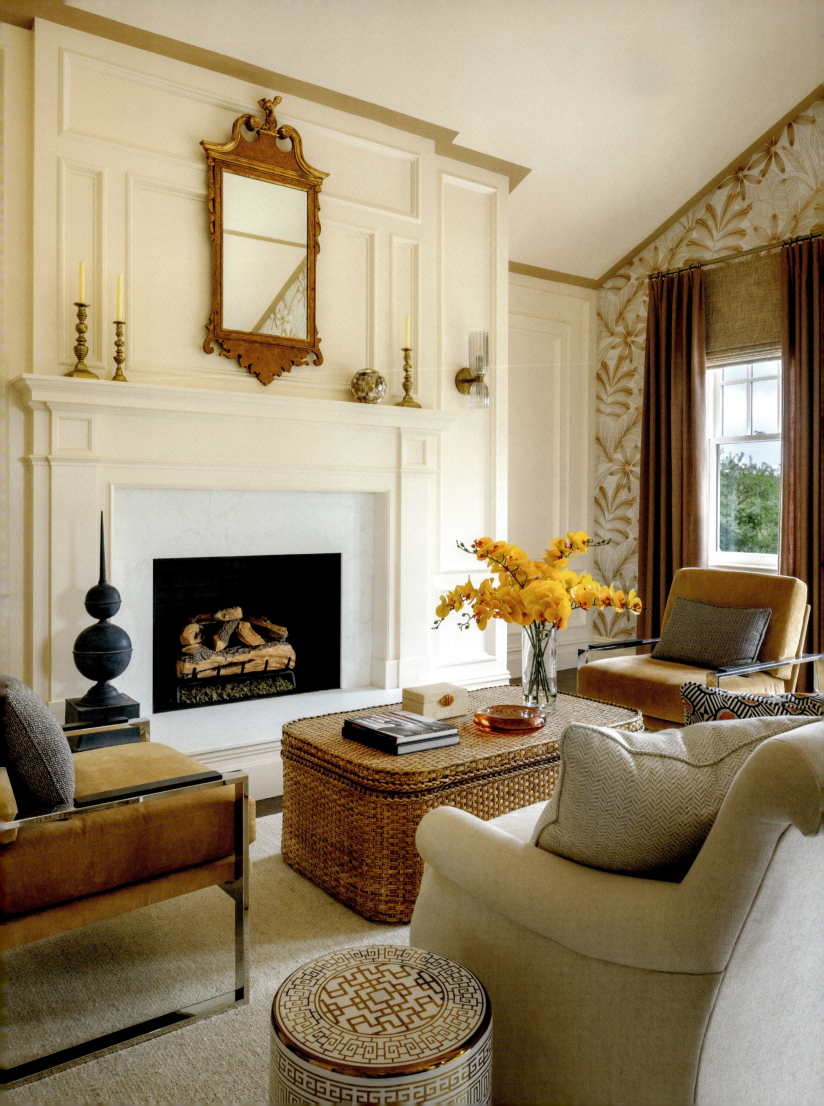

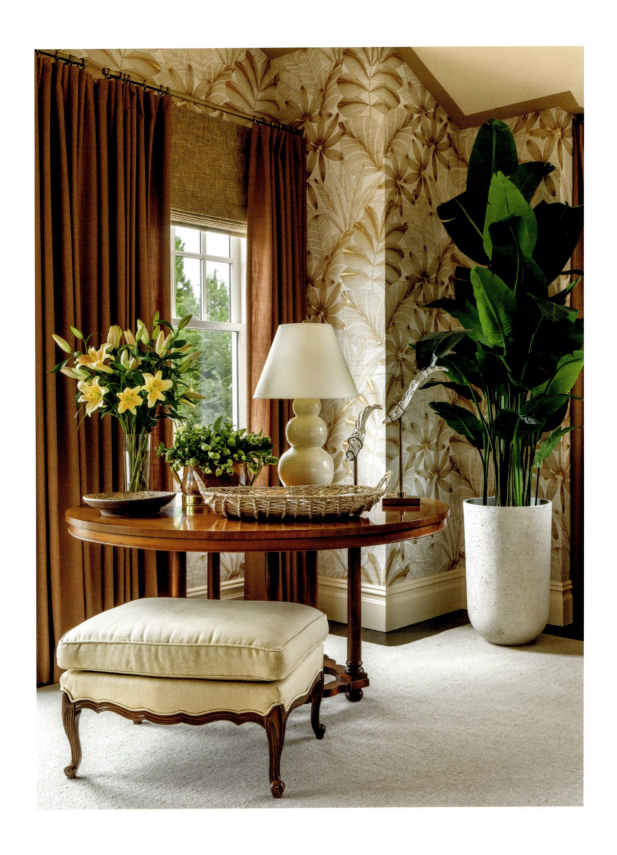

OPPOSITE: A seating group in front of the bedroom's fireplace includes two armchairs that impart a *Mad Men* vibe. A big wicker basket serves as a coffee table. I used a stripe of café au lait paint to set off the walls from the planes of the ceiling. ABOVE: A table and an upholstered ottoman convert an awkward corner into a pleasant place to perch for a while.

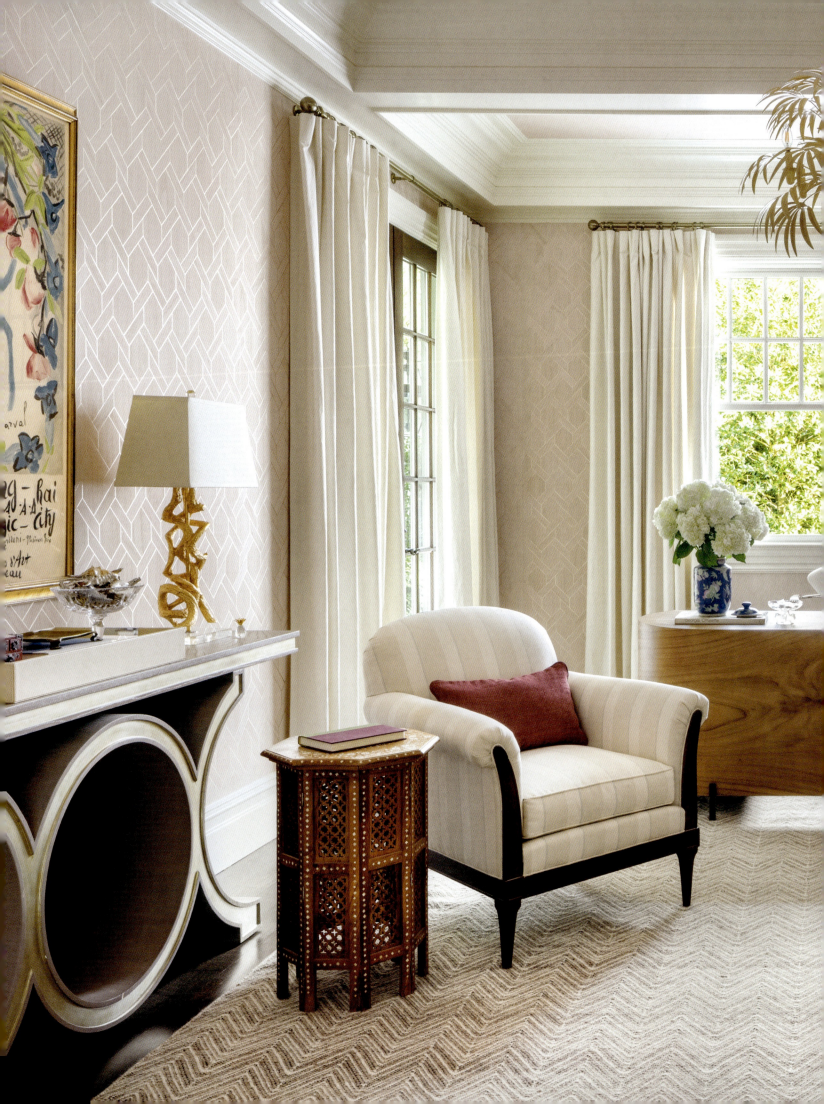

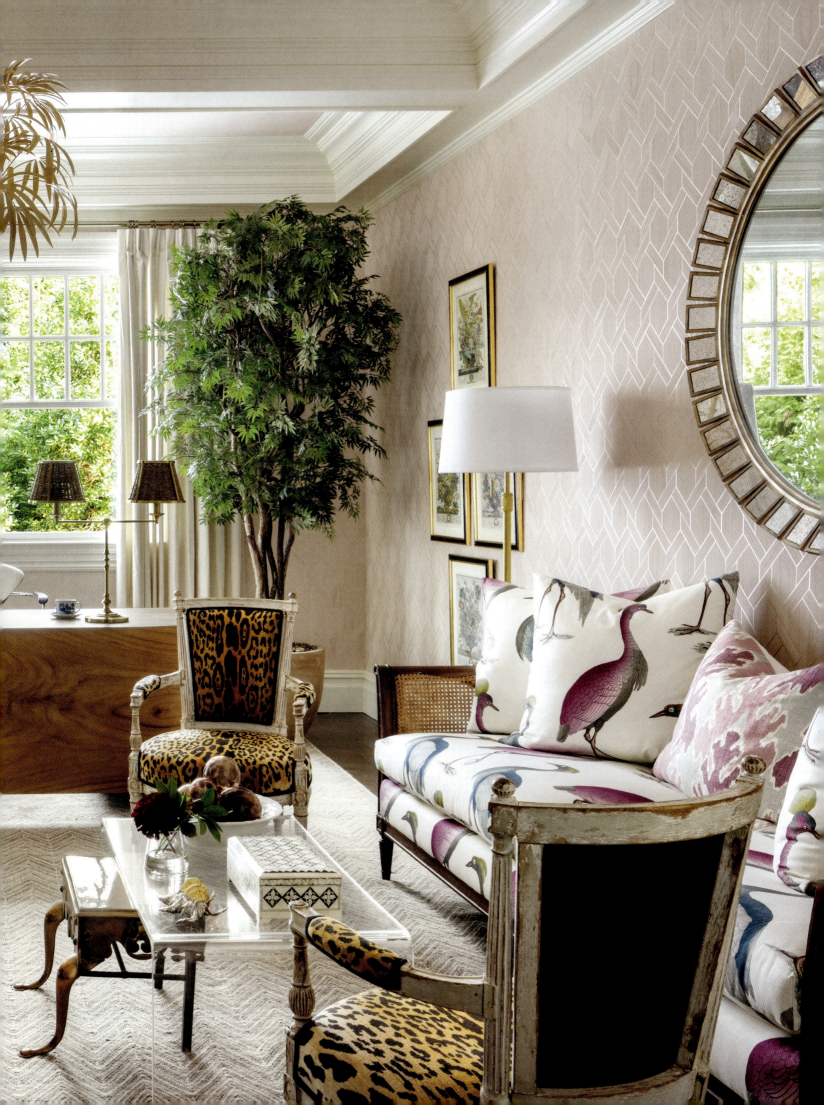

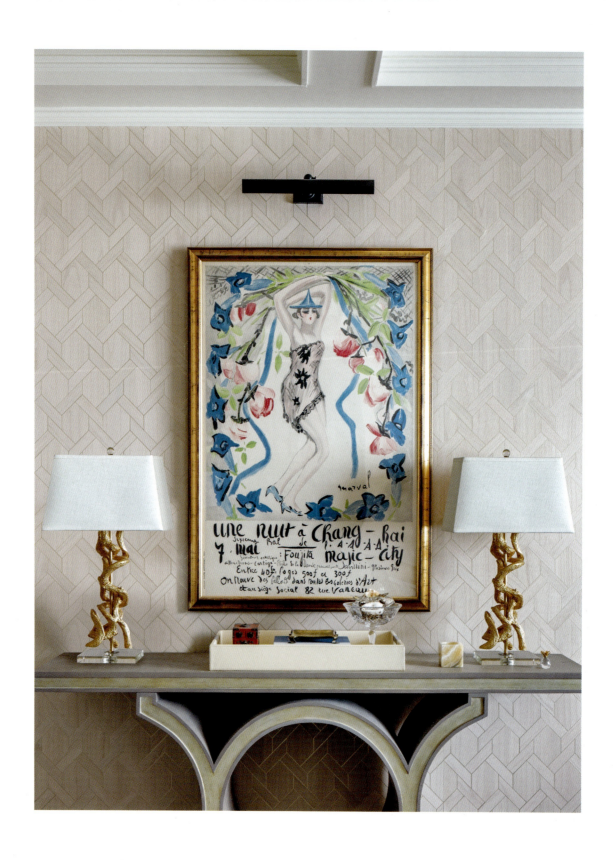

PRECEDING SPREAD: The wife's office is distinctly glamorous; a cane settee (which we re-covered in a fabric featuring oversize herons) and a Moroccan table add touches of rustic texture. ABOVE: This console was previously in a guest room upstairs. It makes a more impactful statement here. OPPOSITE: Circa-1770 Louis XVI chairs, outfitted in a Scalamandré leopard-print velvet, flank a streamlined Lucite coffee table.

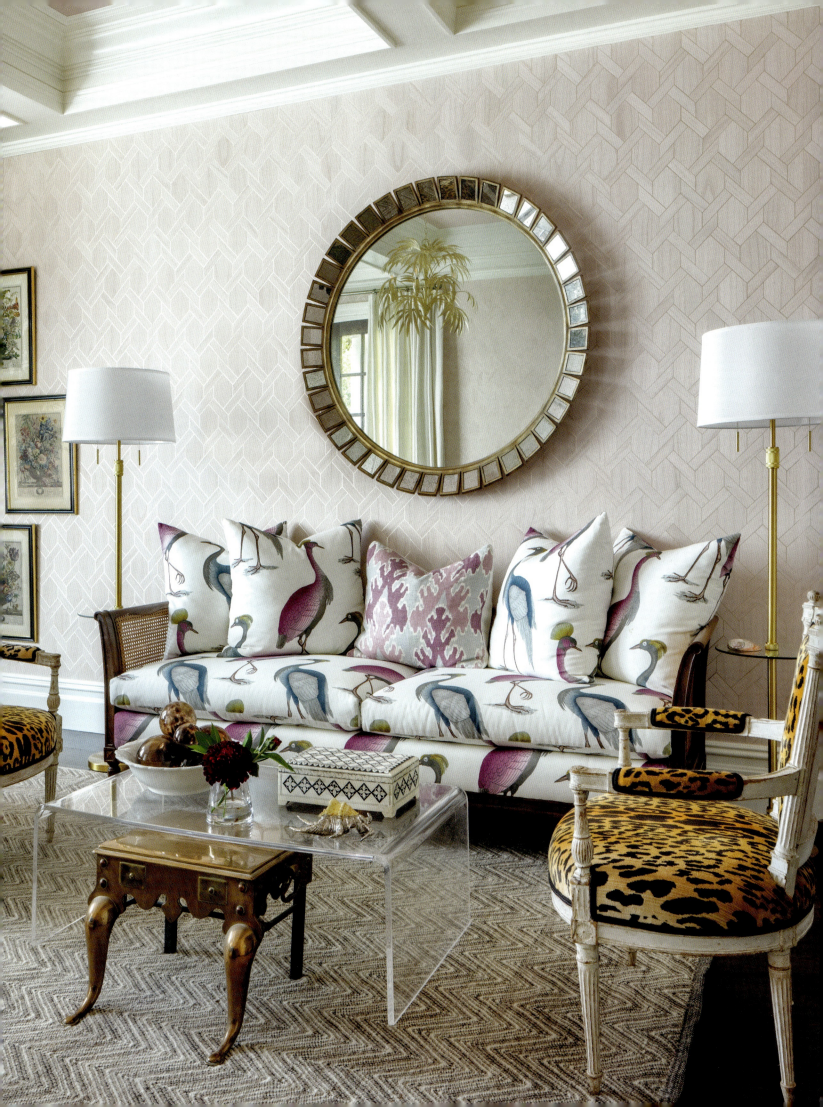

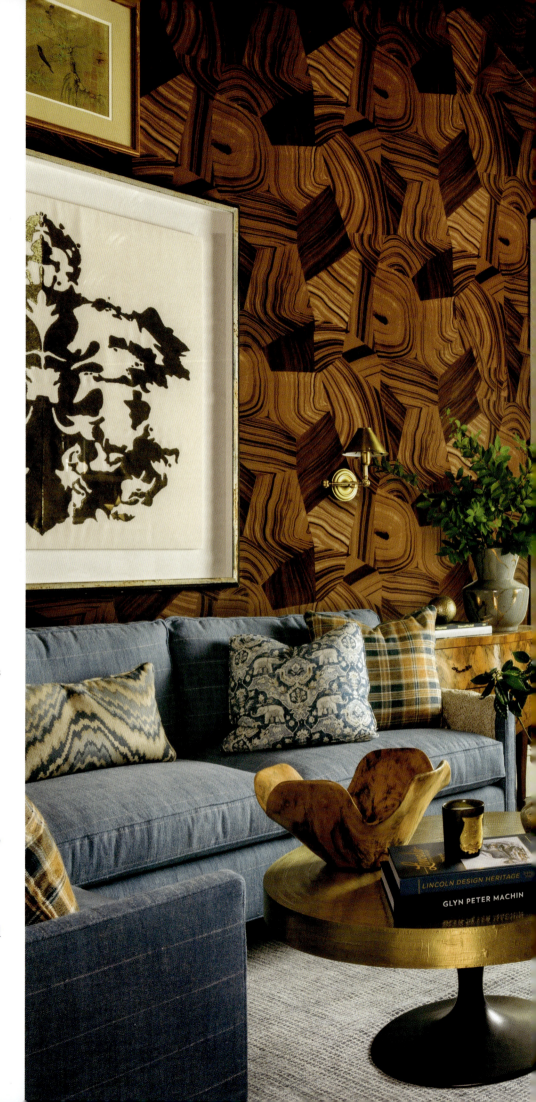

RIGHT: The husband's office is darker in tone than other parts of the house, yet far too tailored and fashion-forward to resemble a typical "man cave." The draperies are topped with a peplum design treatment: loose-fitting panels of blue cotton that match the sectional sofa's upholstery.
FOLLOWING SPREAD: Espresso walls, a ceiling the color of toasted almonds, and creamy white accents make this guest bedroom a rich retreat. The bleached bobbin-style bed provides a tinge of rusticity.

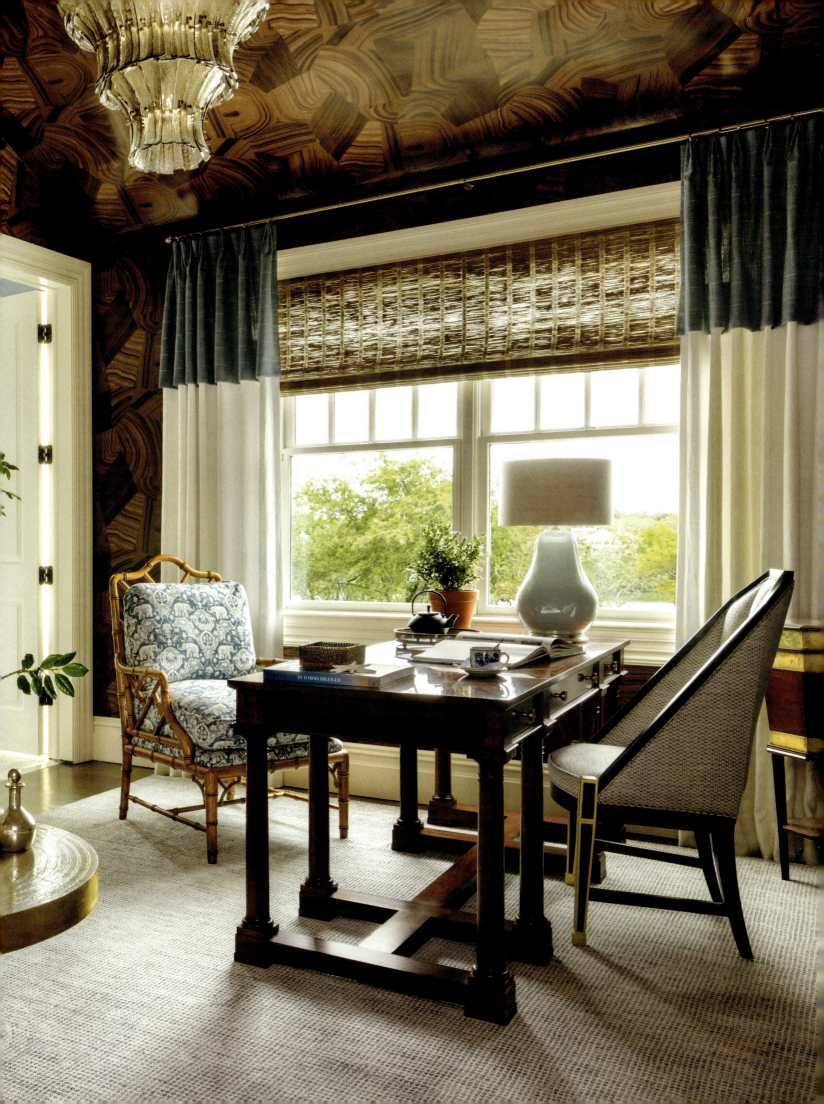

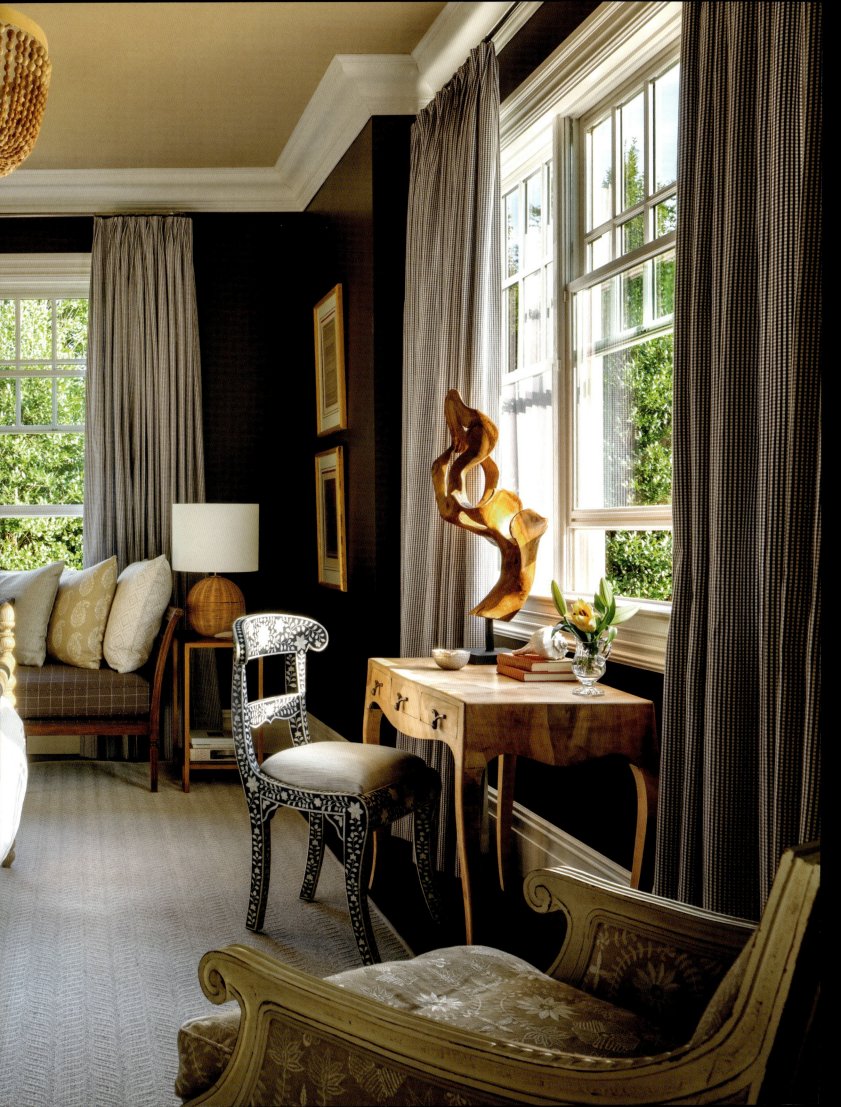

An Elegant Domain

For this stately, circa-1930s manse, the homeowners—a couple well known for their hosting—entrusted us with the gut renovation and redesign of their upper floors. We had been commissioned to refresh a number of the home's luxuriously grand ground-floor entertaining spaces, and were now tasked with creating a more private, personal experience specifically for the family and special visitors.

The private rooms begin at the second-story hall, which can double as a cozy setting for a casual breakfast or an intimate late-night supper. Poised between staircases at either end, the space houses a small octagonal table and a quartet of beautiful antique French chairs. The style here gives a glimpse of themes that continue to play out in the rooms beyond. Paneling and moldings were painted a lovely almond hue. We commissioned a husband-and-wife team of artists to first glaze the walls for added depth and richness, and then stencil a subtle harlequin pattern based on one of my sketches. A different pattern, of linked circles and vines, was brushed onto the periphery of the wood floor, executed entirely in colors drawn from the boards' grain so that it almost appears to be carved.

Many elements in this home are unapologetically classic—it's full of gorgeous antiques, busts, columns, and the like—but every now and then, little hints of modernity, like the double sconce here, pull this historic mansion forward into the twenty-first century.

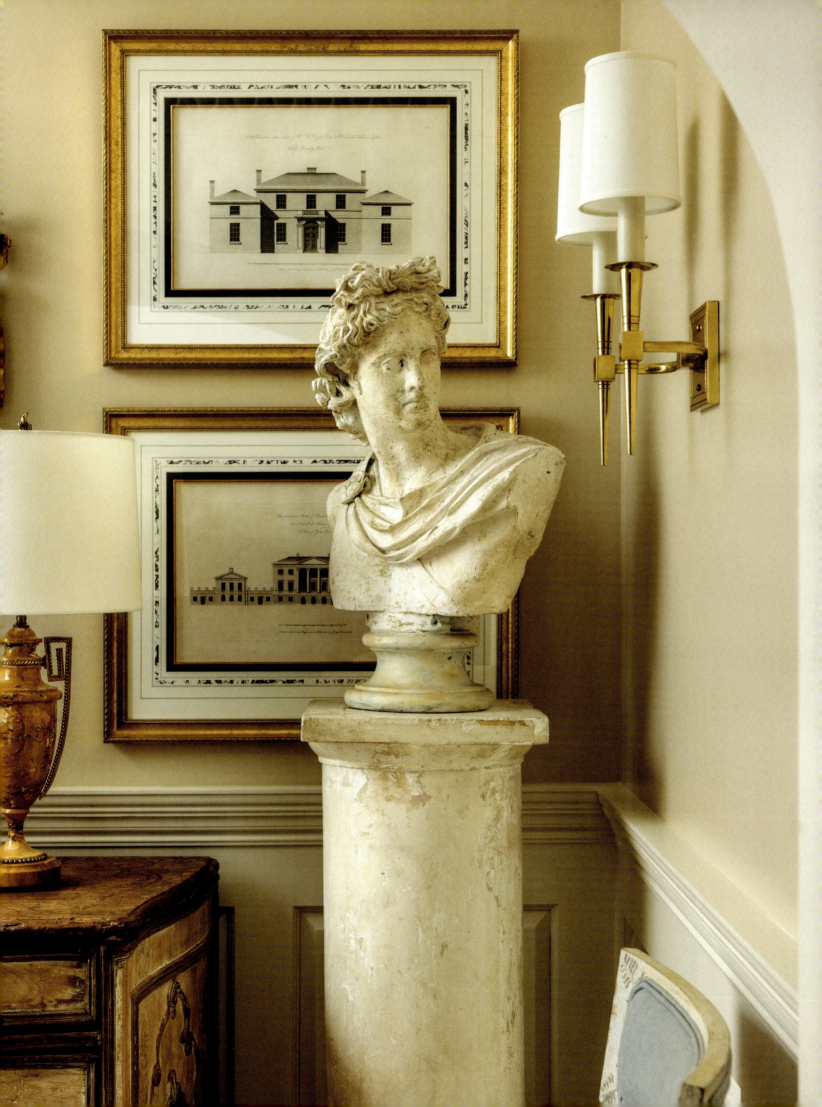

ABOVE: During an extensive gut renovation, we flipped this staircase's orientation to create a more generous walk-in closet in the principal bedroom. You would never guess, however, that the staircase wasn't originally constructed this way back in the 1930s.
OPPOSITE: An antique commode purchased at auction anchors a symmetrical composition on a stair landing. The onyx flush-mount ceiling fixture is another nod to modernity.

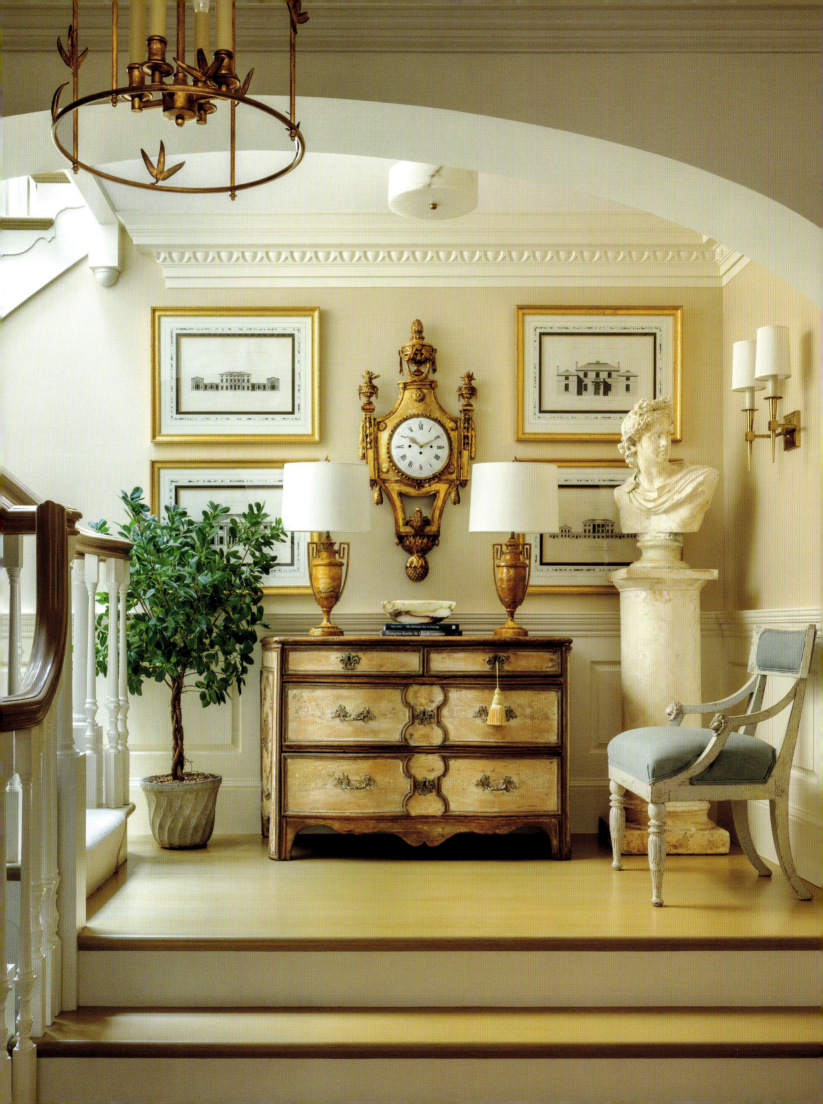

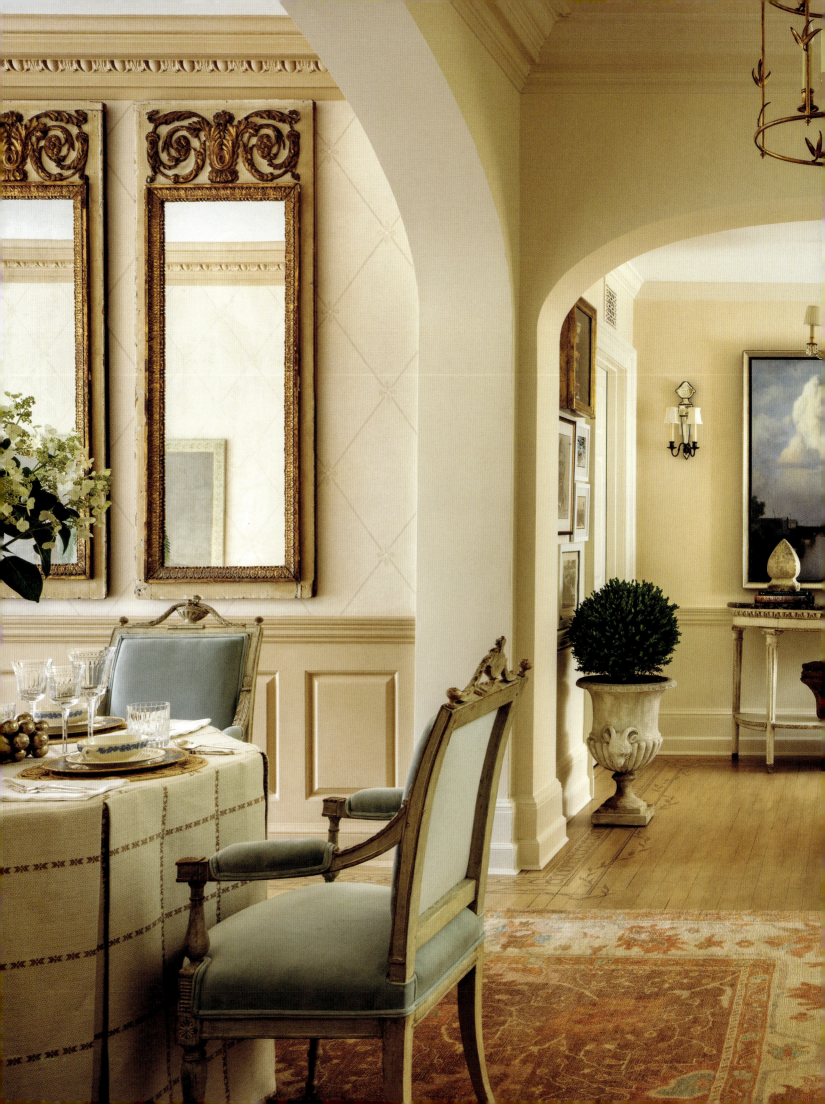

PRECEDING SPREAD: The home's private floors are a symphony of cream and taupe shades, enriched by subtle hand-painted glazes and patterns on the walls and floor. Sometimes people are afraid to paint architectural details anything other than white; I believe you can choose any color you want as long as there is a cohesive design plan behind it. The painting is by John Brandon Sills. RIGHT: An octagonal table on the second floor can serve as a site for meals with friends and family. The antique rug and overscale plaid fabric employed for the table skirt hug opposite ends of the style spectrum.

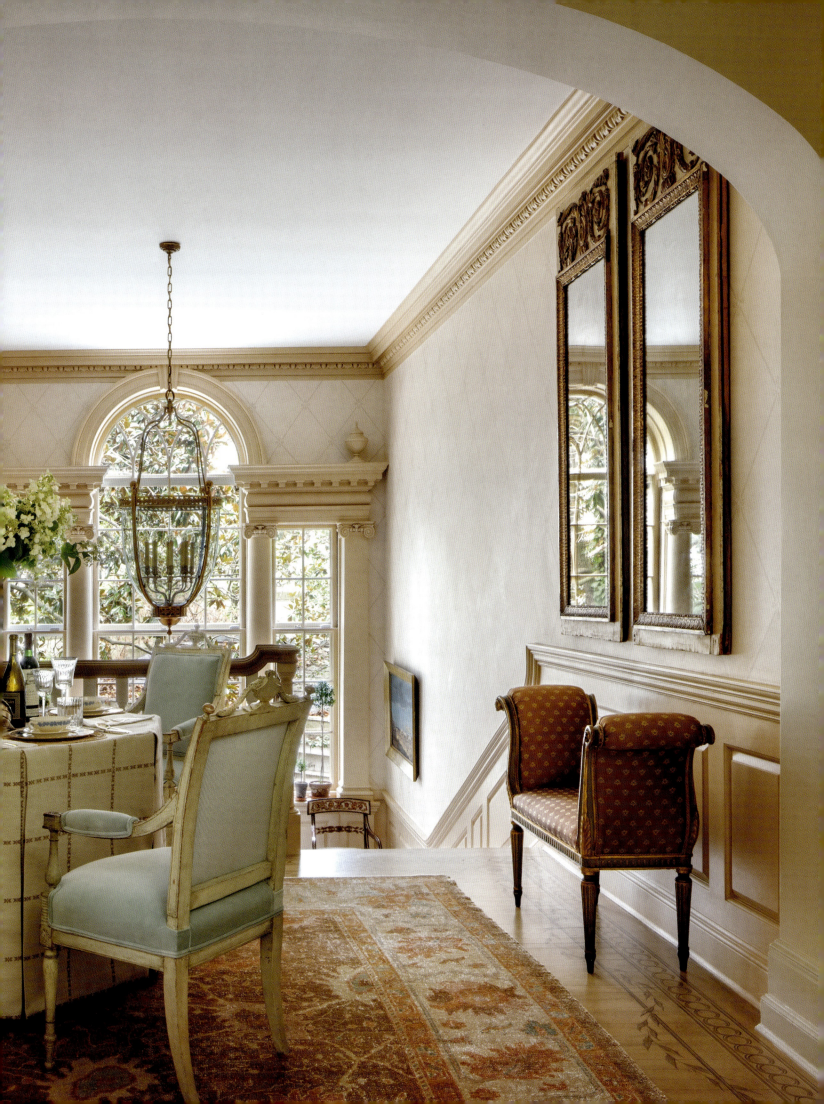

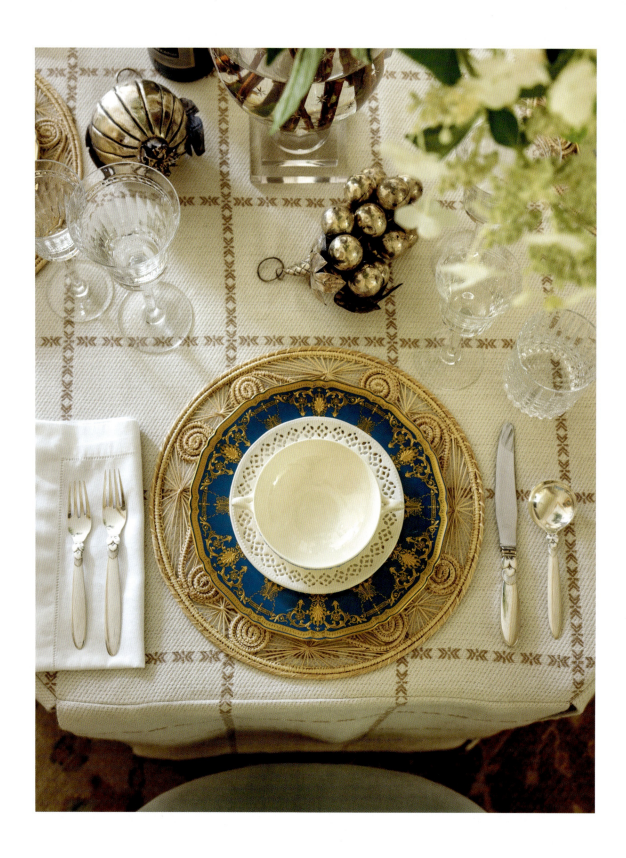

ABOVE AND OPPOSITE: I'm a constant advocate for repurposing things that people already have—they make the soul of a home so much more authentic to the owners' identities—but I rarely use them in the way they've been used before. All of the items on this table came from the family's collections, mixed and matched in my own fashion.

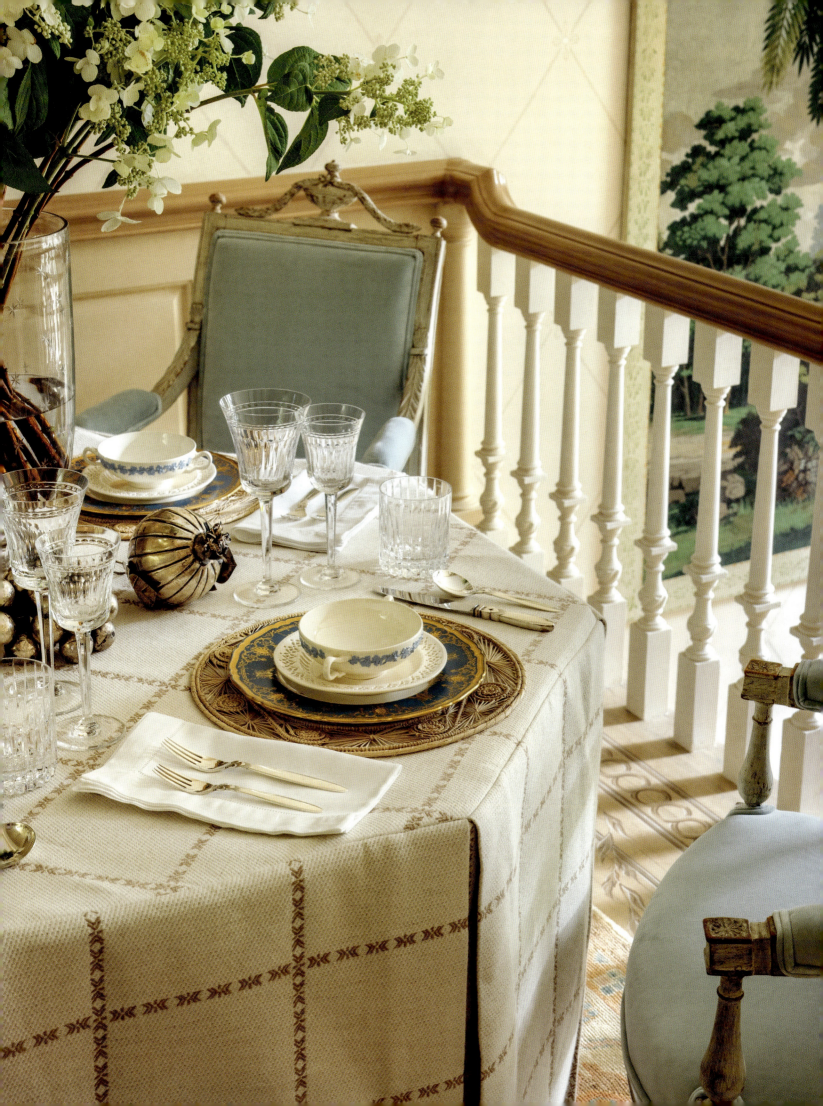

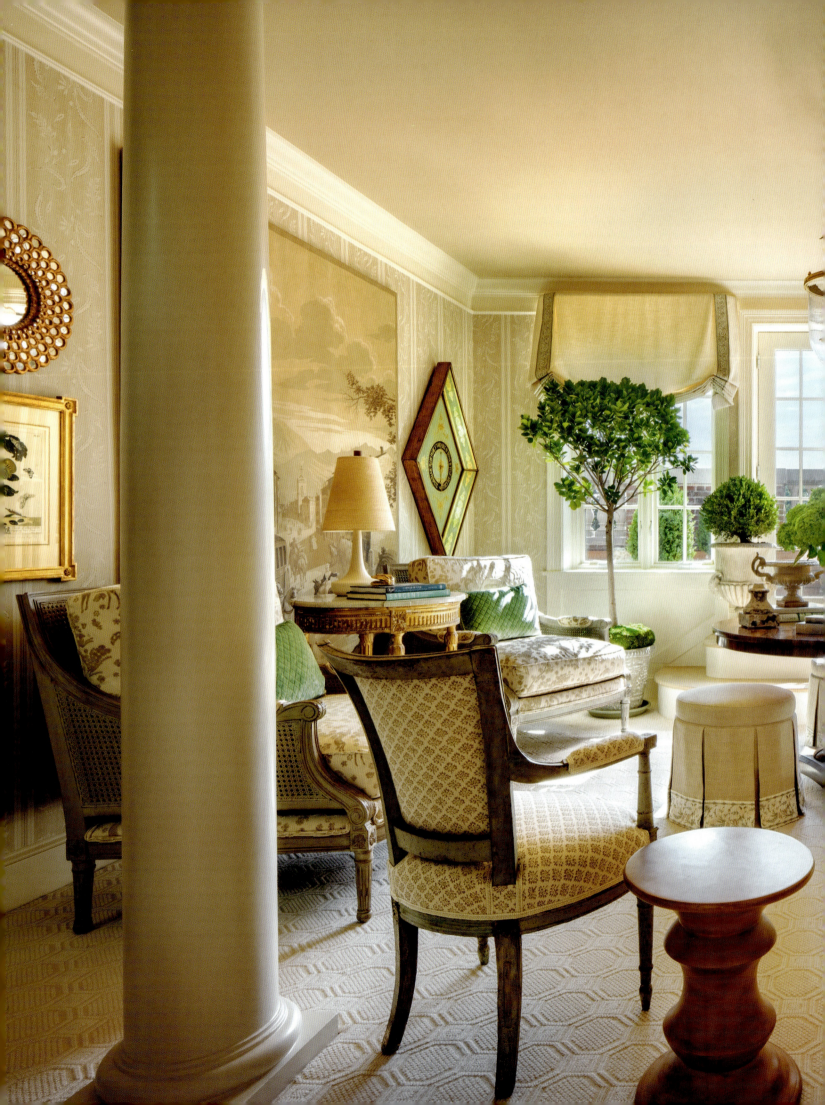

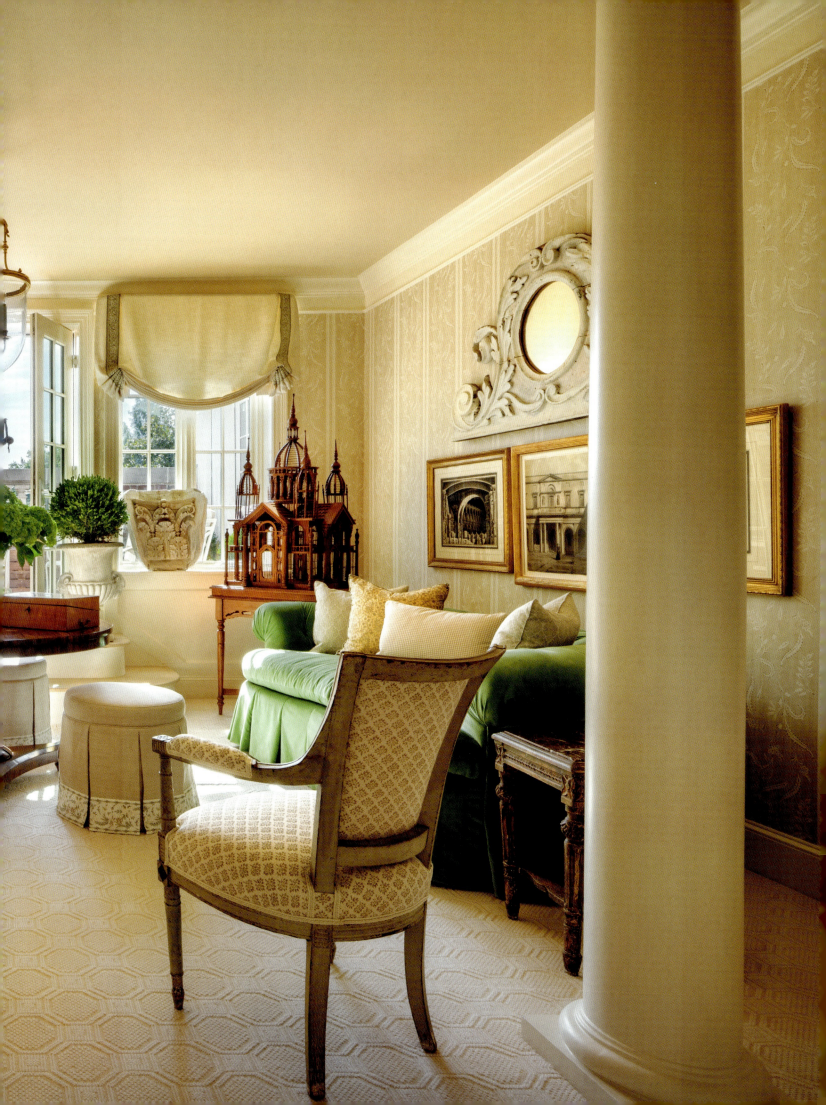

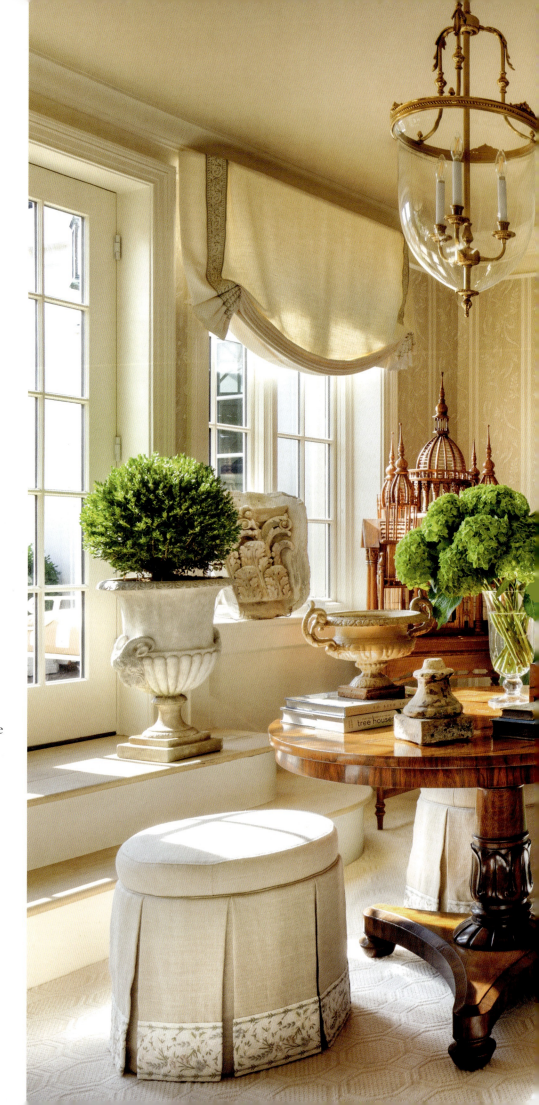

PRECEDING SPREAD AND RIGHT: The third-floor parlor gives guests a place to socialize and is designed to encourage multiple conversations. Luxurious seating is arranged on both sides, with a round center table serving as "connective tissue" to bring the groups together. The three ottomans have casters and can be rolled to wherever they're needed. The sofa was reupholstered in a voluptuous apple-green velvet. The clients have collected several antique birdhouses; I placed one here to soften this corner and serve as a sculptural conversation piece.

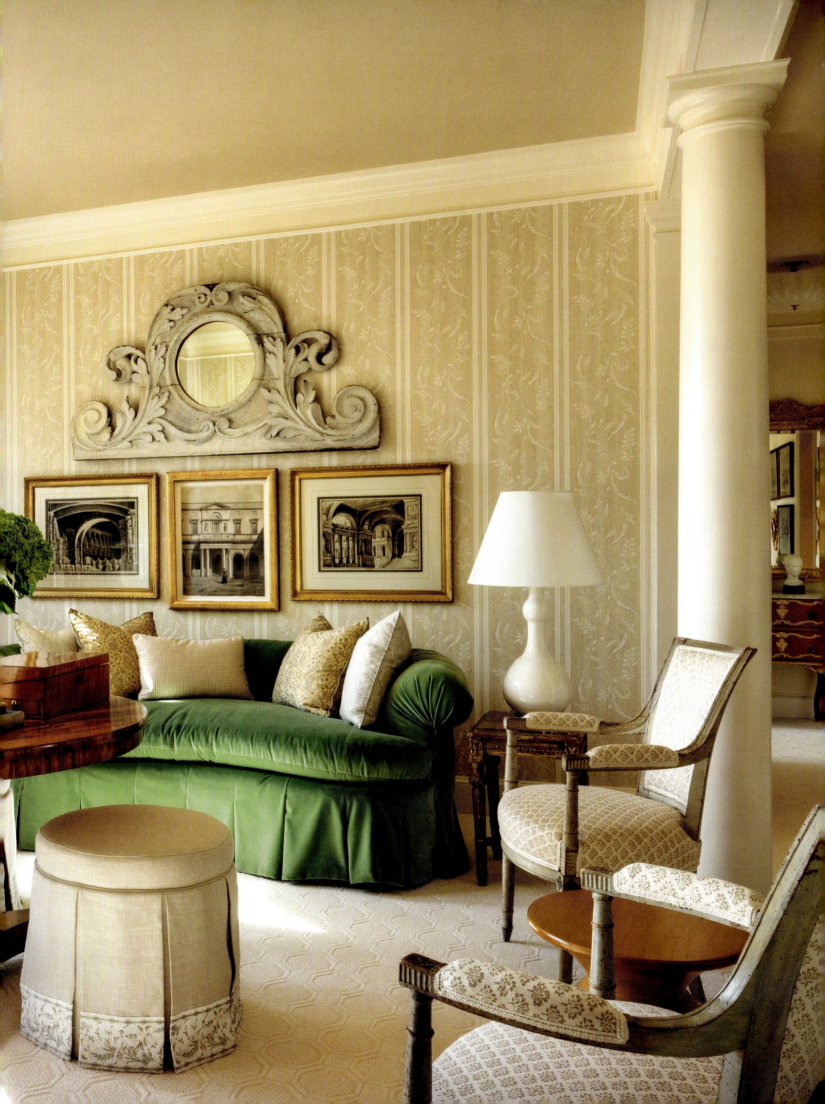

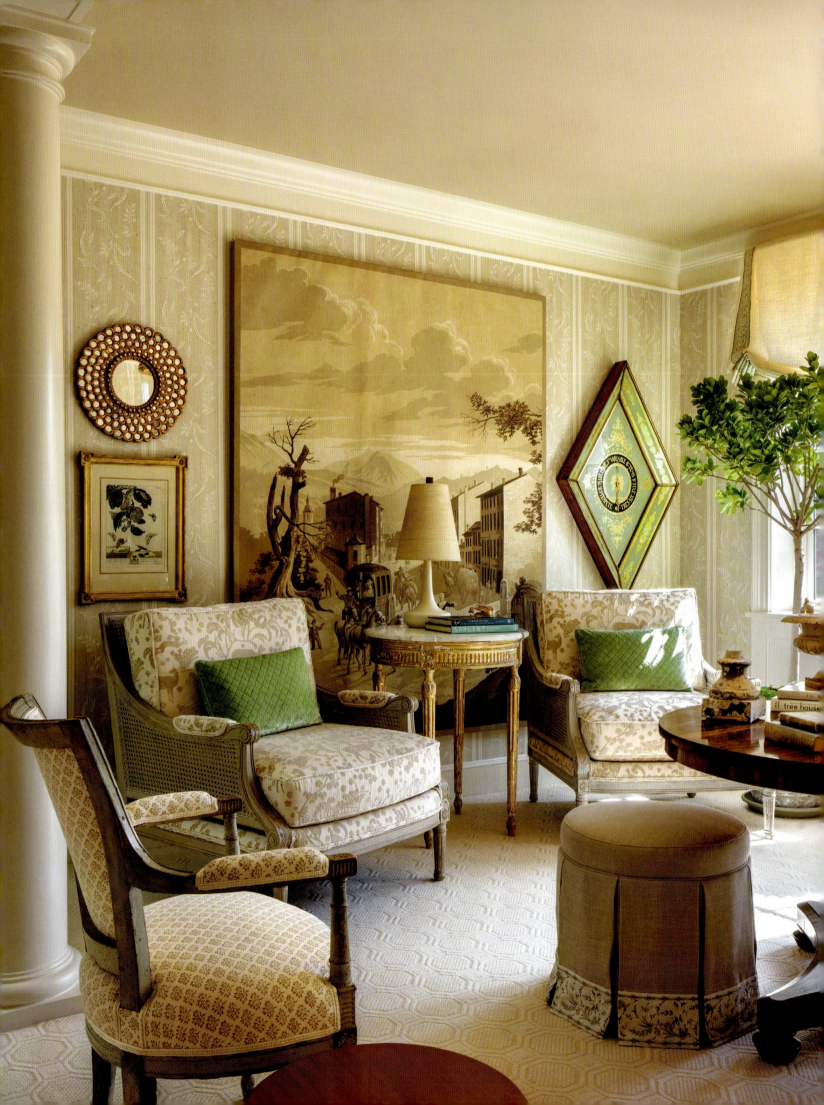

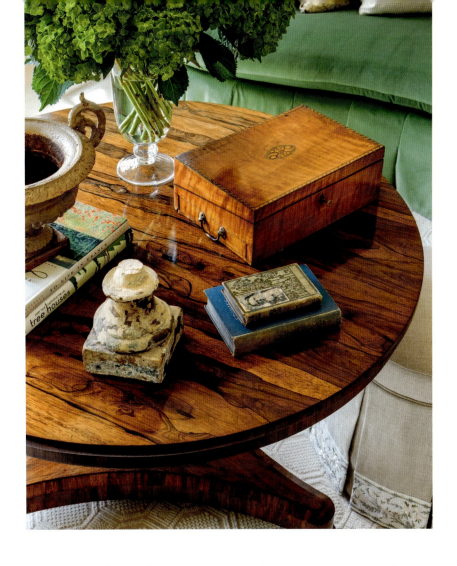

The home's overall tonality is very neutral—an opportunity for us to take one essential idea and speak to it from multiple vantage points, and celebrate soft, earthy shades like taupe, ivory, and blush without being boring. In monochromatic rooms, it's important to layer textures and motifs; intelligent pattern play will let even the most sedate, muted color palette sing. Each level of the house then has its own accent color—touches of a powdery blue on the second floor and a more saturated apple green upstairs on the third—plus occasional hints of chocolate, terra cotta, and burnt umber.

The wife's admiration for craftsmanship encouraged us to push the limits when it came to bespoke finishes. Instead of simple plaster and paint, bedrooms are

OPPOSITE AND ABOVE: The parlor's soft color palette was inspired by the oversize sepia-tone artwork on this wall. We wanted to explore the limits of neutrals: how many ways can you employ shades of taupe, cream, white, beige—and yet never be staid? Diversifying scale, patterns, and textures can give monochromatic rooms depth and interest.

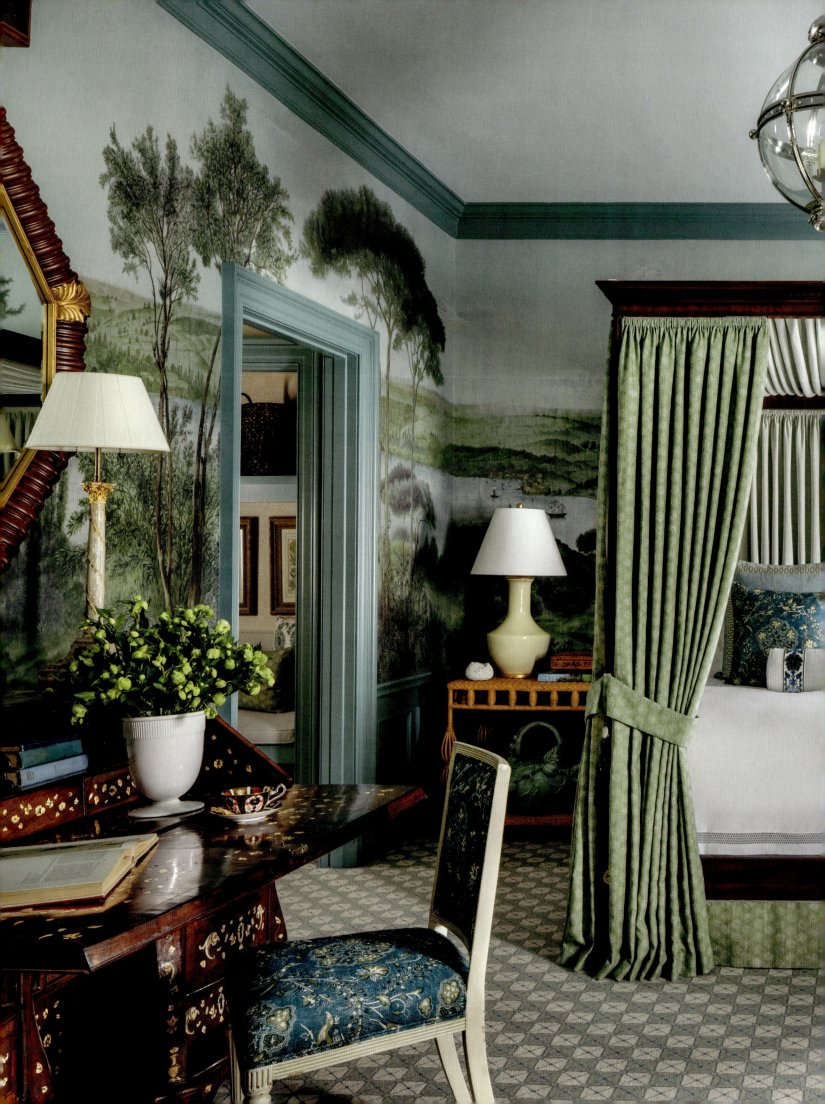

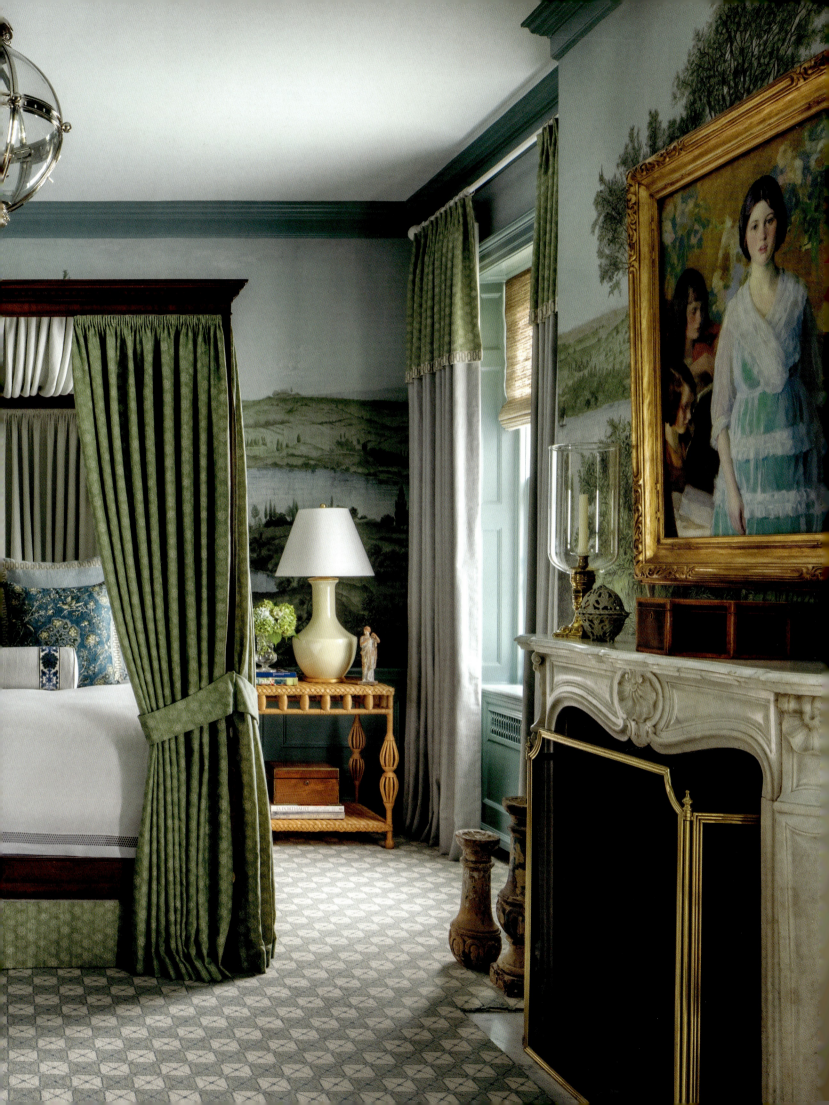

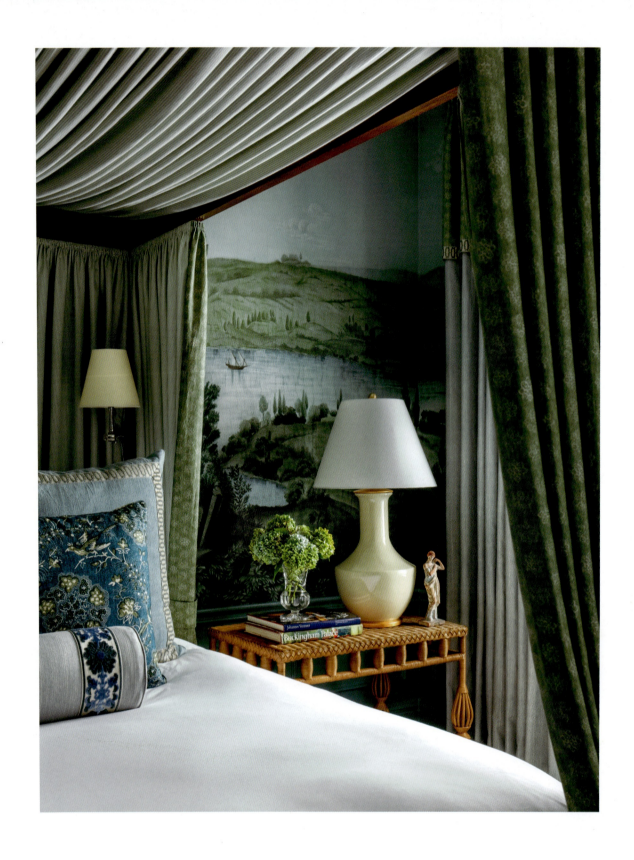

PAGES 94–101: A dreamy paradise of soft blues and greens greets guests who are lucky enough to stay in this room. Some of its furnishings, such as the canopied bed and a spectacular bone-inlay secretary, are extremely elegant; others, such as the wicker-wrapped nightstands, are more playful. A scenic mural creates a rich backdrop for *The Trio*, a portrait done by Ivan G. Olinsky circa 1917.

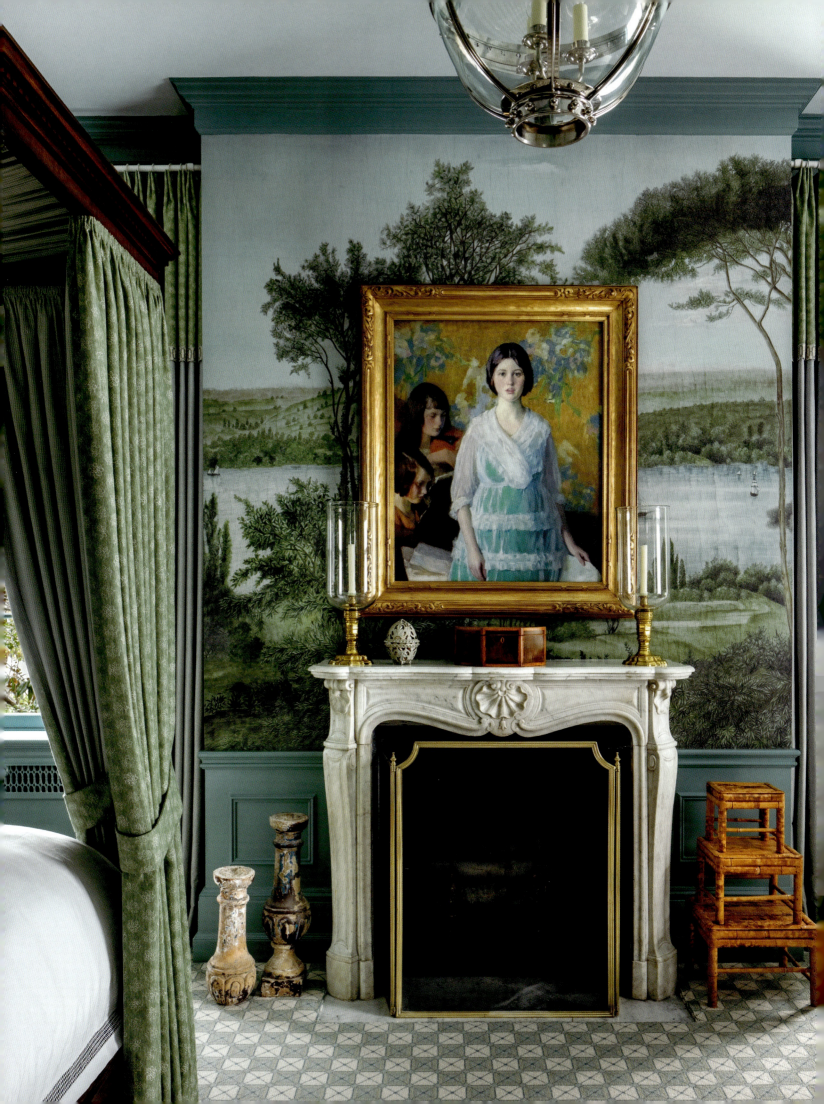

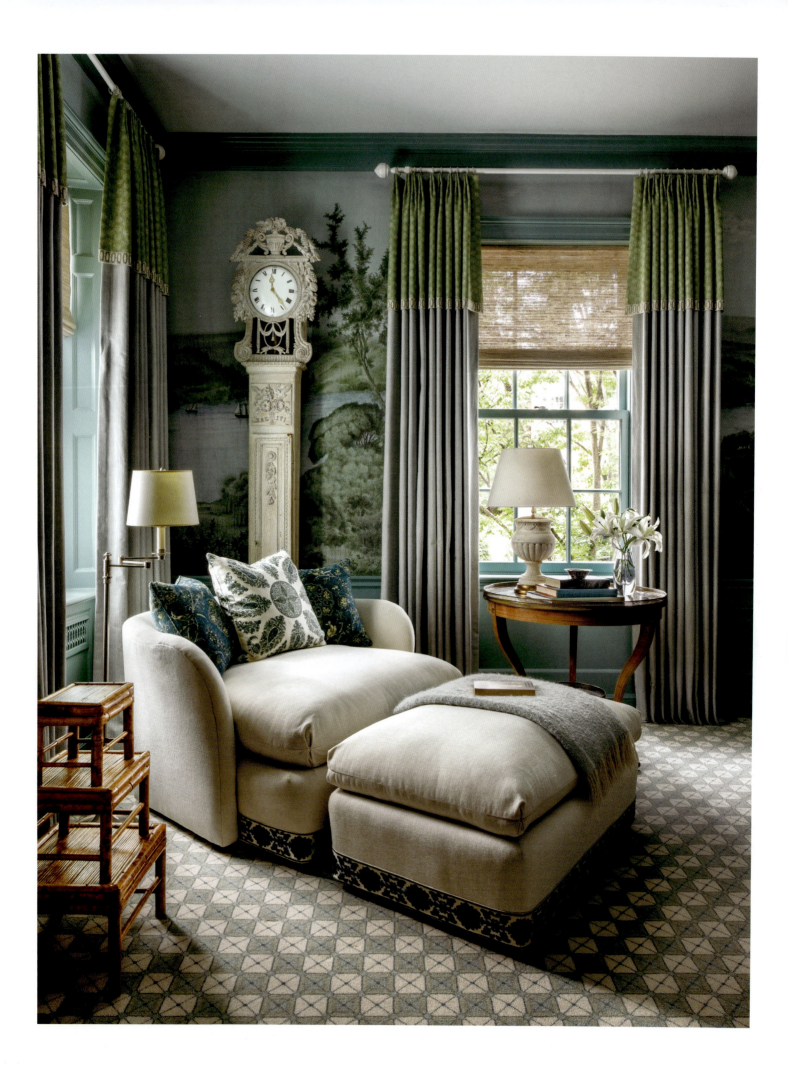

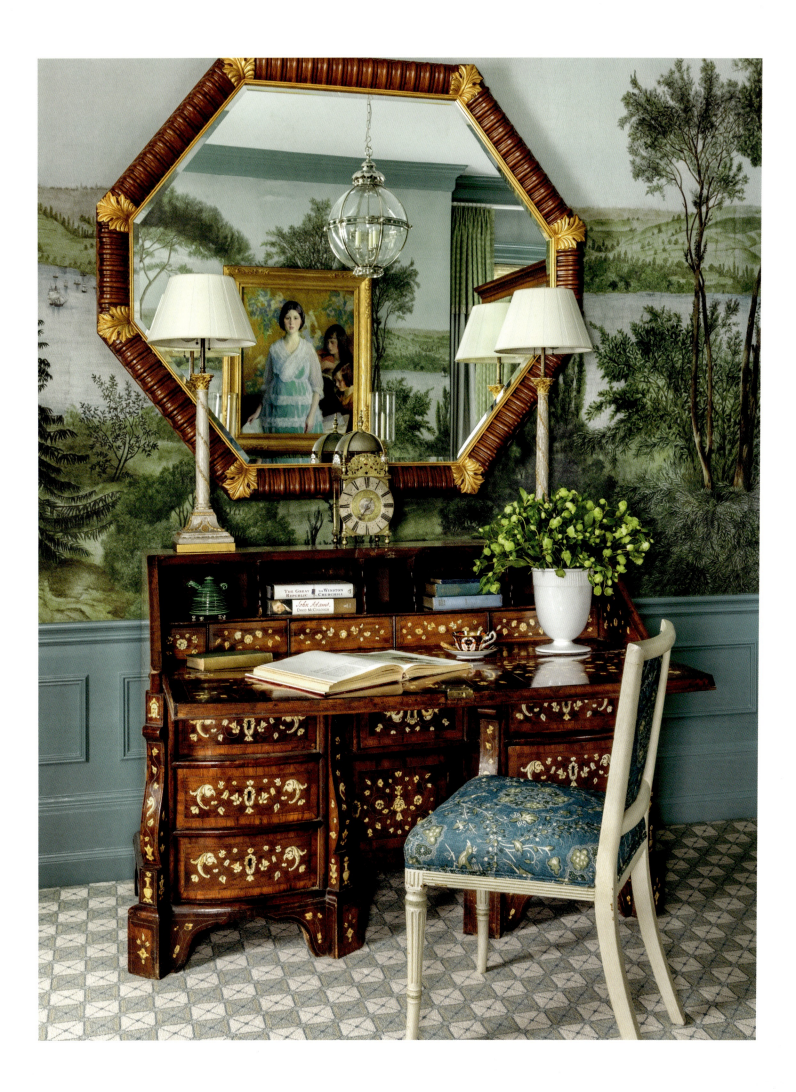

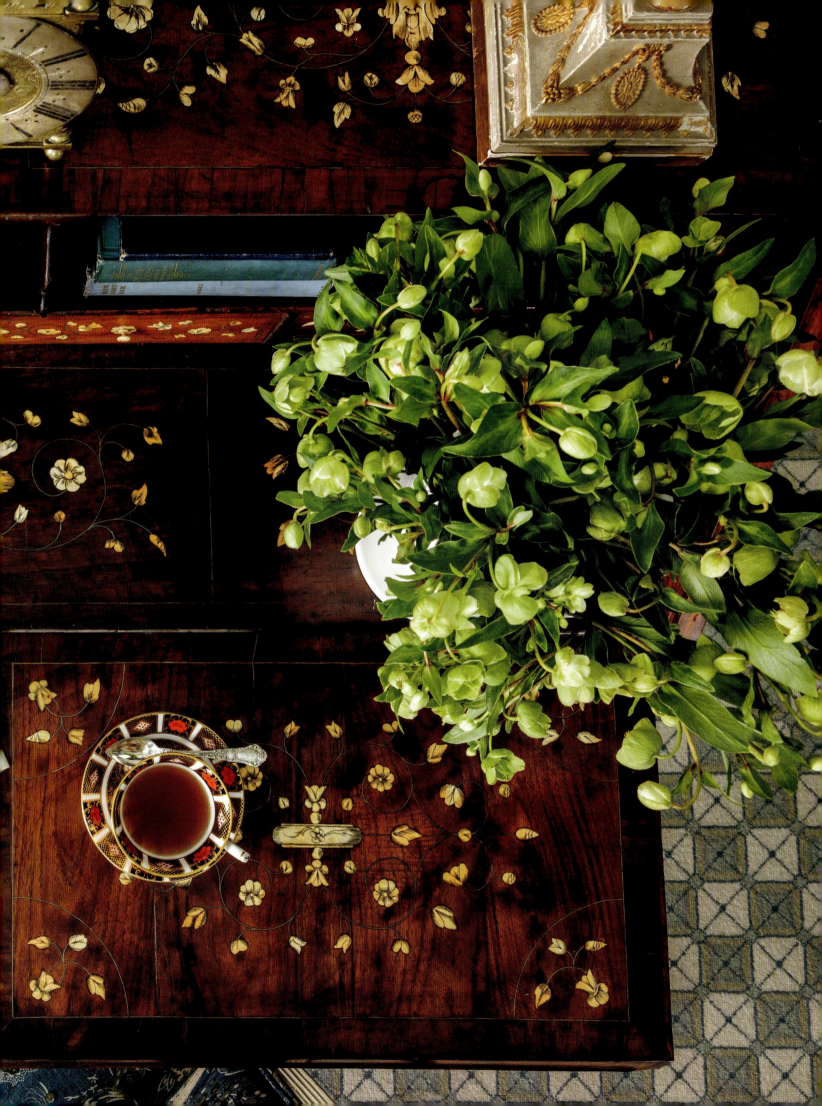

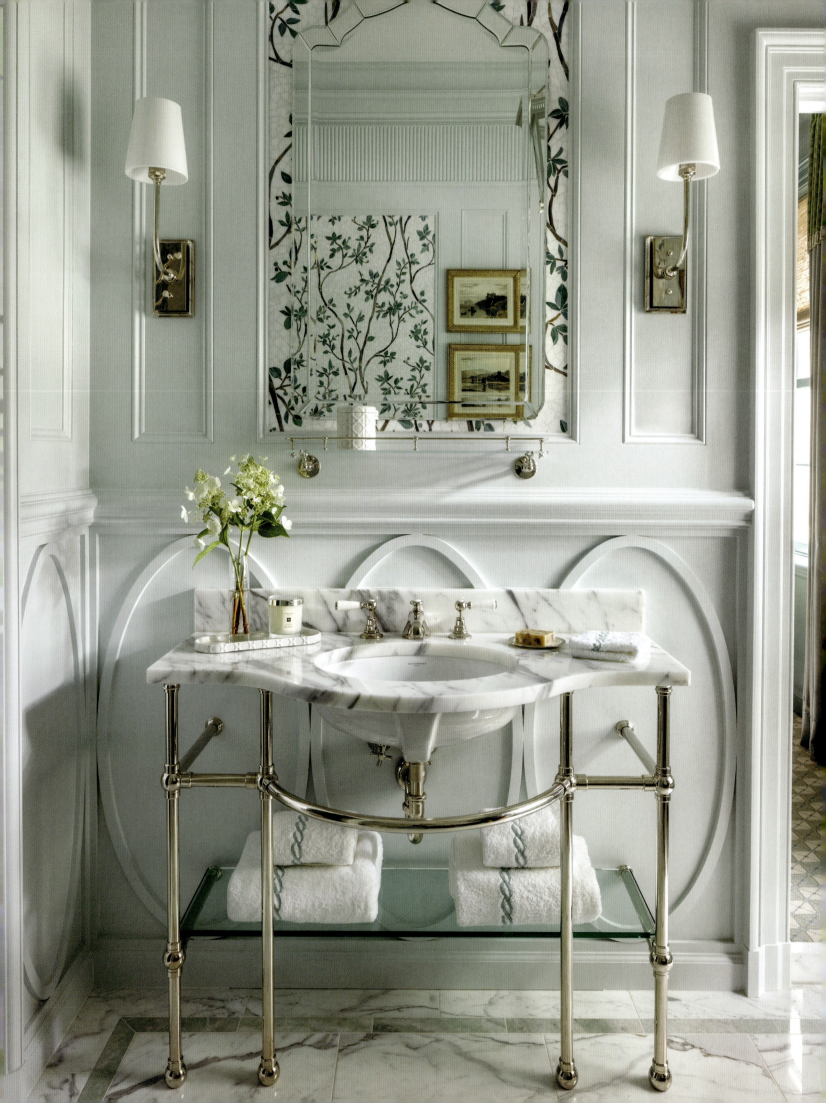

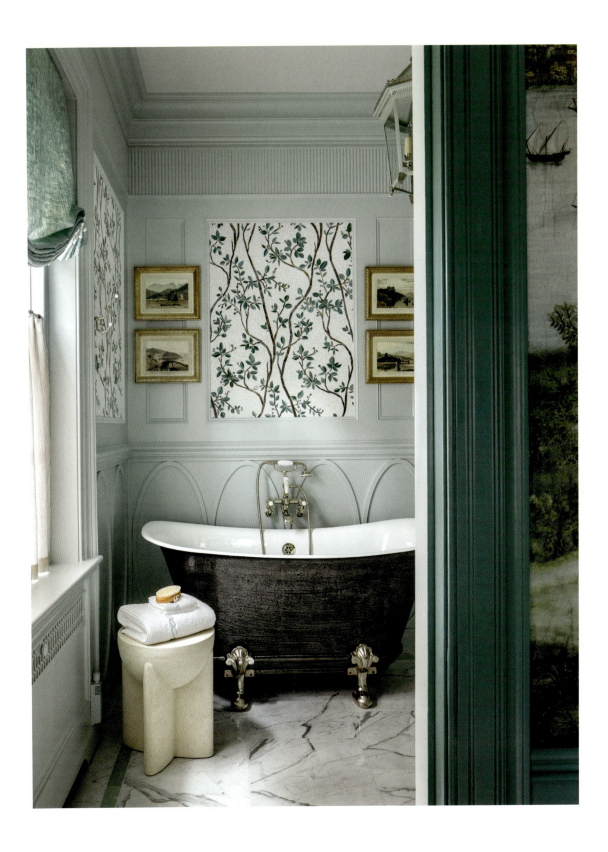

OPPOSITE AND ABOVE: In the attached en-suite bath, our firm designed some ambitious interior architectural details. Multiple bands of millwork—a tambour frieze, rectangular panel moldings, a chair rail, and wainscoting with a raised-oval motif—form a complex backdrop. The room is further embellished with insets of glass-tile mosaics handmade by artists in Zambia. The soaking tub sits on custom polished nickel feet.

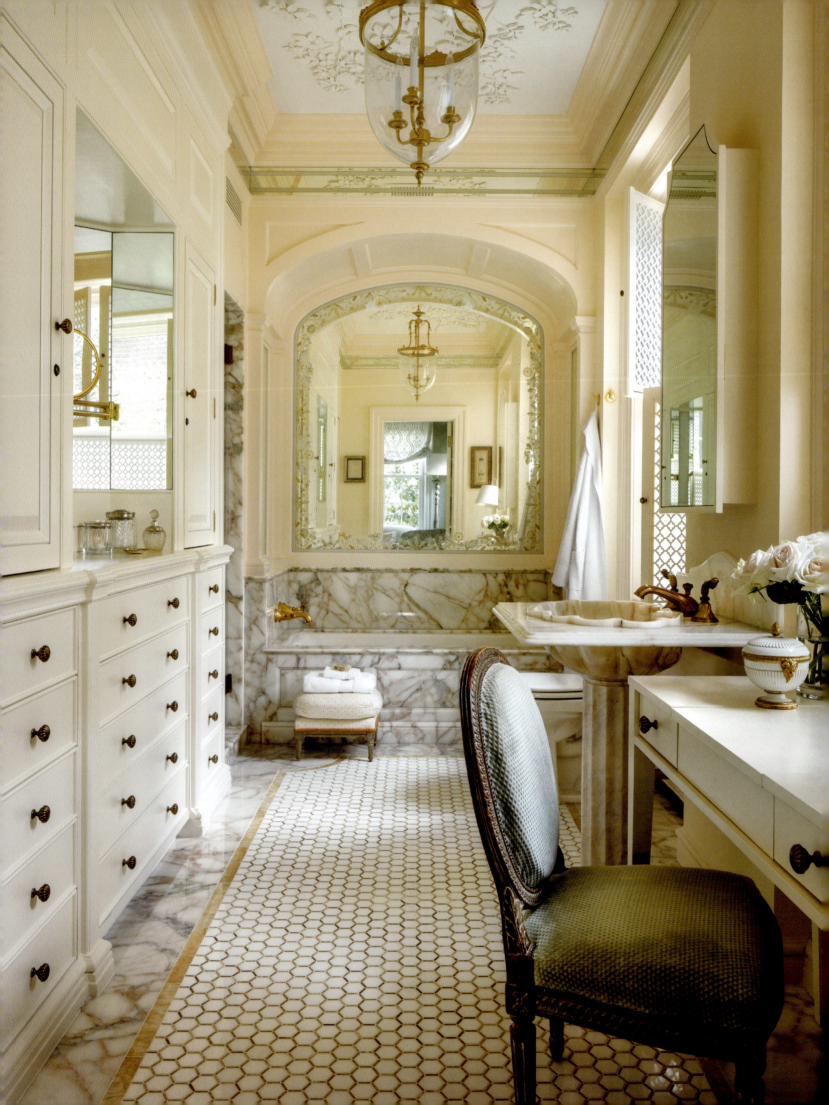

wrapped in mural wall coverings or upholstered in toile. The walls of the principal bath are ornamented with eglomise glass insets beneath a ceiling of branches, butterflies, and flowers carved from plaster. Another bath features paneled wainscoting fashioned entirely from afyon violet marble.

Since the homeowners often welcome guests, much consideration went into designing accommodations that would offer every comfort and make stays memorable. We created a series of sumptuous guest suites, each one distinct from the others. There is also a beautifully appointed top-floor parlor (with its own outdoor terrace overlooking the grounds below) that gives guests a place to gather and relax outside of their bedrooms without disturbing the family.

This project was a perfect example of what can be achieved when there is real synergy between designer, architect, and builder. Much of the home's interior renovation was extensive: we moved walls, reshaped and resized rooms, and even flipped a staircase. But the primary goal was to keep the new updates in harmony with the home's original architecture. At times that meant re-creating things such as newel posts and banisters in precise detail; at other times, we combined elements that weren't necessarily seen together in earlier periods, yet did so in ways that nevertheless feel appropriate to the historical context. Making history now, you might call it.

The biggest challenge in this home was meticulously coordinating the very intricate architectural and design features our team came up with, bringing them to life with uncompromising craft, and then populating the spaces with a "collected" mix of family antiques, artwork, custom pieces made especially for the purpose, and finds picked up at auction. The final effect is rich, elegant, and cultured. It was a joy for me to play a principal role in renovating such a beautiful home for this family.

Plaster branches encrust the ceiling of the wife's private bath. Three different types of stone ornament the space, including an inlaid honeycomb "rug." The arched mirror above the tub is framed in hand-painted eglomise, and we designed Moroccan-themed shutters for the windows, lining them with linen for privacy.

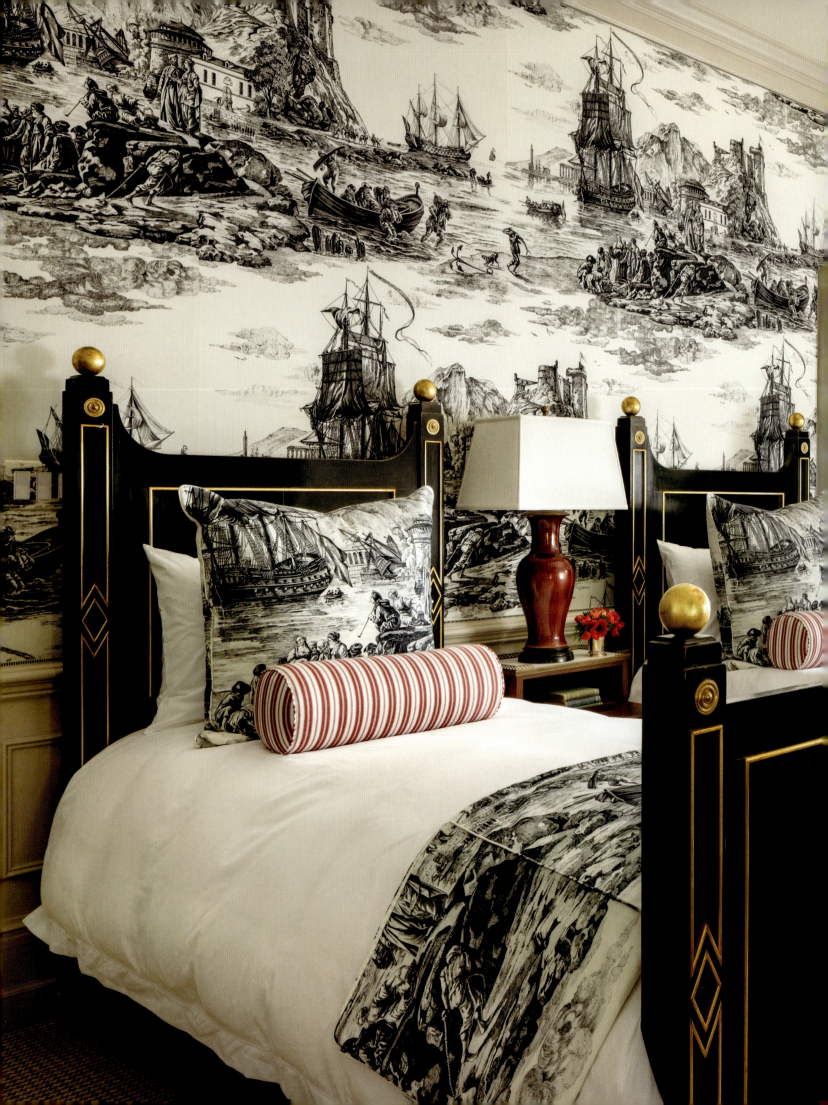

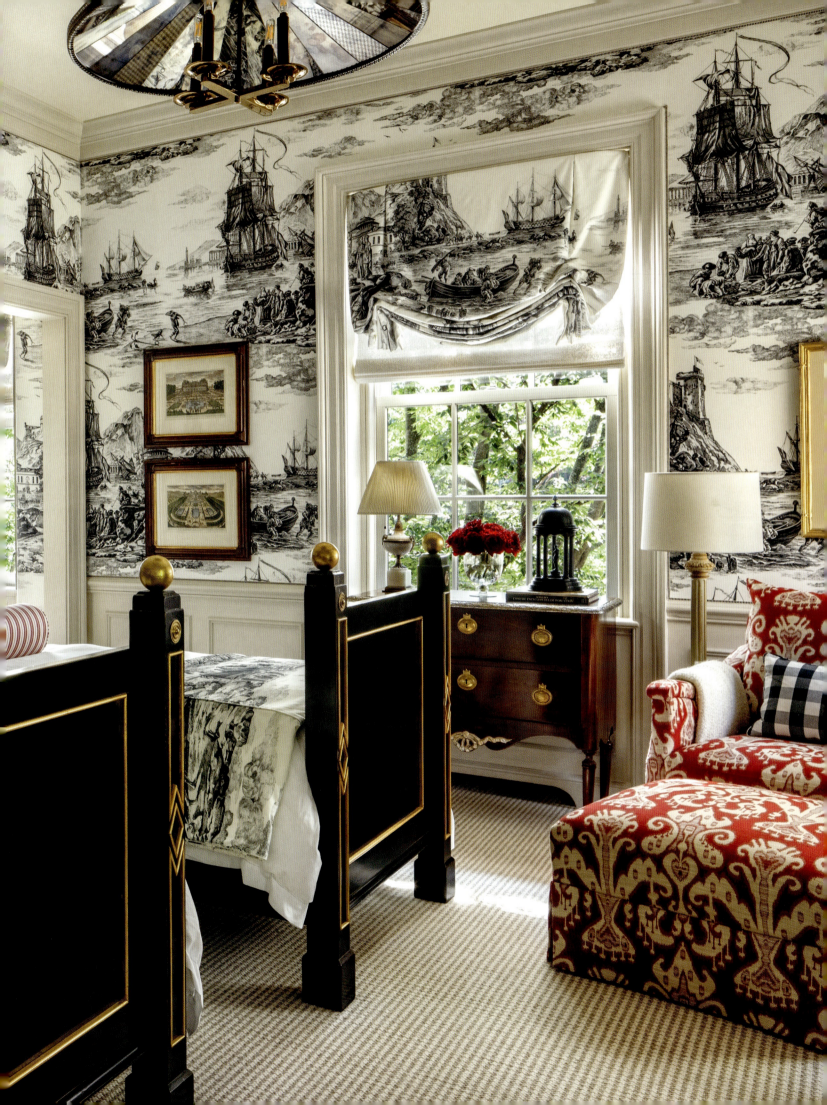

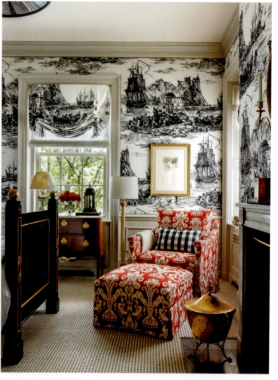
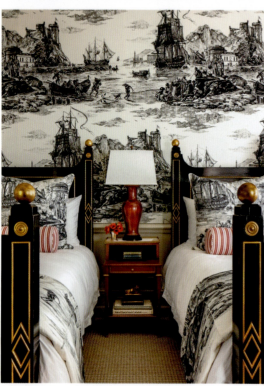
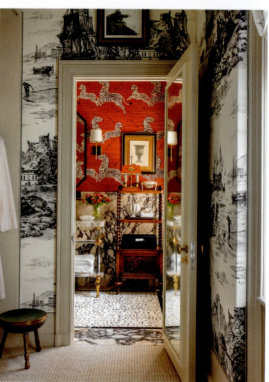

PRECEDING SPREAD AND ABOVE: In another guest room, a single black-and-white toile fabric sheathes the walls and was used for pillow shams, coverlets, and Roman shades. We had the Empire-style beds custom-made in France. They can be slept in separately or pushed together to form a single king-size bed—a practical solution to suit all types of visitors. OPPOSITE: The desk is positioned to give guests a beautiful view while they work.

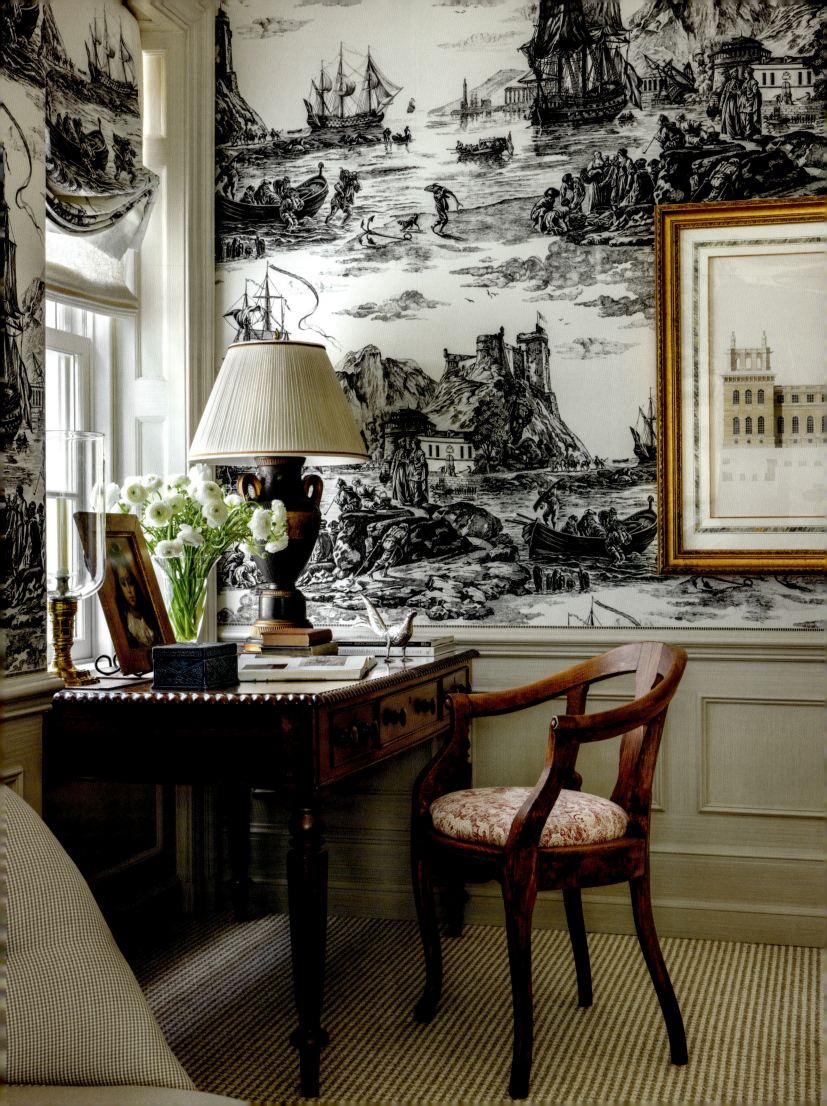

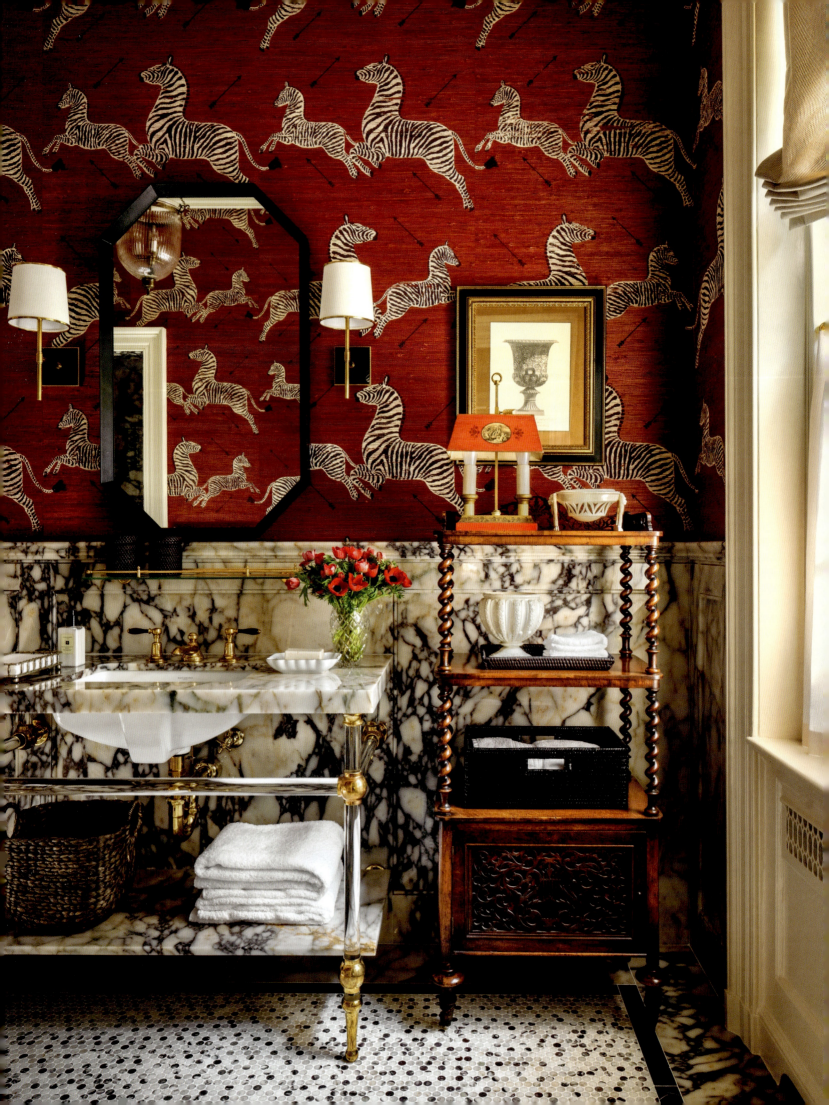

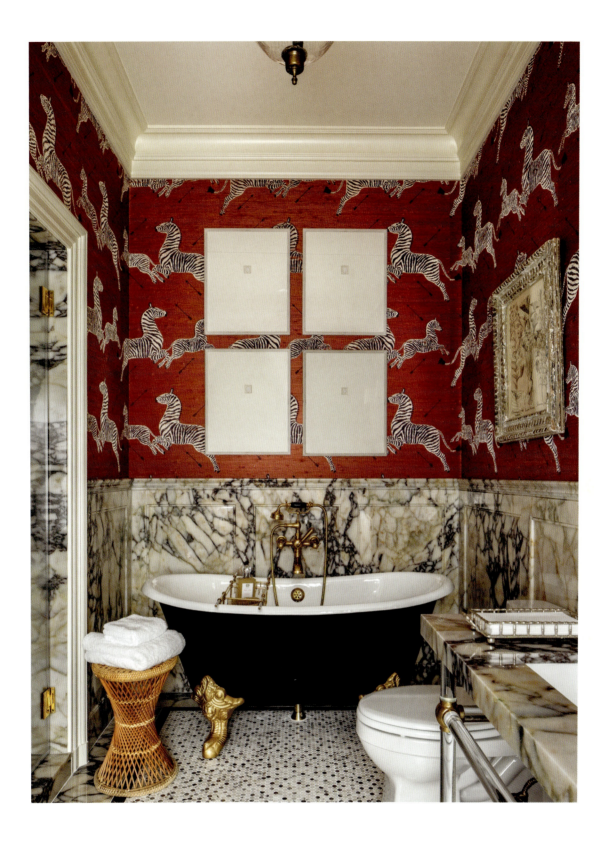

OPPOSITE AND ABOVE: The adjacent guest bath's walls are wrapped in Scalamandré's iconic zebra pattern—but custom-painted on a slubby grass cloth. The traditionally detailed wainscoting is completely executed in afyon violet marble. The same stone was also utilized for the vanity, which is supported by acrylic legs bound in brass. Nearby, an antique whatnot makes a nice landing spot for towels and other assorted items.

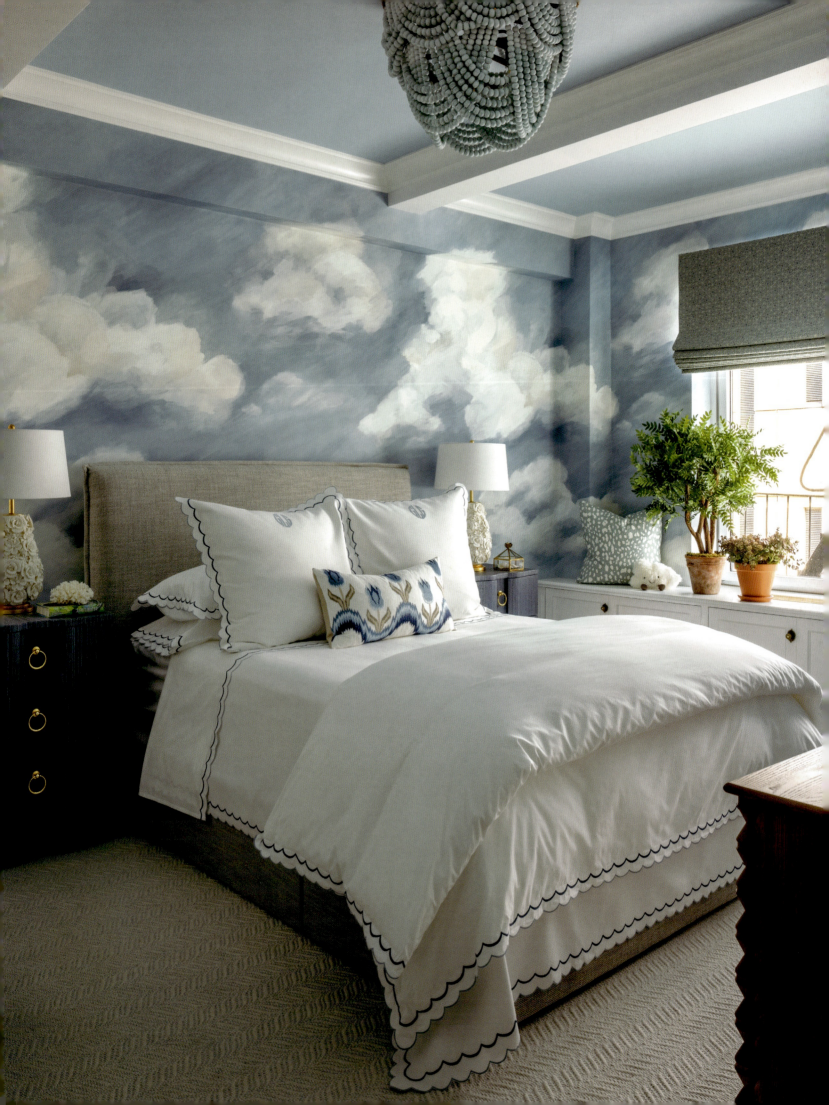

APPLIED EXPERTISE
Guest Suites

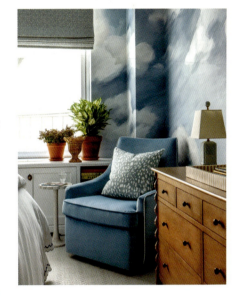

Often, when people are decorating their homes, guest suites are treated as afterthoughts. In my view, they deserve better. Like any part of your house, your guest's room says a lot about what kind of person you are. And the way the room is set up says just as much to the guest about how highly you value *them*.

BED
In terms of mattress firmness, think like Goldilocks and choose one that's "just right": neutral enough for most people to appreciate it. Hypoallergenic pillows and bedding will alleviate worries about guest sensitivities. And if your room design calls for piling on tons of decorative pillows, provide a space for them to be stored while the bed is occupied.

NIGHTSTANDS
In addition to their decorative factor, nightstands are an essential location for functional items. Electrical outlets or charging stations for portable devices should be easily accessible here, as well as a decanter and glass for water. Lamps are critical—they provide a more pleasant atmosphere than a ceiling fixture alone and are easy to operate while in bed. (If you have the space, reading lights attached to the headboard are another luxurious amenity.)

BATHROOM
Guest bathrooms require surfaces to place items like toiletry bags, especially if vanity space is limited. A shelf or a whatnot is a perfect solution and should be within easy reach of the sink. I also recommend multiple hooks for clothing and towels. And why not offer all the little amenities that people might have forgotten to pack? Cotton balls, swabs, a little flask of mouthwash, toothpaste, lotion, and soap will always be appreciated. Of course, conveniently located plugs for hair dryers, razors, and similar appliances are must-haves.

DESK
A desk or secretary (with a comfortable chair) should be part of any well-equipped guest suite, letting visitors do more than simply sleep in the space. Whenever possible, I prefer to place a desk perpendicular to the wall (so the desk's user isn't staring directly at the wall like a misbehaving child having a time-out). Avoid having the desk face away from a window, too, so your guest isn't backlit during virtual meetings. The desk is a perfect location for fresh flowers or a plant—and don't forget to include a card with helpful information such as the Wi-Fi access password.

OPPOSITE AND ABOVE: Guests always appreciate a sense of respite. This serene bedroom is all about nature: sun, sky, water, and things of the earth. An all-around mural of billowing clouds serves as art, and plants in terra-cotta pots represent life and growth.

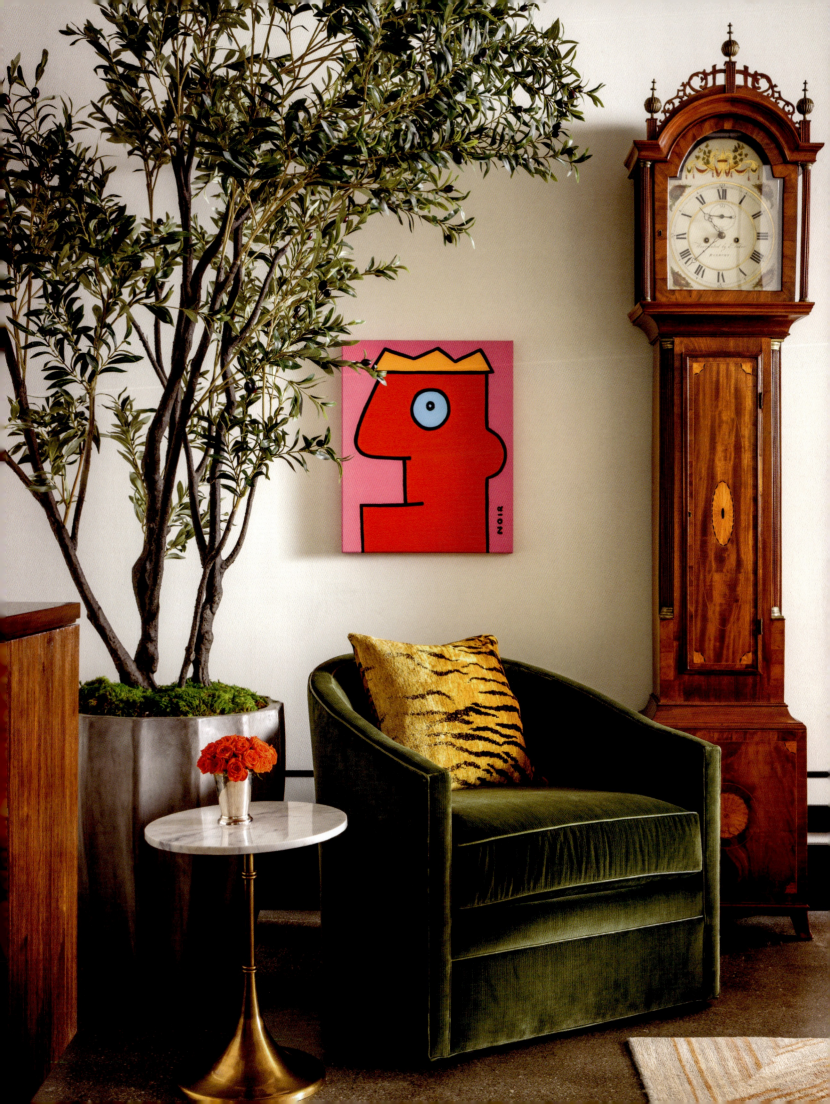

Gwendolyn's Pied-à-Terre

Shortly before Thanksgiving 2023, Sotheby's contacted me with a fascinating idea. Visions of America would be a new approach to the company's annual auctions of furniture, art, and decorative items that had previously gone under the label of "Americana." The sales would be reorganized to give a broader, more in-depth view of the different cultures and craftsmanship traditions that have been woven into the history of the United States. Fashion designer Thom Browne (one of my personal favorites, by pure coincidence) was being tapped as a guest curator to select his favorite lots from the upcoming sales, and I would then incorporate some of his choices into the interiors of a mini–show house we'd create inside the auction house's New York galleries.

 It was an exciting prospect, but also a challenge: Sotheby's offered us a 2,000 square foot space, with concrete floors and completely devoid of any architectural elements—or even walls—to structure our concept. We'd have to plan and execute everything in only a few weeks, with construction slated to take place over the Christmas holiday. And since I would be in France at the time, I would be directing the contractors' installations virtually. No pressure at all!

This vignette perfectly shows what I love to do with antiques. A tall case grandfather clock and an elegant, velvet-covered barrel chair contrast with an incredible painting by Thierry Noir that exudes lighthearted, comical energy. A beautiful juxtaposition, but not overly serious.

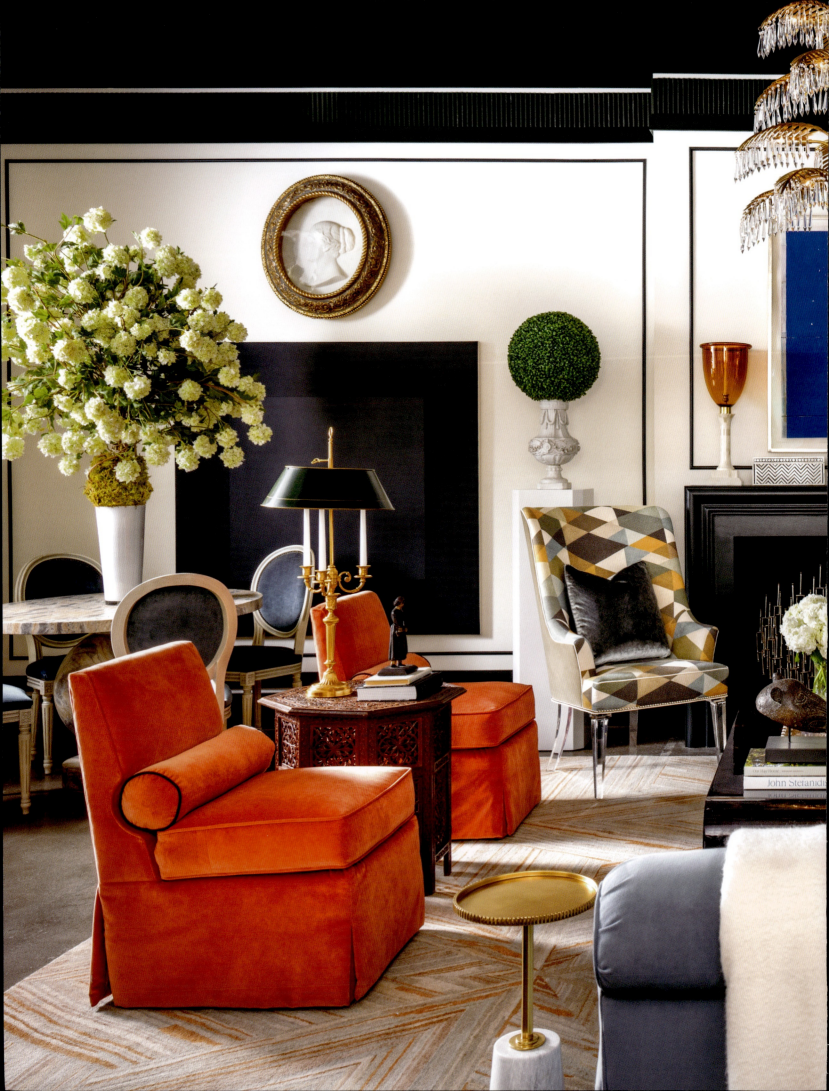

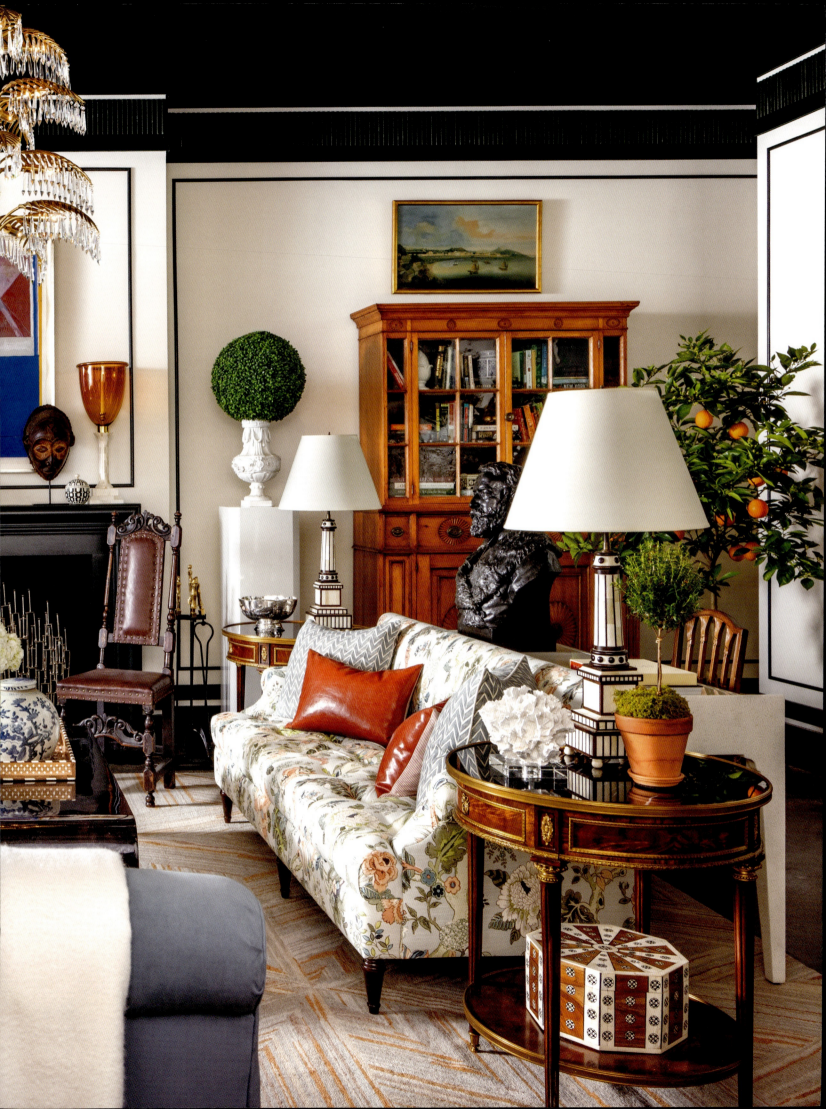

Whenever I'm embarking on a new project, the first thing I ask myself is, "Who am I designing this space for? What is their worldview?" For this show house, I decided to imagine an apartment my mother would have fashioned for herself in the 1970s. Naming the project "Gwendolyn's Pied-à-Terre" in her honor, we fashioned rooms and added intricate moldings and a fireplace—in essence, building out an almost complete urban apartment comprising an entryway, living room, dining corner, study area, and bedroom.

The pieces drawn from the Sotheby's sales dated from colonial times to the early twentieth century. Chippendale chairs and chests, Federal clocks and cupboards, a spectacular classical looking glass, portrait busts, landscape paintings—there was so much for us to pick from. To lend all that antiquity a present-day spin, we consulted with the Sotheby's art department to bring in contemporary works. Additional furnishings, borrowed from several of my favorite New York City sources, spanned a wide range of styles, from a formal chintz-covered sofa to a faceted gold side table that could almost be mistaken for a gigantic mineral specimen.

An embroidered and painted silk picture from 1809, depicting Lady Elizabeth Grey entreating Edward IV to protect her children, became what I call "the tie that binds," acting as a touchstone when we assembled our color palette. Using strong color is more complicated than using neutral tones. The hues must be harmonized, and dashes of similar but not quite identical tones must be sprinkled consistently across the space to form a balanced web of relationships. You must have a formula, yet the application can't be too formulaic.

In like fashion, we alternated between antique ornateness and modern simplicity. The chintz sofa, which is very Mario Buatta, faced a pair of tangerine velvet slipper chairs; a William and Mary side chair was placed beside an abstract fire screen—and so on, to keep the delicious tension going. In the bedroom, we went

PRECEDING SPREAD AND OPPOSITE: Color can be the element to both tie adjacent spaces together and give them their oomph. Common denominators, whether they be textiles or art, help tell a convincing visual story. Over the fireplace hangs Richard Diebenkorn's "Blue," 1984, woodcut in colors.

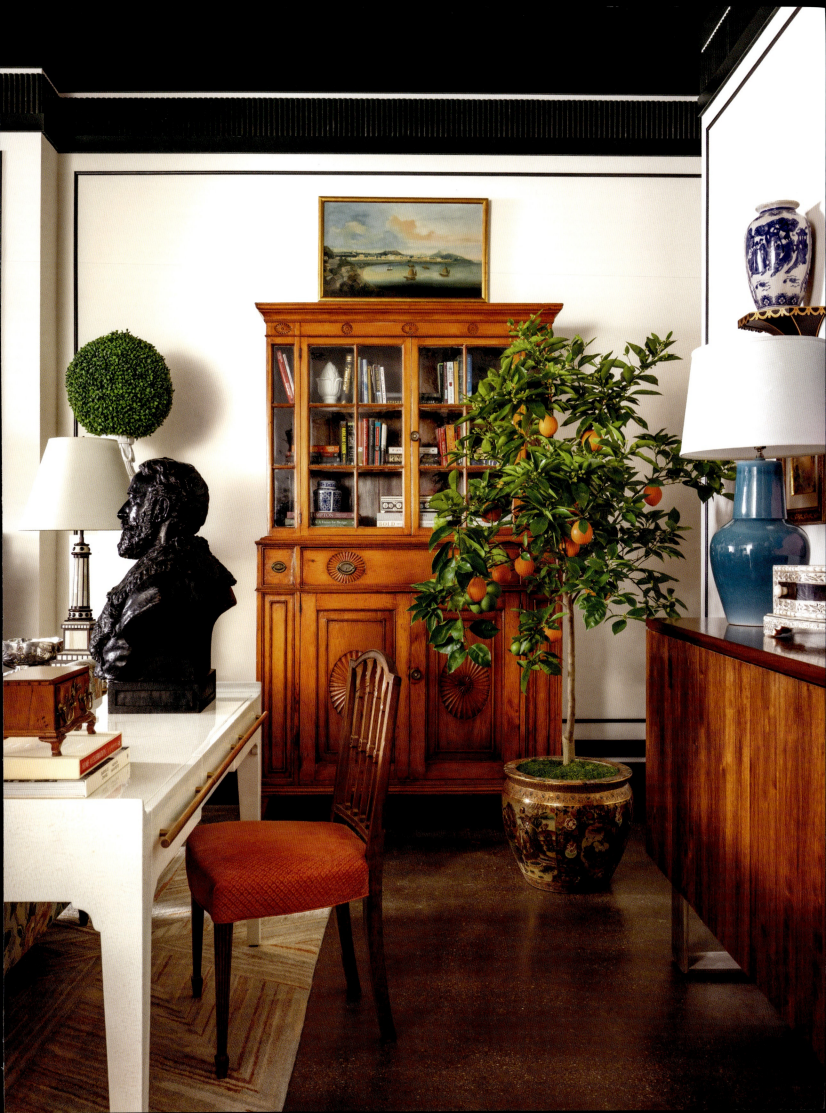

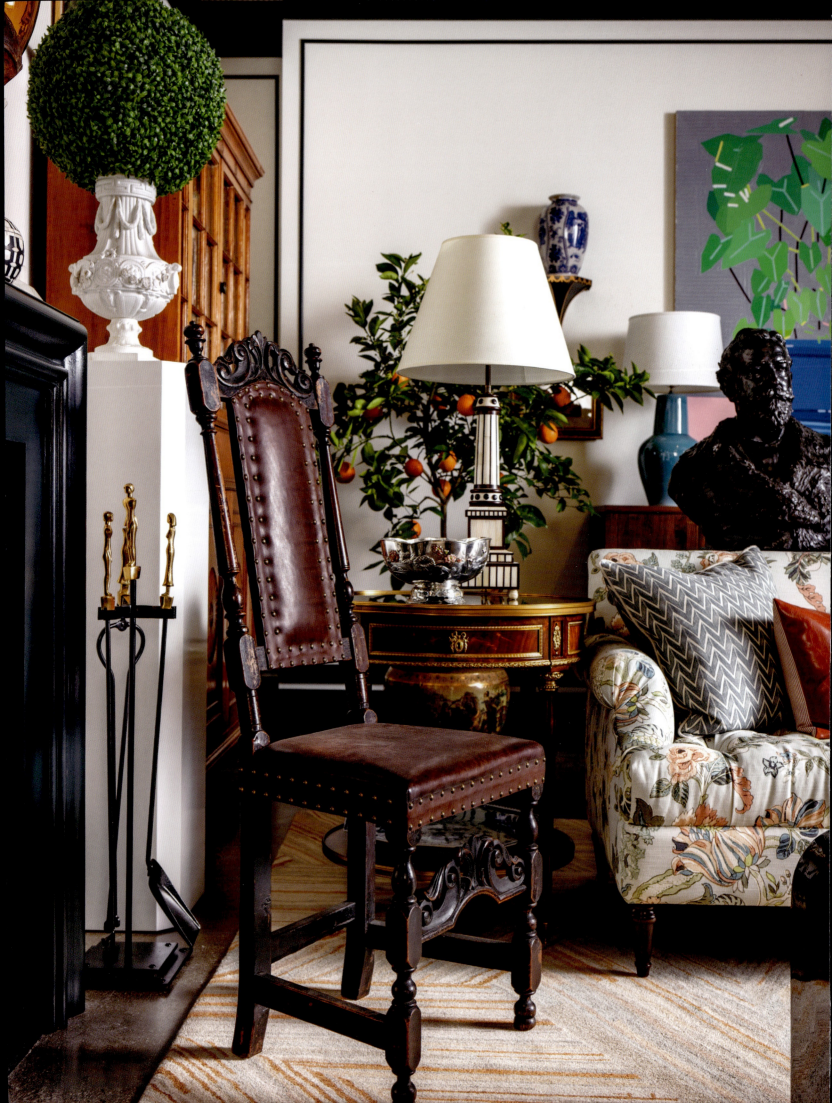

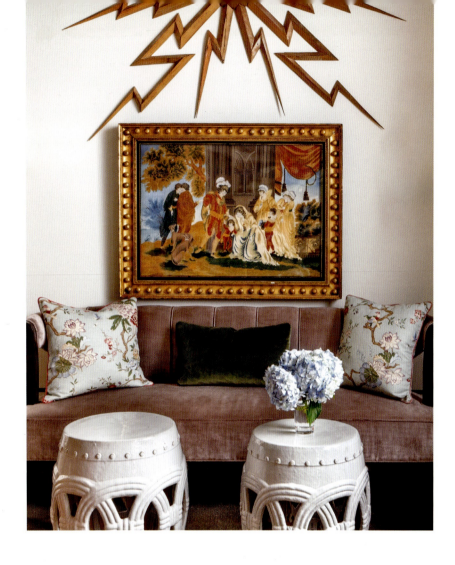

in a dark and decidedly sexy direction. Done entirely in oranges, golds, and coppers, the room was an advanced exercise in matching patterns of different scales and geometries. The organic, branching design on the wall mural, the tiger-striped chair, and the dramatic rug, with its Greek key and octagonal motifs, coordinated beautifully. The overall impression, once everything had found its place in the rooms, was one of maximalist energy held inside a quiet neoclassical shell.

I've long advocated for a deep appreciation of antiques and artifacts that have come down to us from the past. So, it was a delight to orchestrate such a public demonstration—for young collectors, in particular—of why these items remain relevant and desirable, and of just how effectively (and eclectically!) they can be used.

OPPOSITE: A circa-1710 side chair stands happily atop the geometry of a modern STARK rug.
ABOVE: The dusty plum color of this channel-back settee was drawn from the antique painting above it. The Bakudan sunburst sculpture by Mike Diaz is made from two-hundred-year-old pine.

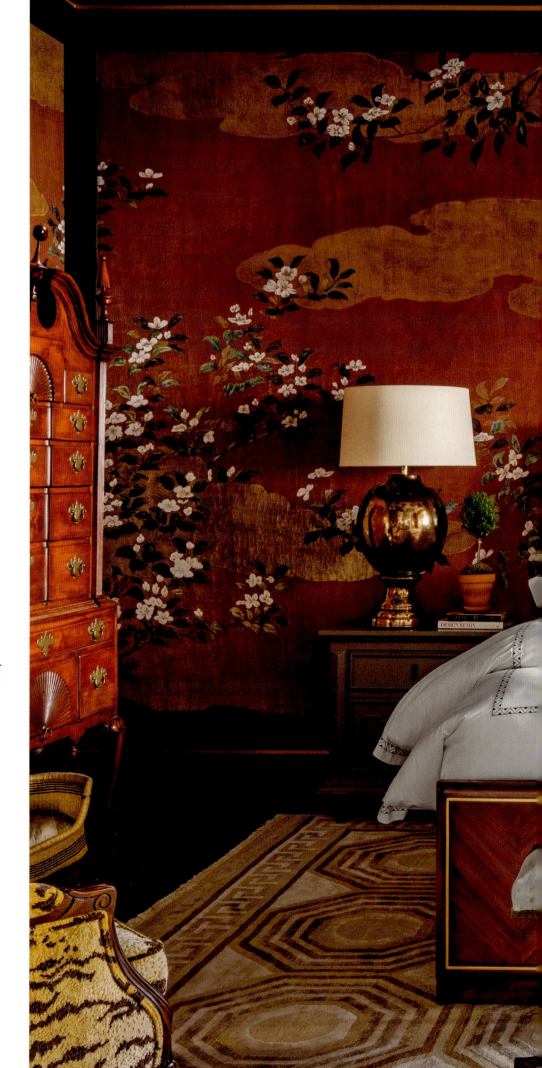

RIGHT: A wall mural inspired by Japanese Edo-era paintings sets a sultry mood in the bedroom. The white of the dogwood blossoms is picked up in the snowy Matouk bedding, a pair of cowhide-covered stools, and elsewhere. The Murano chandelier is vintage. I love the tension between the modern bed frame and the painted neoclassical nightstands. FOLLOWING SPREAD: A circa-1785 Chippendale-style highboy in pristine condition holds pride of place on the side wall.

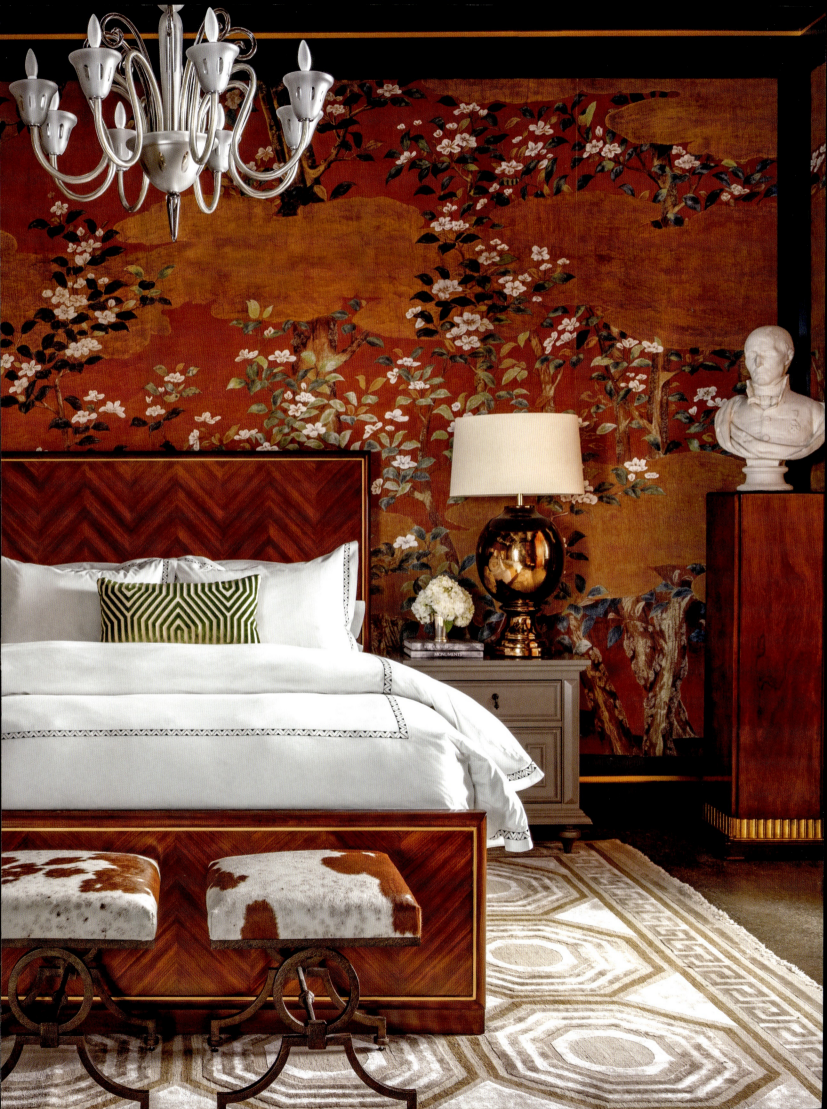

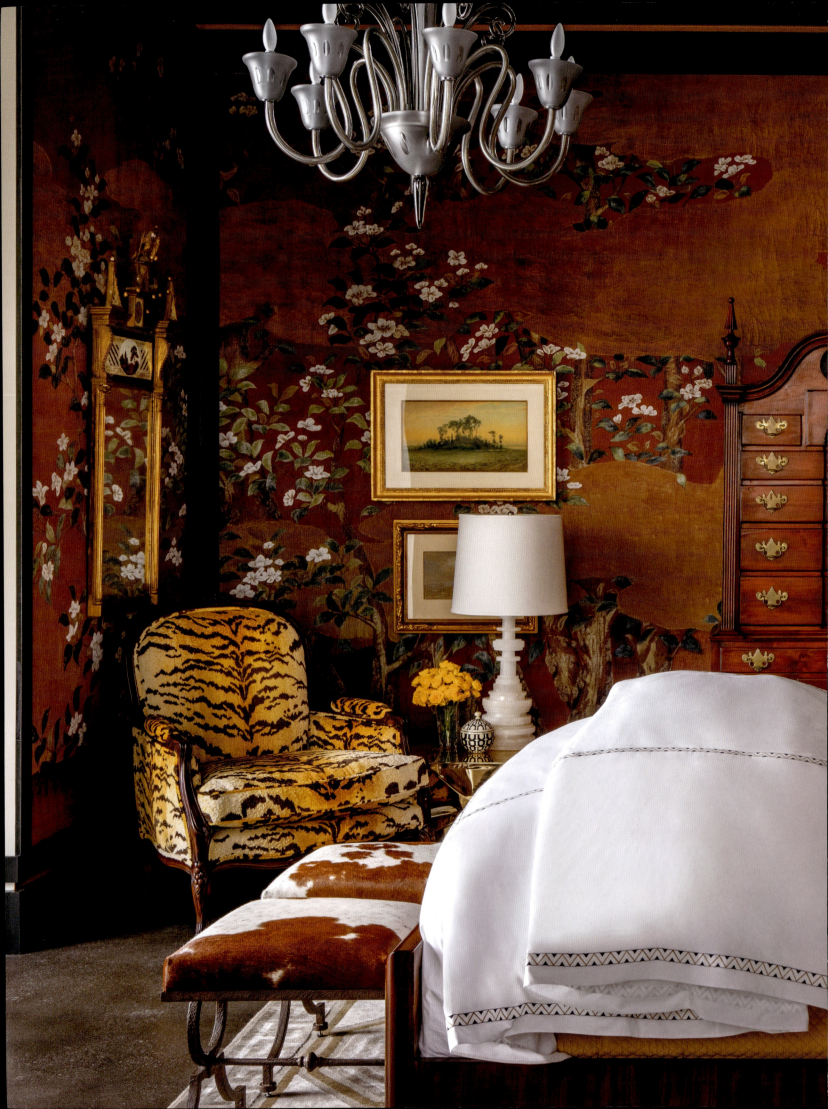

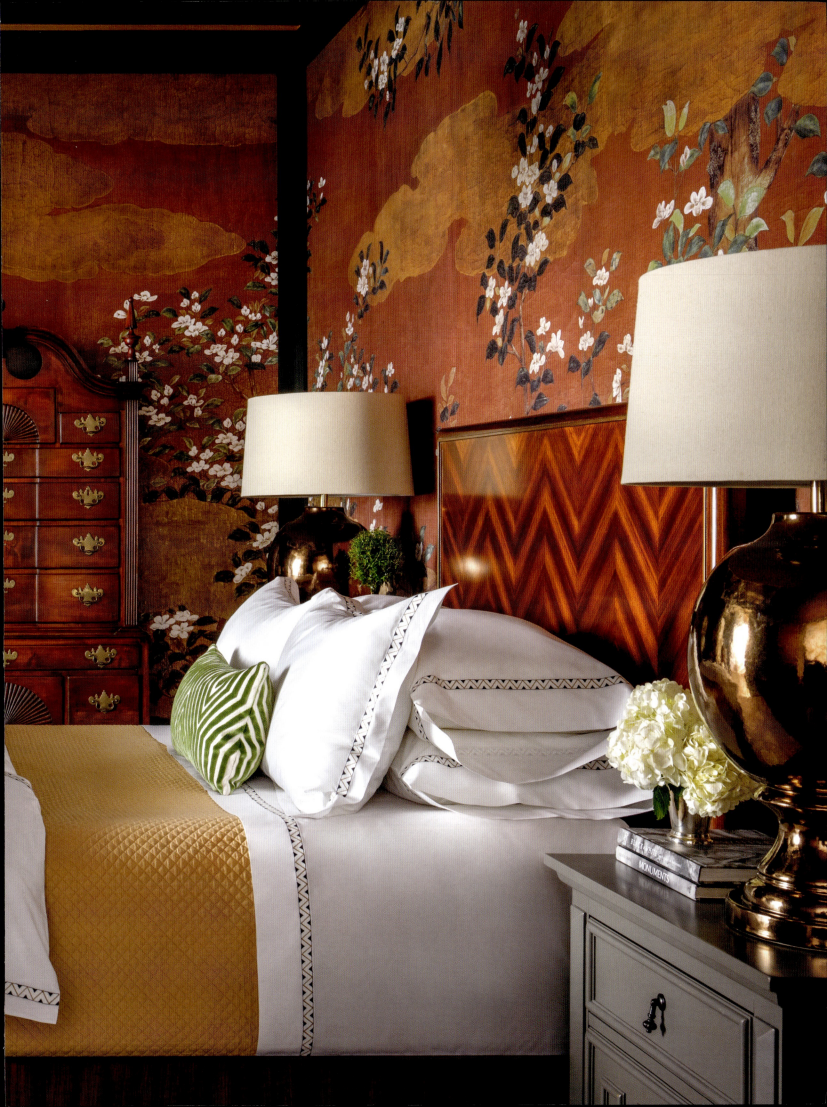

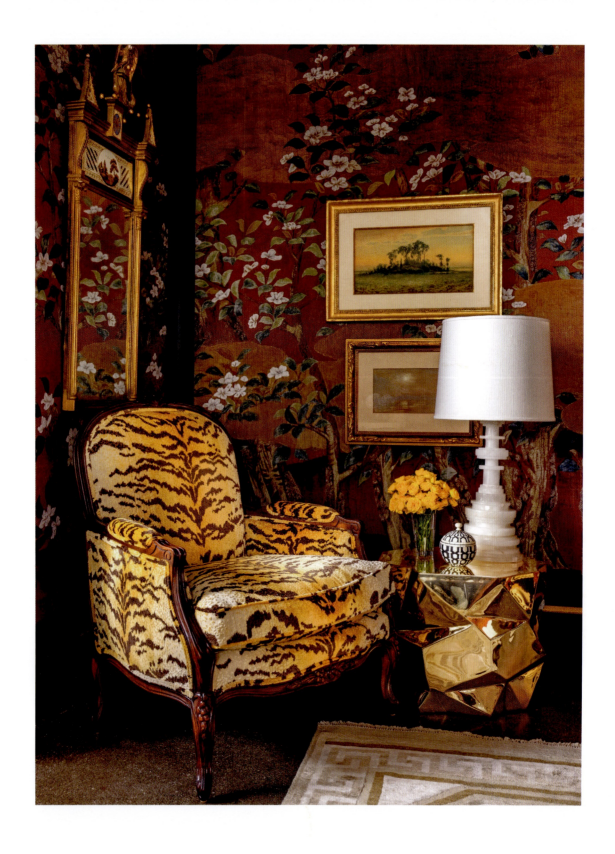

ABOVE: Designed by my friend John Lyle, this faceted side table is plated in polished bronze and doubles as a stunning work of art. It's a perfect foil for the nearby tiger-striped bergère. OPPOSITE: This bedroom also serves as a prime example of how artwork can inspire a room's color choices: its entire palette was informed by this 1825 portrait by Micah Williams from one of the Sotheby's Visions of America auctions.

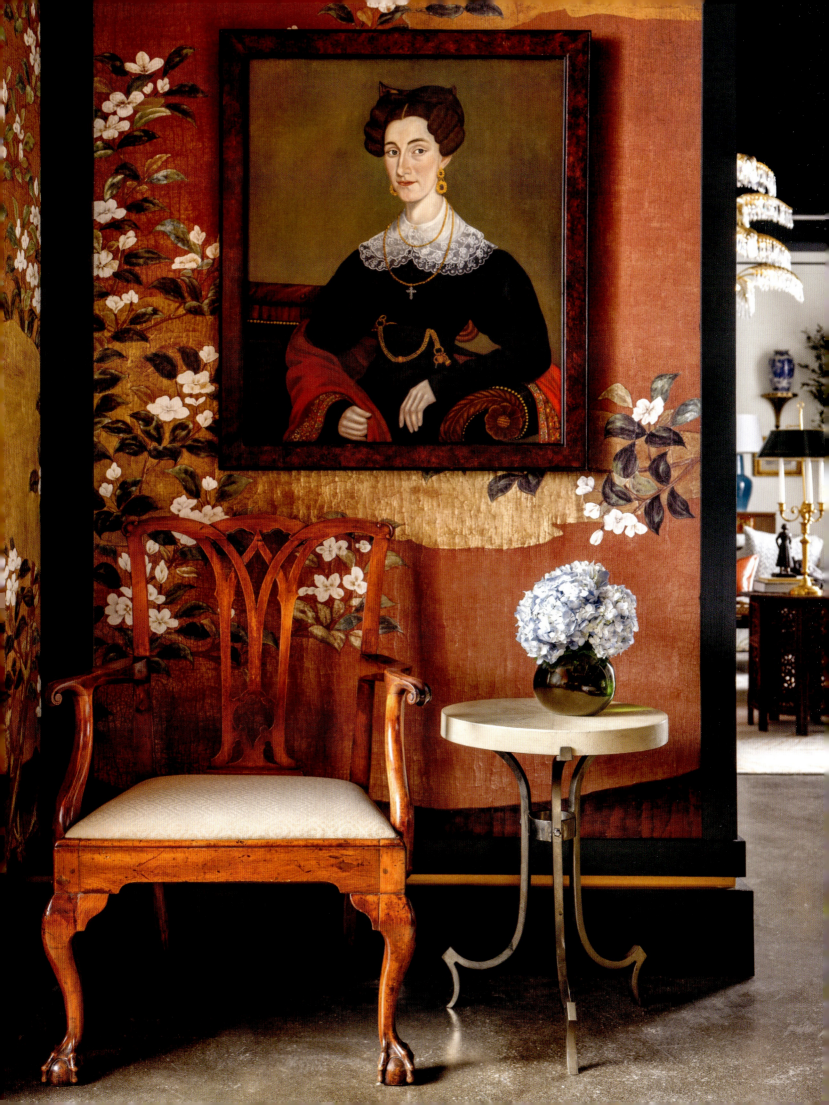

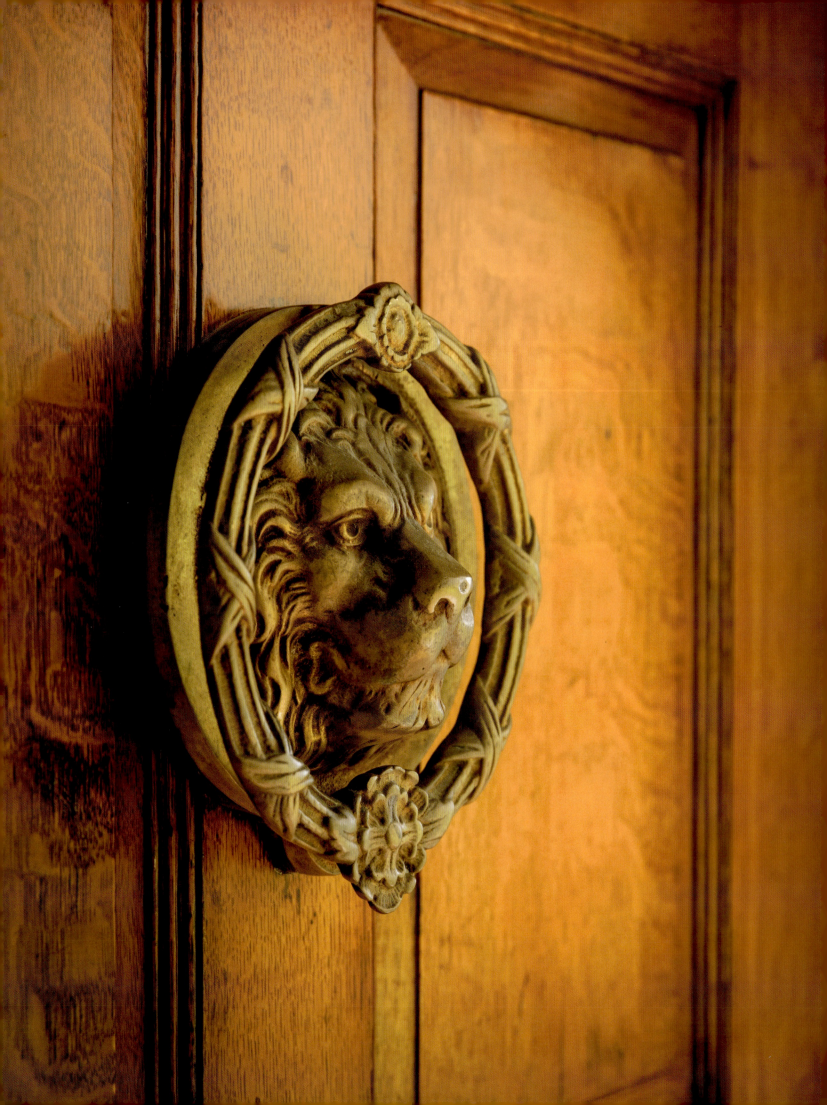

Lions and Tigers and Chairs

When I first walked into this circa-1900 Victorian home in coastal Greenwich, Connecticut, I was immediately struck by its sense of soul. The house was an architectural wonder, sitting high up above the street, overlooking the sprawling neighborhood. A dramatic series of turrets and towers, and an amazing wraparound porch, gave it a Victorian feel, and, once inside, I was completely mesmerized by the intricately carved millwork and the multitude of stained-glass windows—all original—that were visible in every direction.

Even better was the whimsical, almost tongue-in-cheek character the early twentieth-century craftspeople had added to the interior architecture: impish human faces peered out from the sides of columns, lions with fangs roared from the pilasters in the foyer, and the fireplace canopy in the study was festooned with literal carved balls of fire.

The vintage door knocker on this house in Greenwich, Connecticut, gives a preview of the period architectural details that will be found inside. A welcome part of my task was to celebrate those details in the context of contemporary interior design.

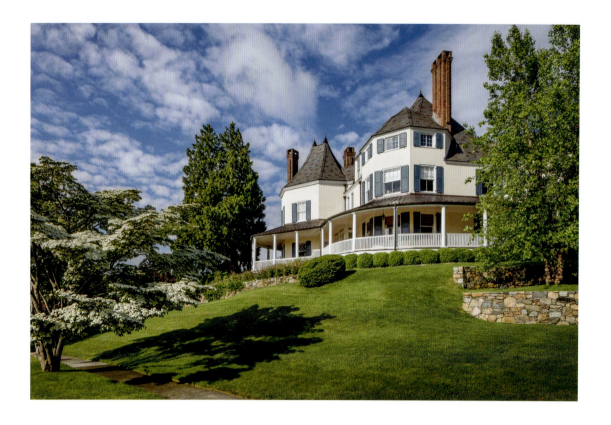

That delightful first impression was a big reason I took on the project of renovating and restoring the home, in collaboration with its owners (some decorative decisions had already been made, and the couple asked me to layer them into my design plans). Our intent: to bring the dwelling forward to the present without losing its essential nature, to evolve a twenty-first-century interpretation of classicism and elegance that would seem fresh and modern.

The homeowners had seen the library I designed for the 2019 Kips Bay Decorator Show House in New York City, "To the Lady of the House, with Love." They wanted a similar vibe for this home: classic with a modern twist. While developing that earlier project, I had referenced Jacqueline Kennedy's fashion choices as my inspiration, so the wife and I had great fun connecting over lunches and researching dozens of the former First Lady's clothing ensembles from the 1960s—the suits and the jackets, the pumps and the purses, the

ABOVE: The home has a commanding view of its neighborhood. The exterior, like the interior, exhibits relatively few right angles. OPPOSITE: A mixed-media portrait of First Lady Jacqueline Kennedy by Mark Boomershine looks out from an arched fireside niche in the front hall.

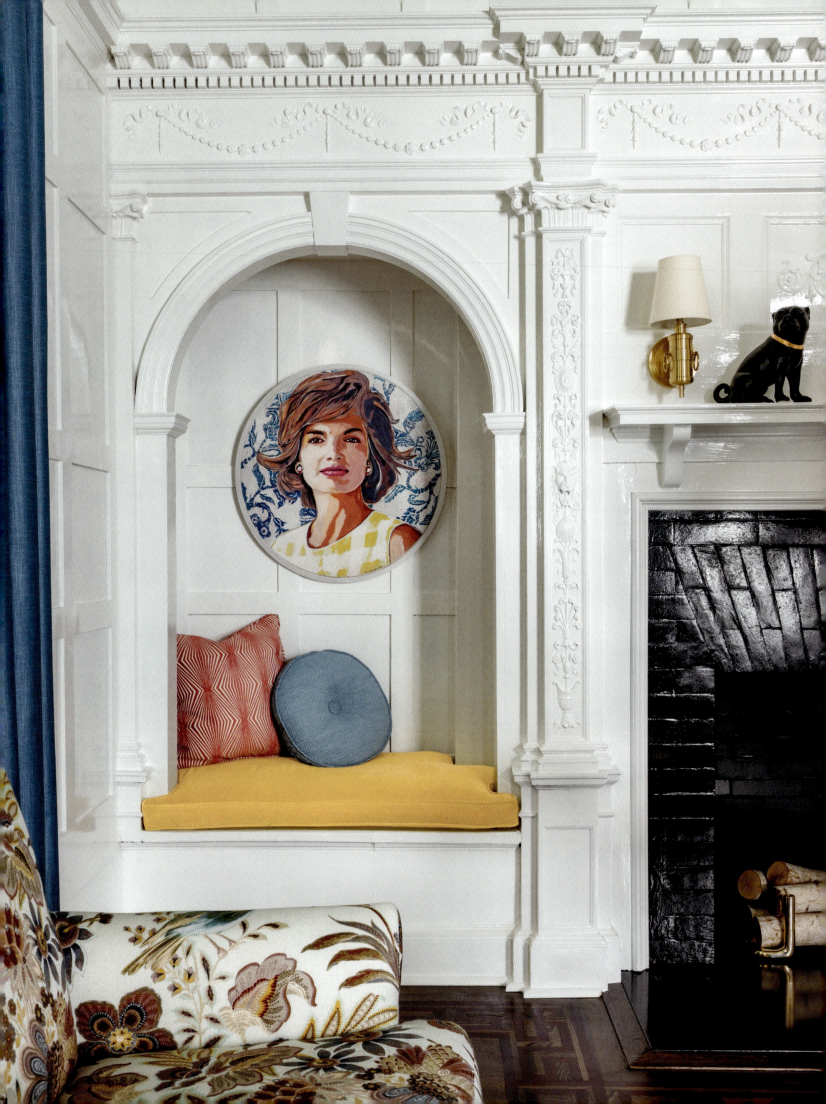

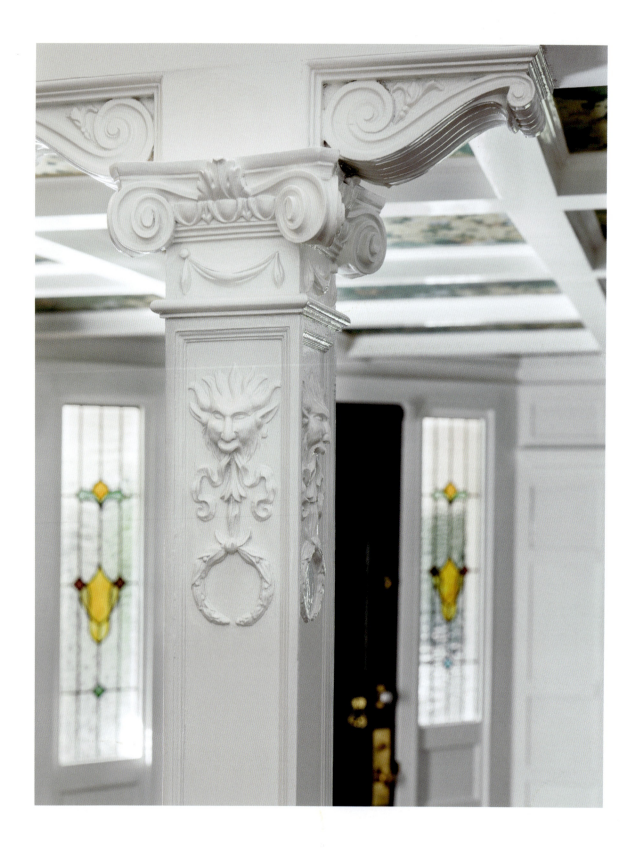

ABOVE AND OPPOSITE: Coating the woodwork in white lacquer gave its sculptural features more presence than they had with their previous, chestnut-colored finish—now they appear to have been carved from fondant. FOLLOWING SPREAD: The hall is both a gathering spot and a traffic lane for people entering and leaving the house, so it had to be both functional and welcoming.

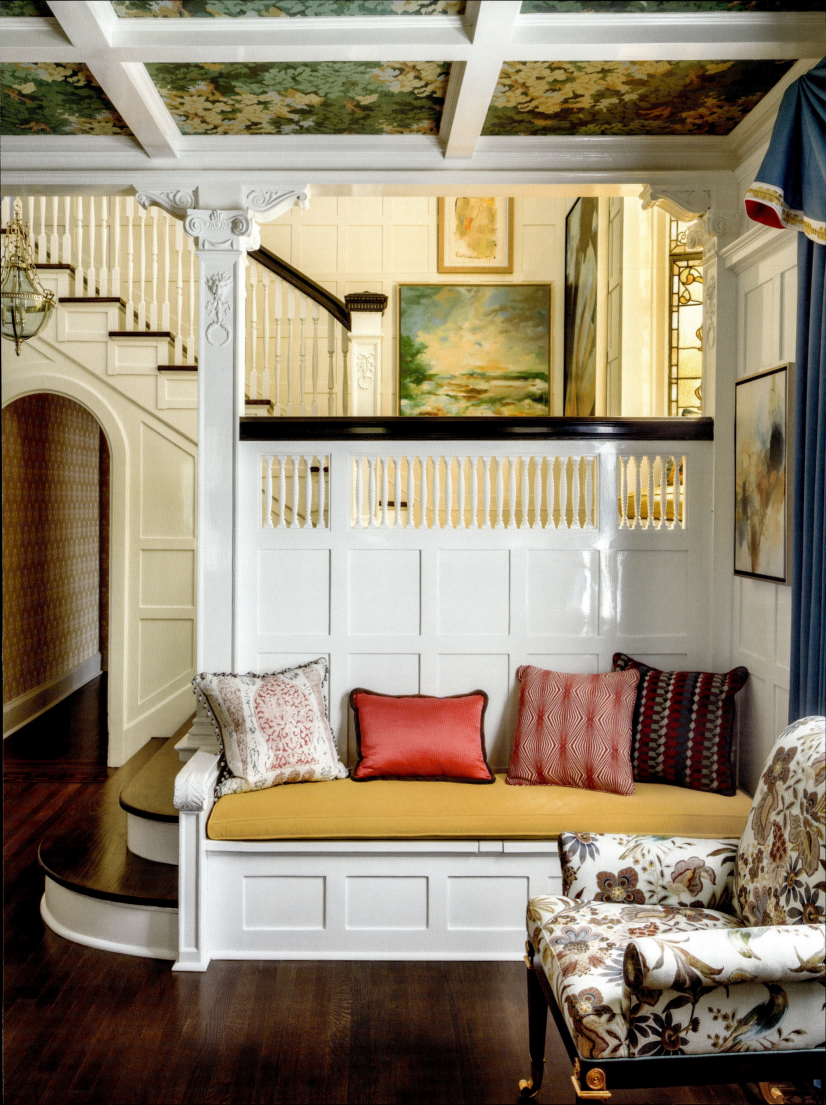

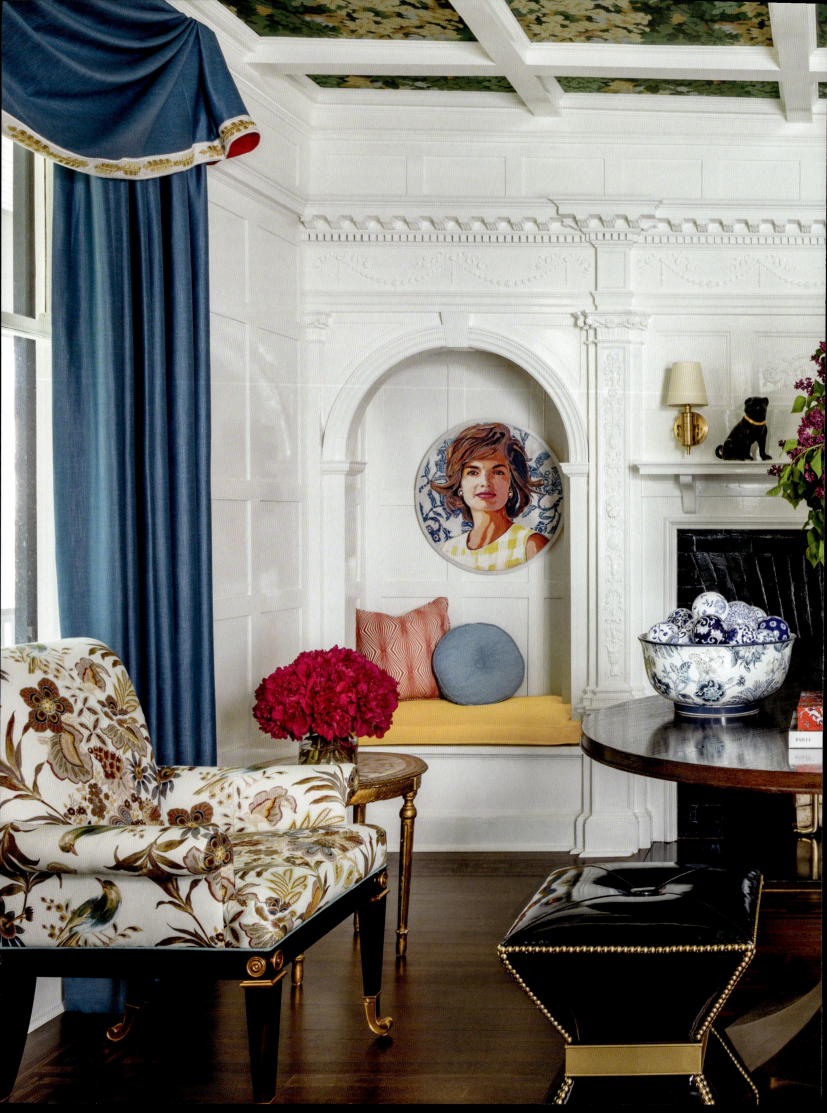

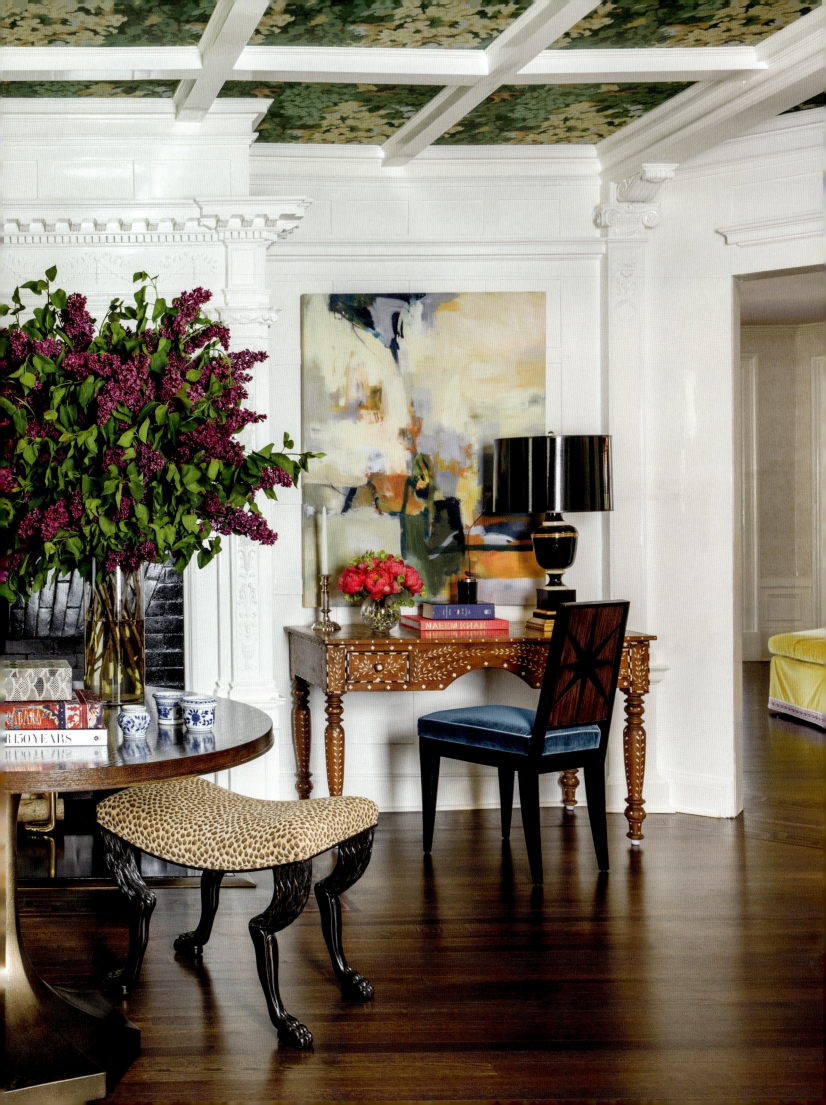

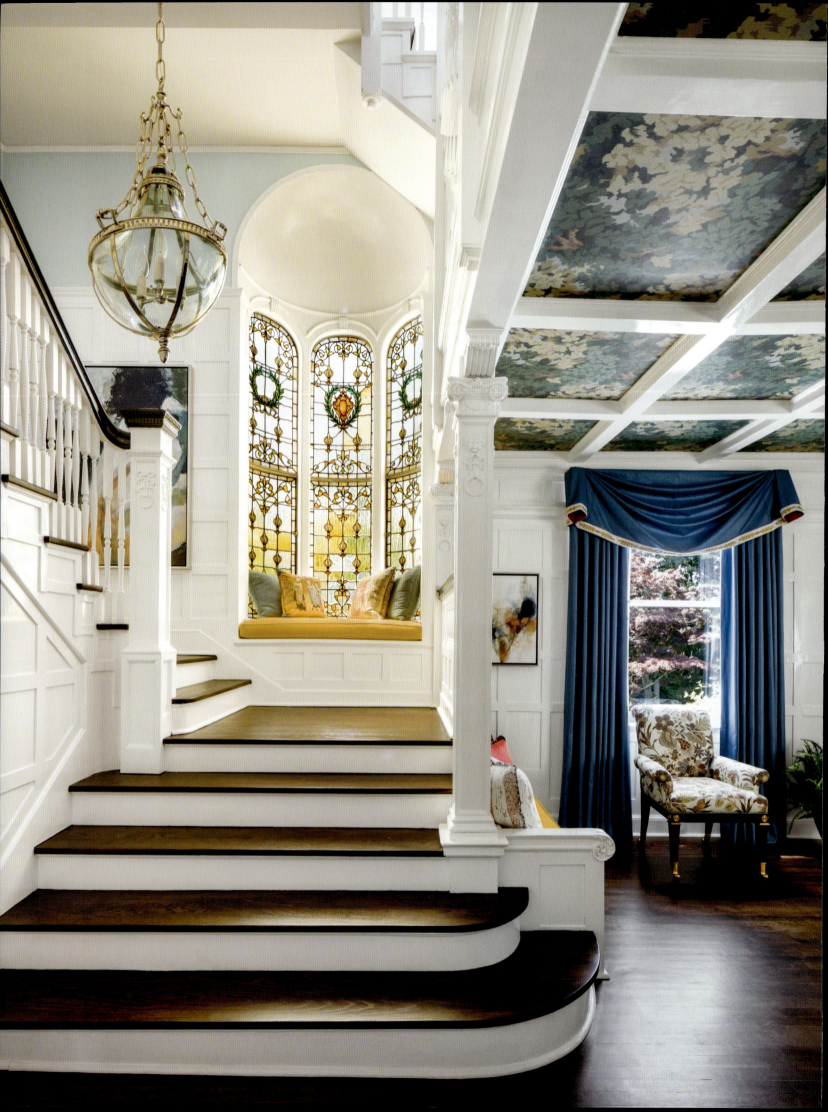

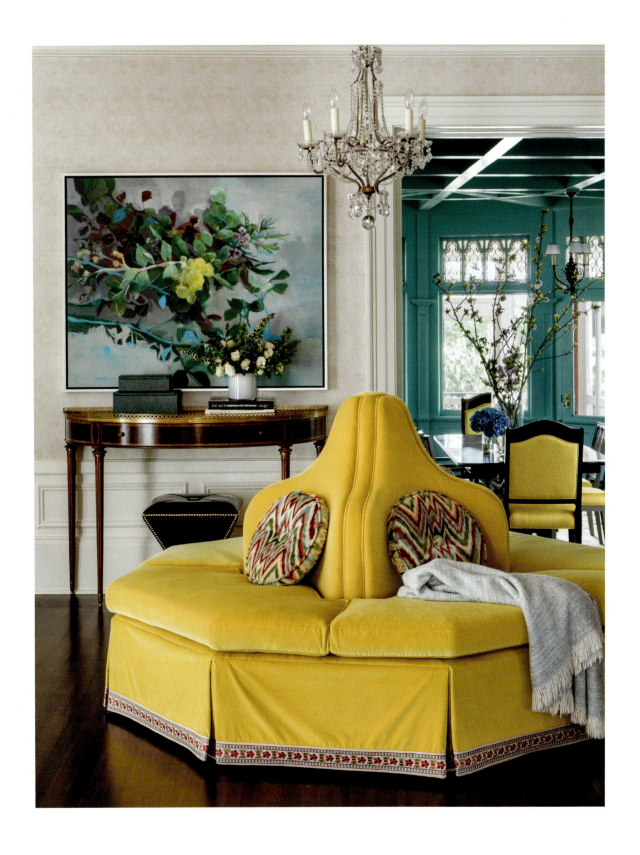

OPPOSITE: The coffered ceiling is embellished with wallpaper in a stylish botanical print. ABOVE: A lemon-hued borne settee adjacent to the living room gives people a place to linger and have an enjoyable chat. FOLLOWING SPREAD: Bold splashes of persimmon enliven the living room, which is otherwise a domain of soft colors and patterns. Even the wall covering has a subtle bone-inlay motif. The painting at far left is by Susie Zolghadri for Leftbank Art.

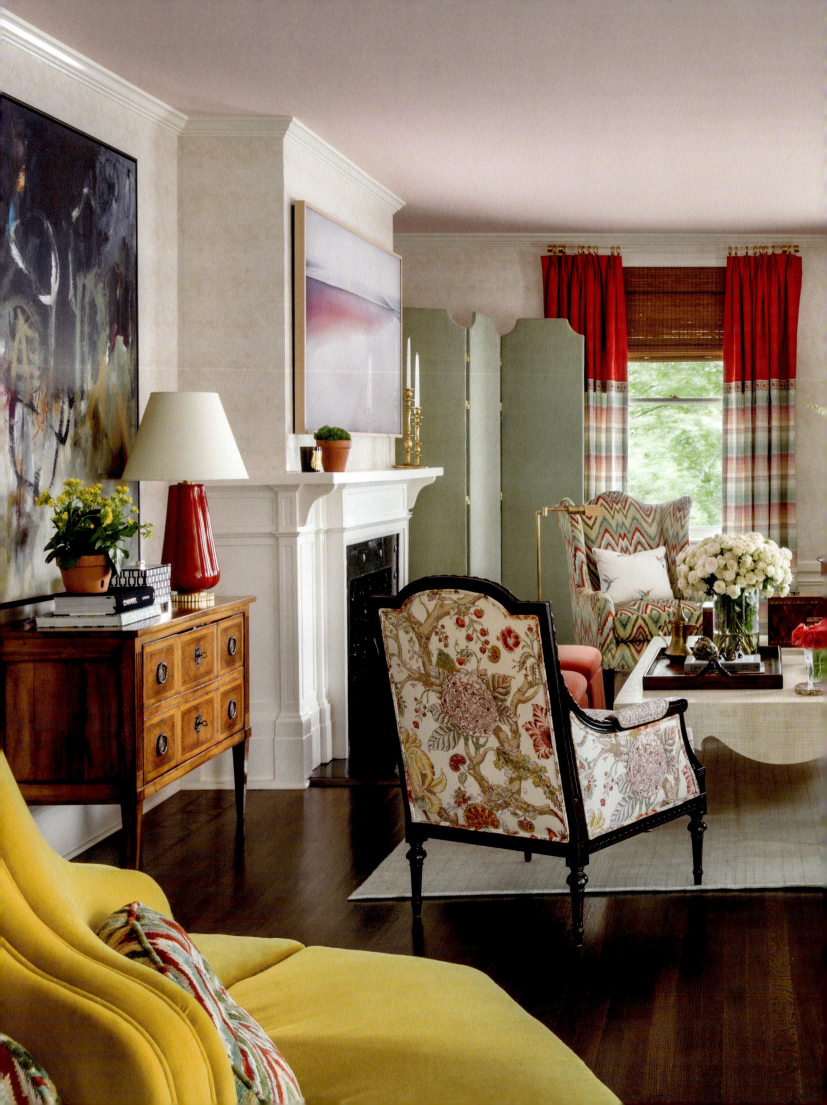

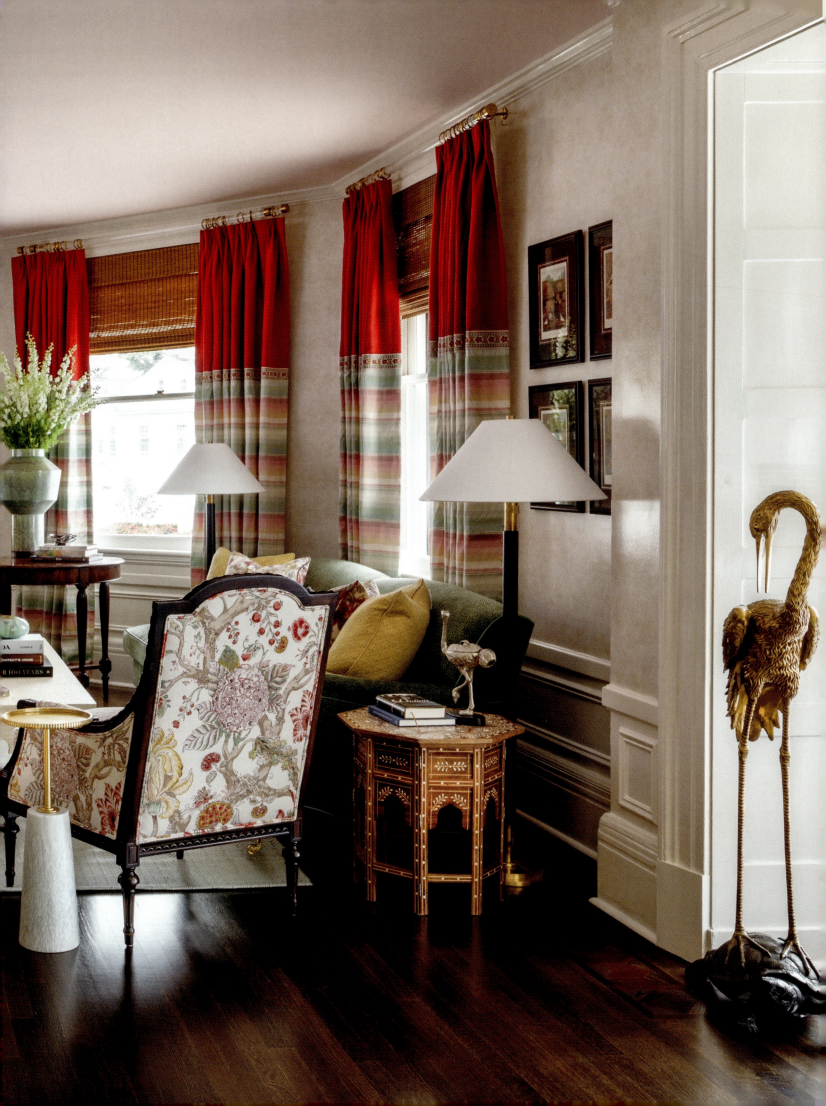

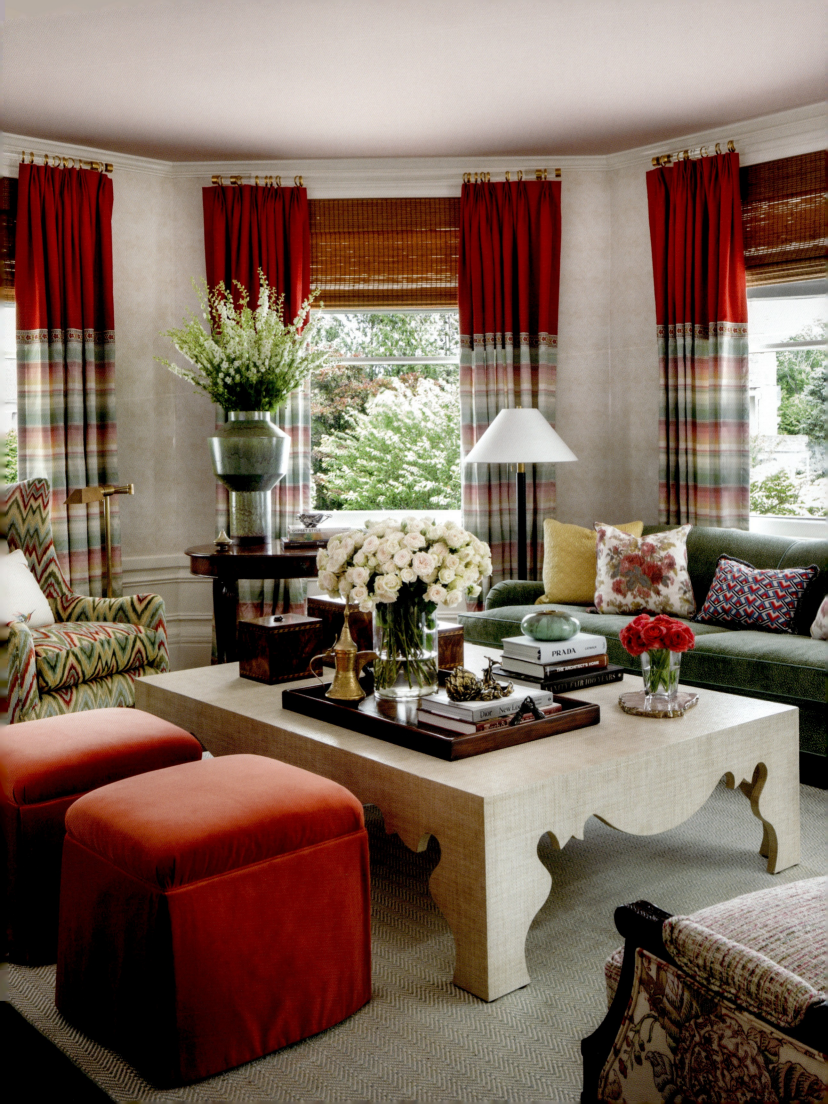

OPPOSITE AND ABOVE: The grass-cloth-wrapped cocktail table, with its shapely Moroccan curves, was custom-made for the homeowners. Big tables are perfect for displaying collections and interesting objects. FOLLOWING SPREAD: A white-lacquered desk, flanked by herons perched on turtles, looks out to the porch. PAGES 144–45: This ebonized console was originally gray. The glossy new surface accentuates the carved elements of the piece.

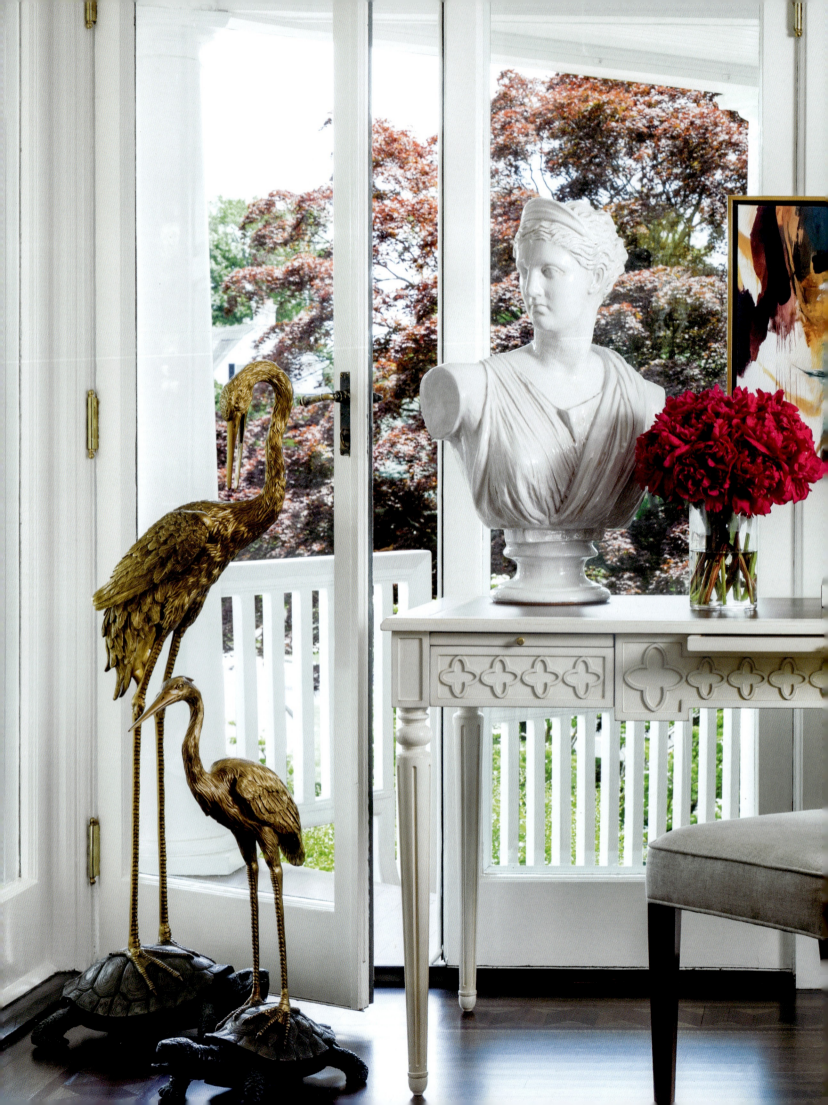

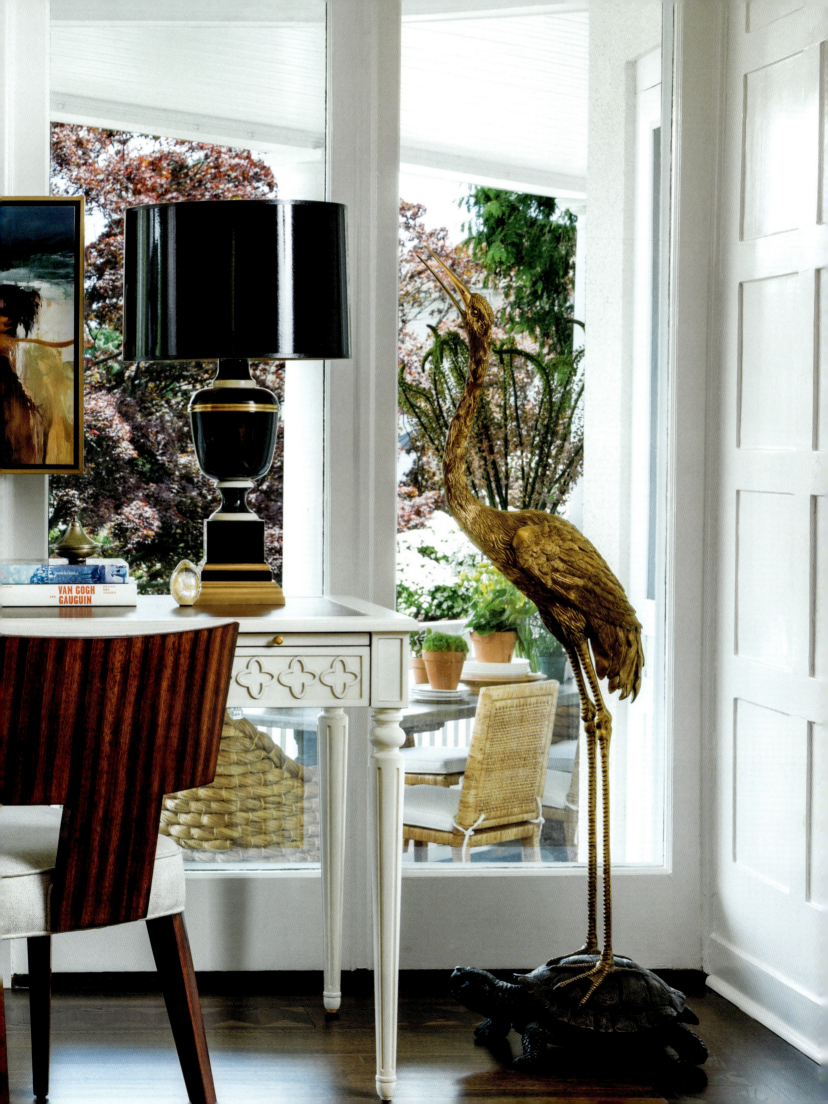

pillbox hats. We used them to inform our decision-making; hence the home's color palette of mint and jade, goldenrod, pinks and raspberries, cream, and pale blues and aquas. The other hues were inspired by the home's original stained-glass windows: vibrant green and dashes of amber and saffron. We likewise made sure that we had a good blend of couture-derived textures flowing throughout the rooms: leathers, velvets, linens, tweeds, and bouclés in various combinations.

One interior design challenge came from the very quality that gives the house its stunning curb appeal: the geometric energy of its architecture. With so many angled walls, there's hardly a simple, rectangular space anywhere to be found indoors; they're all irregular, frequently asymmetrical, and full of awkward

ABOVE AND OPPOSITE: My clients had previously painted their dining room this Tiffany blue, so we added complementary hues such as tangerine and a butter yellow in the furnishings, then lined the ceiling coffers with a wallpaper that recalls the marbled endpapers of an antique book.

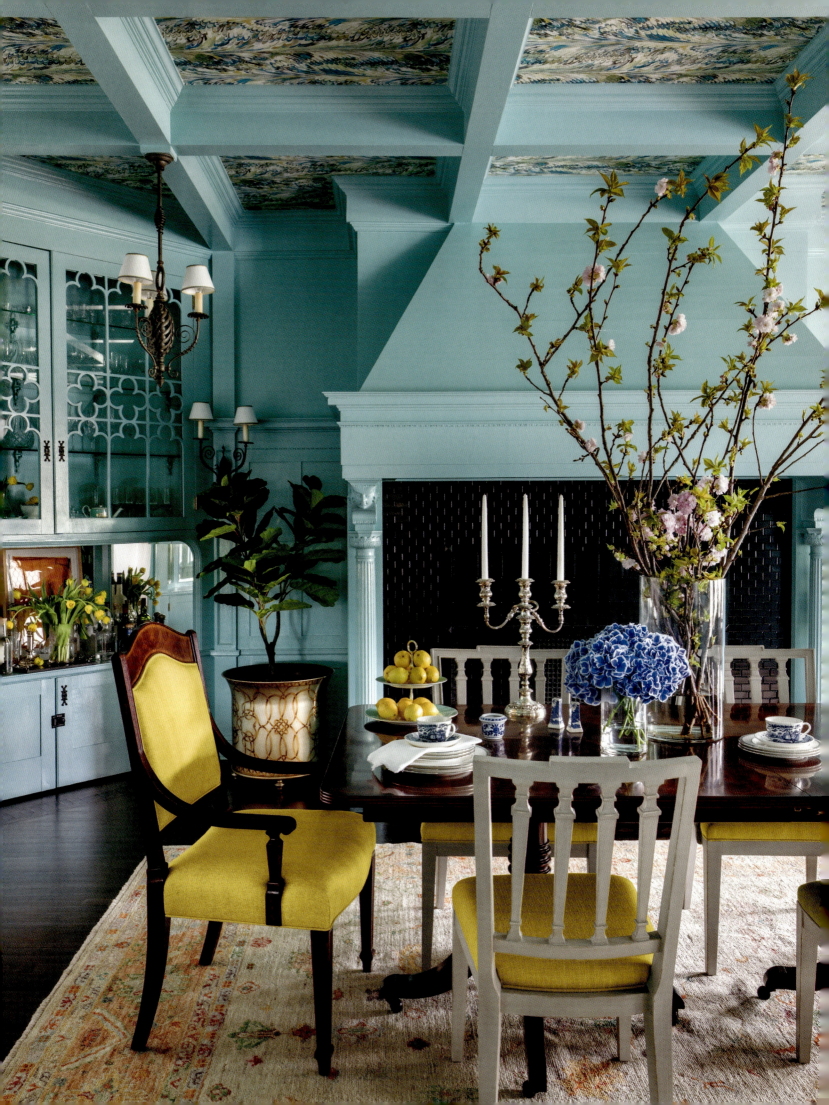

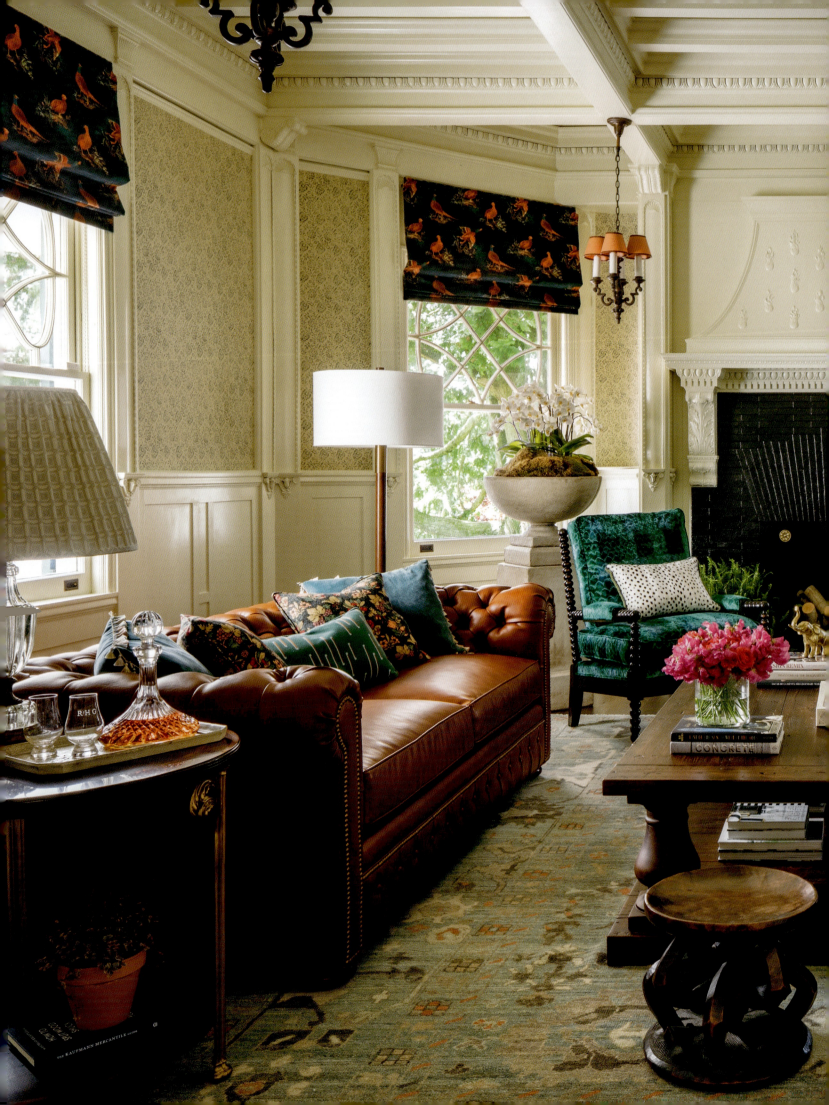

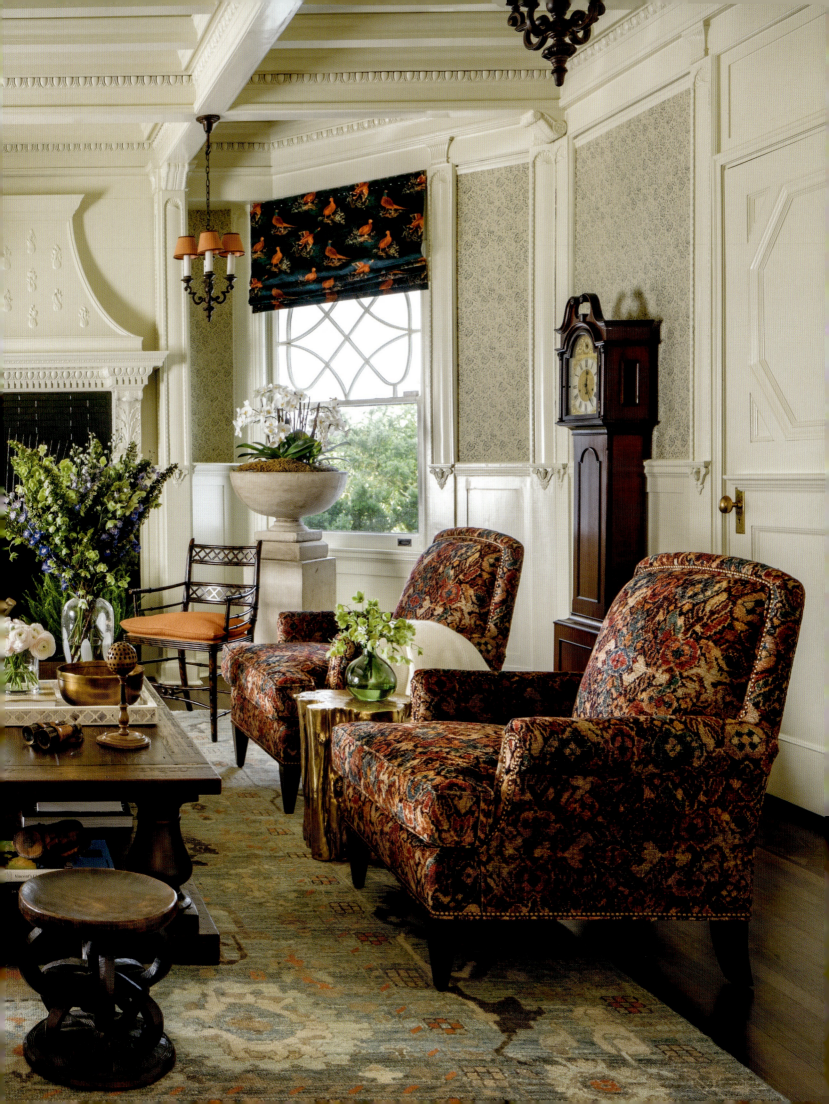

corners. The couple's bedroom is oval-shaped with a domed ceiling—gorgeous, but unexpected. How could we make such rooms cohesive and cozy?

In many cases, we floated furniture in the middle of rooms, away from the quirky edges. In large spaces this had the added benefit of keeping the sofas, chairs, and tables that compose a seating group close enough for easy conversation. In the living room, a tall, velvet-covered folding screen softens an awkward corner; a pair of stone pedestal planters performs a similar function in the study.

Our experience in this house underscores the value of not always following a strict formula for every room's design. Sometimes you need to be flexible about how you pull spaces together, because each one is unique. Consistency comes from carefully repeating shapes, colors, and fabrics. A black lampshade here echoes a black patent-leather ottoman over there. The bone-inlay desk against one wall has a partner in the Moroccan table across the way. Pops of rattan, wicker, or cane crop up again and again. Organic patterns abound, from a botanical wall covering layered into the coffers of the front-hall ceiling to a cheetah-print pillow and the idyllic landscape shown in the bedroom's handpainted mural.

The real joy of working on a period home is figuratively tapping into a conversation across the decades with the original makers, understanding their vision, and then reimagining the interiors with our own personal statements today. Many of our design choices in this house would have been far from conventional in 1900, but we always made them in the spirit of what was already in place. While honoring the soul of the house as it was first built, we created something friendly and comfortable for a young family to enjoy.

PRECEDING SPREAD AND OPPOSITE: The study has a masculine yet whimsical vibe, with a custom Chesterfield sofa, carved stools the husband bought in Africa, and velvet Roman shades ornamented with ducks and pheasants. The petite chandeliers are original to the house.

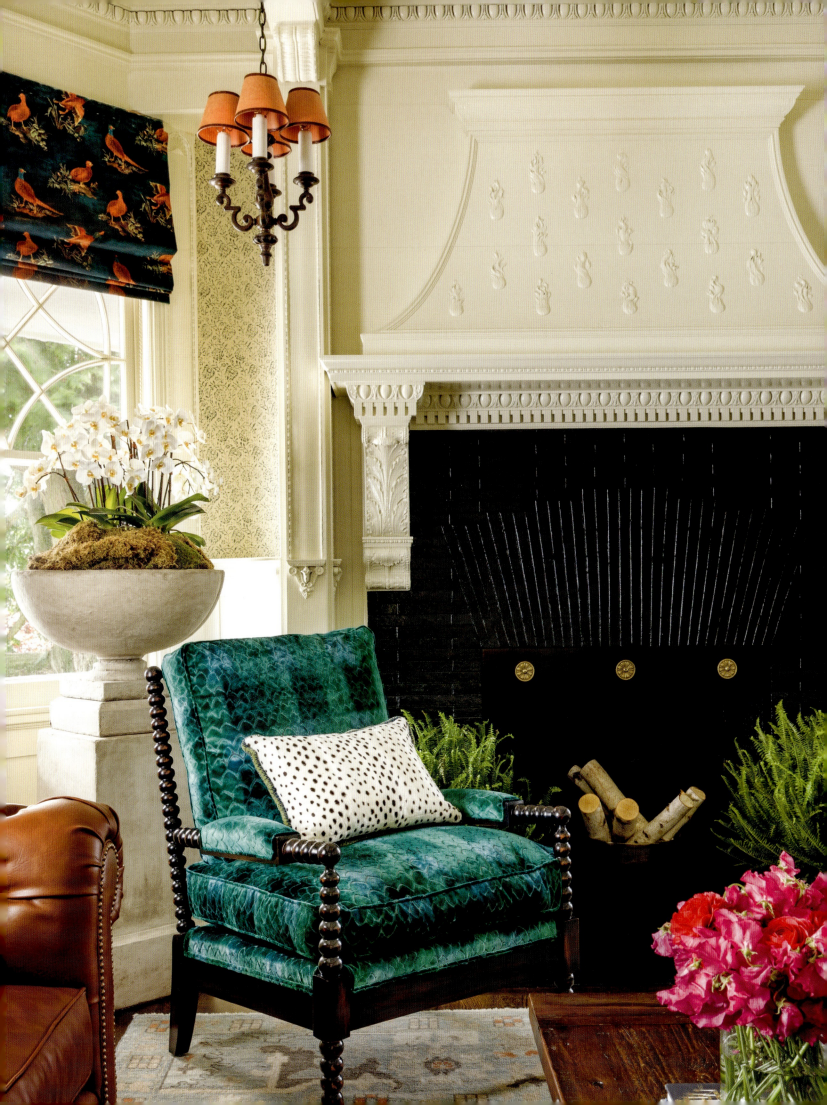

ABOVE, OPPOSITE, AND FOLLOWING SPREAD: No effort was spared to preserve and emphasize the breathtaking architecture of the owners' bedroom. When you are given a gift of architectural detail, use it! The cove ceiling was painted a butter yellow, and the elaborate millwork was lacquered in a mossy olive color. The Empire chandelier is a 1930s antique. The low-slung bed was designed specifically to fit into the configuration of the mural that now encircles the room.

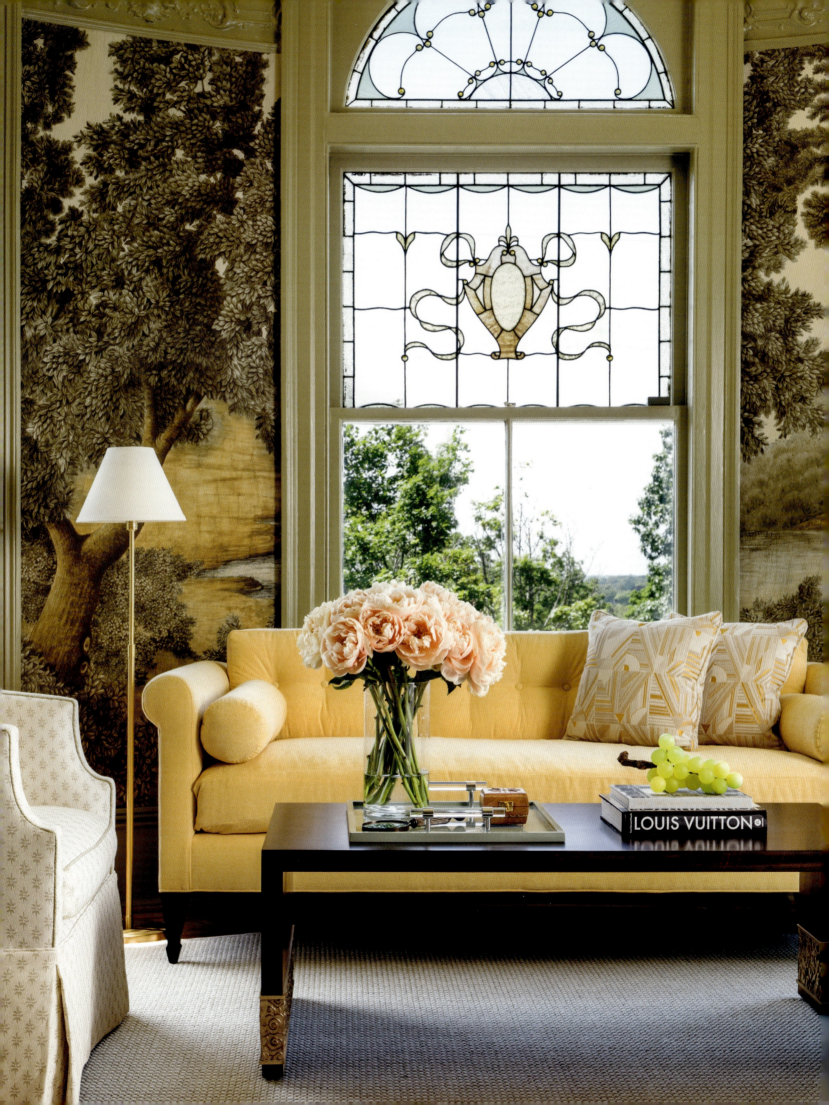

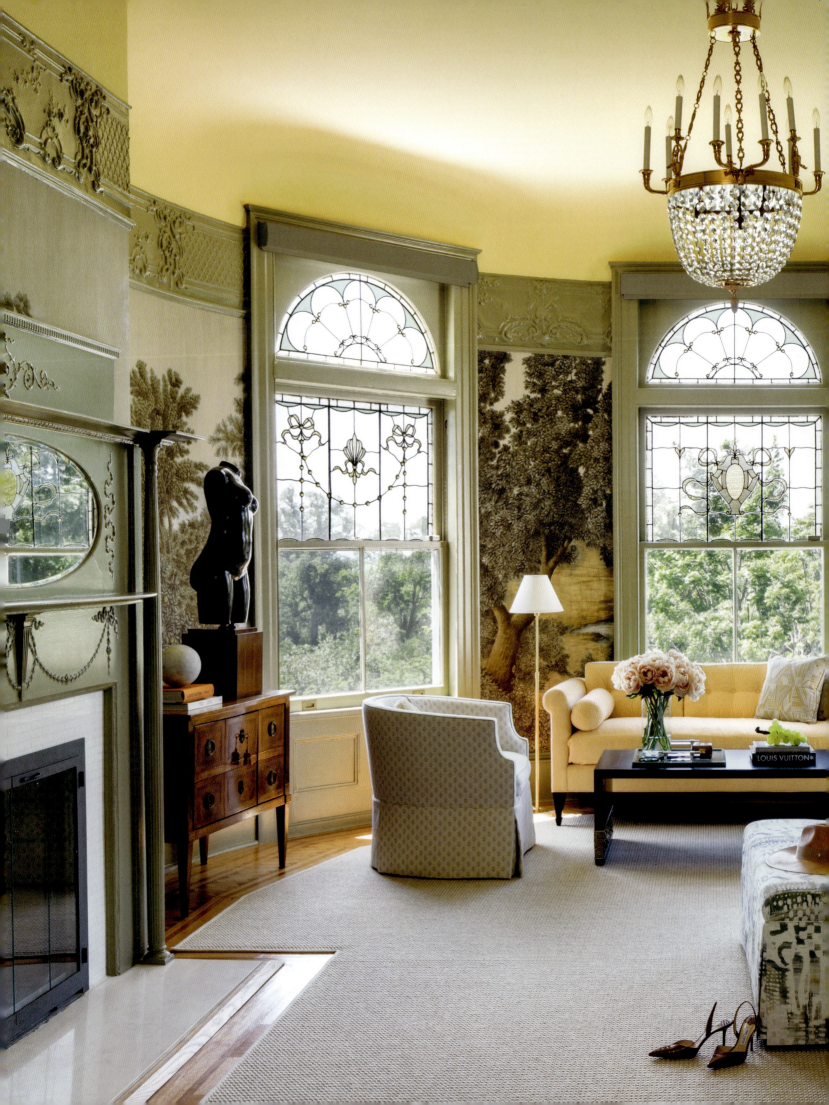

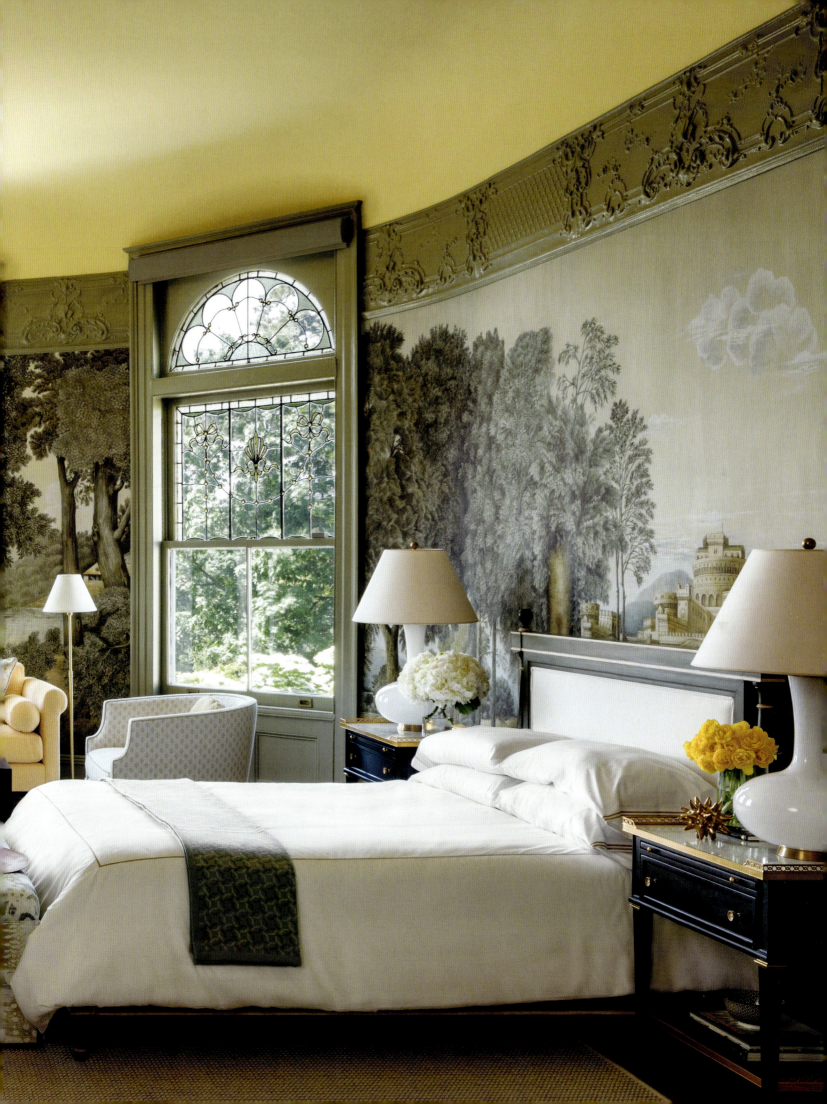

APPLIED EXPERTISE
Living Rooms

When designing a living room, whether it's open concept or a compartmentalized space, aim to make it as versatile as possible. In other words, living rooms should offer multiple functions to meet a variety of needs. Many people think the kitchen is the heart of the home, but I would gently push back on that: I believe the living room carries that distinction. After all, it's where you entertain guests, spend time with family, watch movies, and make memories.

FURNITURE GROUPINGS

I prefer to divide a living room into separate zones, each one meant for a different purpose. Perhaps you have a sofa, chair, and credenza arranged for TV watching, and in another area you have a round table and chairs for game playing. (The same table can be used for occasional meals or set up as a buffet for parties.) While it may be tempting to plop down a spaceship-size sectional in the middle of a big room to fill it up, remember that most folks appreciate a measure of elbow room. Having several seating arrangements makes a large living room feel more intimate and encourages many conversations to flourish during gatherings.

FURNITURE PLACEMENT

When space allows, I like to float furniture away from the walls. If you create a grouping in the center of a room, make sure the furniture silhouettes are as visually attractive from the back as they are from the sides and front. I prefer sofa-with-chair combinations, but sectionals can also be effective, especially set in a corner to produce an additional conversation nook.

DESKS

Almost every living room is well served by having a desk and chair—the perfect spot to pay bills, write letters, or read a magazine. For people who have back issues and can't slouch on a sofa for hours on end, this furniture combination gives them an alternative, and more ergonomic, seating option.

LIGHTING

Illumination should be judiciously placed throughout the room—not just overhead—so have a number of lamps available to provide eye-level ambient lighting. (A pharmacy lamp stationed by an armchair for reading is always nice.) If you are building or renovating a home, consider where outlets can be strategically installed in the floor. This will eliminate tripping (and aesthetic!) hazards caused by having electrical cords strung across the room.

OPPOSITE AND ABOVE: We covered the living room in jewel-tone colors and a rich assemblage of patterns—including chintz, flame stitch, and animal prints—turning it into an interior garden. Fabrics are from my Trad Nouveau collection for Kravet Couture.

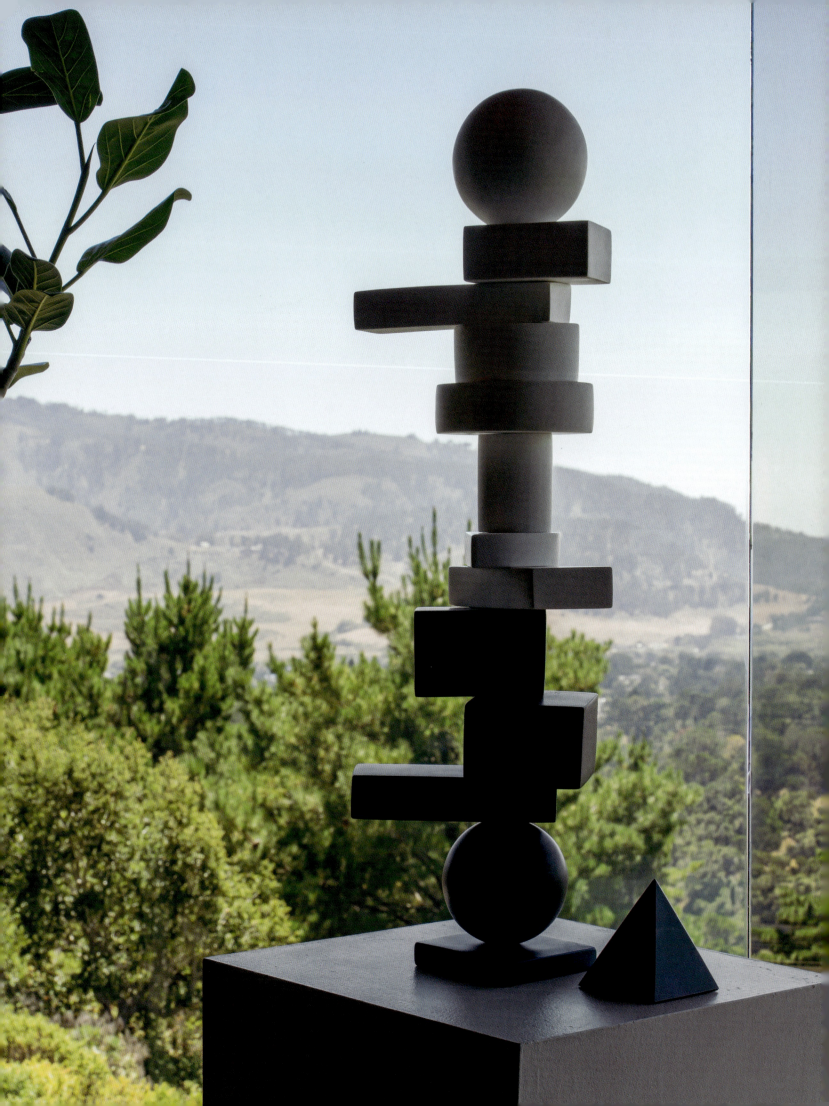

Sanctuary by the Sea

Oh, how I love a challenge. That thought was top of mind as I met with the Lincoln automotive team in Detroit to discuss a new collaboration. For the first time ever, the automaker would unveil its newly designed Lincoln Navigator SUV at Monterey Car Week against the backdrop of a show house thoughtfully created in the vehicle's image.

Any show house is a challenge. You never have enough lead time, and to transform completely the aesthetic experience of a room—let alone an entire home, as I was being asked to do here—is a complicated exercise in imagination, planning, and logistics. But my team and I were up to the task.

The all-new Lincoln Navigator would be modern, streamlined, and very much about understated luxury and elegance. My firm's mandate, therefore, would be to translate the experience of the vehicle into a correspondingly sleek, nuanced interior design, turning a low-slung contemporary residence on a ranch in the coastal hills of Carmel, California, into a faithful reflection

This sculpture by artist Martha Sturdy is positioned in front of a guest bedroom window. It encapsulates an important thematic characteristic of this house: its fusion of simplicity and energy juxtaposed with calming elements of nature.

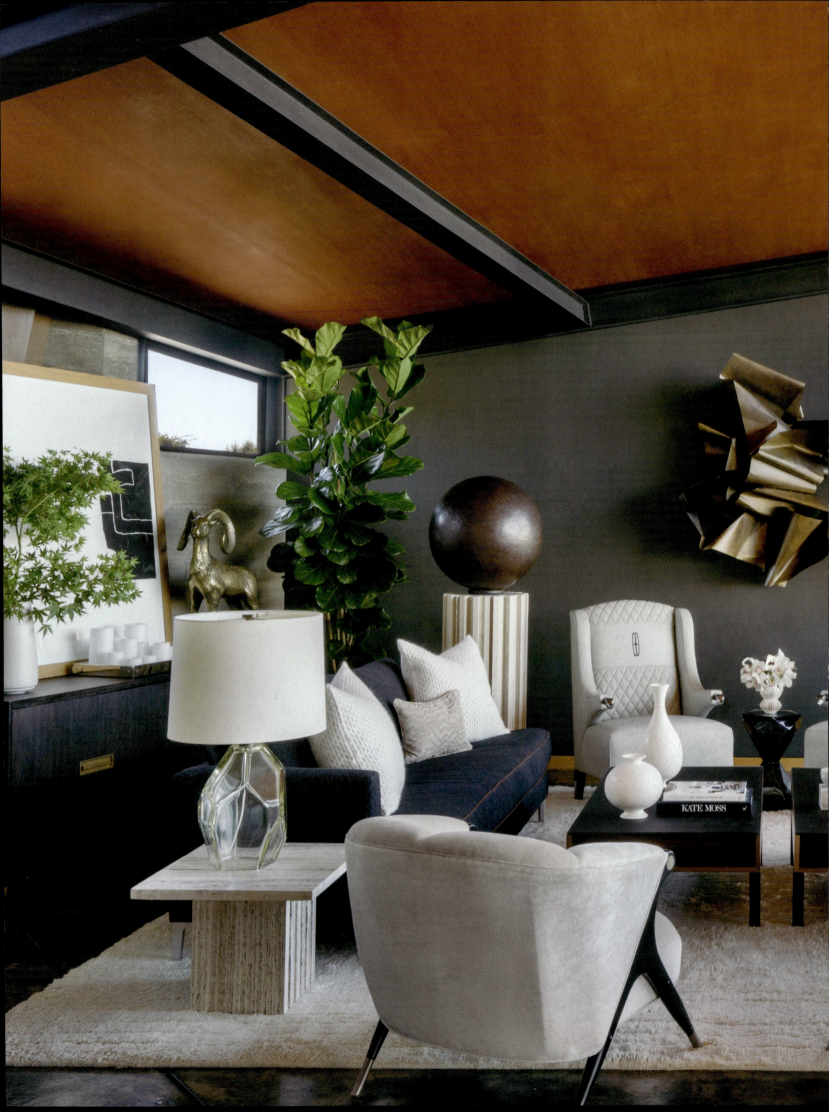

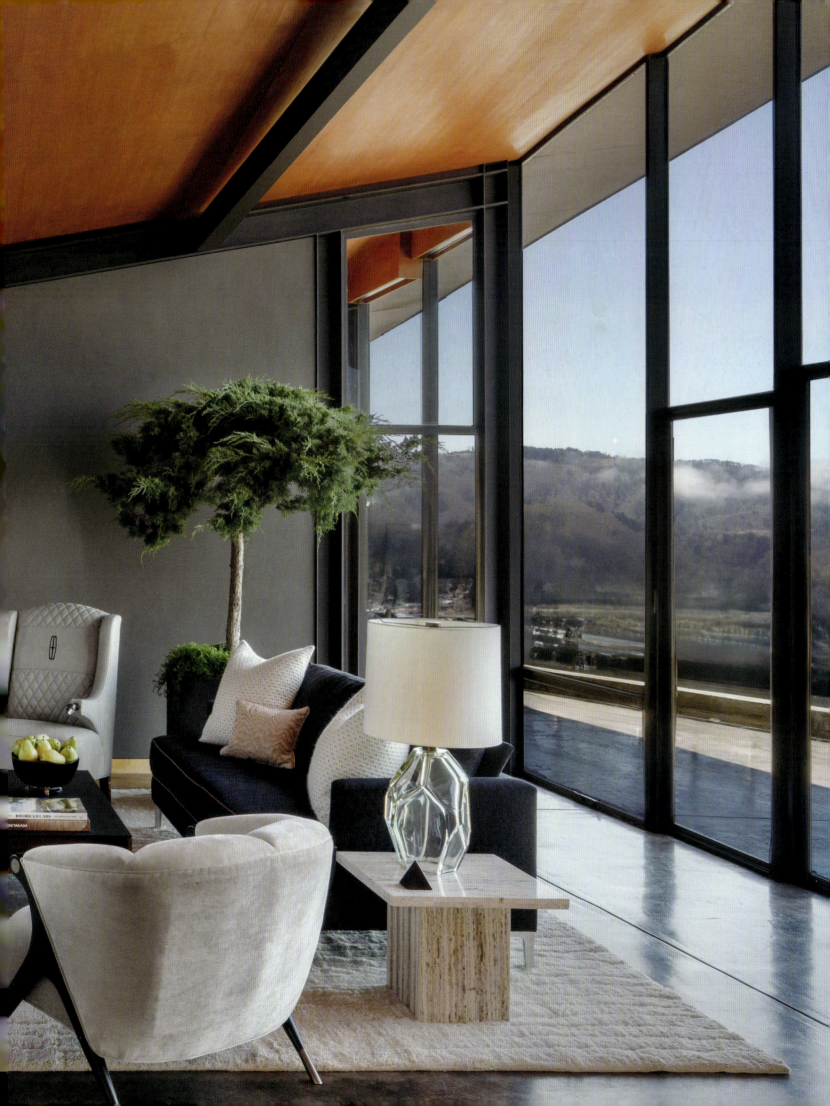

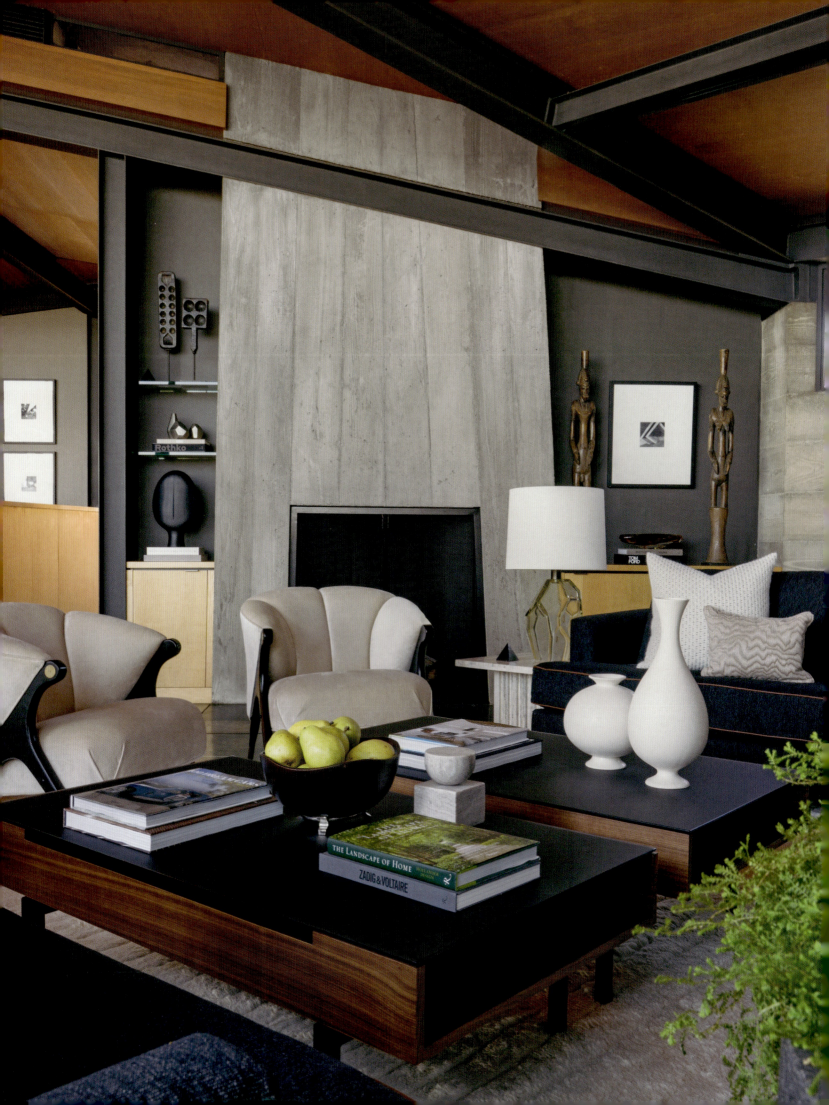

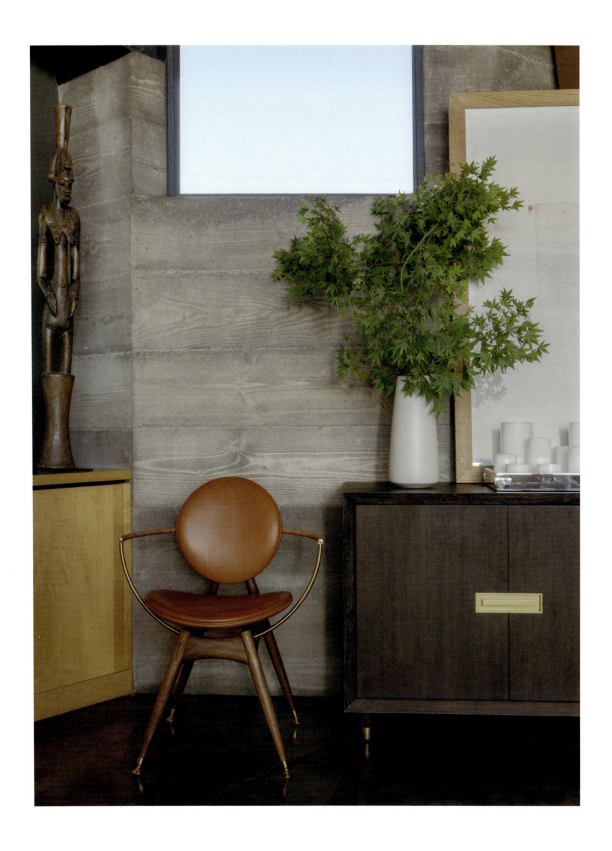

PRECEDING SPREAD: Materials used in the living room, such as the dynamic brass wall sculpture by Martha Sturdy, allude to the Lincoln Navigator. Certain color pairings do, as well, including the combination of black upholstery and chocolate leather piping on the pair of custom Kravet sofas. OPPOSITE: Double coffee tables reference the Navigator's split-gate feature. ABOVE: The African sculptures in the room are antiques.

of the Navigator as an oasis of calm. The overall color palette, the materials used, the lines and curves of the architecture and furnishings—all would take their cues from aspects of the Navigator's interior and exterior styling.

The collaboration would be a homecoming of sorts, since I'm a Detroit native and I worked in the automotive industry earlier in my life. But even more important, it would furnish a welcome chance for my team to play against type, to show off our versatility. It would be an adventure.

Although the schedule we were given was tight (as I predicted), we were still able to add personalized touches to the house with a few furnishings we had specially made, including the living room's sofas and a pair of Doxon wing chairs from my furniture collection with Hancock & Moore. Custom work is an opportunity to tailor a design precisely for your clients; in this case, the chairs' dog-head arm finials recall the greyhound insignia that was featured on Lincoln automobiles in the 1920s and 1930s, while the company's present brand mark is embroidered into the gray leather upholstery. The stitched diamond detail on the chair backs also echoes the quilted seats offered in the Navigator design. Other appropriate furnishings were brought in from design showrooms in New York and San Francisco, and we partnered with the Bay Area's Caldwell Snyder Gallery to curate a selection of fine art and sculptures.

The home's overall atmosphere is relaxed and meditative. Elements of glass, wood, stone, and metal allude to the grounding quality of natural substances that make up the earth. In lieu of a chandelier, a tall juniper tree acts

Two custom armchairs incorporate the greyhound insignia and quilted interior seating details that historically have been associated with Lincoln. This show house was unique because our mandate called for translating a client's highly defined brand identity into a different medium.

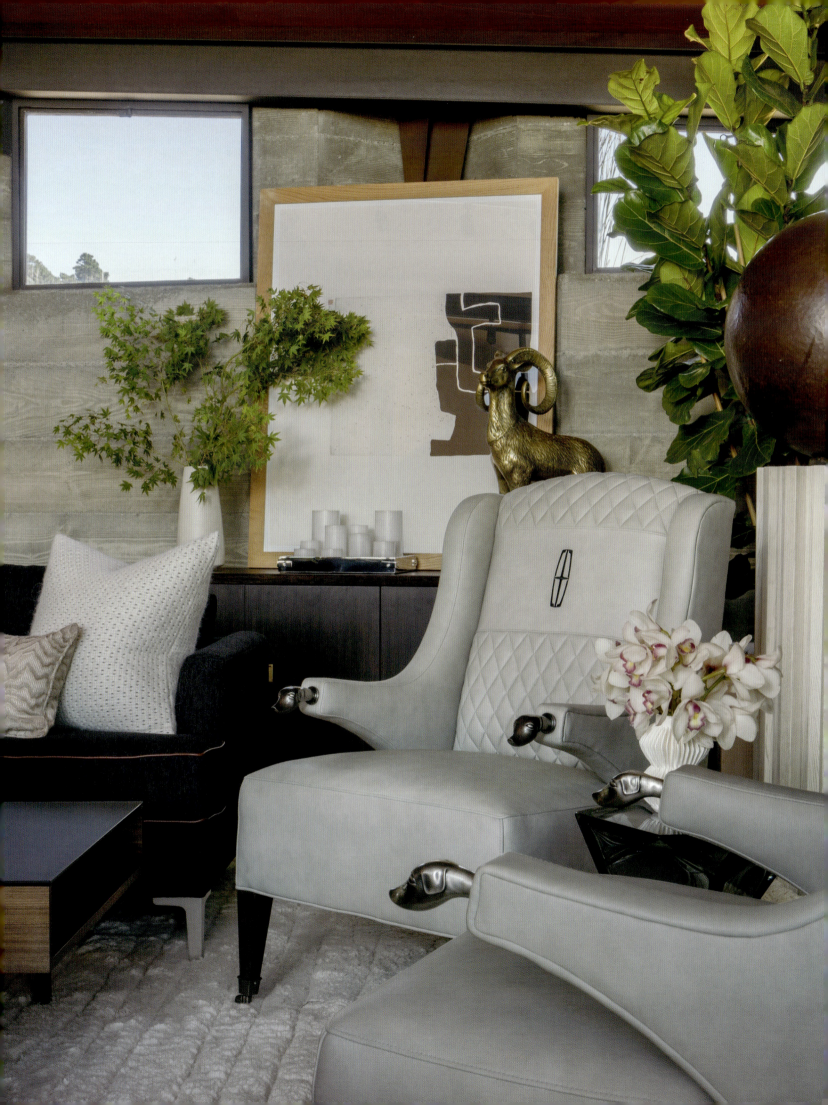

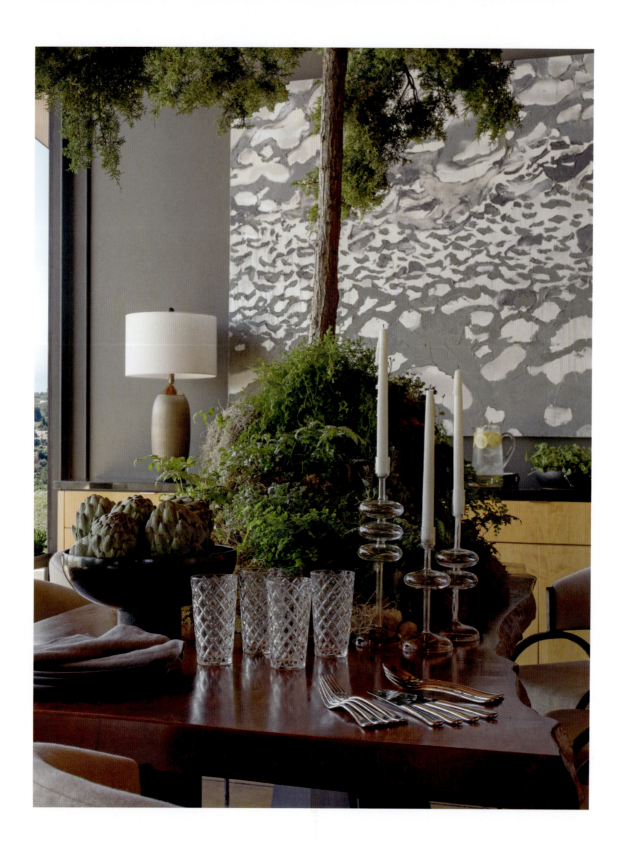

ABOVE: Glass objects call to mind water and ice, as does the Brendan Stuart Burns painting behind them, which resembles floes breaking apart on a thawing river. OPPOSITE: The dining table melds a natural slab of live-edge wood with a very modern metal base. FOLLOWING SPREAD: The secondary bedroom celebrates shades of noir. The dark, neutral palette contrasts beautifully with the organic textures—both inside and beyond the windows.

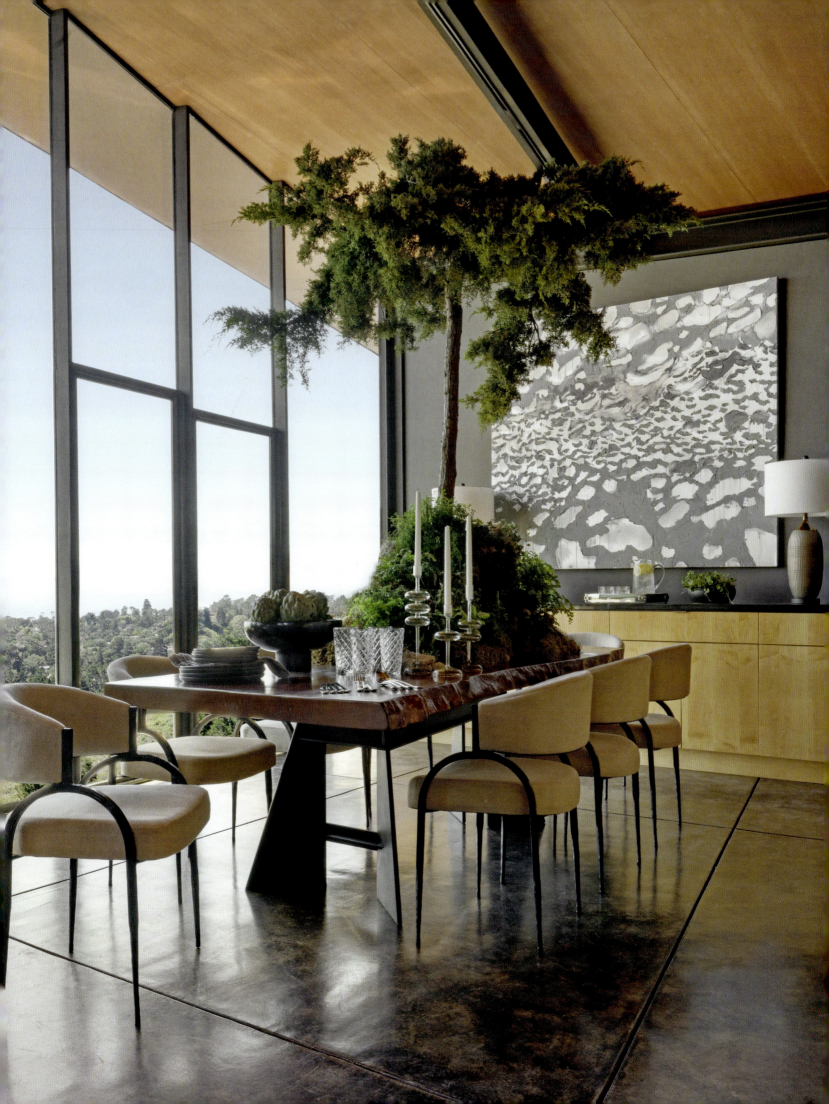

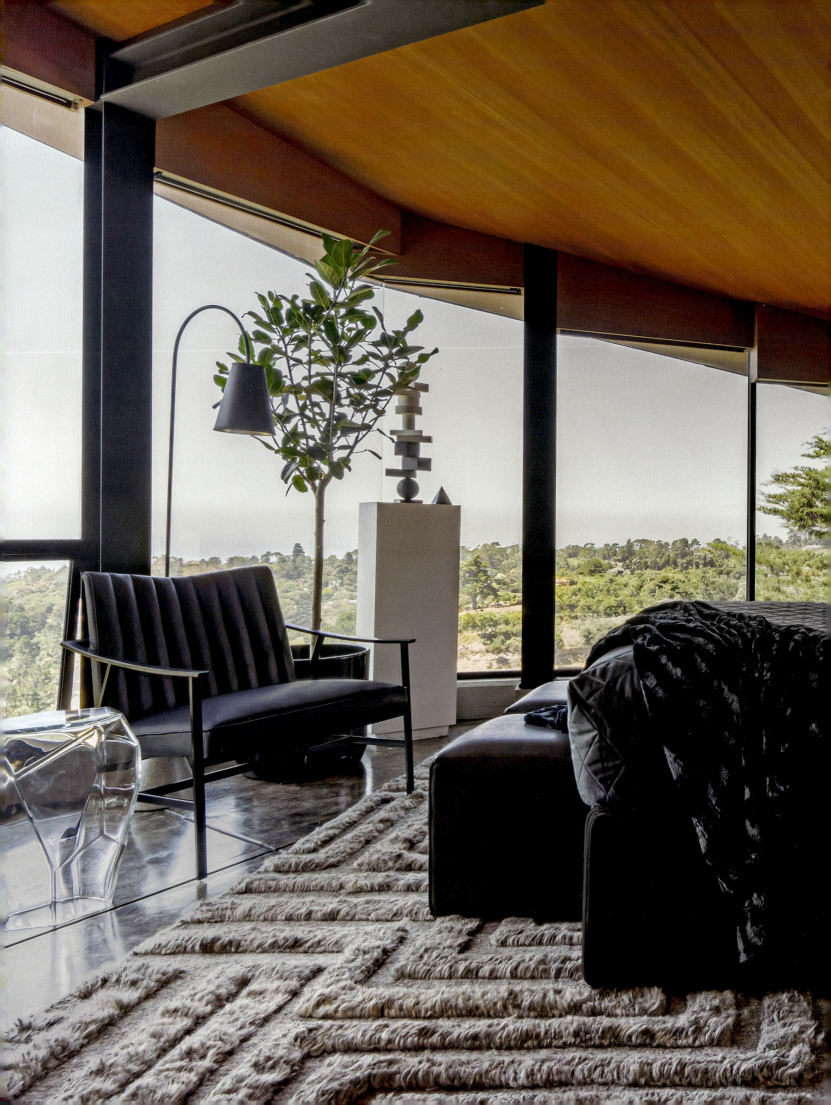

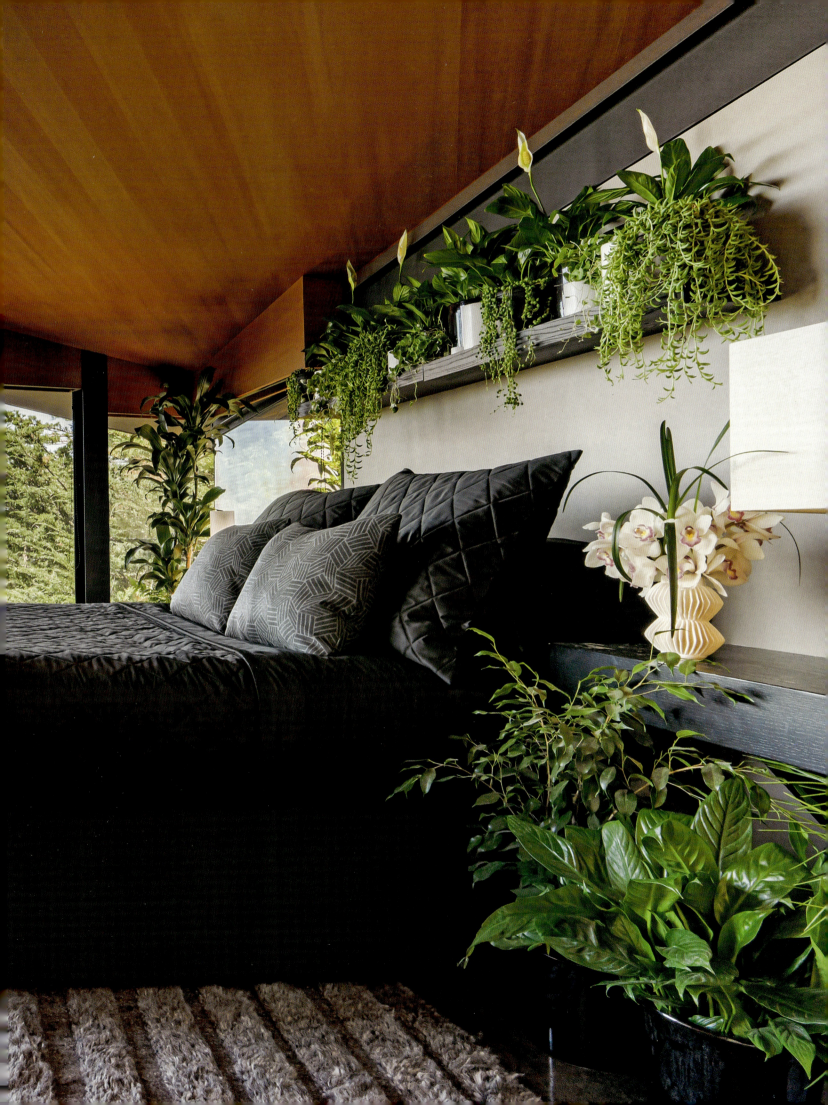

ABOVE: Sculptural artist Martha Sturdy created forms of vertically stacked blocks, geometric shapes, and spheres that I featured prominently throughout my design. OPPOSITE: Each gradation of darkness gets its own surface quality, from sleek to shaggy. FOLLOWING SPREAD: The ethereal primary bedroom is designed to make you think of the elements: clouds, fog, and wind. Even the concrete floor might call to mind a stormy sky.

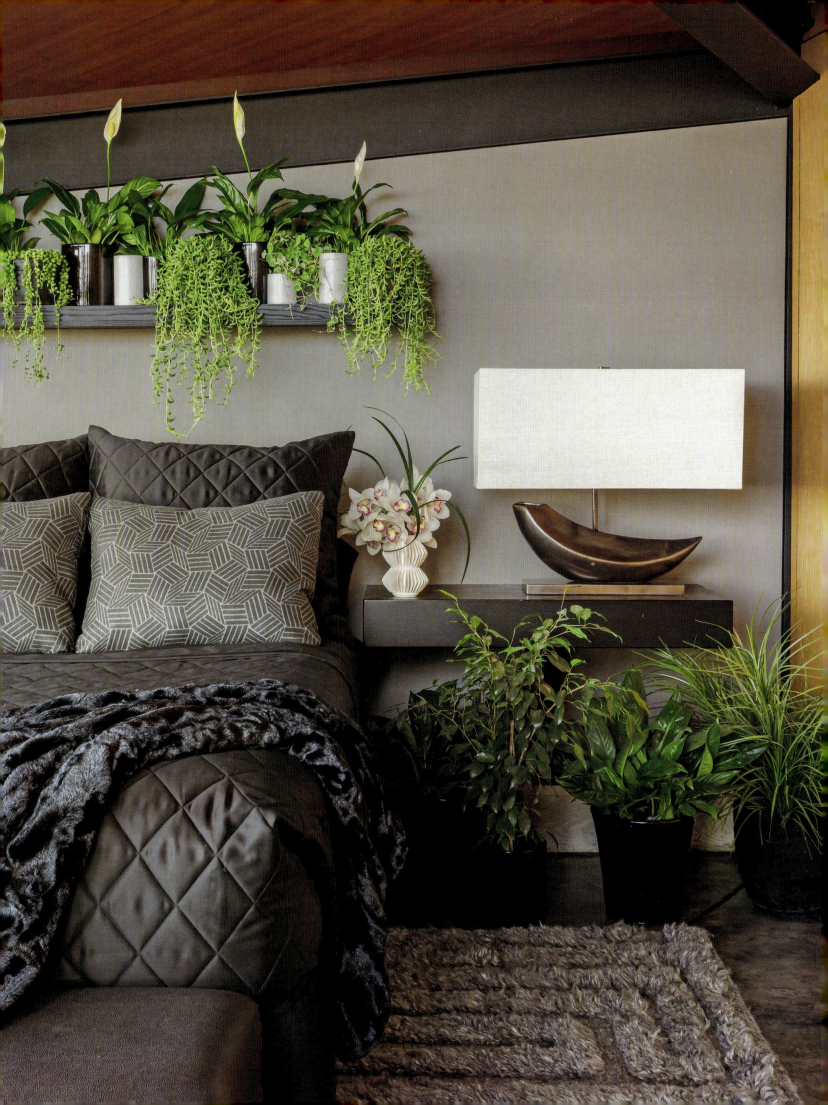

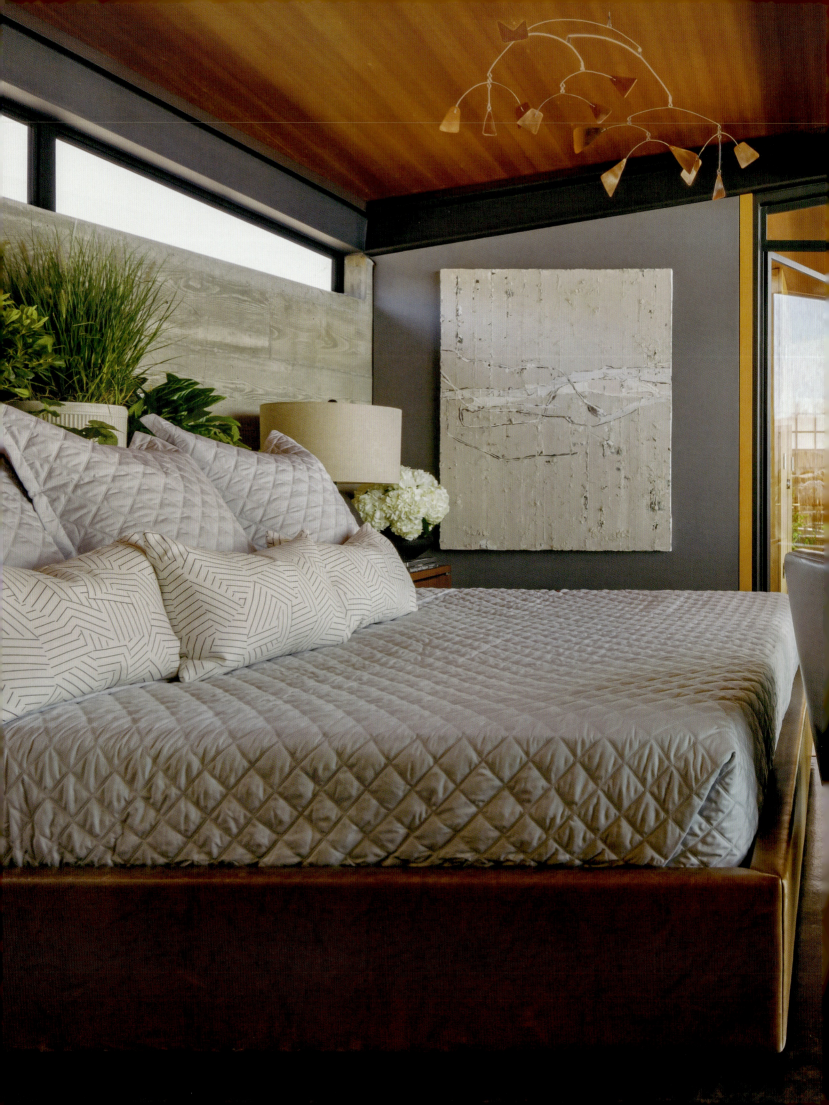

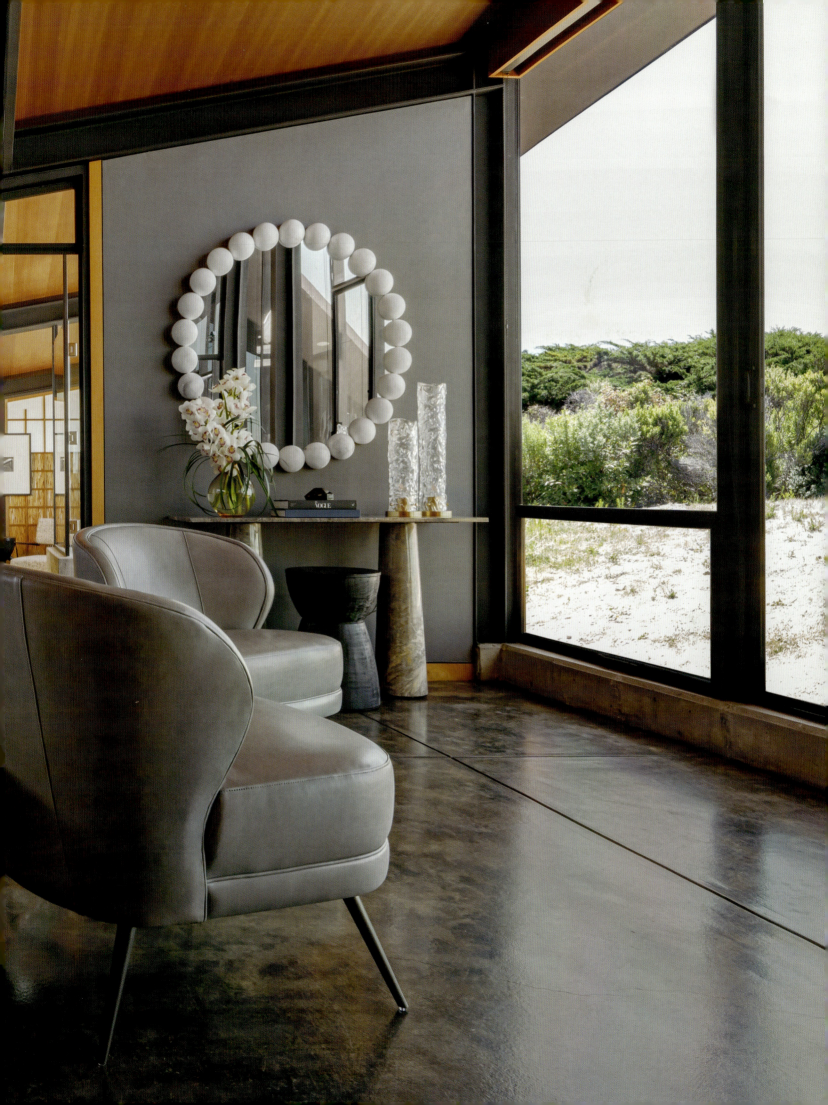

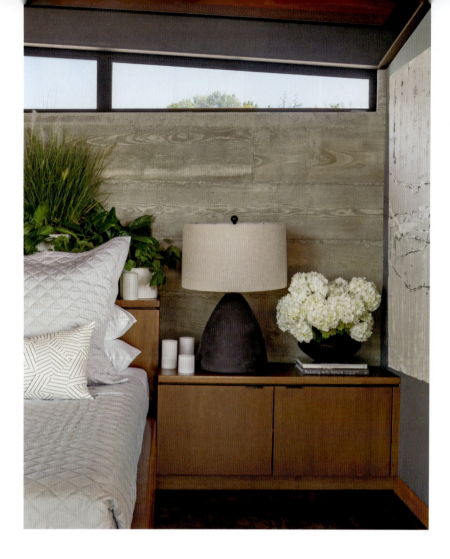

as a canopy over the dining table. Whenever possible, I like to incorporate lush, aromatic plants in my spaces for the organic freshness they impart.

Greenery aside, the house is a symphony of black, gray, white, taupe, and cream mixed with brown and copper hues. In such a nearly monochrome context, the play of textures and subtle patterns becomes doubly important, with polished concrete floors, sculpted rugs, and other similarly tactile surfaces supplying the necessary quota of visual interest and sumptuousness.

This project was all about invention, deploying limited colors and simple forms in varied configurations to achieve a tranquil yet powerful result.

ABOVE: Every space is enlivened by the addition of fresh flowers and plants.
OPPOSITE: The Zen-like spa room is a place of meditation and rejuvenation. Like the rest of the house, really, it embodies the idea of sanctuary.

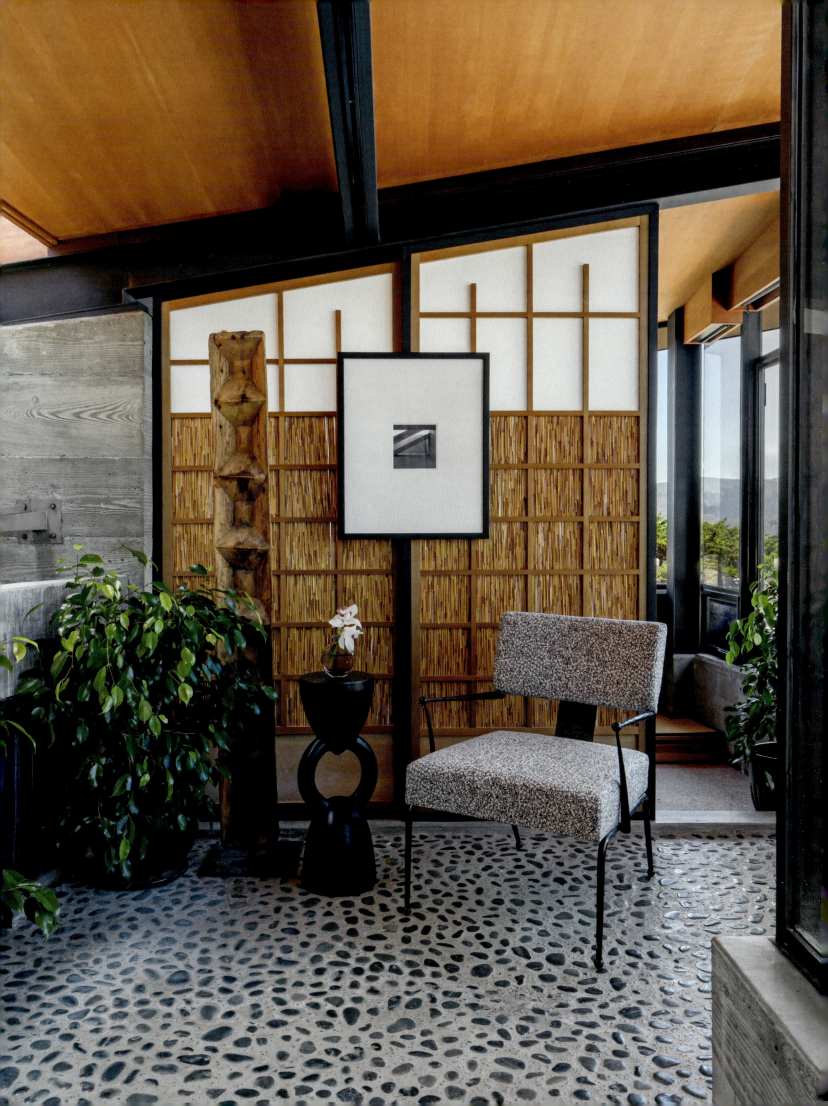

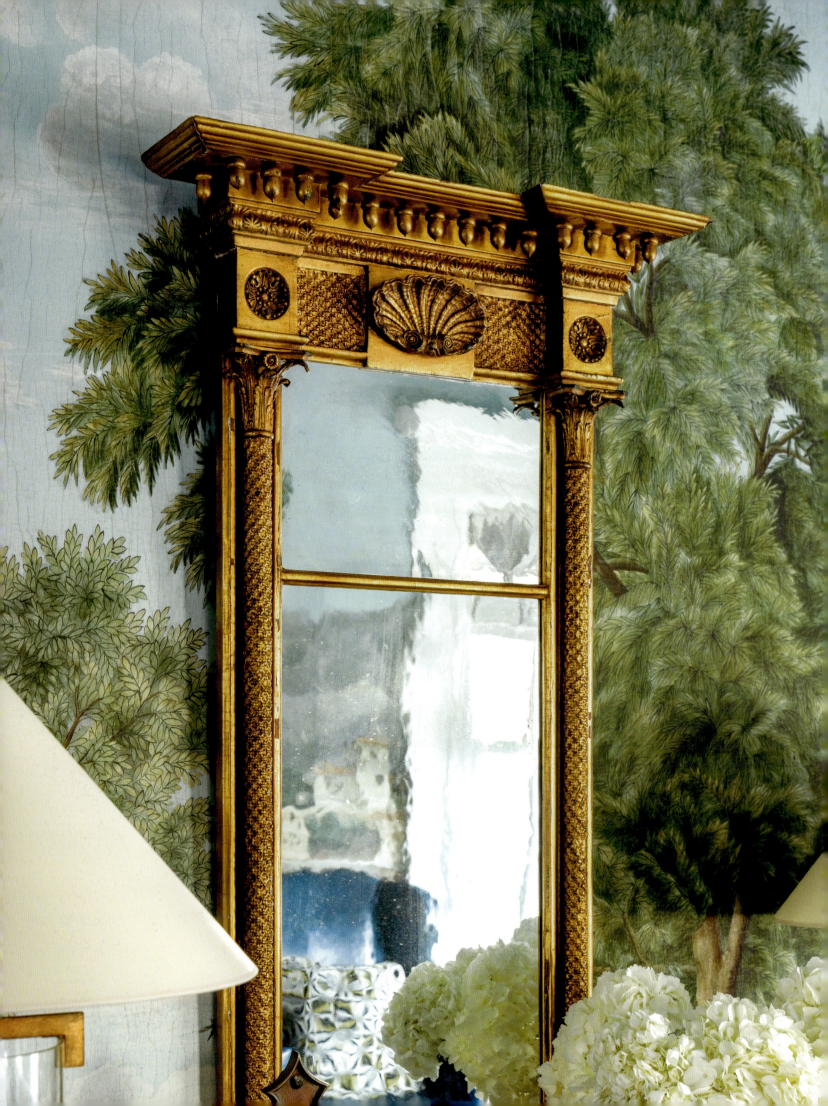

A Diplomatic Mission

When my clients bought this former sea captain's house in the historic coastal town of Cohasset, Massachusetts, they were a young couple just embarking on the journey of starting a family—and looking to create a home that would reflect their life together.

The couple asked me to be a referee of sorts, to coach them through the renovation process and bring their sometimes disparate viewpoints into harmony. The husband, a native German, has a very elevated sense of taste and loves contemporary Italian design—the less fussy, the better. The wife, a former New York City fashion executive, is a traditionalist, and has been the lucky recipient of heirloom furnishings from her family's estate. So, the question was how to marry antiquity and modernity in ways that would make them both happy, while also producing spaces durable enough for a rambunctious dog and incoming children.

On the outside, the residence is exactly what one would expect from its neighborhood: a classic Greek Revival covered in bright-white clapboards, with a few Italianate trimmings and a gracious wraparound porch. Within an overall traditional envelope, we wanted this home to be hip and youthful, sophisticated, even witty. Step inside and time takes a definite leap forward. Clean-lined sofas,

A nineteenth-century gilt pier mirror, adorned with an eye-catching seashell medallion and rosettes, hangs against a mural inspired by the French painter Nicolas Poussin. These elements combined are an example of the fresh, Continental mix this young family desired for their coastal home.

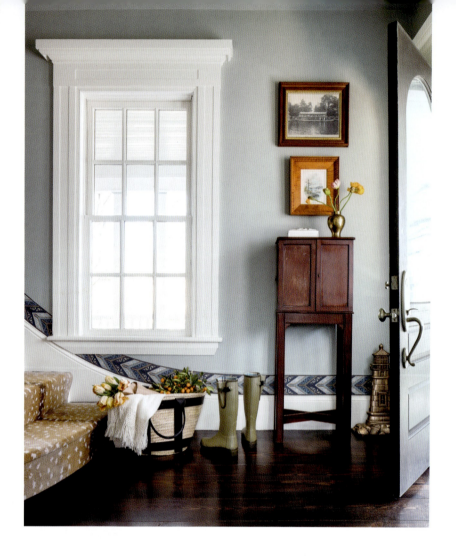

sculptural lamps and chandeliers, animal-print walls, and fanciful patterns on ceilings overhead leave no doubt that we're firmly in the twenty-first century. Yet as sophisticated, colorful, and fun as they all are, the elements of today's style have been painstakingly—if imaginatively—chosen to stay in perfect sync with the home's Yankee pedigree.

Nowhere is this more apparent than in the library. Red silk draperies hang against midnight-blue walls, and the ceiling is lined with a plaid wallpaper that extends several inches down on the sides to finish in a strip of fabric tape studded by nailheads—the final effect makes you feel as if you're standing inside a gorgeously gift-wrapped box. The room's furnishings provide an object lesson in

ABOVE: The house came with great bones, such as a beautifully sinuous staircase and stately corniced casings on the tall windows. OPPOSITE: We ran an antelope-print carpet up the stairs and applied a broad fabric trim atop the high baseboards for a "wow" statement.

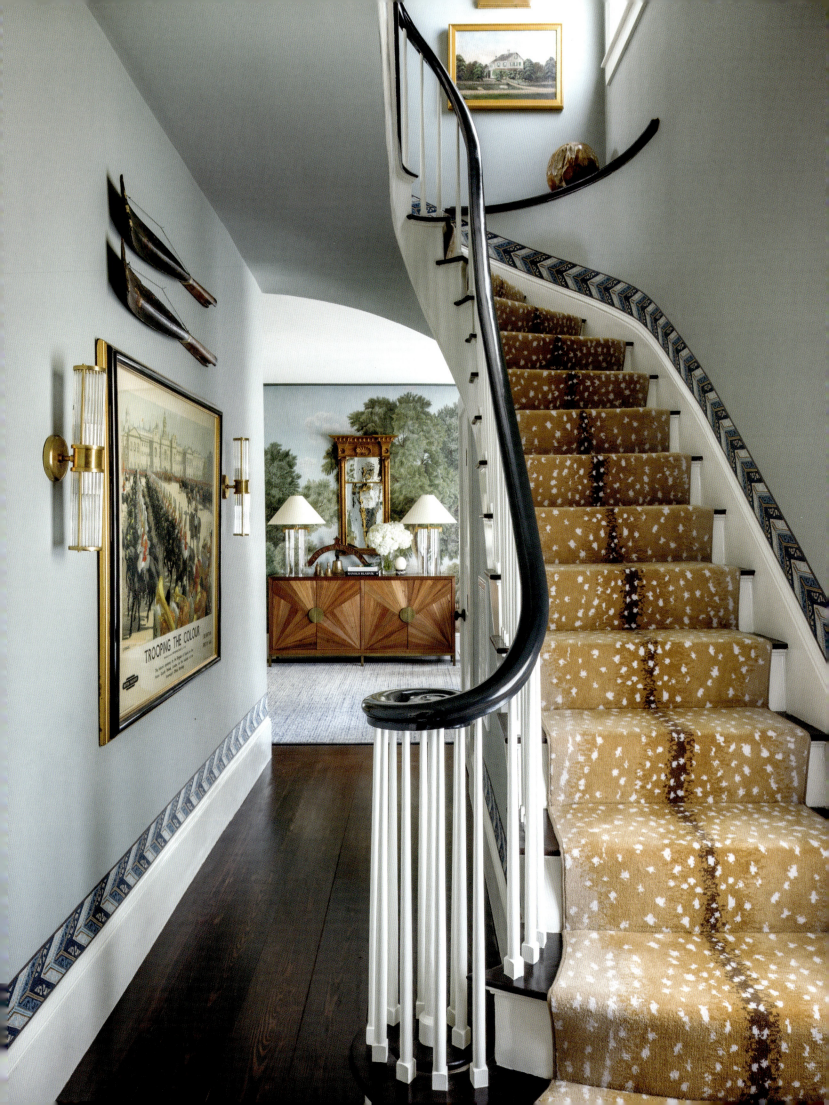

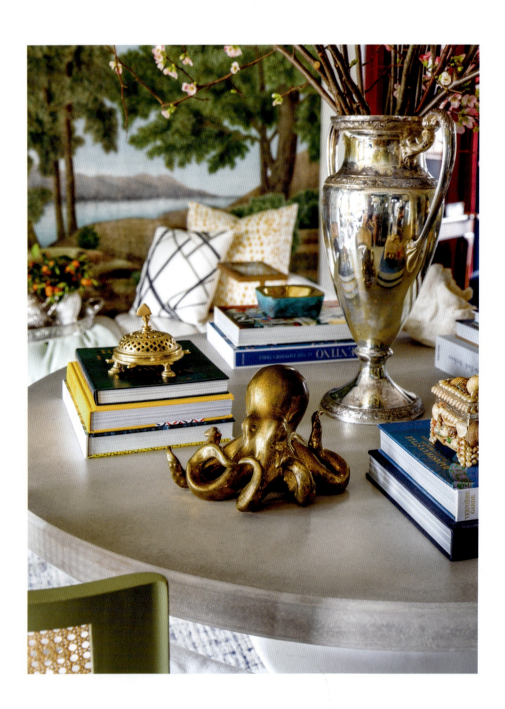

ABOVE: A sculpted octopus is one of the few overt nods we made to the coastal location. OPPOSITE: The living room's floor plan features four groupings of furniture to accommodate guests for large gatherings. Since the space has no crown moldings, I added a painted "racing stripe" to separate the wall mural from the ceiling.

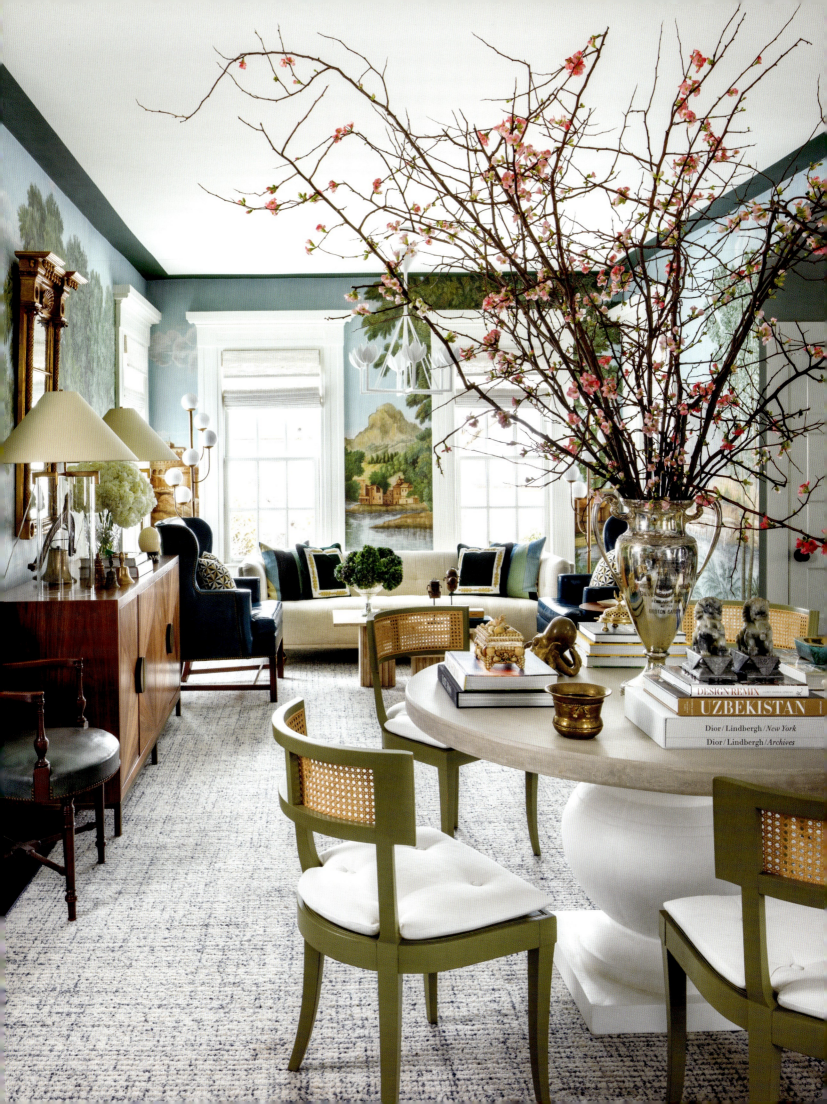

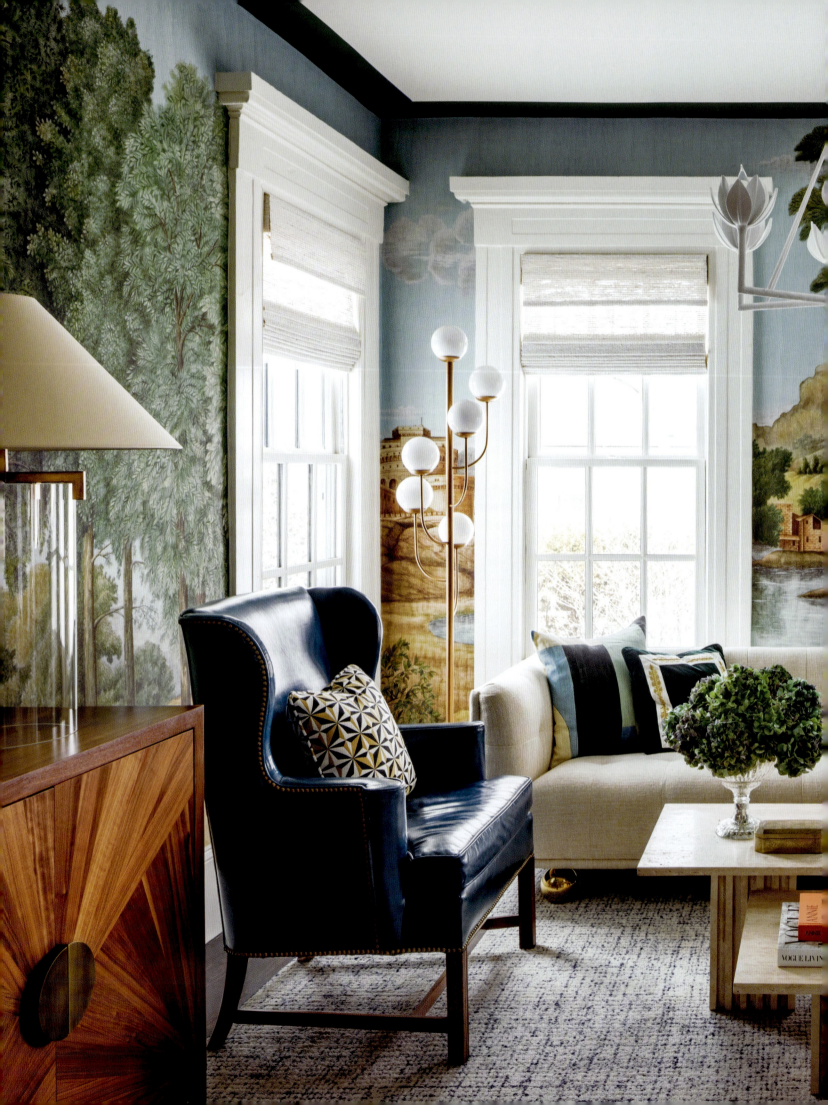

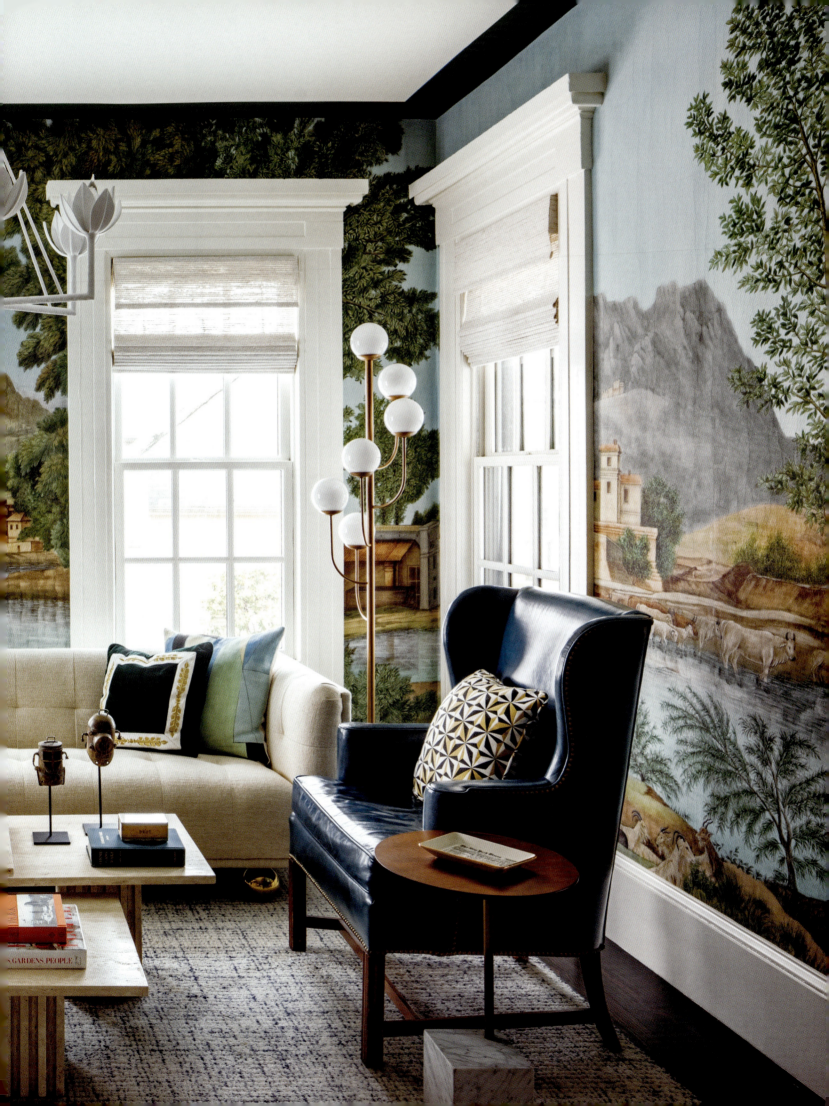

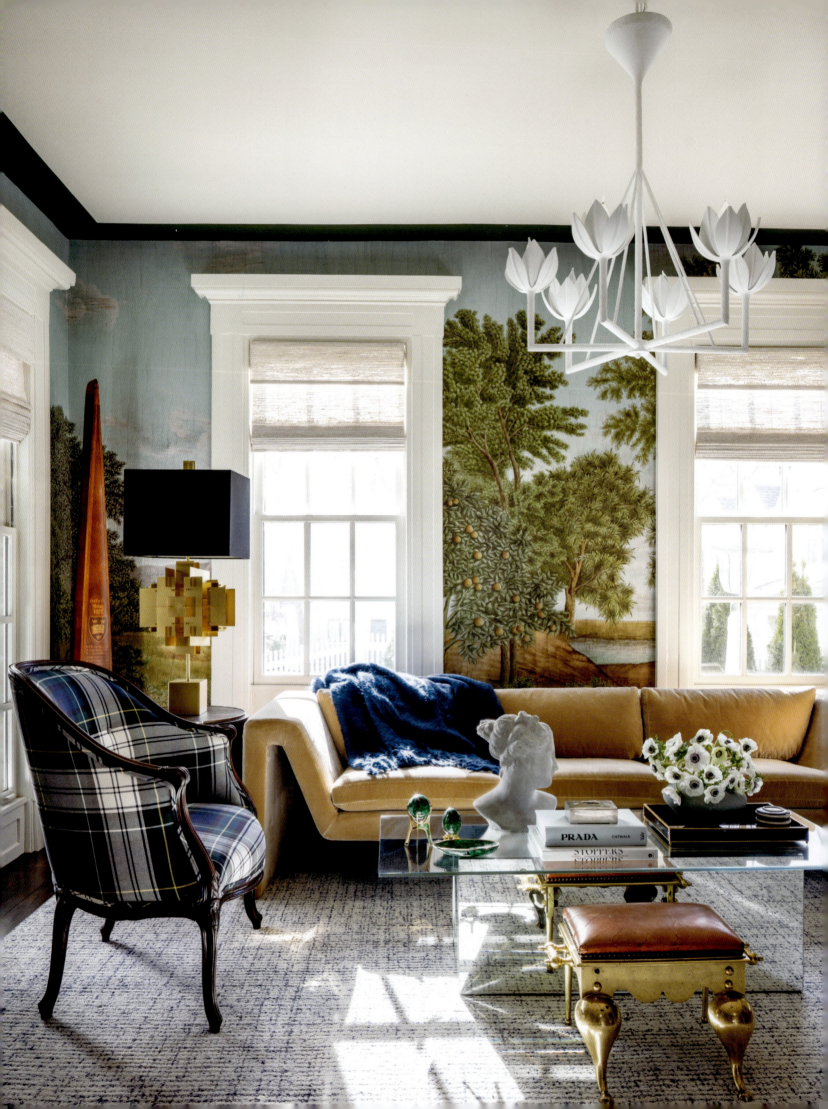

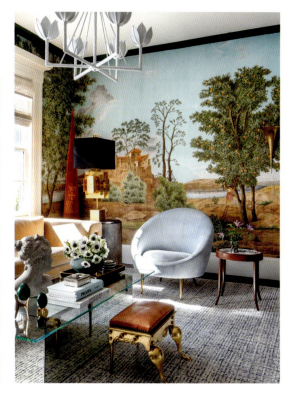
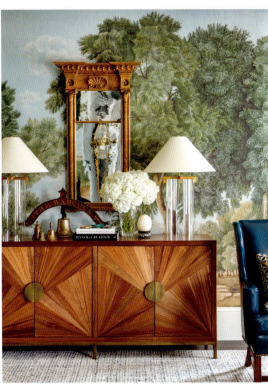

PRECEDING SPREAD, OPPOSITE, AND ABOVE: At one end of the living room, a custom sofa sitting on glittering brass spheres is flanked by antique, navy-colored leather armchairs; at the other end, a glass-and-mirror coffee table stands next to a curvy, tartan-clad bergère. Every recent note is paired with a piece of the past.

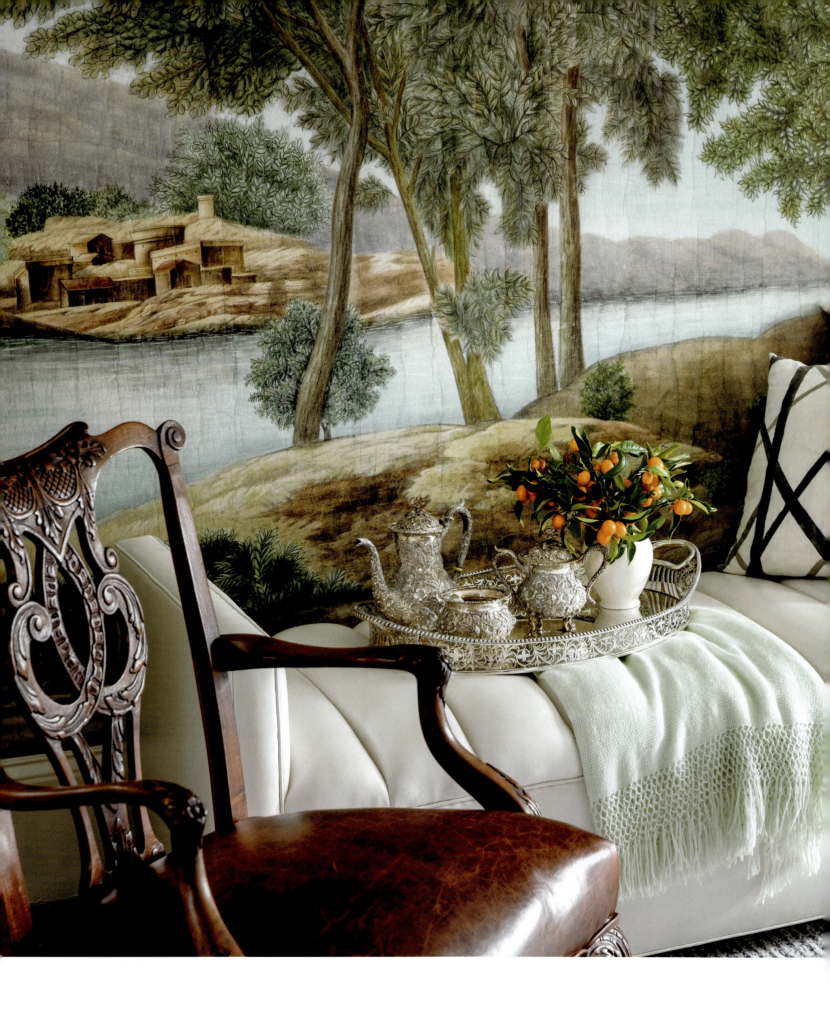

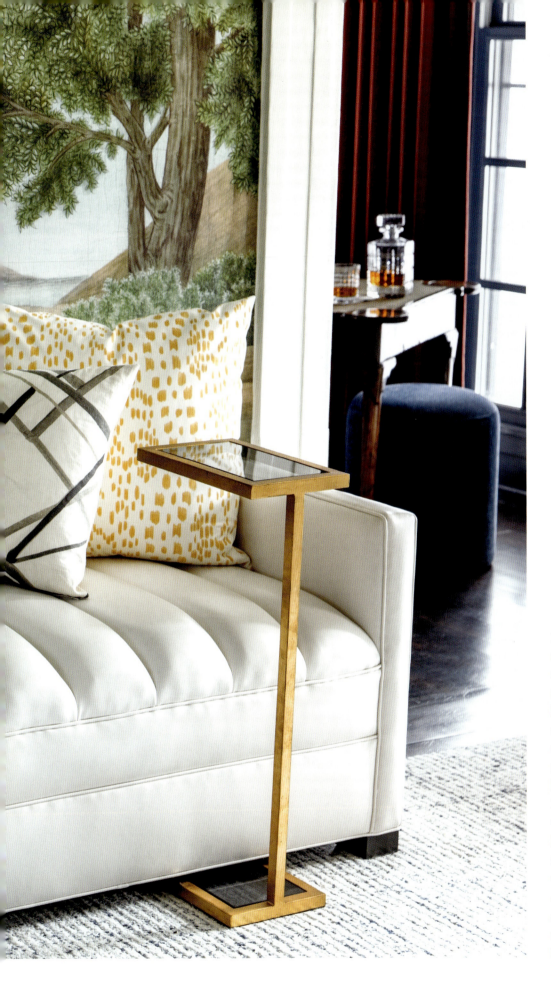

LEFT: The wife inherited many beautiful silver pieces, such as this tray and coffee set. I encouraged her to keep it out for everyday use and enjoyment rather than storing it away. FOLLOWING SPREAD: The dining room hearkens back to 1920s Hollywood glamour: windows and woodwork are lacquered in the darkest imaginable shade of green, walls are fashionably dressed in a Ralph Lauren ocelot flocked paper, and chairs are upholstered in bold geometrics.

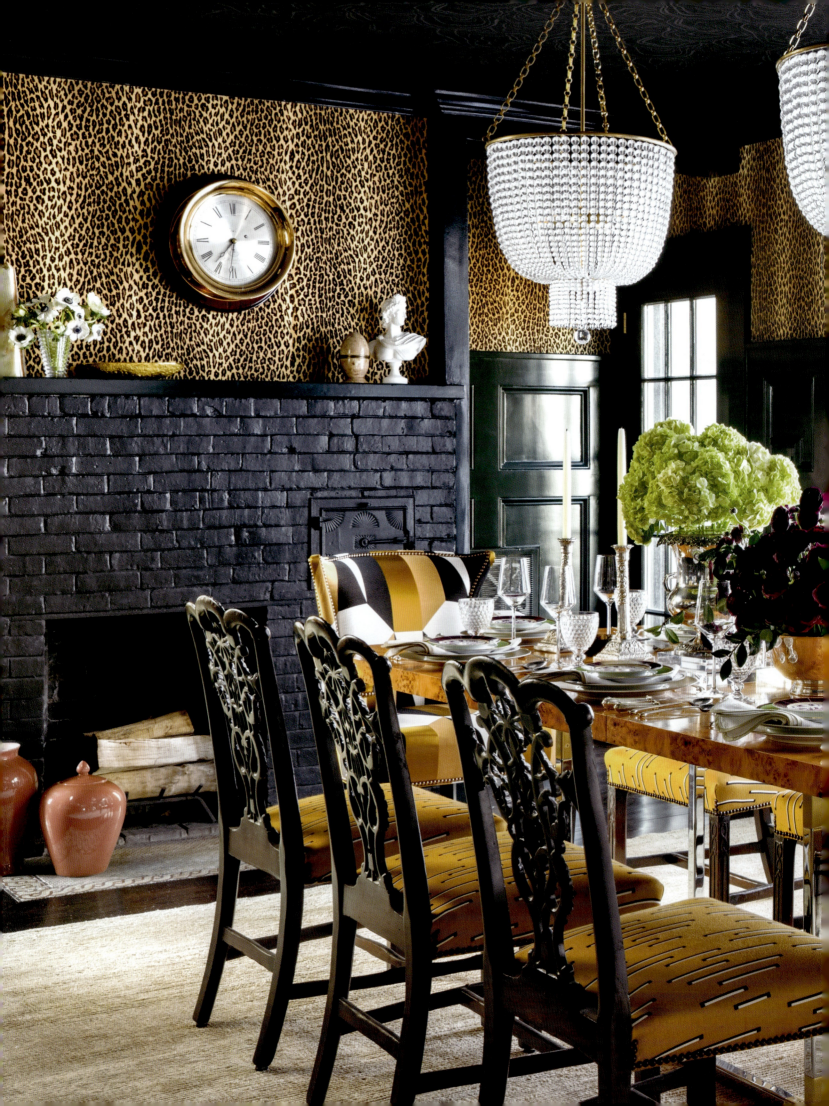

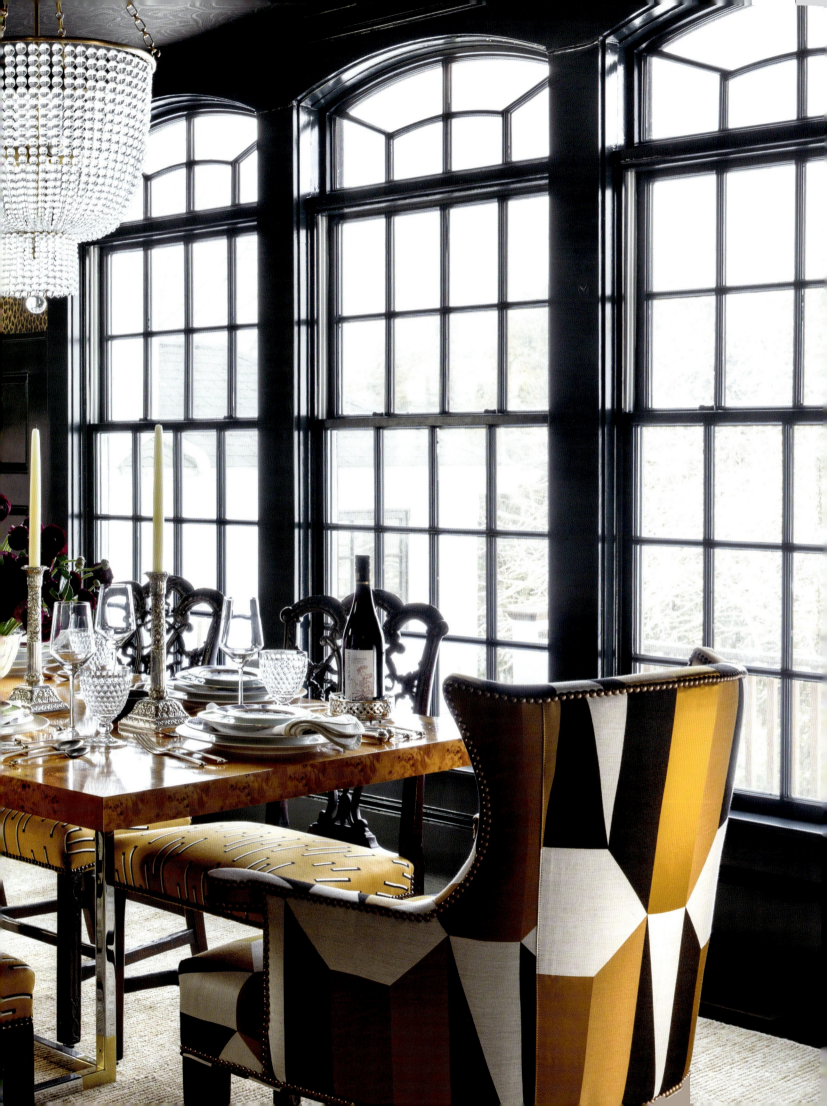

how inherited pieces can add resonance to an interior while not being in any way stuffy. Our new finds, such as the vintage L-shaped vegan croc sectional and circular burl wood coffee table, impart some *Mad Men* sleekness. But when they are mixed with the Oriental rug, tall case clock, and low chest of drawers—all of which were passed down through the wife's family—the room's rich, masculine vibe is deepened. At the end, I threw in a cowhide-covered club chair—because *why not*! The sum of these parts is a degree of sophistication that simply wouldn't be there if everything had been bought new.

Many of the textiles used in the home reflect the wife's particular fondness for Ralph Lauren's fashion work. Tweed-like rugs and upholstery fabrics, Roman shades crafted from windowpane-plaid wool, throw pillows of velvet, houndstooth check, damask, and paisley all speak to that sensibility. Other materials supply a little glint, a little glamour, to counterbalance the historic aspects of the architecture. For example, rough beams and beadboard in the kitchen are offset by gleaming black subway tile, polished brass stools, and an island topped with showy Panda White marble. In the dining room, an ocelot-print flocked wallpaper is complemented by glossy formal paneling painted in Essex Green, one of Benjamin Moore's darkest hues.

I loved working on this project because we were able to seamlessly blend both the husband's and wife's visions, as well as pay homage to her family's heritage, by mixing pieces that would represent them in every single room. What the couple has now is something that tells their story, while at the same time launching a welcome new chapter in the home's long and honorable history. The entire house is now a legacy, ready to be lived in and loved by the next generation.

OPPOSITE: An ebonized-paneled credenza fits the dining room's mood precisely. FOLLOWING SPREAD: The chandelier is one of the first elements I selected for the kitchen. The couple love to ski, and the fixture's glass and metal orbs remind me of the ski lift gondolas you see in Aspen.

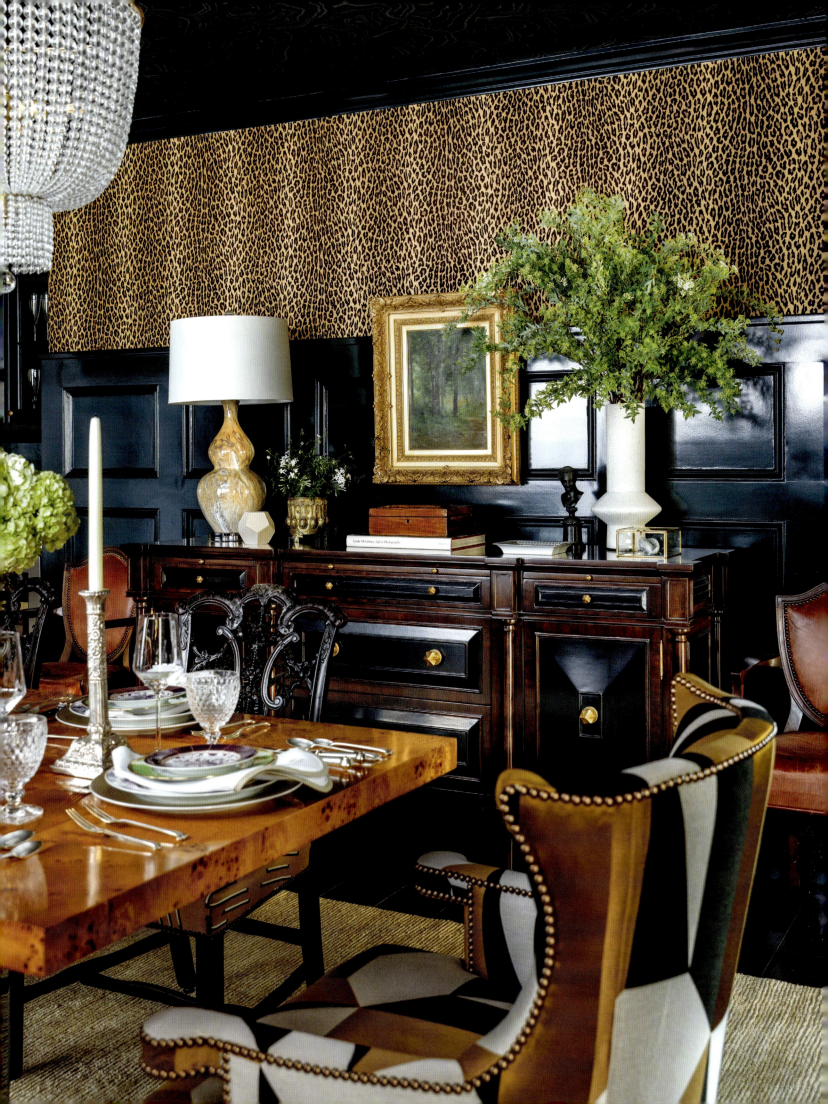

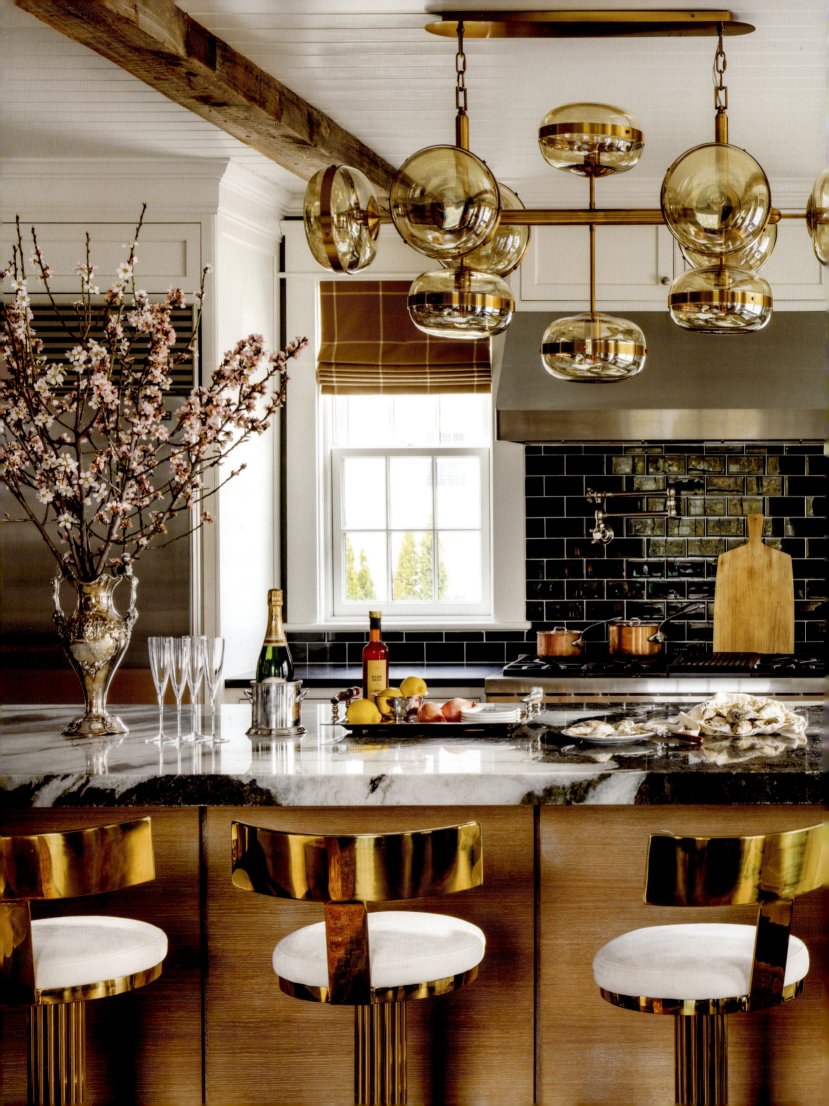

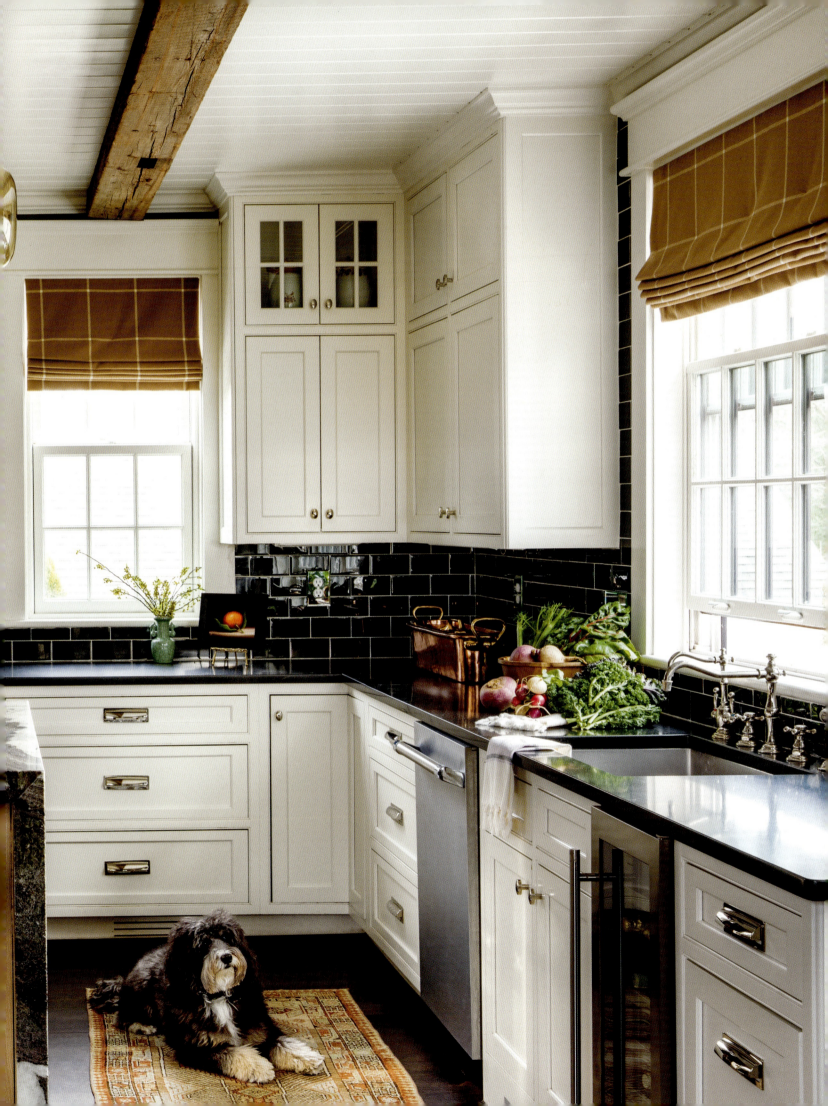

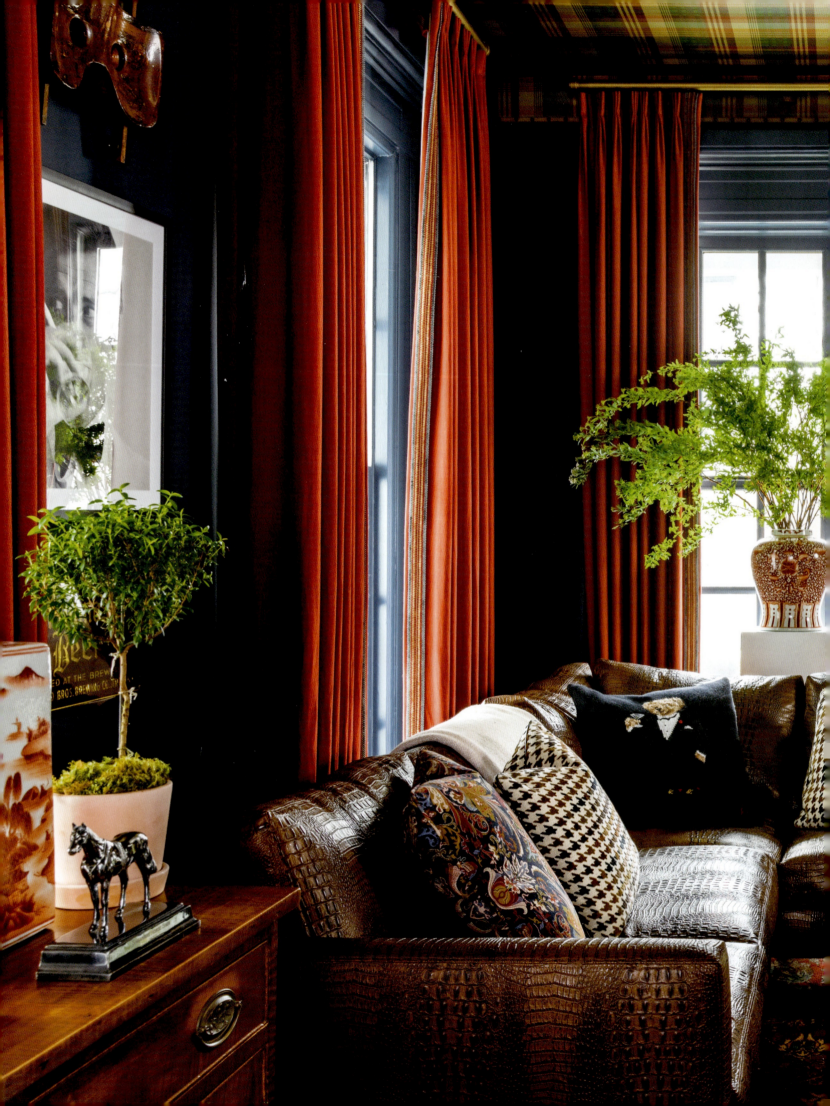

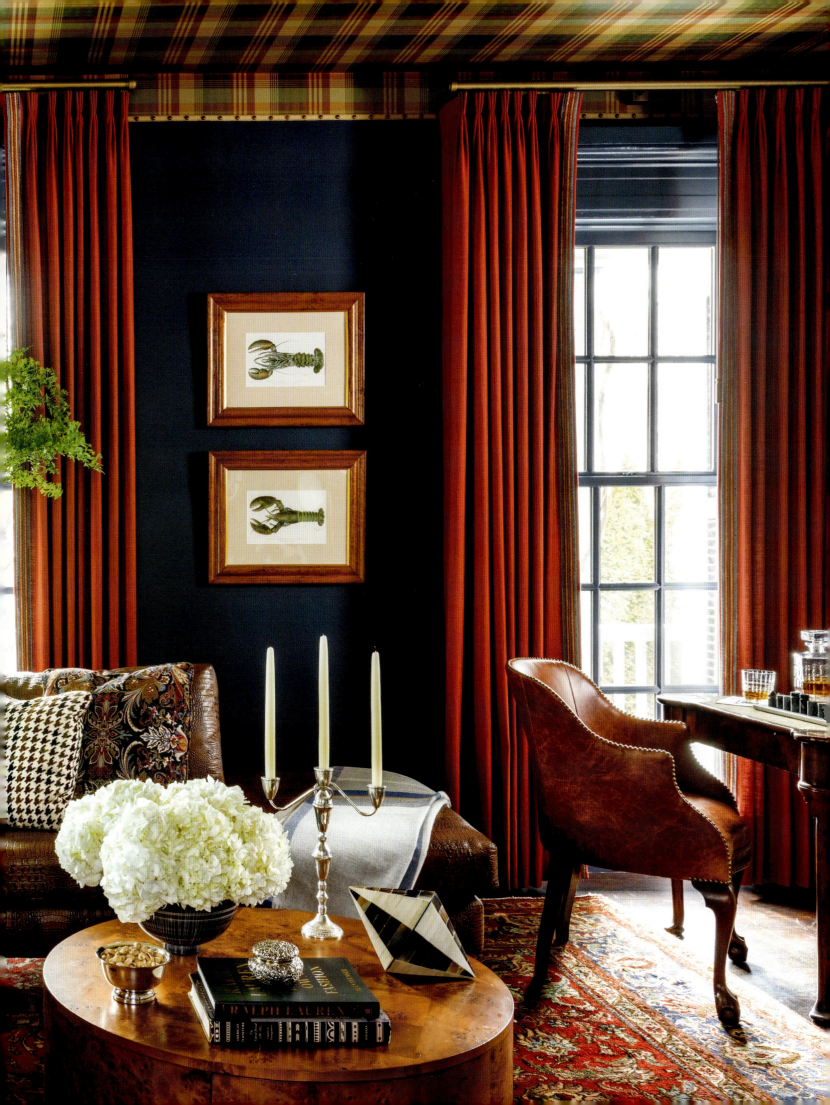

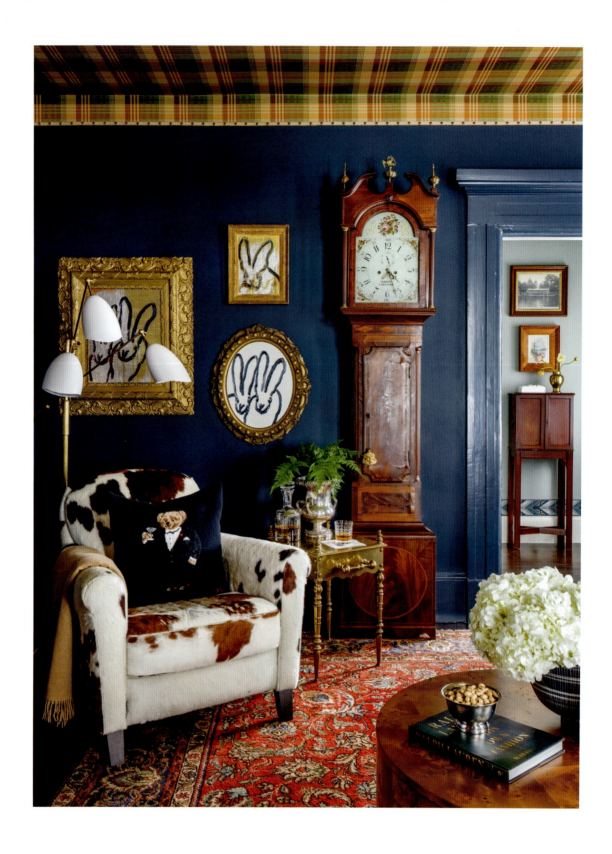

PRECEDING SPREAD: The library is a hangout for grown-ups—suave and a little cheeky. Simple crimson drapes glow against the dark walls, and two lobsters refer discreetly to the sea. ABOVE: An heirloom grandfather clock keeps company with three oil paintings from Hunt Slonem's *Bunnies* series. OPPOSITE: Eclectic pieces—an antique sled seat, a photo of Roger Moore, and a vintage beer sign—are hung together as art.

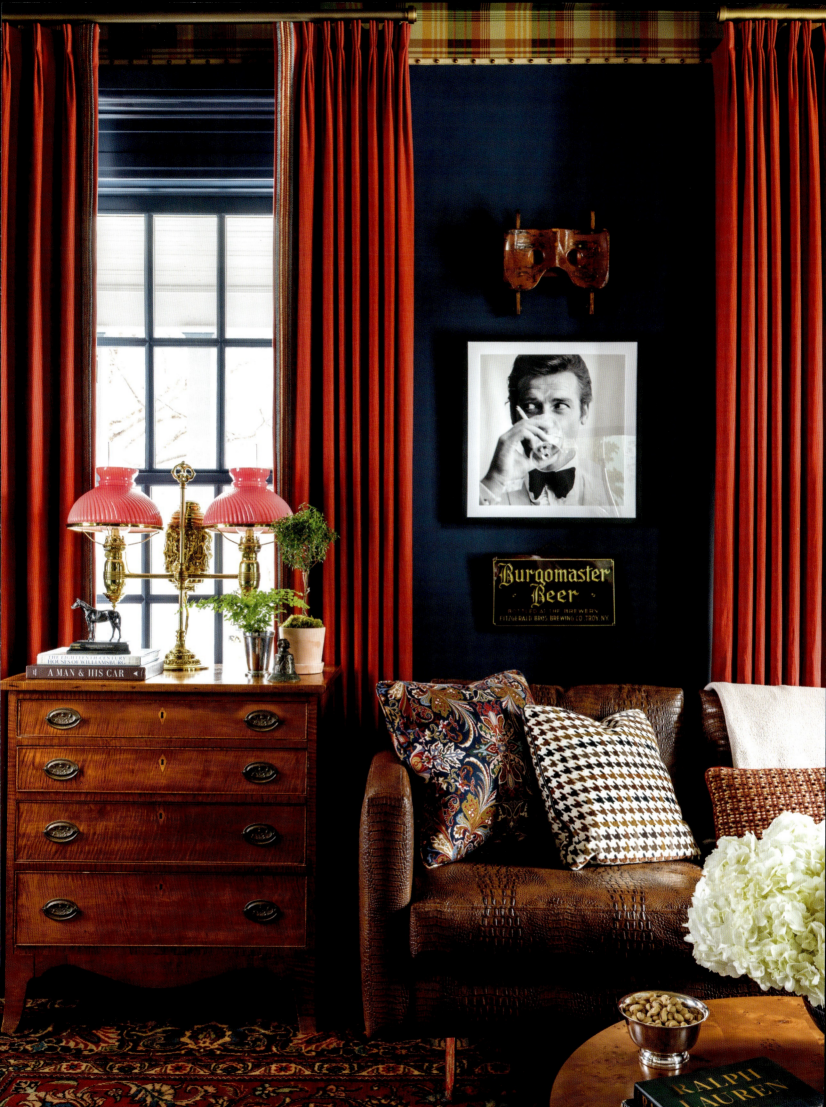

APPLIED EXPERTISE
Special Spaces

Your home may have spaces that you simply don't know what to do with: an unneeded closet, a void below the stairs, a windowless "den" in the basement. Just shrugging off these chunks of square footage as lost causes, however, would be a missed opportunity. With some imagination, these overlooked areas can be given a real purpose! Whether as a venue for more storage, a place to handle household business, or perhaps a whimsical and romantic space—like a private club where you and your friends can slip away from the world—these rooms can be reimagined into something special.

UNDER THE STAIRS
How about kitting out the area under a staircase as a reading nook? Throw in some sconces and an upholstered bench, maybe with some pull-out storage beneath, and you'll have just enough room for someone to curl up with a favorite novel. Another idea: transform the space into a listening station to showcase your collection of vintage LPs, CDs, audio cassettes—with a stereo, high-quality headphones, and a turntable.

CLOSETS AND ALCOVES
Years ago, I converted a never-used coat closet into a temperature-controlled display for my client's extensive wine collection, complete with a glass door and floating cable racks holding the bottles. For another homeowner, I transformed a hall closet into a butler's pantry. Even quite shallow niches can become sheltered mini-offices if you install a desk and shelving flush against the interior wall. Just remember to choose a chair that will easily slide underneath the work surface to keep it out of traffic flow.

LOWER-LEVEL SPACES
Basement rooms can present a real challenge, with their lack of natural illumination and sometimes low ceilings, but if you flex your design muscles you'll still be able to turn them into noteworthy destinations. Adding beams or coffering overhead can, paradoxically, give the illusion of greater height, as will choosing a wall covering or paneling that has a vertically oriented pattern. When there's no room for a chandelier, multiple wall sconces, LED features, and tabletop lamps will provide agreeable lighting. Next, leverage color, pattern, and dynamic artwork to create visual interest. Finally, choose a mix of furniture that presents a real sense of occasion—taking a difficult space from pointless to purposeful, empty to exceptional!

OPPOSITE AND ABOVE: In the dark, windowless basement of a mansion in Atlanta, I designed a bright and lively speakeasy, thanks to a Gracie scenic mural, white oak floors, a blush-pink ceiling—and, of course, a wet bar for libations. Showcased alongside antique paintings, a collage by artist Shanequa Gay (right) adds an unexpected modern twist.

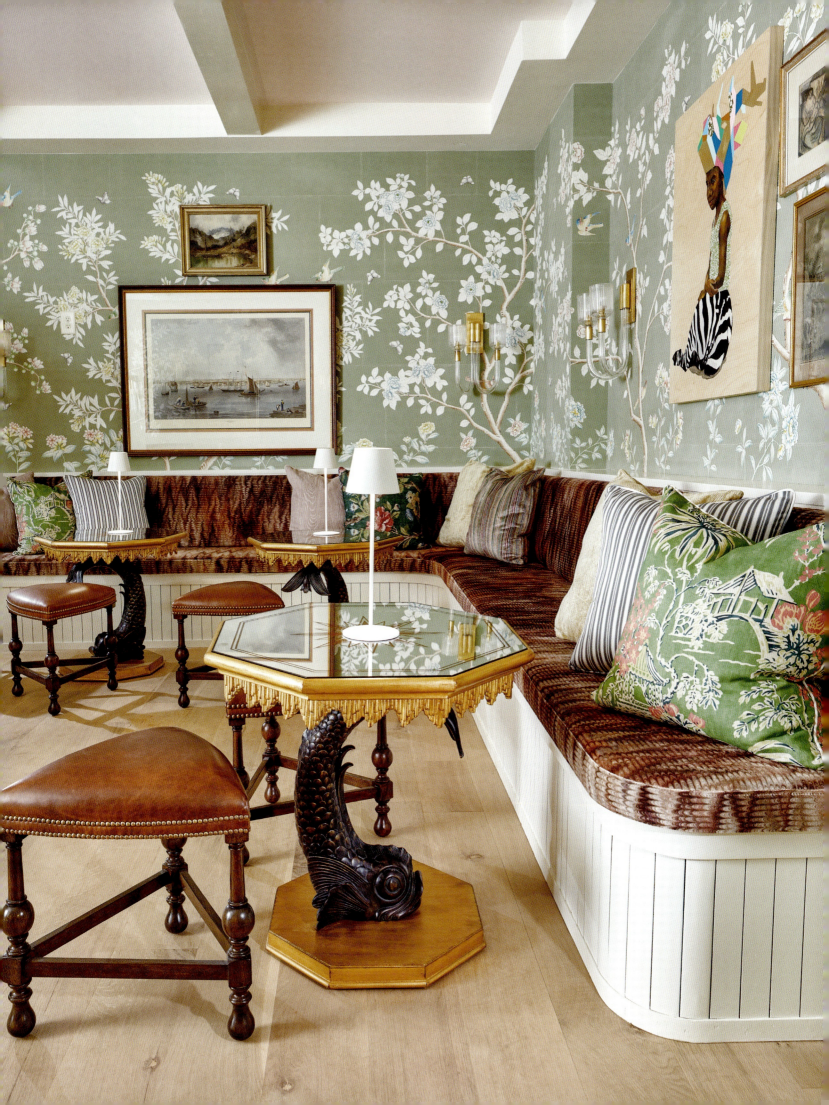

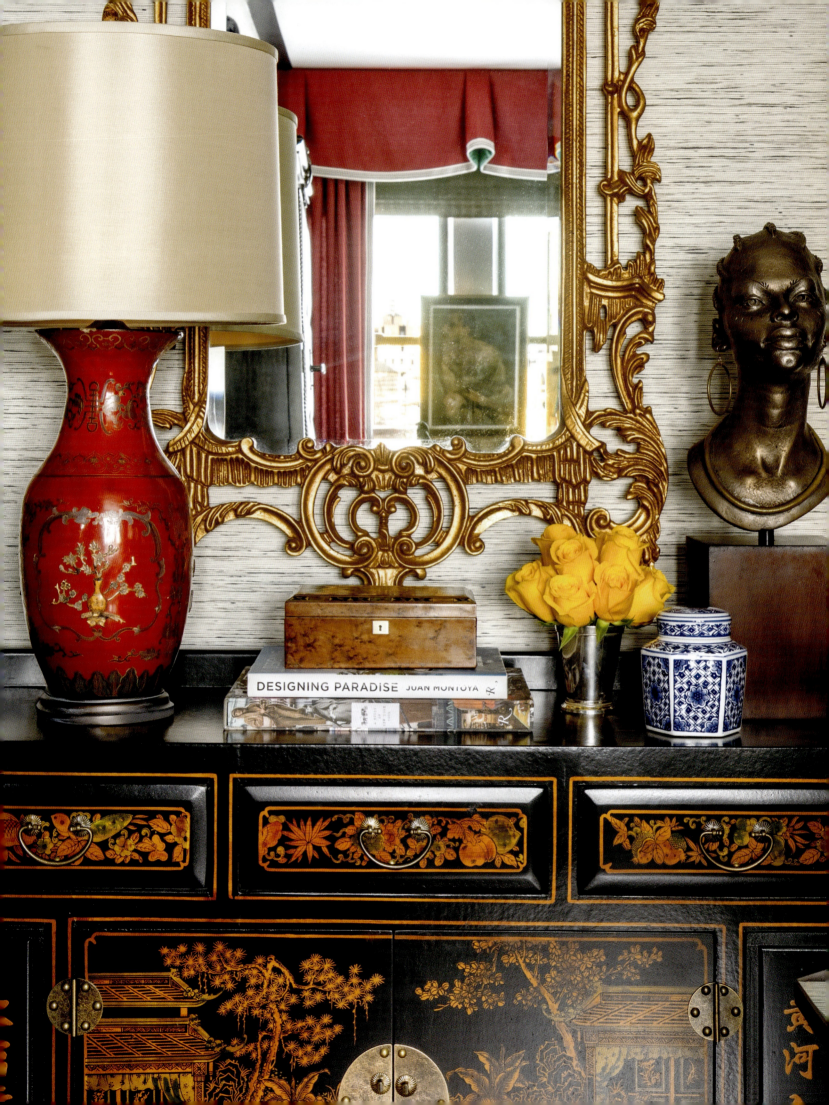

Balancing Act

When my partner, Adam, and I first got this condominium in Manhattan, it was meant to be a pied-à-terre. We each had our own apartments in New York, and I also had a home in Michigan. Then the COVID-19 pandemic hit, and the world stopped spinning for a while. We started investing in this condo because we had the leisure time to do it. It was the perfect opportunity to revamp the place and to make it truly ours.

Designers practice diplomacy every day. We often settle matters between two homeowners who don't necessarily see eye to eye about what needs to happen with the interiors of their residence. The goal is always to honor the opinions and tastes of both partners, ensuring neither feels disenfranchised and that each scores a few "wins." In this case, as one of the vested parties in the negotiation, and already having the upper hand as the design professional, I wanted to show even more deference.

The process began with the question of how to handle a specific piece of furniture. Adam had a large navy sectional sofa that he really loved and wanted to bring to our combined home. Prior to 2019 B.A.E. (that is, "Before Adam's Era"), I had used sectionals very rarely in my work, mostly because the spacious rooms I'd been designing for tend to demand floating collections of furniture

In our dining room, a vintage red lamp with bone-inlay details joins an African bust and a burl wood box on top of a japanned sideboard. And, of course, it wouldn't be a project of mine without at least *some* blue-and-white porcelain!

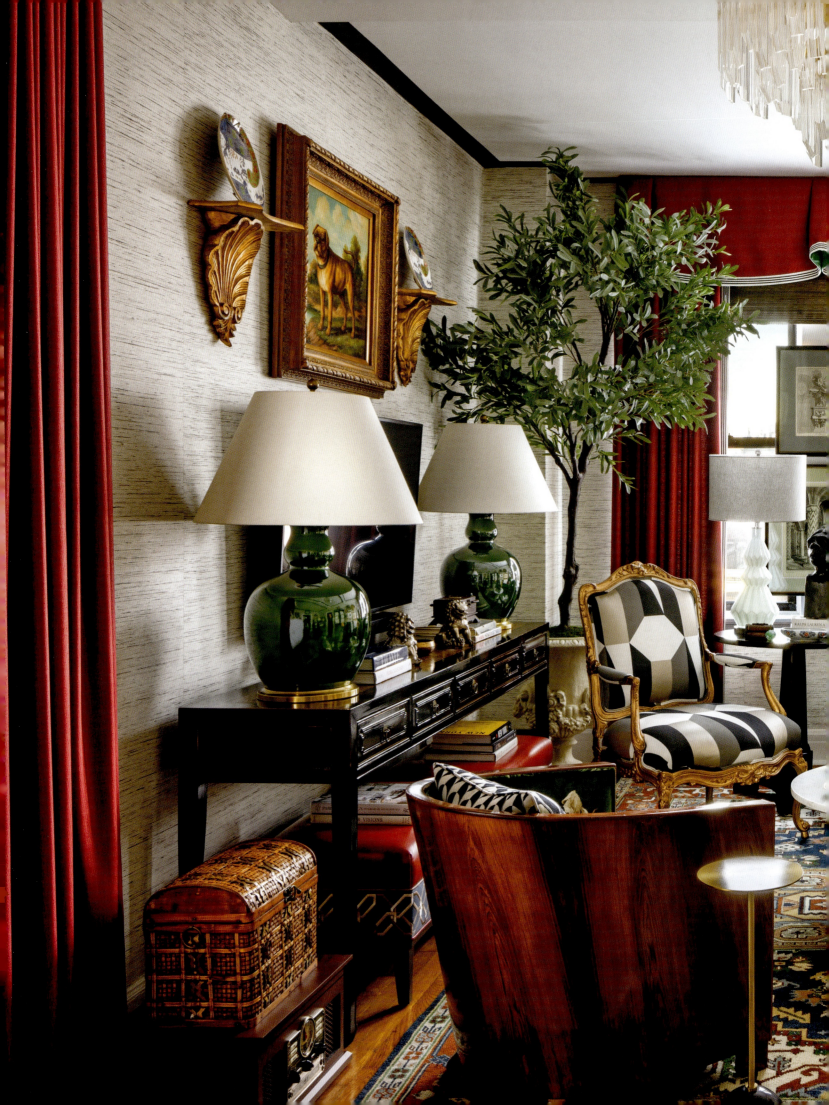

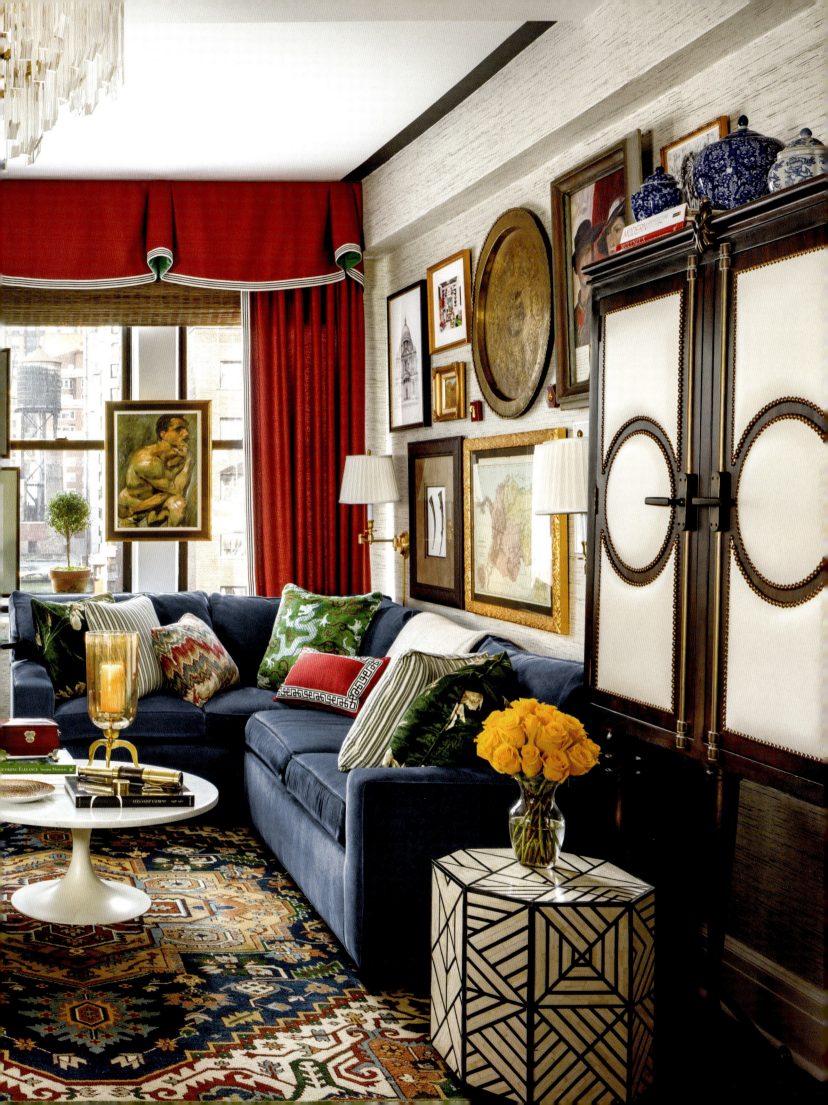

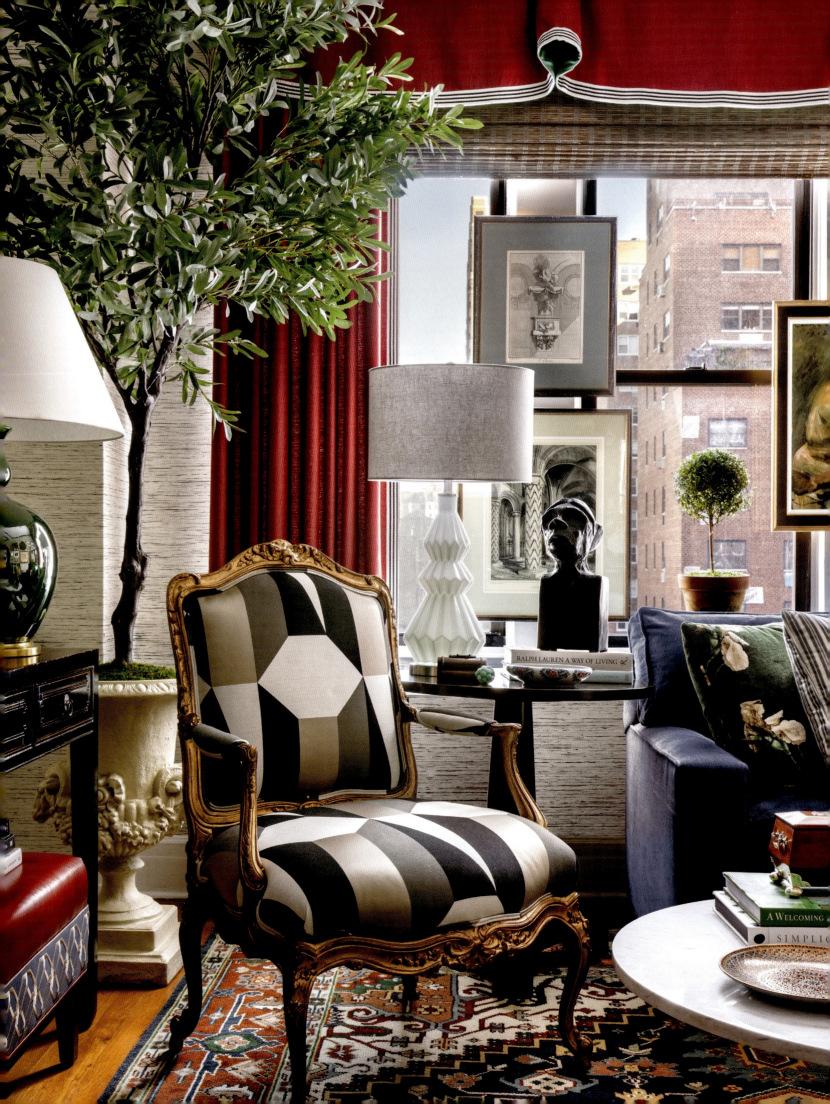

that are pulled away from the walls. In this space, however, Adam's sectional proved to be a great addition, anchoring one corner of the living room as if it were always meant to go there.

The sectional's navy hue served as a starting point for our color palette. After blue, red is Adam's other favorite color. My favorite is emerald green, and I love gold, black, and white. How could we put all of these colors together and not have the condo look like a year-round Christmas display? My solution was to employ red, blue, and green as the primary jewel-tone colors—garnets, emeralds, and sapphires have historically represented royalty—with black and white as neutral foils. Brass metallic elements would be used to inject a bit of glamour.

Next, we began mixing and matching styles. Instead of trying to stick to a set formula—"OK, we're going to do everything traditional," or "OK, we're going to do everything modern"—we agreed to simply do *everything*. We have a blend of antiques and contemporary furniture and fixtures, deco-inspired things, and 1960s and 1970s vintage pieces as well. We have funky geometric fabrics applied to elaborately carved and gilded Louis XV chair frames. We have chinoiserie, black-and-white photos, rare mid-century "Atomic" Lucite chairs, and an African portrait bust. I'm an eclectically exuberant individual, and I love walking the line between modernity and classicism.

Art choices were key for mingling our personalities into a cohesive story. Paintings and drawings from my collection now hang side by side with works

PRECEDING SPREAD: Our living room is very layered, and we brought in lots of geometric energy. The chandelier adds a deco flair; the Saarinen table is early 1960s. I designed the leather-fronted bar cabinet on the right. OPPOSITE: Covering an antique gilt chair frame with a fabulous geometric print creates a bold tension between classicism and modernity.

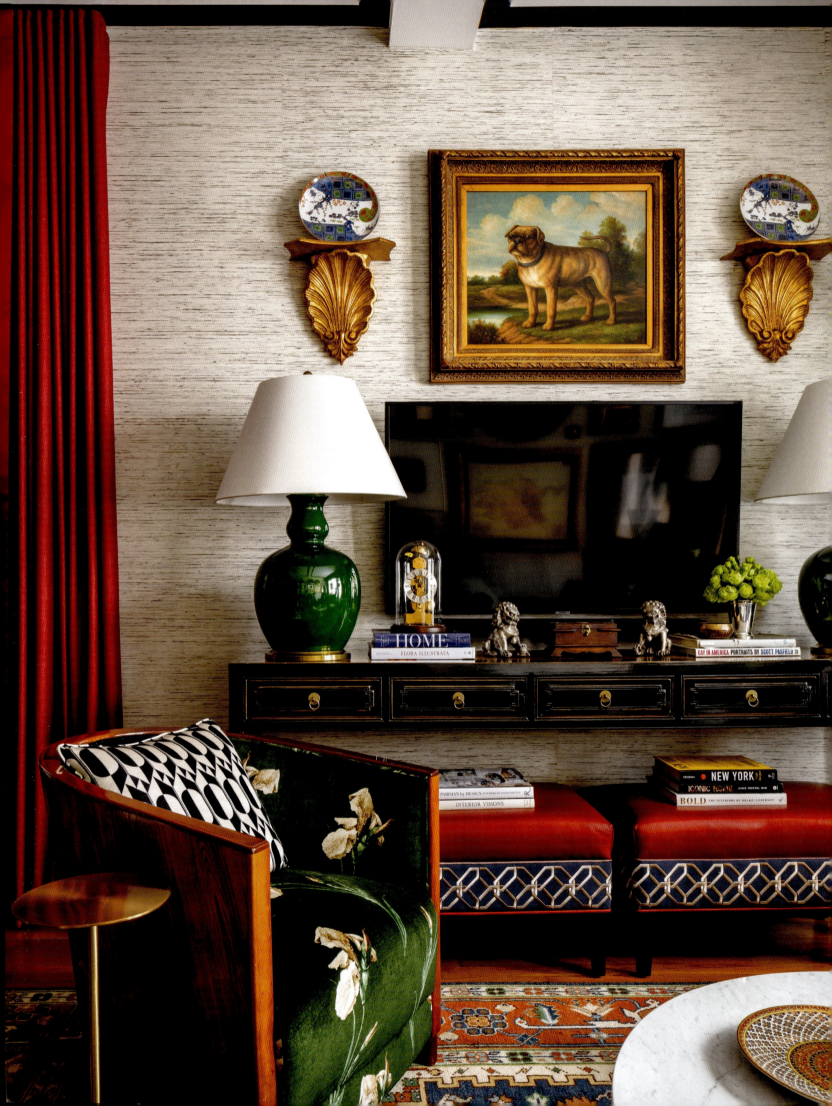

OPPOSITE: You don't *always* have to conceal your TV. Here, I included it in a salon-style grouping of art. The two ottomans look great beneath the console when they're not in use. ABOVE: When you mix sculptural items on a tabletop, remember that the more disparate they are, the more visually interesting the composition becomes.

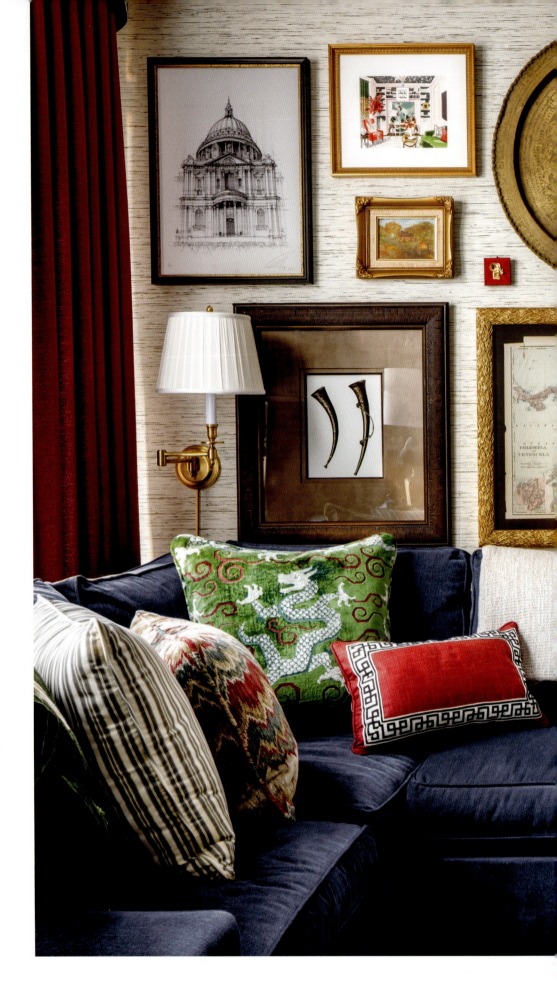

A medley of pillows on the corner sectional incorporates all of the colors in our palette. The art wall brings together works from Adam's and my collections and world travels, and even includes references to our astrological signs. The brass medallion is an early-1900s Moroccan tabletop etched with intricate Moorish details and calligraphy.

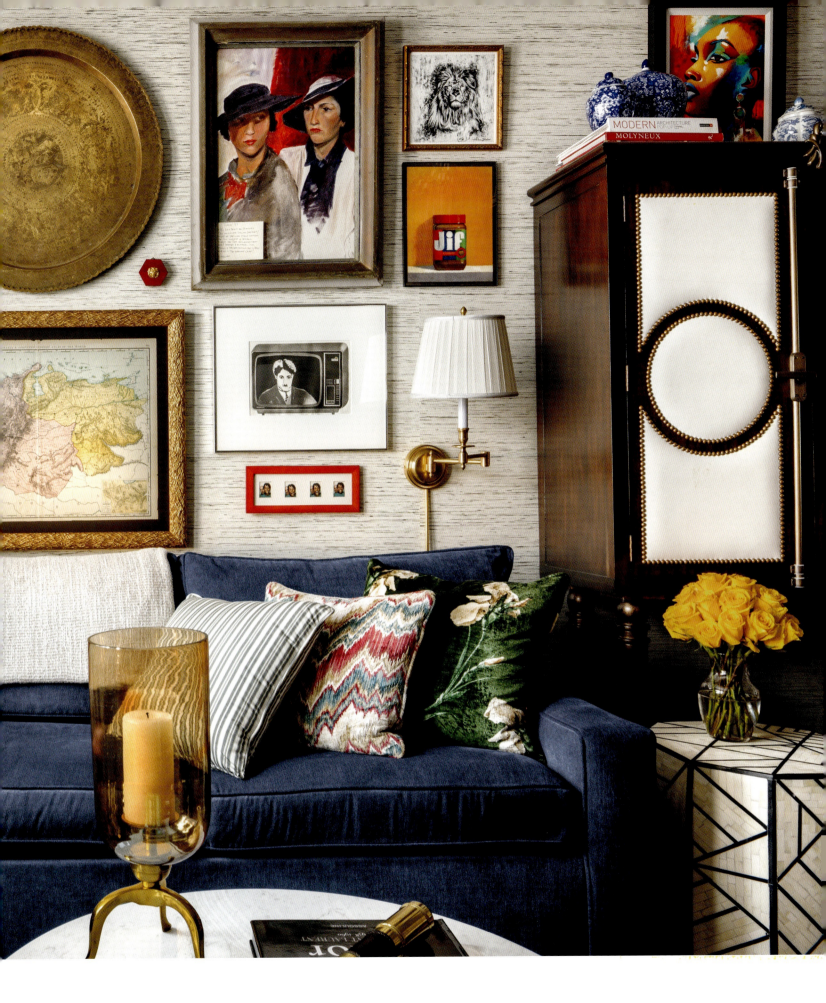

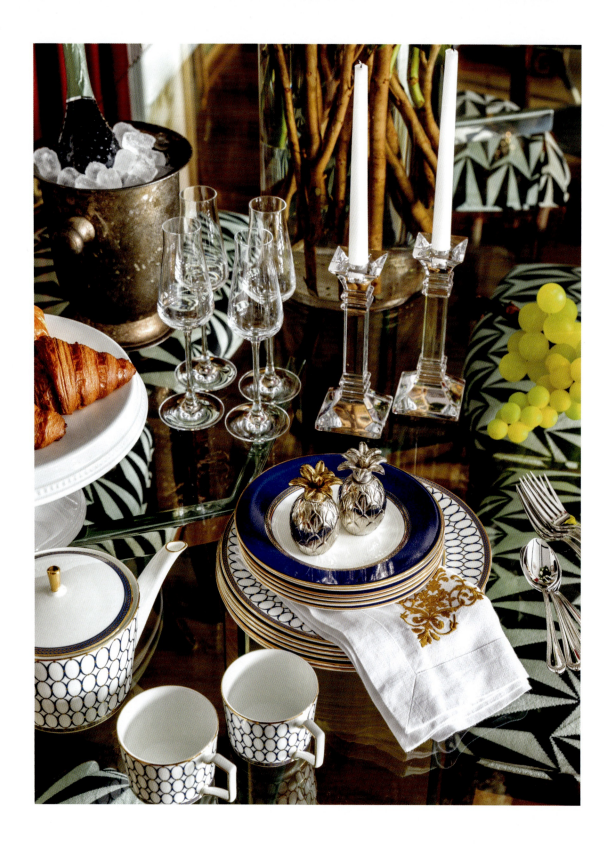

ABOVE: When we entertain, I love to let my imagination fly for the place settings (see also page 218). OPPOSITE: In our dining room, an early-1970s Pace Collection glass table is surrounded by vintage Biedermeier-style chairs wearing an almost op art black-and-white print. I like combining unusual and quirky things. They don't necessarily go together, conventionally speaking, but they flow together. Eclectic exuberance!

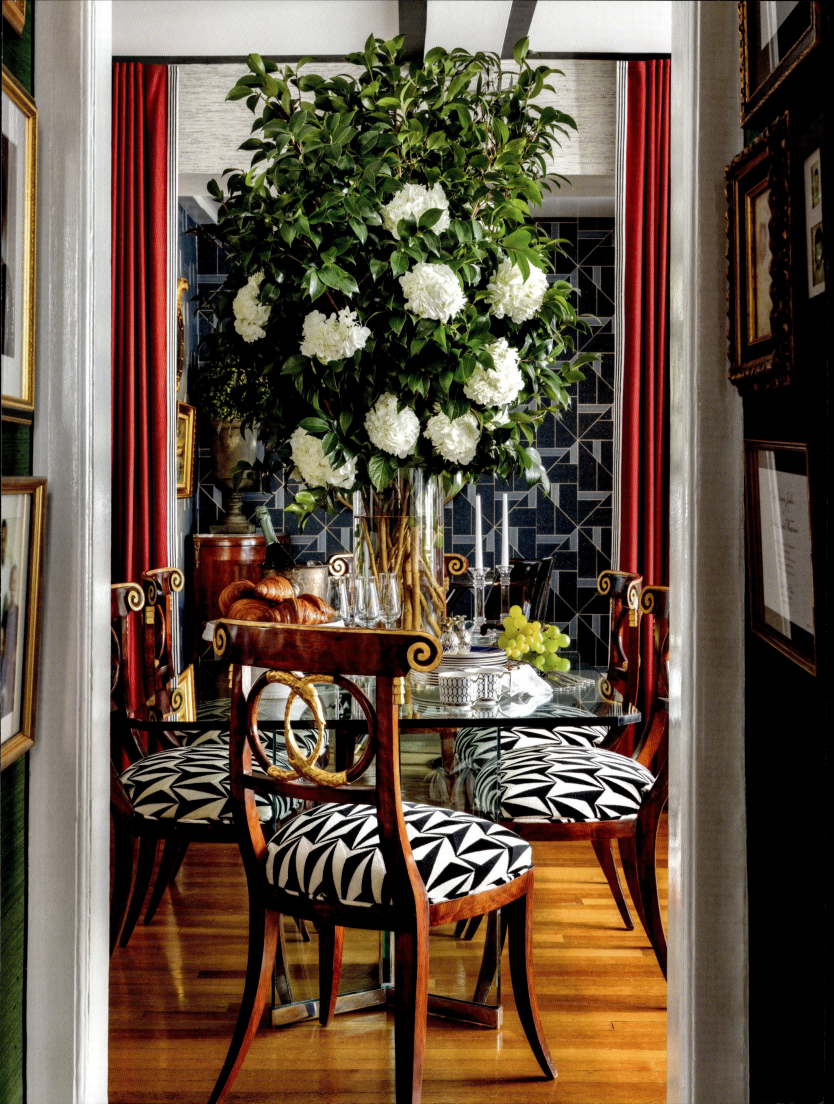

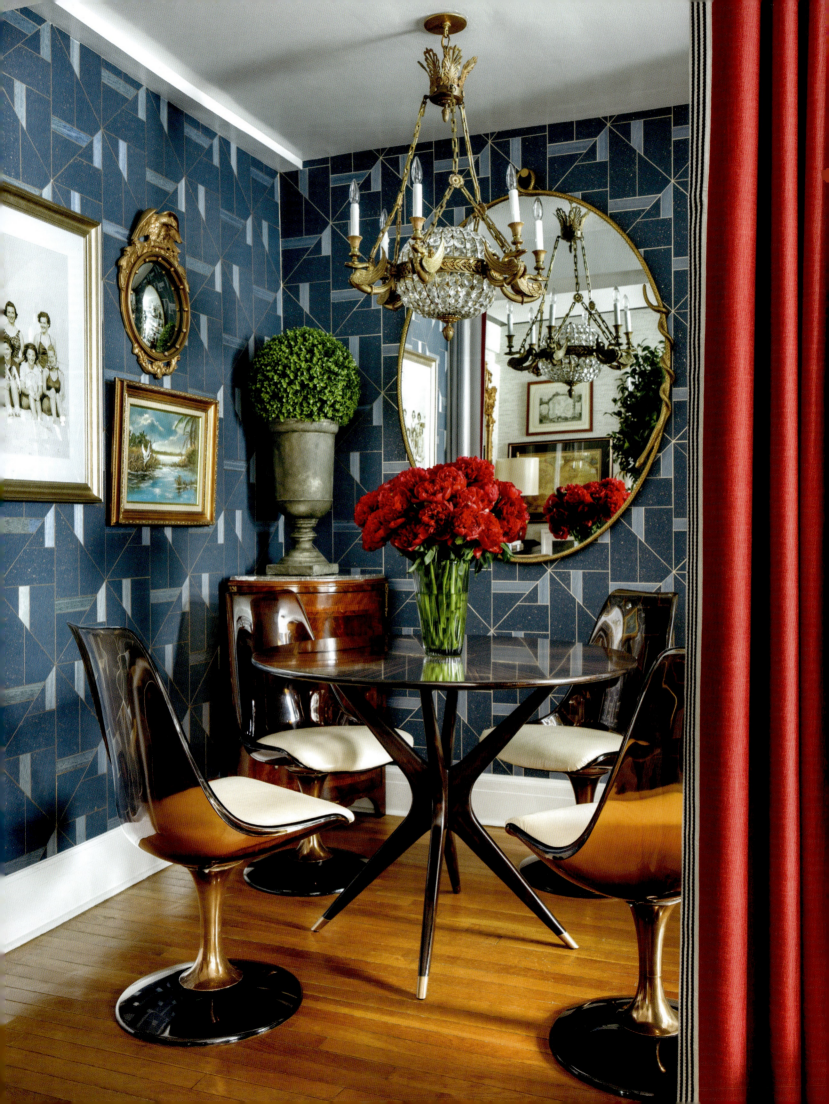

Adam had (including a playful "portrait" of a jar of peanut butter—a gift from his mother). As a nod to Adam's ancestry, I had an antique map of Colombia framed and installed in a position of honor above the living room sectional.

The unit came with practical issues of its own (as many New York apartments do). For one, what is now our principal bedroom was originally a den. The space enjoys the condo's best city view through the windows on one side. Behind the head of our bed, however, another window looks straight out at the bare bricks of the building next door. You'd never know it now, though, since I draped that entire wall with chocolate silk to both conceal the eyesore and create an elegant backdrop for a wonderful nineteenth-century Federal-style bull's-eye mirror. Design inspiration was driven by necessity.

This apartment has become our hip, unexpected getaway in the sky. We enjoy hosting big dinner parties for our friends, but the place works equally well when it's just the two of us and our Havanese-mix puppy, Charlotte—who loves romping through the rooms. Having grown up in the rural suburbs of Rhode Island and Michigan, respectively, Adam and I also appreciate the balance afforded by the town and country lifestyle. While we're looking forward to renovating a country house in the future, we're truly thrilled with our pied-à-terre in the Big Apple.

The breakfast room houses a mid-century-modern table and a quartet of Saarinen-style "Atomic" tulip chairs. The circa-1970 chairs were a rare find, and are noted for their unusual amber-colored Lucite frames. A golden snake coils around a nearby oval mirror.

Our bed backs up to an expanse of chocolate silk drapery panels; they hide a window that overlooks a dull exterior view. The magnificent nineteenth-century Federal mirror was a gem I discovered while scouring the Antique Center in High Point Market, North Carolina. The room's walls are covered in beautifully collaged grass cloth from Holly Hunt. The etched-brass frame on the bed's headboard cleverly conceals an LED strip for nighttime reading. The bedside table lamps are perhaps my favorite antique finds: their metal bases are reclaimed remnants from the case of a mid-eighteenth-century church organ.

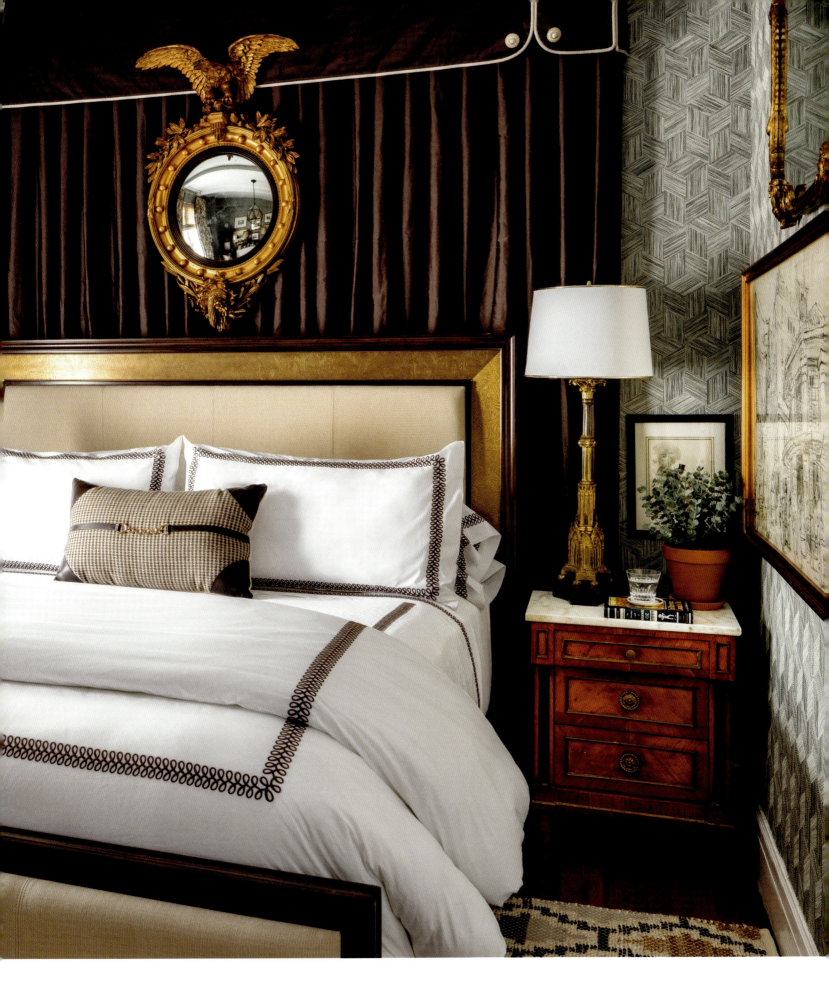

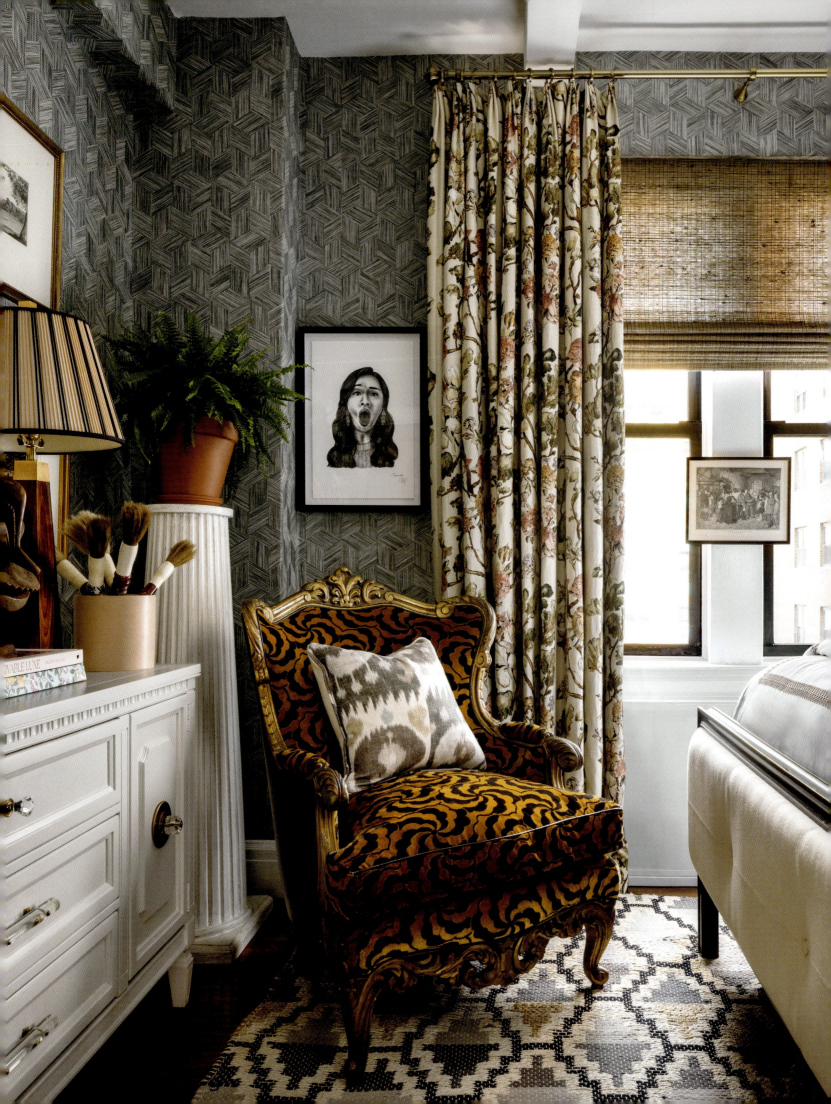

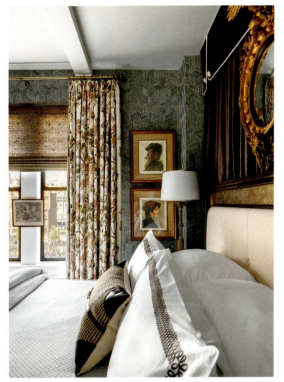
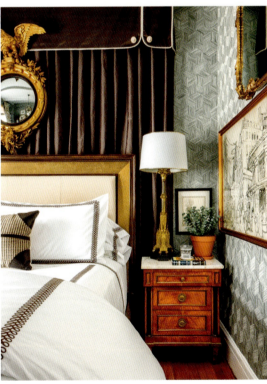
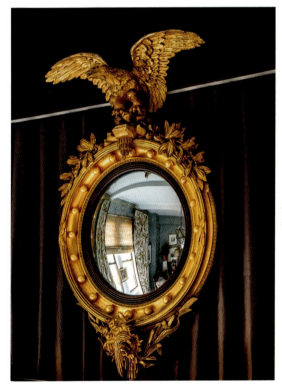

OPPOSITE AND ABOVE: There's a *lot* of joyful pattern play in this bedroom, between the flatweave on the floor, the Japanese kimono cloud motif on the antique bergère, the ikat on the pillow, the chintz drapery fabric, and the geometric wall covering. Home is the perfect place to lean into what you love; I love to experiment in mine.

APPLIED EXPERTISE
Setting an Elegant Table

One of the most enjoyable aspects of hosting a dinner party is designing the tablescape. There are several essential elements to consider as you're creating a dining experience that will be truly enjoyable and—most of all—linger in memory.

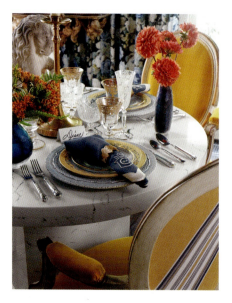

TABLEWARE AND NAPKINS
I won't go so far as to say that chargers are *absolutely* essential—but whether silver or gold, patterned or patternless, they go a long way toward defining a theme. Dishes, glasses, and silverware furnish equally big opportunities to flex your imagination. Although there's nothing *wrong* with having everything come from a single set, mixing and matching shapes and materials will add distinctiveness to your table. And don't forget to be super-creative with your napkins! If your dishes are simple, striking napkins are a practical means to engineer a whole range of looks, from subtle to vibrant.

PLACE CARDS AND SEATING
There's something particularly refined about welcoming guests to their seats with a place card. Place cards indicate that you've put time and thought into where each person should be seated to best enjoy the occasion. Place guests together that you know will vibe well; don't have all your extroverts at one end of the table and all your introverts at the other end. I'm also not usually a fan of separating spouses and partners at meals. I understand that you may want everyone to mingle, but sometimes conversations flow best when guests are in their comfort zones next to the people they came with.

CENTERPIECES
Fresh flower centerpieces are classically lovely. If you use them, make sure they're tall (or low) enough that they don't block the view across your table. Or, instead of flowers, how about a collection of ginger jars, stacked books of varying heights, or decorative silver ice buckets overflowing with fresh fruit? Even a series of candelabra can do the trick—day or night, lit candles contribute a wonderful aura.

MUSIC
This isn't strictly for the table, but ambience is crucial. Never let people walk into a room that is devoid of music, whether recorded or live. It doesn't have to be blaring, simply loud enough for people to understand that they are entering a festive gathering. An aural background will maintain the atmosphere despite any lulls in conversation.

OPPOSITE: The fully draped walls and ceiling of the dining room I designed for the 2021 Kips Bay Decorator Show House in Dallas create a tentlike atmosphere. More than 400 yards of fabric were needed to achieve the look. It's a centuries-old idea that I updated with bold, contemporary forms and colors. The abstract acrylic on canvas is by Jason Trotter.

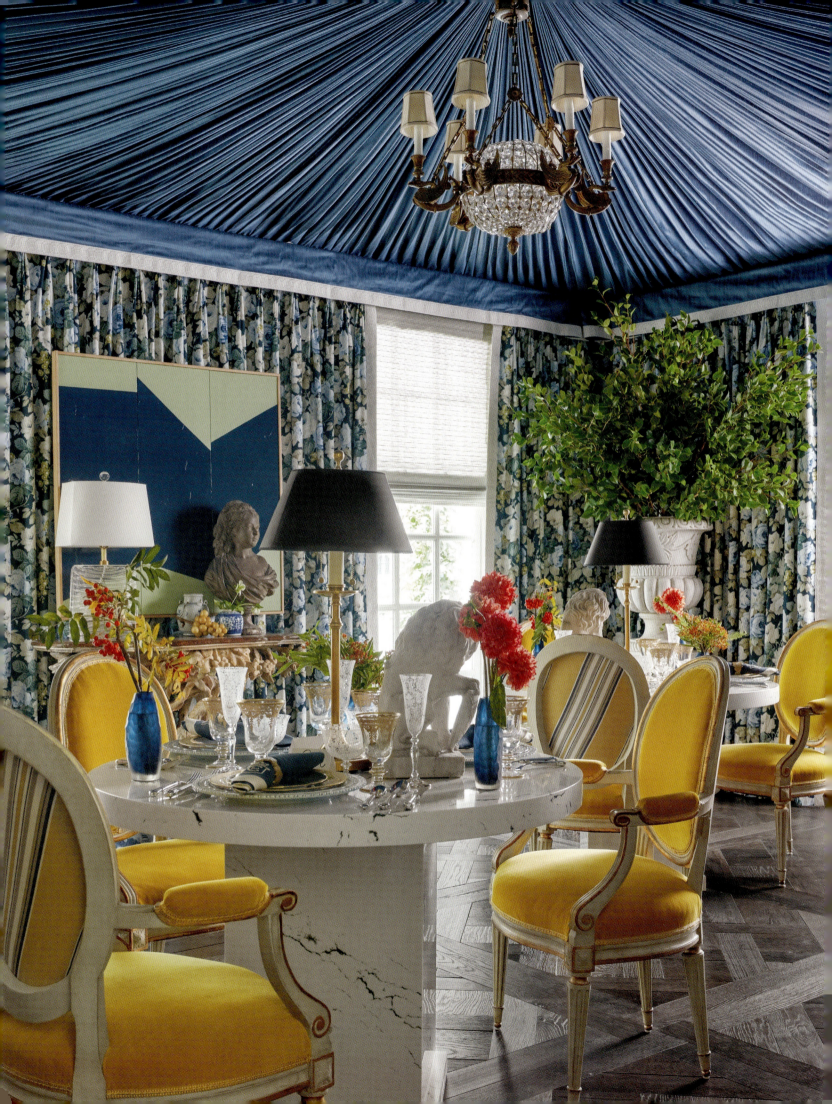

Executive Order

Since 2018, I had been splitting time between our flagship studio in Michigan and an office in New York, with staff at both locations. Being positioned in two states offered strategic advantages—but when the 2020 pandemic-related shutdowns created significant logistical challenges, I was forced to make some tough decisions. Coincidentally, the lease on my Michigan atelier was coming up for renewal that same year. And so, as painful as it would be to say goodbye to longtime employees who had become like family to me, I made the difficult choice to close our Metro Detroit offices and dramatically expand our presence in New York.

We began a comprehensive search for a much larger workspace in Manhattan. I wanted something bright, joyful, and optimistic: a home base that would represent a new era for my team. When my agent first showed me the space we now occupy—a former photographer's studio on the penthouse floor of a prewar building in NoMad—I wasn't instantly captivated. Architecturally speaking, it had few redeeming qualities: makeshift cubicles composed of unfinished drywall partitions, low quality cabinetry, and a mélange of garish colors painted on every wall. On the plus side, however, it was light and bright, with eighteen-foot cathedral ceilings, a series of gable skylights, and walls lined with huge windows. A peek around a corner into what would eventually become my executive office

Since I spend so much time in my office, it was important to surround myself with things that make me feel comfortable and happy. We all deserve a romantic, beautiful environment in which to labor and be productive.

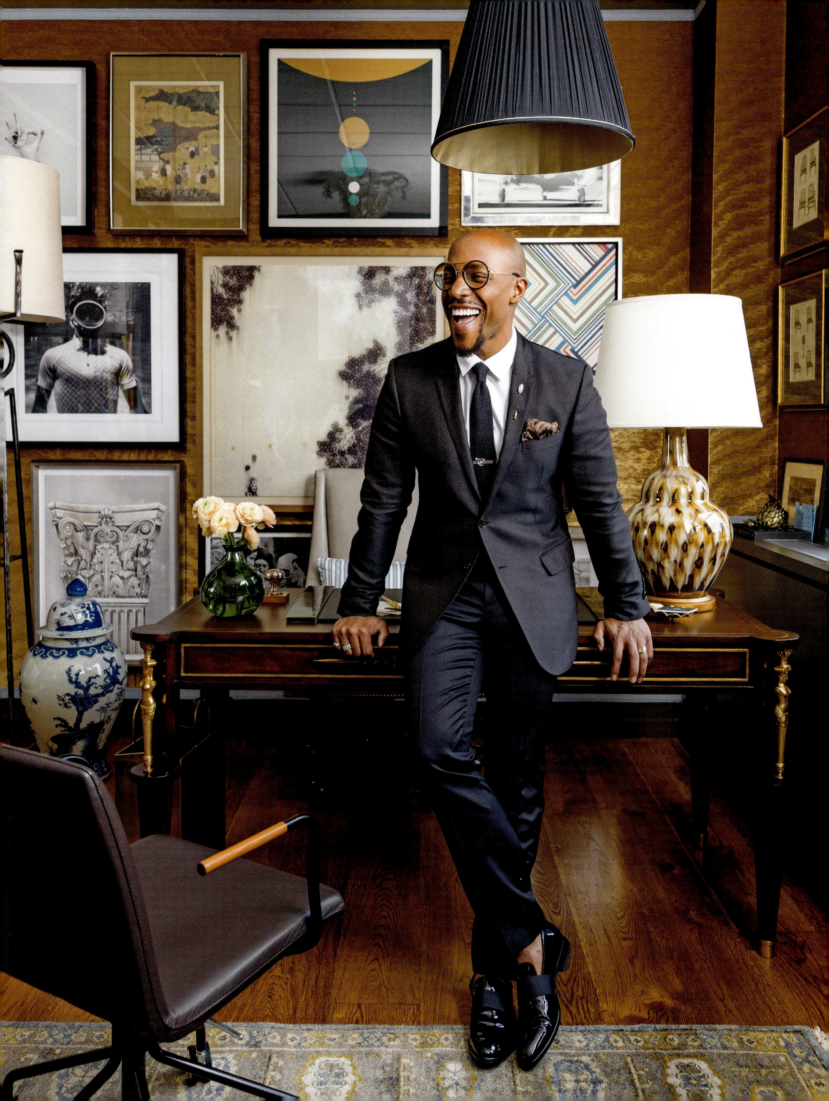

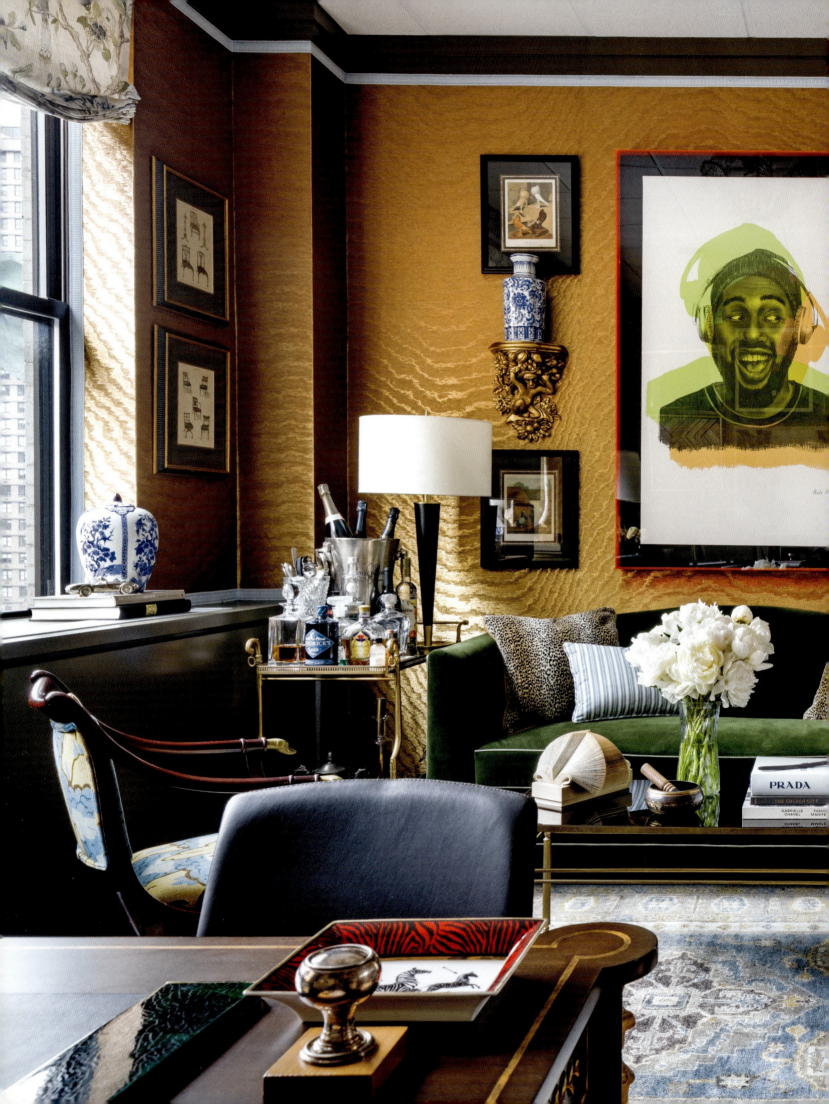

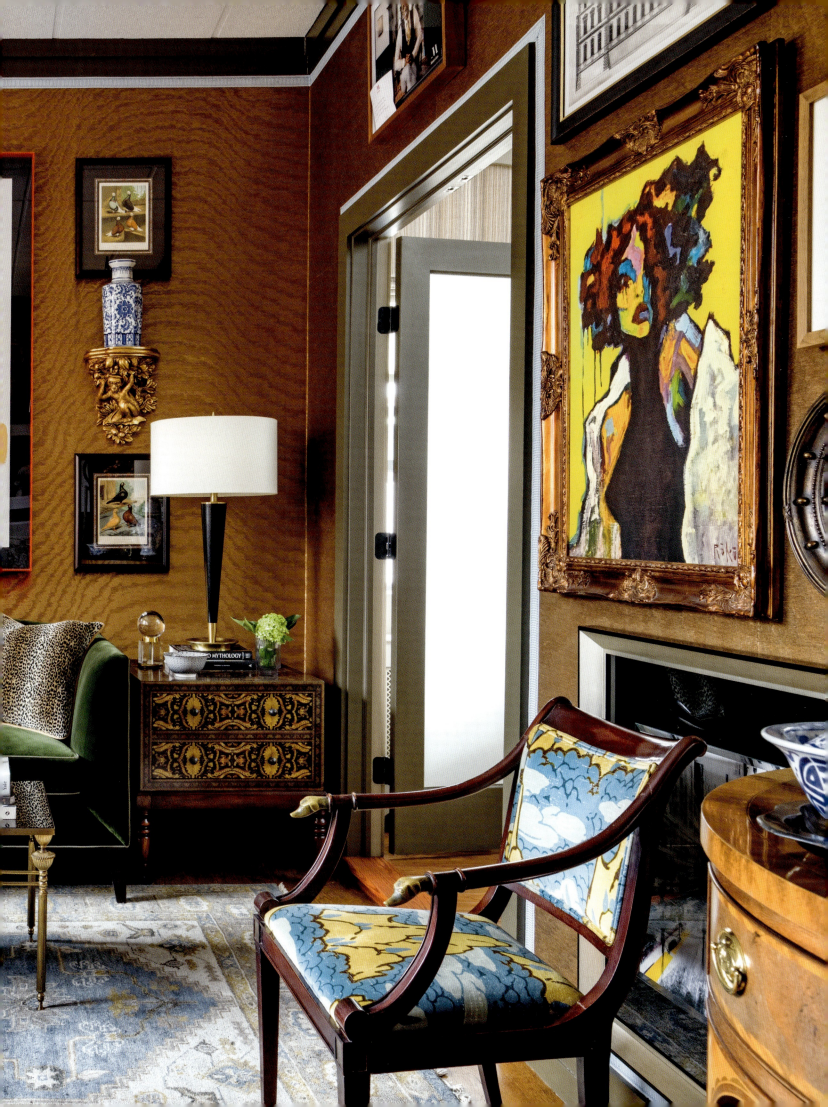

revealed an urban panorama with the Chrysler Building—my favorite tower in the Manhattan skyline—gleaming like a silver sculpture in the distance. Perhaps these premises *would* suit, after all!

Next, we kicked off an extensive renovation: tearing out and moving walls, reworking plumbing, pulling up carpet, refinishing wood floors, and layering in architectural character the rooms desperately needed. Our team enhanced the best of what was there and then devised clever improvements for inherited elements that were less attractive—for example, we encased the exposed radiators in furniture-style covers with brass mesh inserts. A flimsy partition separating the foyer and administrative offices was replaced with a substantial arched portal.

We kept the window treatments throughout the atelier simple, to maintain the focus on the dramatic skyline outside. The colors of the New York City mosaic—its chocolates, coppers, creams, and slate grays—inform the palette of hues and materials we used inside. To give the impression that you're stepping into an elegant private residence, the foyer's walls are dressed in an overscale Schumacher floral print. My personal office resembles a gentleman's study, with silk moiré walls, a bottle-green velvet sofa, Turkish rug, and an eclectic art collection hung salon-style on every vertical surface.

Although our new atelier is filled with furnishings designed specifically for the purpose, it also showcases the firm's legacy. A 1930s vitrine packed with books and objects made the journey from our Michigan studio, while other pieces are prized acquisitions that I've been collecting for decades. Since we first moved in, we've doubled the size of our footprint with expanded studio and conference spaces, and we're excited for continued growth in the years to come. Light, airy, efficient, and seductively stylish, the New York digs of Corey Damen Jenkins & Associates embody both continuity with our past and a view toward our future.

PRECEDING SPREAD: These furnishings were collected for my previous homes and brought to New York. The brass trolley on the left was one of the first high-end antiques I ever acquired.
OPPOSITE: I consider blue-and-white porcelain to be a neutral in decorating. Here, a disparate collection—unified by its colorway and Asian patterned motifs—stands on a 1980s Baker demilune.

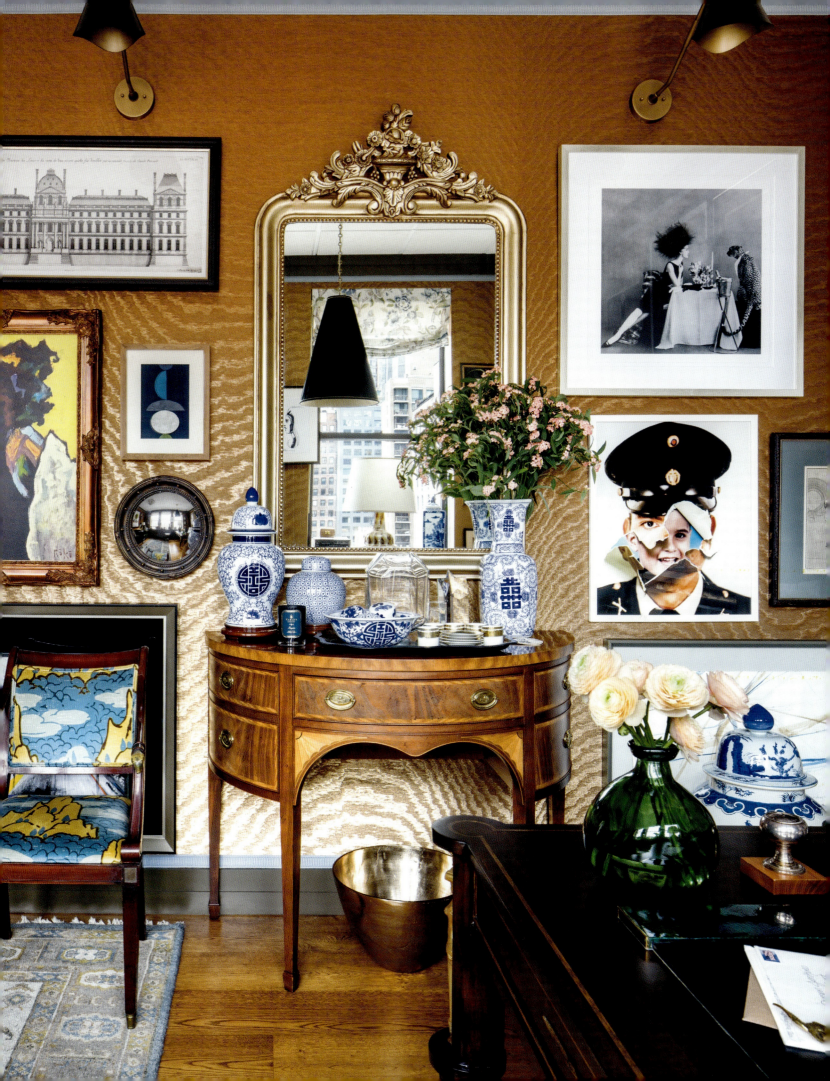

Design Democracy

In the summer of 2021, I was invited to meet with a new client at her magnificent Colonial Revival home, which stands on the idyllic shores of Chesapeake Bay. Although we had already enjoyed several email and virtual conversations, this would be our first time meeting in person. As we sat down for lunch, the lady of the house said something to me that would set the tone for our new working relationship: "Corey, I want you to feel that you have equity in everything we do together on this project. I truly consider this a partnership."

Those heartwarming words resonated with me, since I, too, have always viewed these extensive collaborations from the same vantage point: we join forces with homeowners to create something beautiful. To have a flourishing relationship with any client, however, one must possess more than sheer creative ability and technical education; a degree of humility is also required. My client had a refined eye and loved scouting antique stores and auctions for serendipitous finds. She and her husband had amassed collections of fine furniture and objets d'art from their world travels, but these items needed to be given a cohesive place in the home. So, our joint inspiration here came from leveraging the family's trove of lovely things as a starting point, and then judiciously filling in

When decorating large expanses of wall space, you don't have to rely strictly on framed artwork as a solution. Here, a flock of crystal swallow sculptures flutters up the home's main stairwell, providing company for a vintage sunburst mirror from the client's estate.

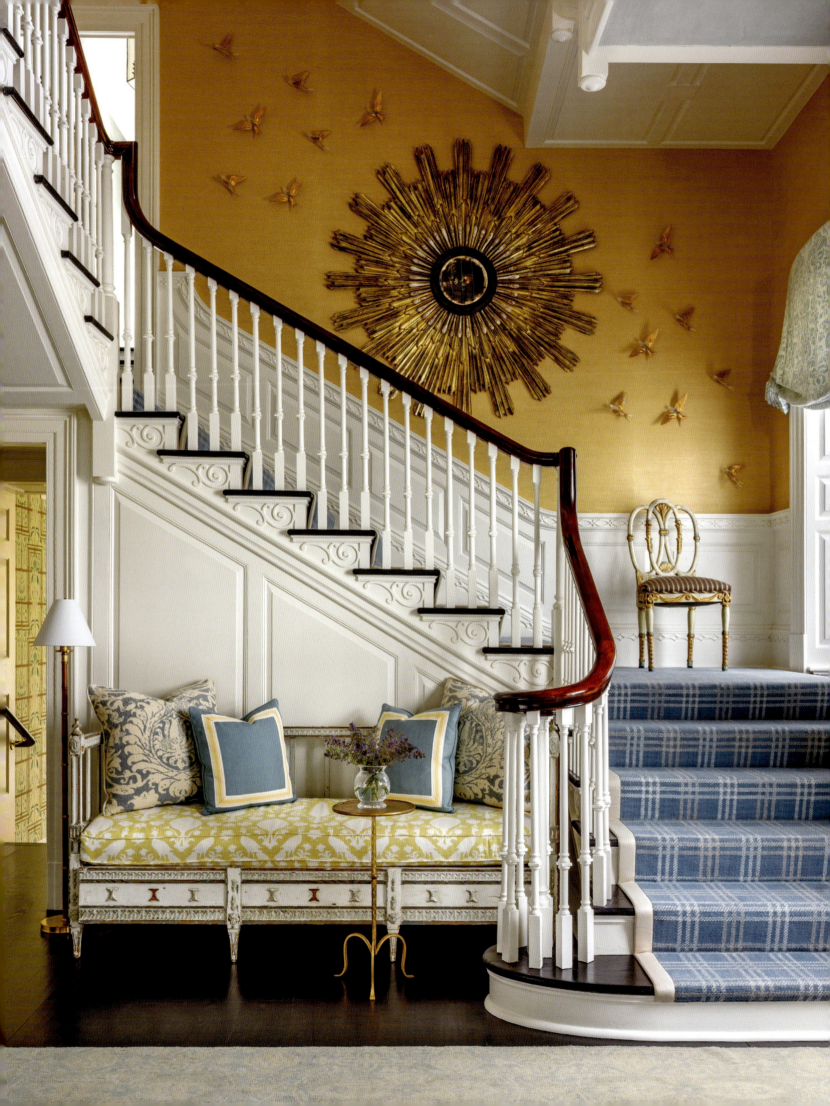

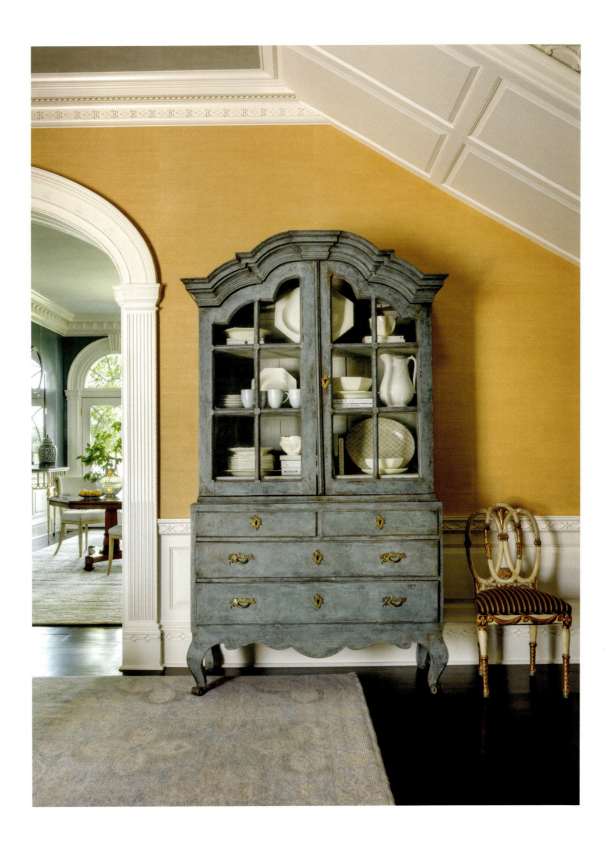

OPPOSITE: My client already owned the lovely Louis XVI daybed that is now tucked into the stairs; we re-covered it to give it a new vibe. ABOVE: The moment I first laid eyes on this shale blue breakfront, I knew it would play a pivotal role in our color palette. FOLLOWING SPREAD: For a home at the shore, we wanted to introduce some patterns, such as plaid, that weren't too tailored or formal.

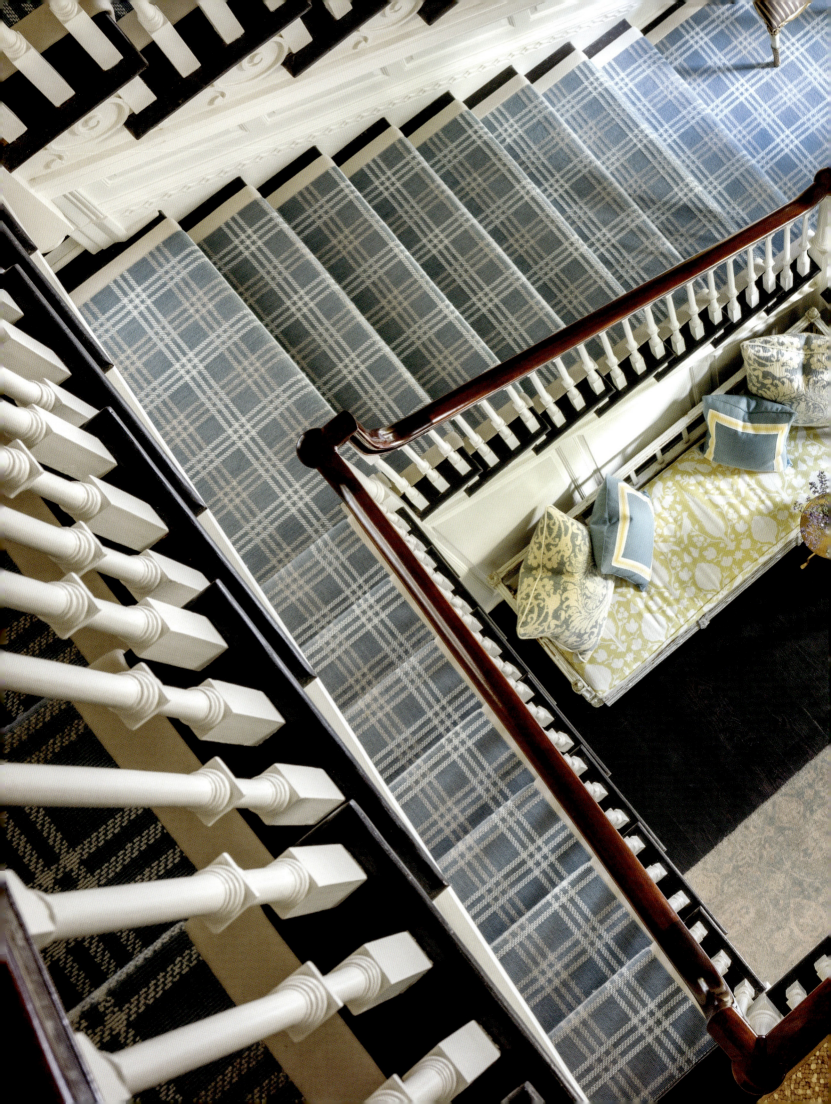

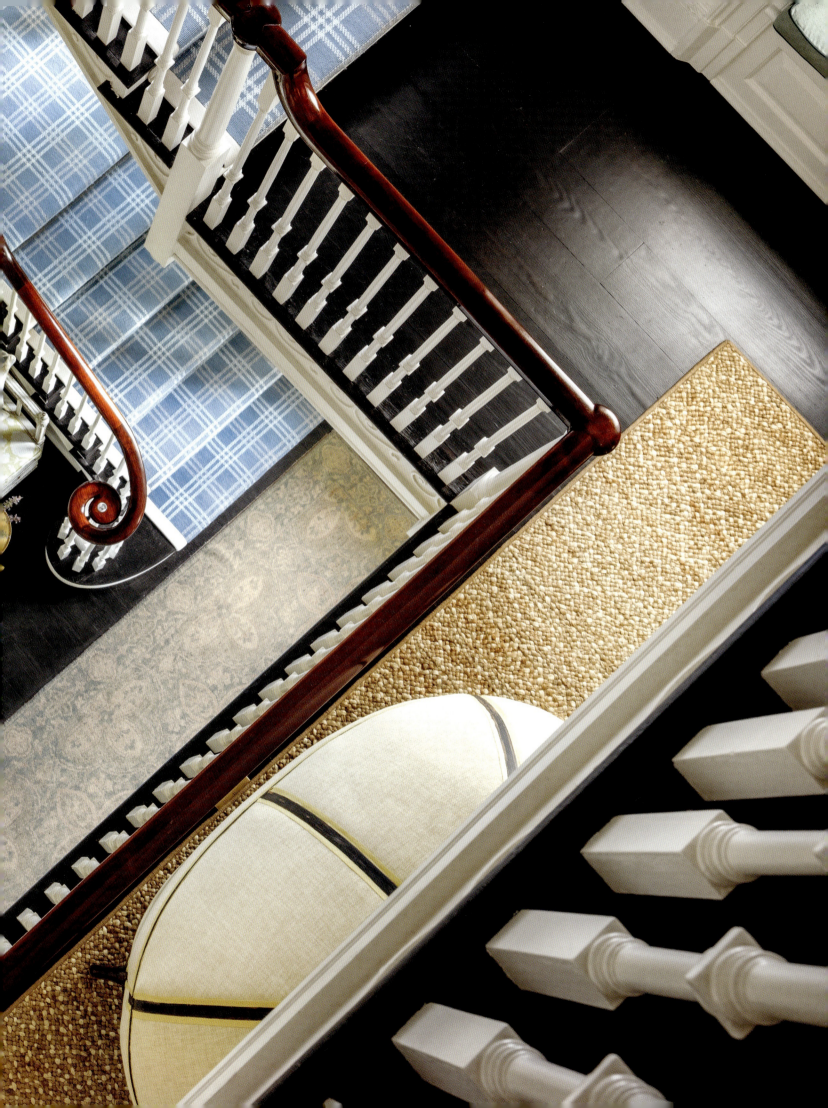

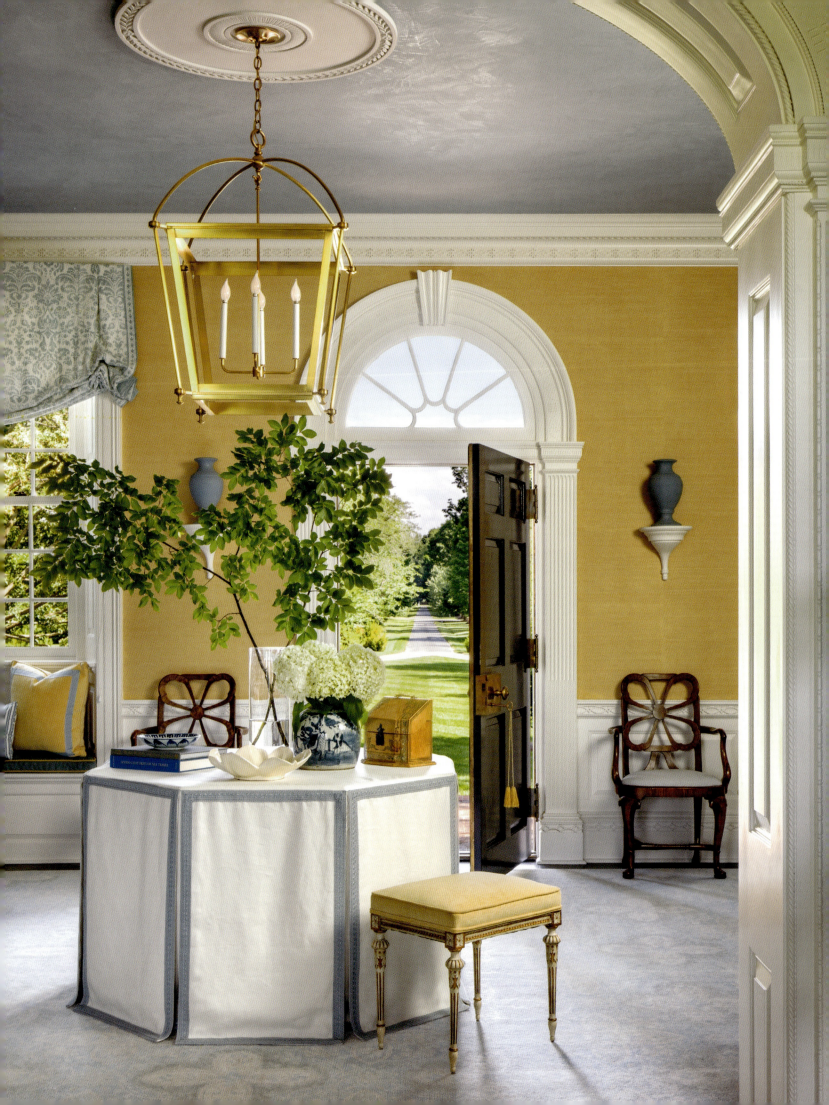

the blanks with new acquisitions and bespoke finishes sourced by my firm.

As grand as the house is architecturally, it needed to feel less formal than the couple's other residences, as would befit a coastal retreat—elegant and tailored, yes, but not too precious, and able to stand up to children, dogs, and lots of guests. For that reason, we selected mostly textured performance fabrics and wall coverings in summerhouse-friendly patterns like plaids and gingham checks. The family embraces the breezy coastal lifestyle, and often windows and doors are flung wide open, so we steered clear of crystal chandeliers, preferring to hang simple open lanterns. In the same vein, sunlight glows through window treatments that have been left unlined.

Despite the relaxed aesthetic, we still made sure to add touches of fine craftsmanship. The grass-cloth walls of the front hall and main stairwell, for example, were glazed with a special plaster, mixed on-site, which gives them a weathered, timeless patina. Stately walnut bookcases designed by our office hug

OPPOSITE AND ABOVE: The home's architectural details were phenomenal; we augmented them with custom plaster ceiling medallions in the front hall.
FOLLOWING SPREAD: Decoratively, we brought in soft, informal treatments and durable finishes that would hold up well to entertaining, children, and pets.

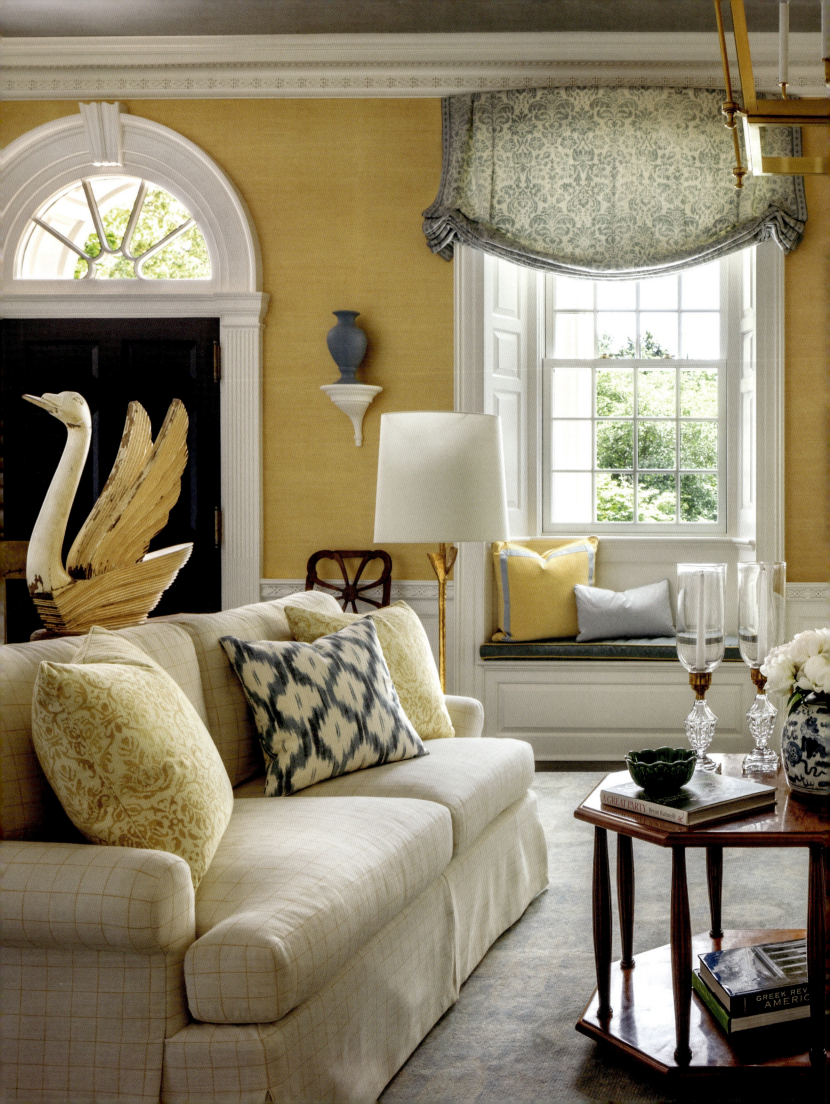

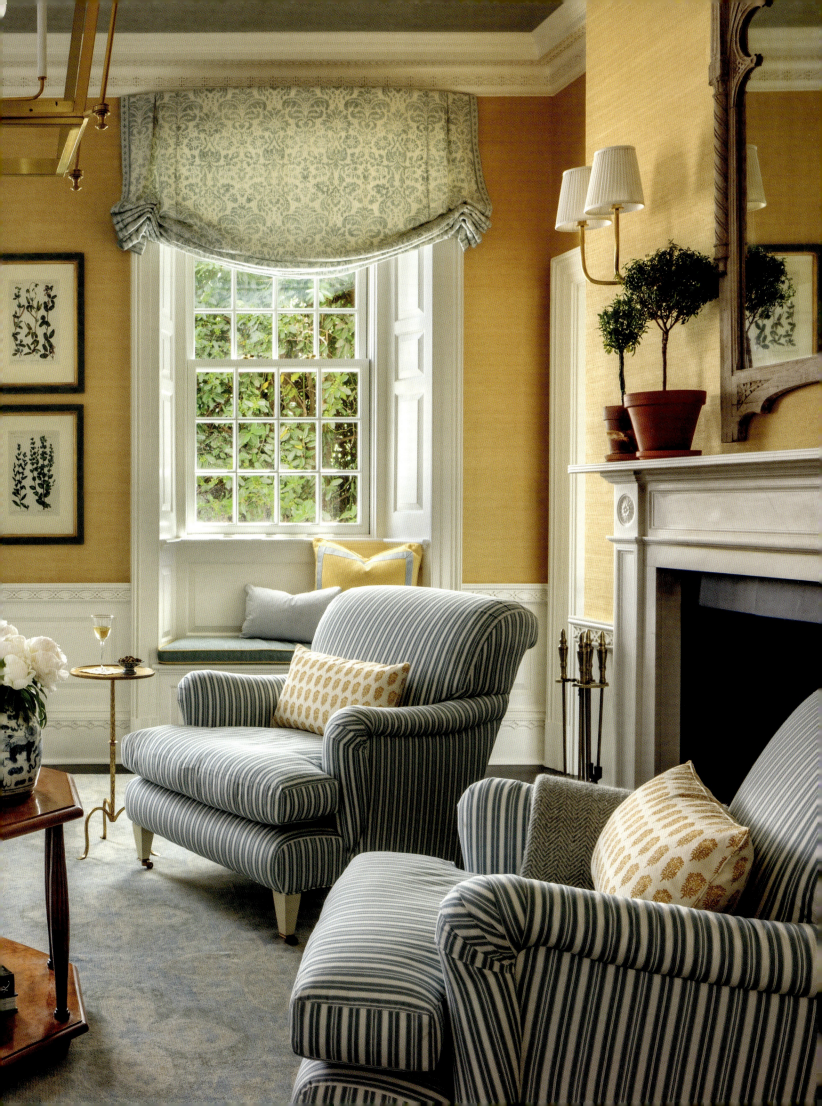

the windows in the second-story parlor. The downstairs study underwent a surgical renovation that included the addition of a nearly 130-year-old limestone fireplace of French origin (it was last seen completely assembled in New York City's historic Waldorf Astoria Hotel back in 1931).

The glories of the outdoors are best enjoyed from the home's spacious veranda. It's important to treat terraces and porches as exterior rooms; they should receive the same amount of thought and attention as any other section of the house. Here, I knew I wanted to create expansive seating and dining areas. A center table divides the two zones. A sofa, chairs, pillows, daybed, banquette, and skirted console are clad in an array of carefully coordinated solid and patterned fabrics, all performance-

ABOVE: The client's favorite color, sunshine yellow, is integral to the home's palette.
OPPOSITE: Birds are a recurring theme throughout the residence, including a striking pair of antique wooden swans that holds pride of place on a console near the front door.

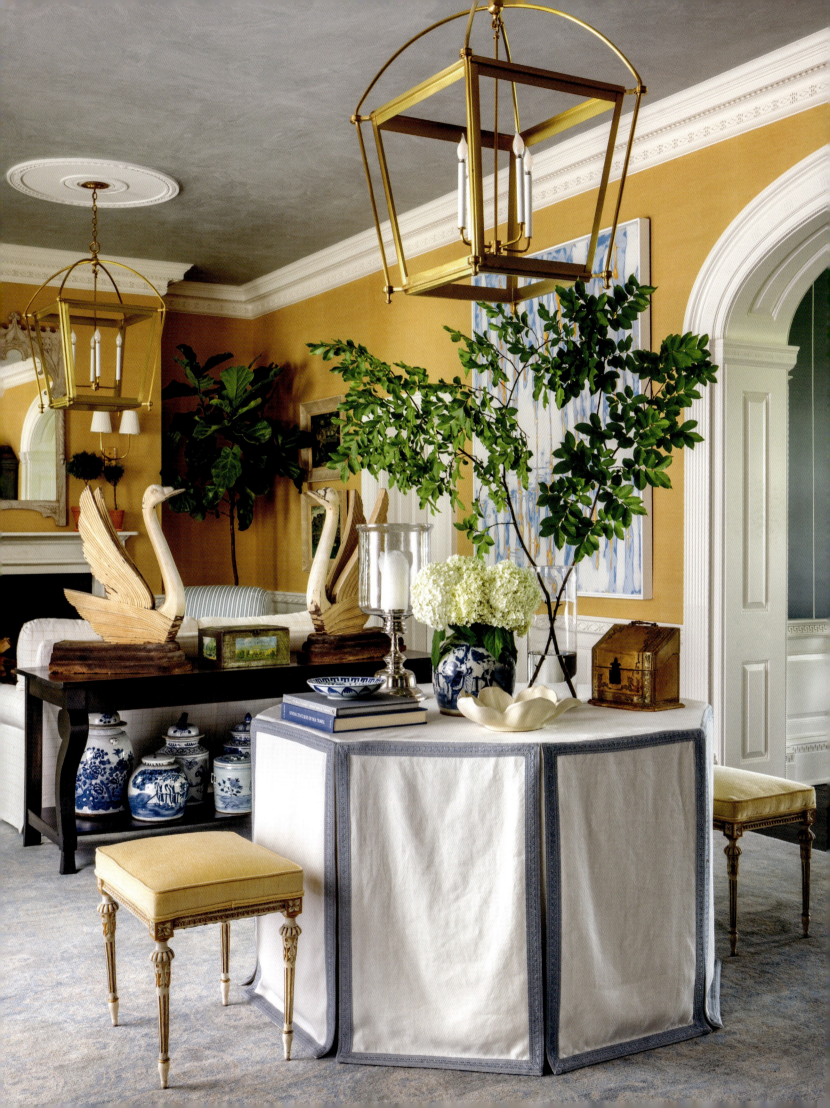

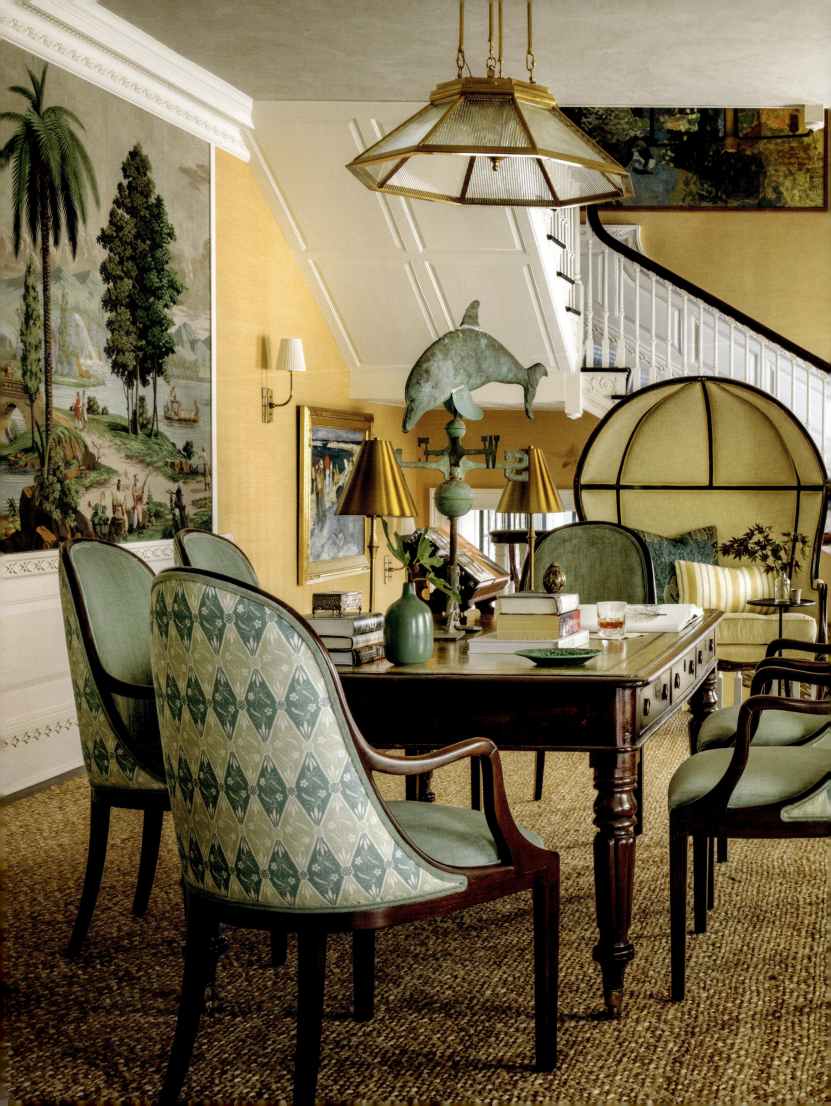

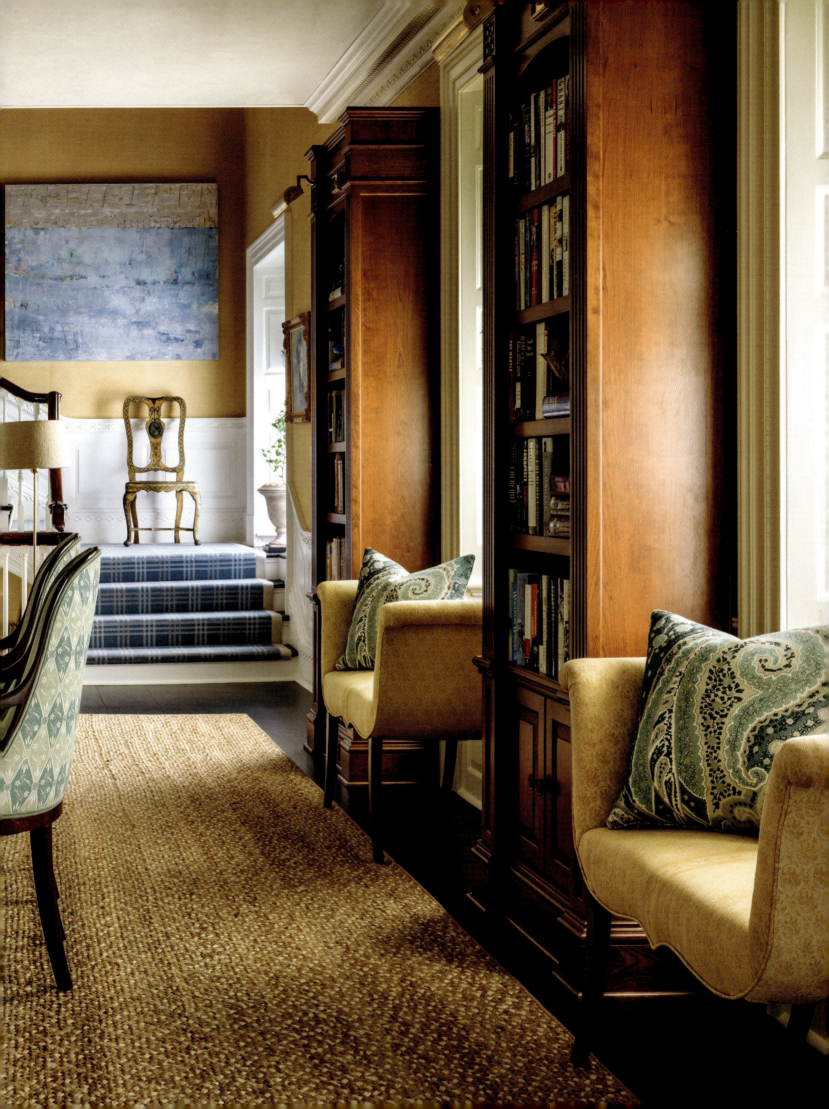

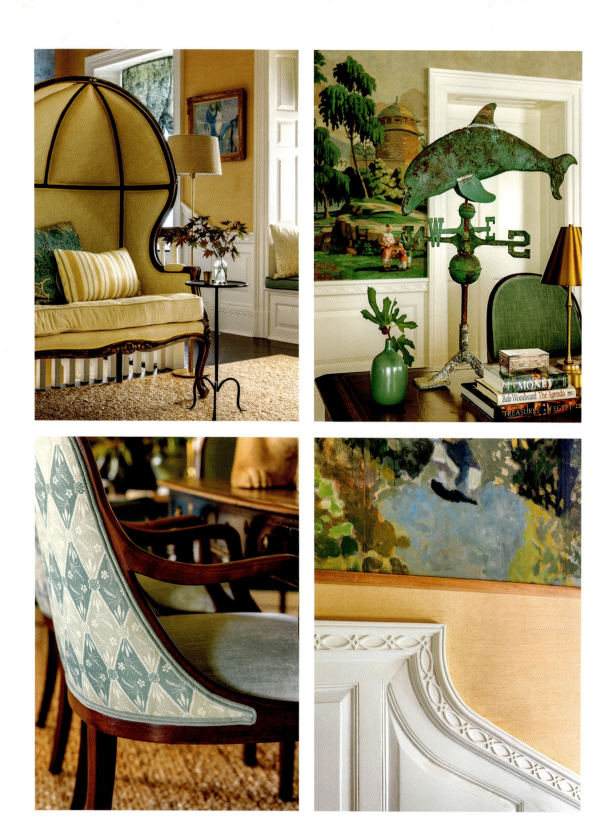

PRECEDING SPREAD: The second-story library is used frequently for entertaining. We acquired the vintage Dessin Fournir armchairs at auction and re-covered them. The jute rug furnishes a soft texture underfoot and contributes a touch of casual elegance. Painting on landing by Takefumi Hori. ABOVE: Fun details in the room include an antique dolphin weathervane and a balloon settee. OPPOSITE: I designed the bookcases and had them built by a brilliant local furniture maker.

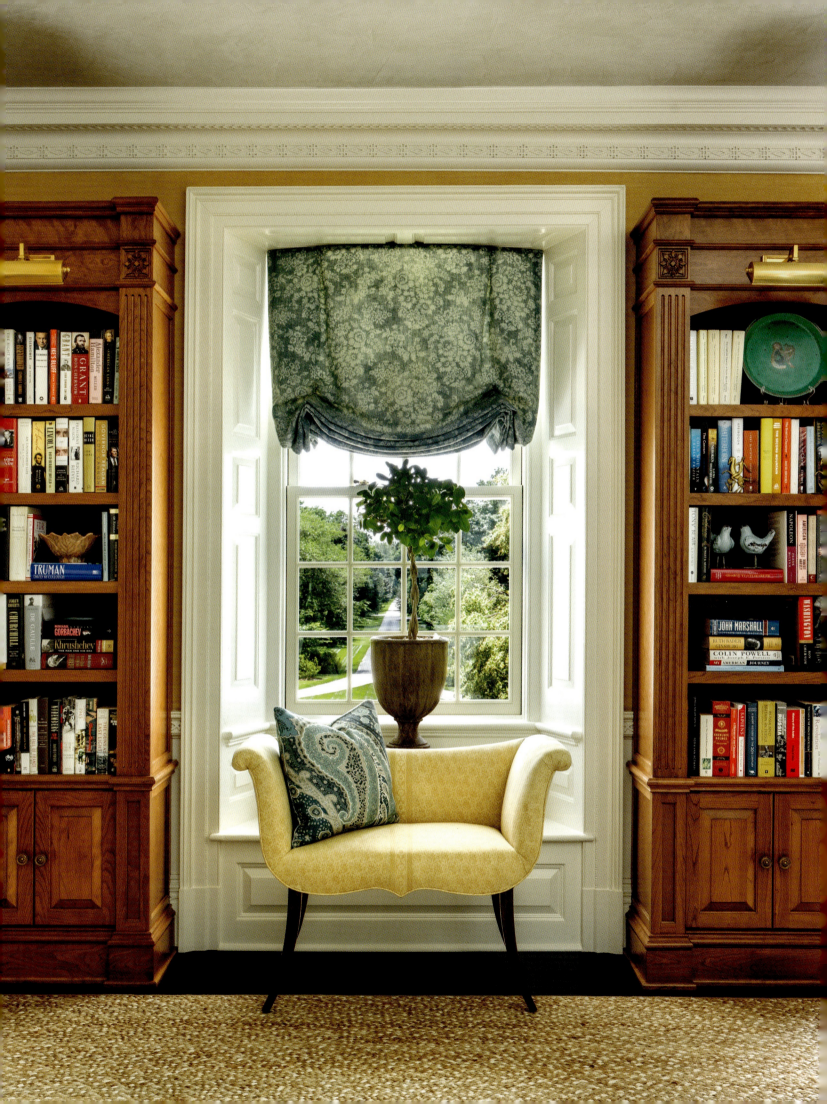

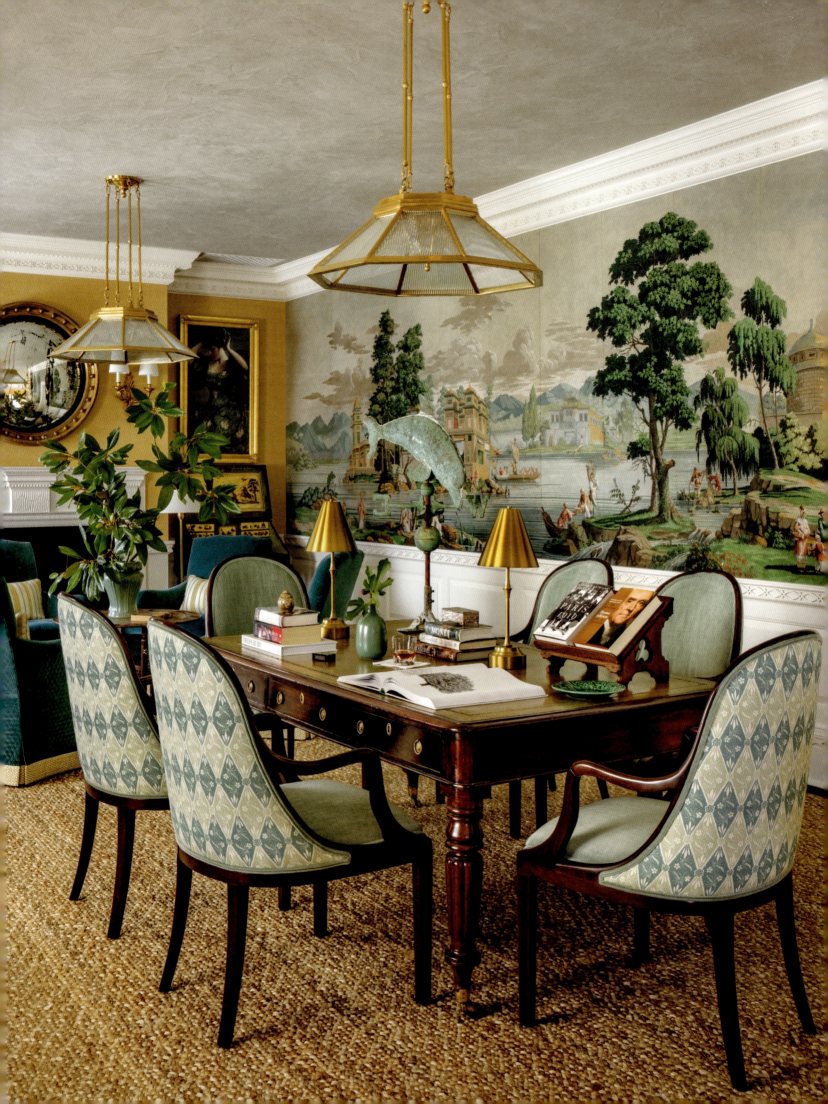

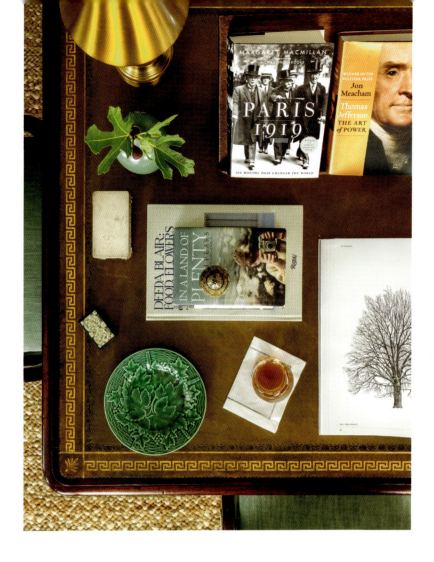

rated to stand up to the weather. To add a decorative flourish, antique blue-and-white porcelain plates were mounted onto custom-fabricated metal grilles, which were then attached to the whitewashed brick walls for a multidimensional effect. Vintage ginger jars abound, partially filled with rocks and sand to make sure they stay where they belong even on the windiest days.

In the end, we created a harmonious interior and exterior design that truly reflects the couple's personal taste and appreciation for beauty. The delightful renovation of this summer home illustrates what can be achieved by a true meeting of minds, where the clients and interior designer share equity in the vision they're forging together. And that, dear reader, is what "design reimagined" is all about.

OPPOSITE AND ABOVE: My client bought the leather-topped library table in New Orleans. The stormy gray of the Roman Clay ceiling was drawn from the overcast sky in the scenic wall mural. The atmospheric finish extends over the whole room like a canopy.

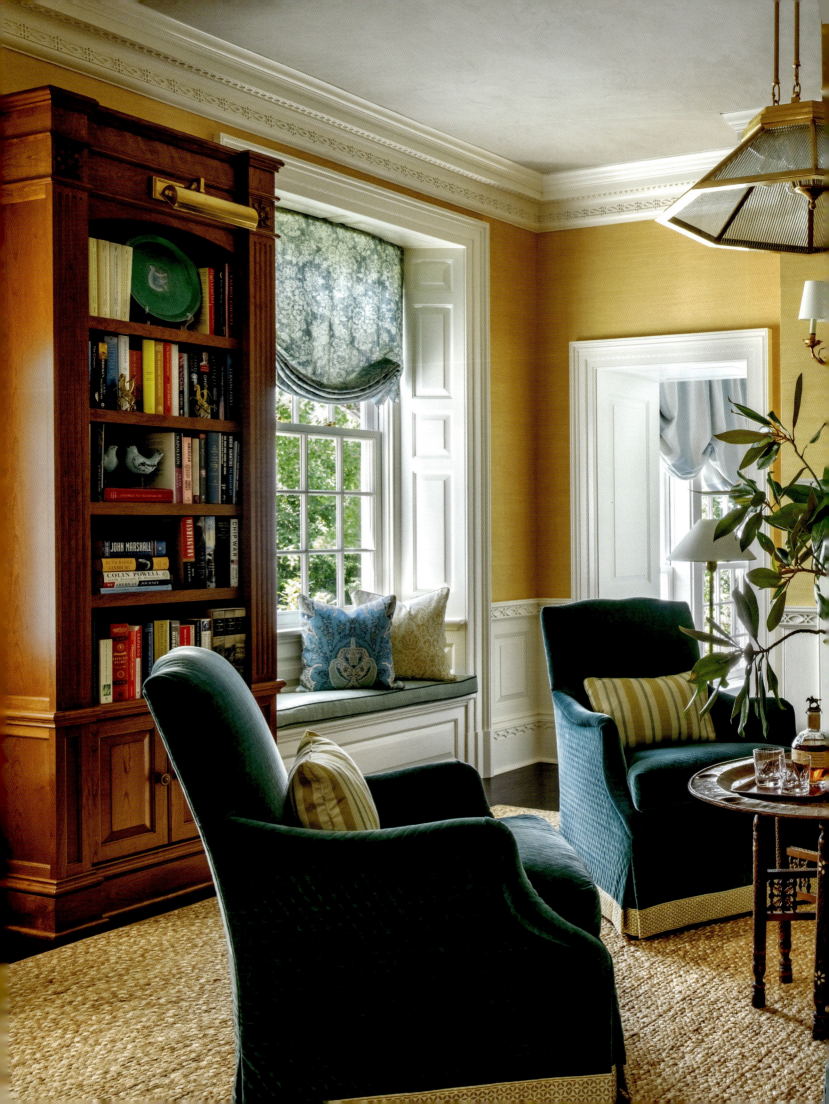

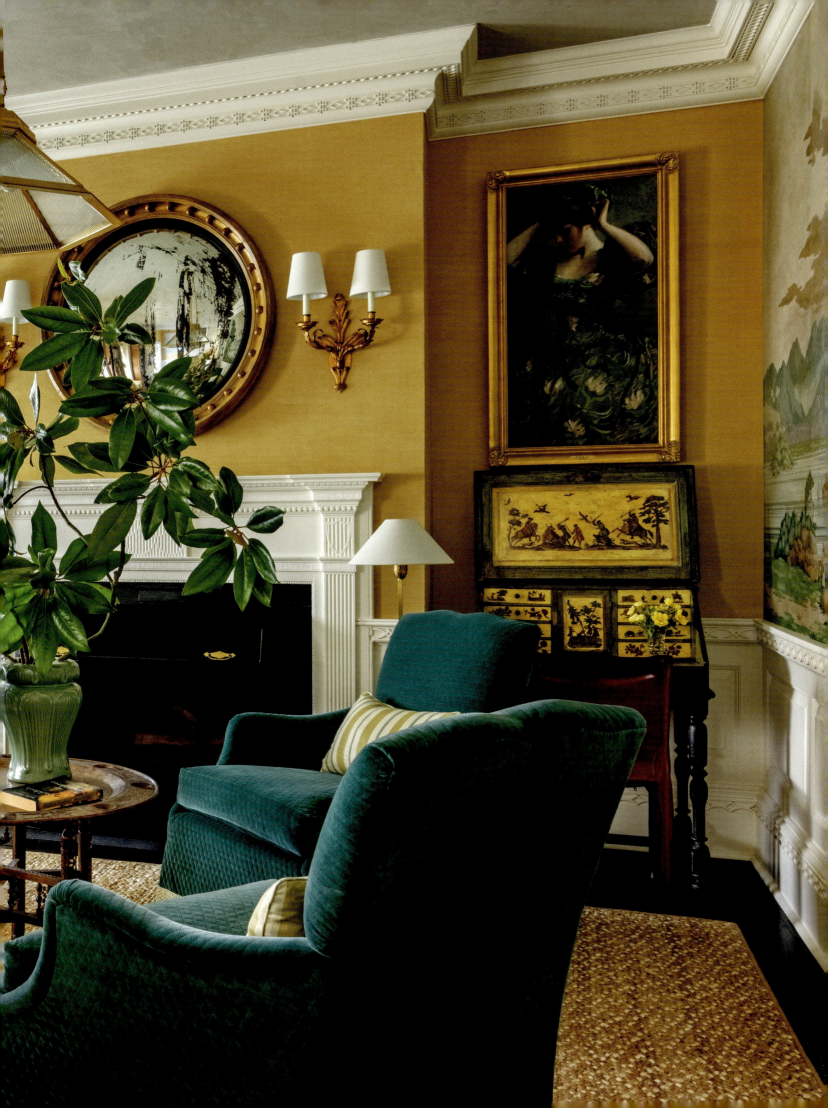

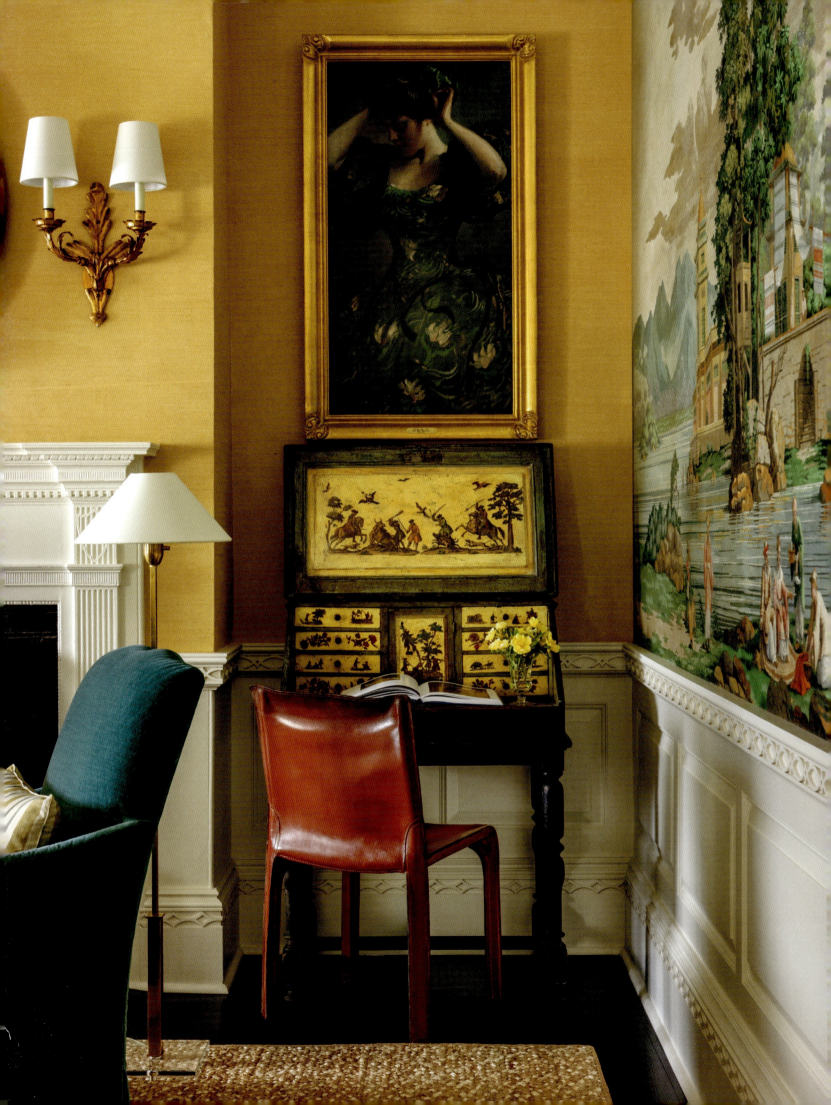

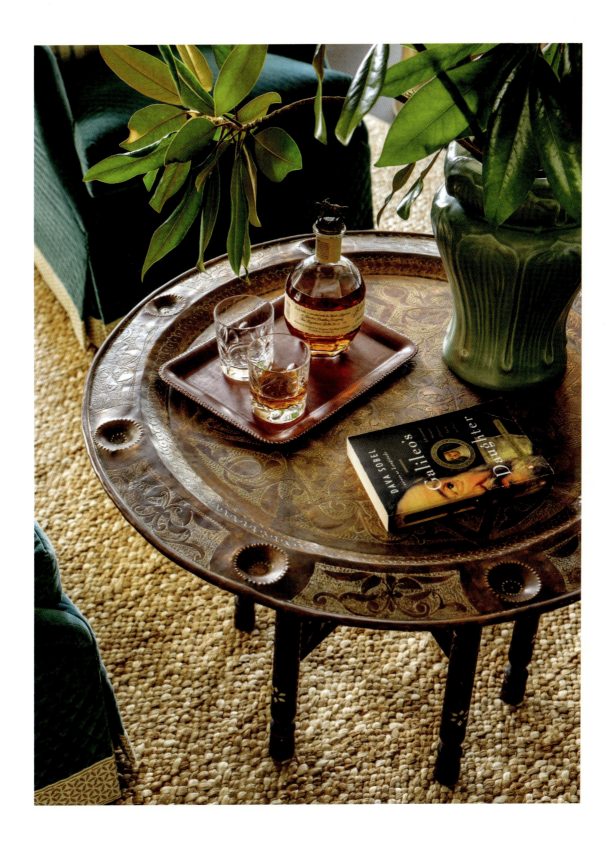

PRECEDING SPREAD: A sitting area near the fireplace is perfect for reading and conversation. Quilted velvet chairs add richness; the unlined window treatments strike a more casual note. OPPOSITE: We brought together a French painted secretary, a contemporary leather seat, and one of my client's favorite paintings by John White Alexander to fashion a corner tableau. ABOVE: The Syrian copper tray-table is an antique find.

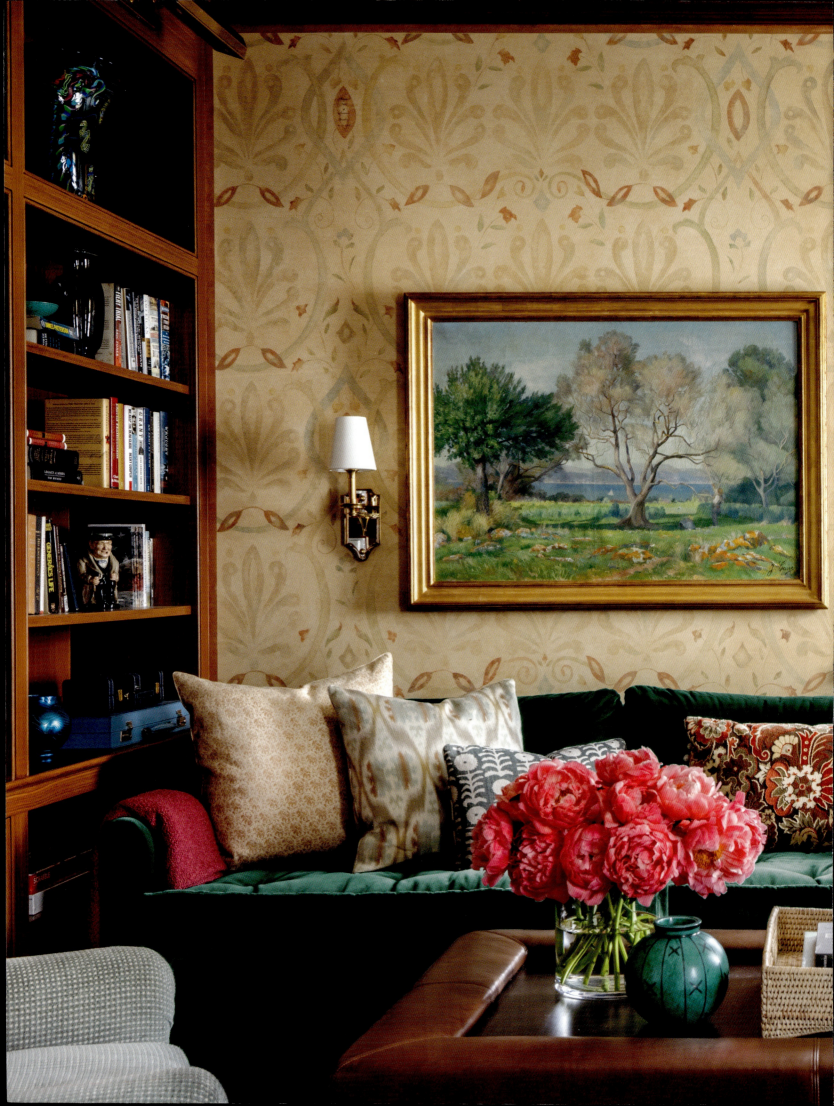

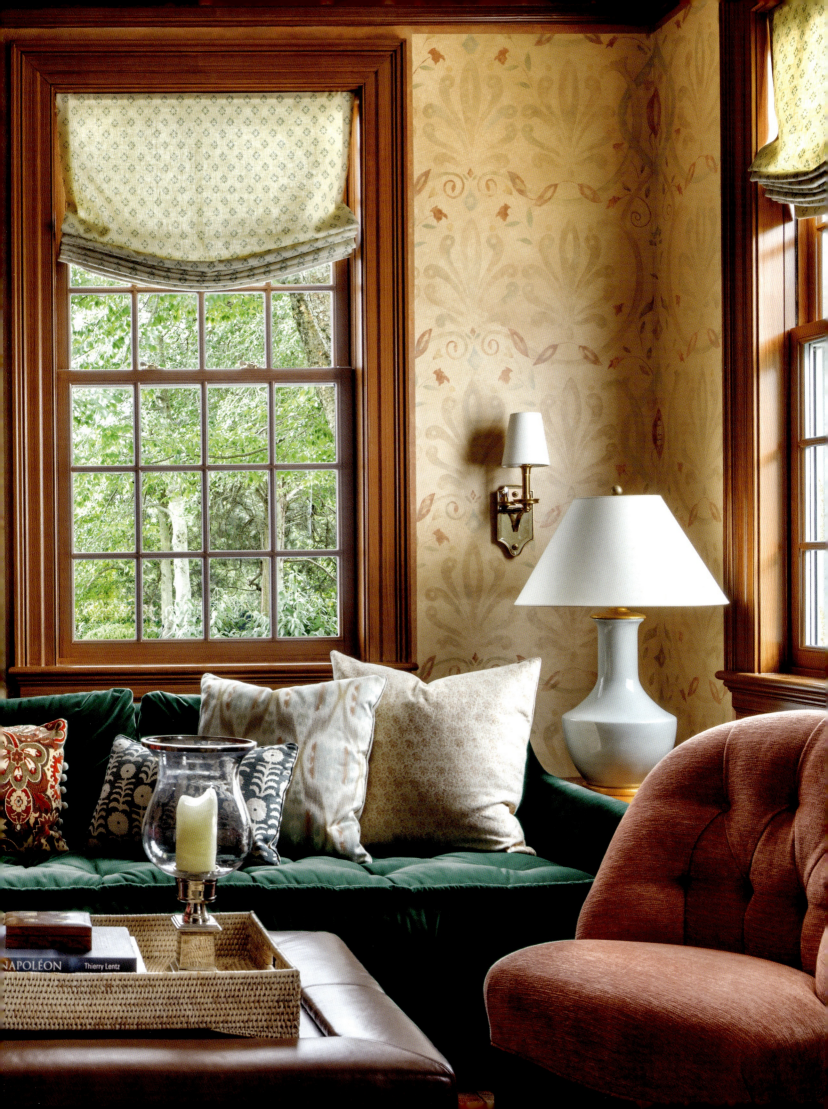

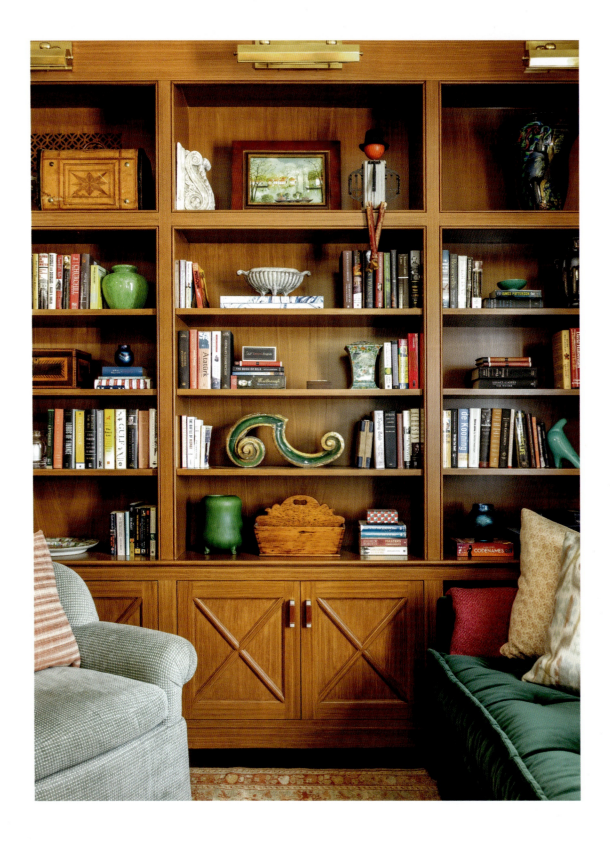

PRECEDING SPREAD: An extra-long sofa in the den is the perfect place for the family to pile on and watch television or movies together. ABOVE: We had the previously painted trim and bookshelves meticulously finished to resemble wood. OPPOSITE: The restored French limestone fireplace once graced a room at New York's Waldorf Astoria Hotel. The custom wall decoration was hand-applied by a team of artists.

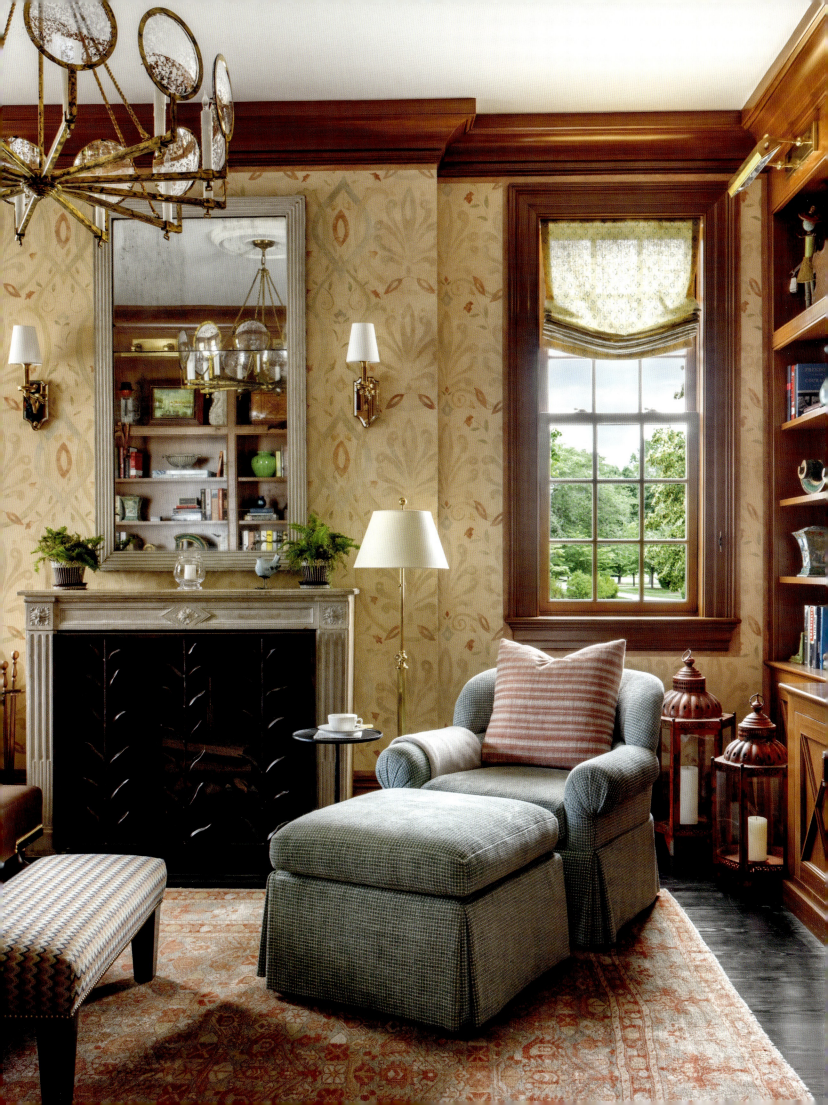

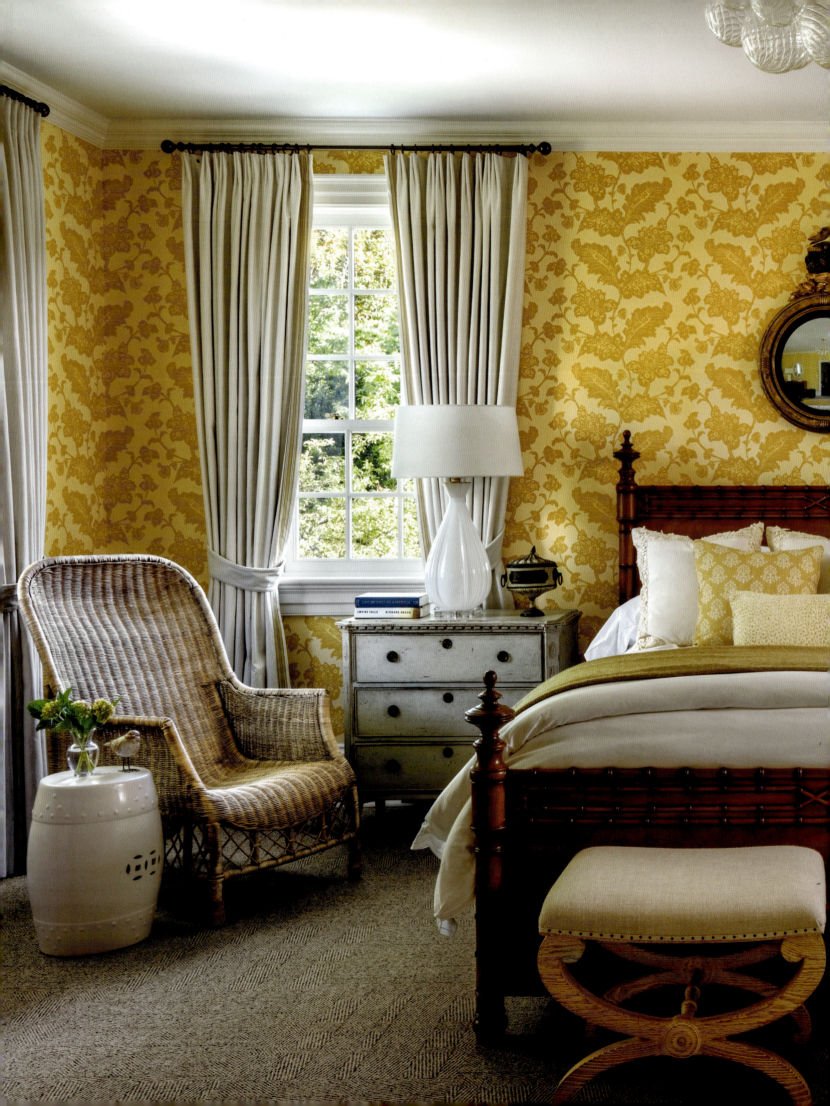

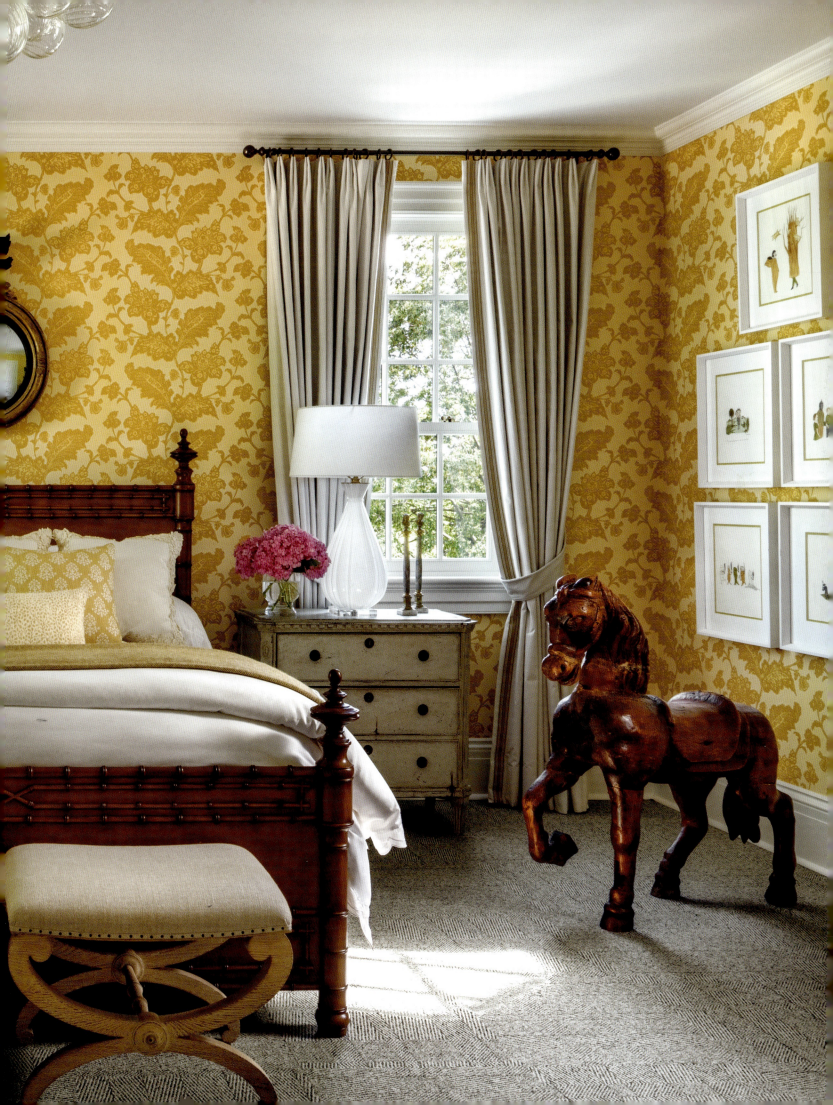

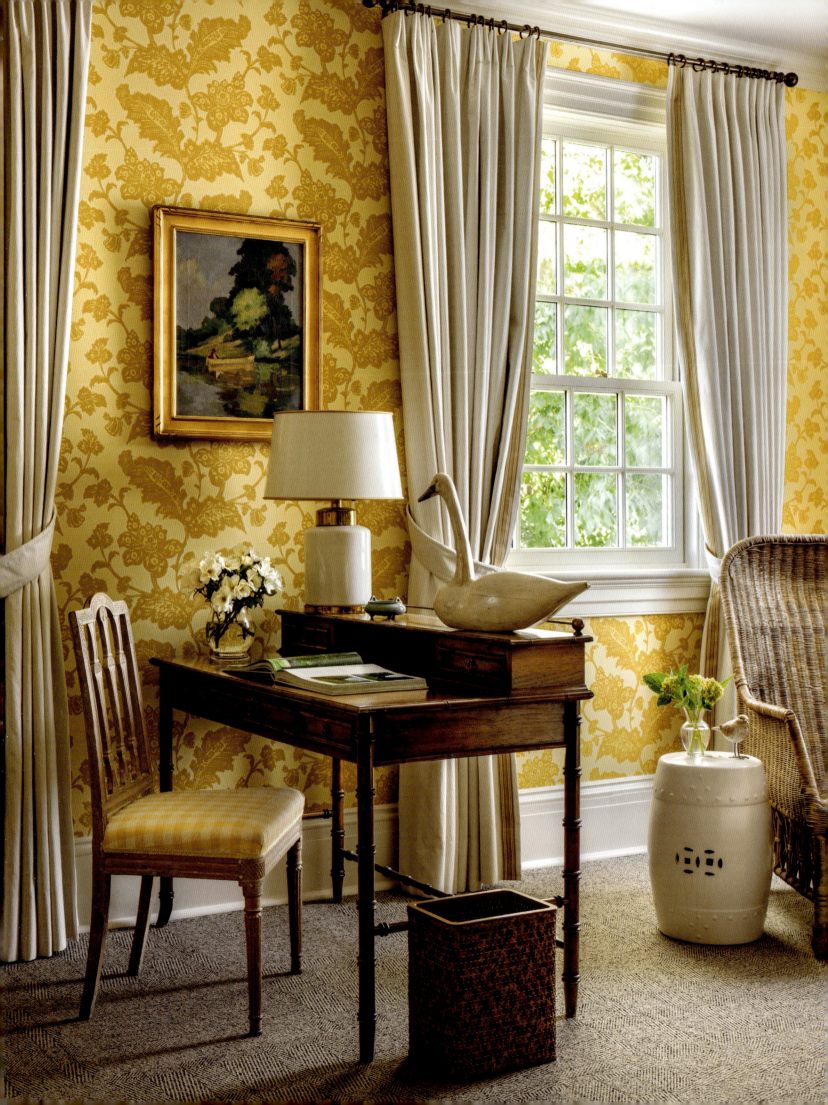

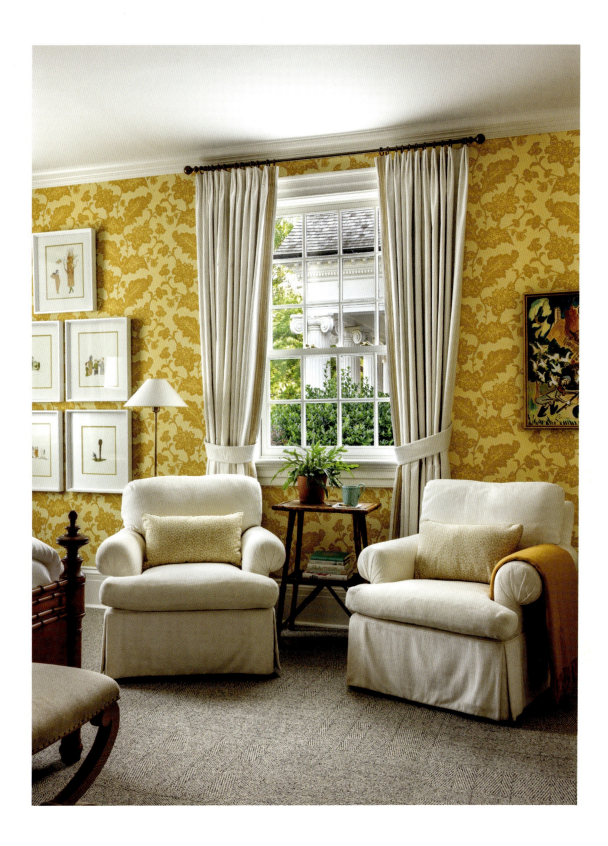

PRECEDING SPREAD: As you can see in this guest room, I love the idea of mixing in some playful quirkiness with very prim-and-proper motifs. The vintage horse sculpture brings visual balance and a whimsical moment to the space. OPPOSITE: A gingham-covered chair seat and tweedy carpet are additional informal touches. ABOVE: Armchairs and drapery panels in a solid ivory hue are a quiet counterpoint to the patterned walls.

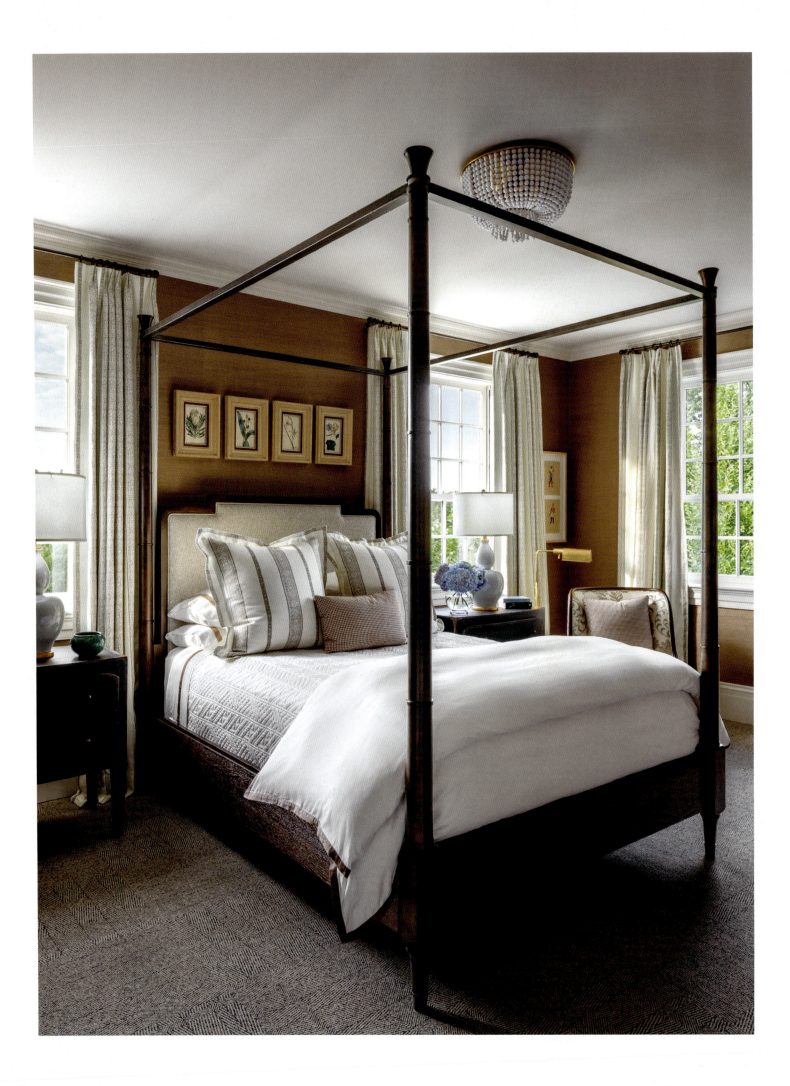

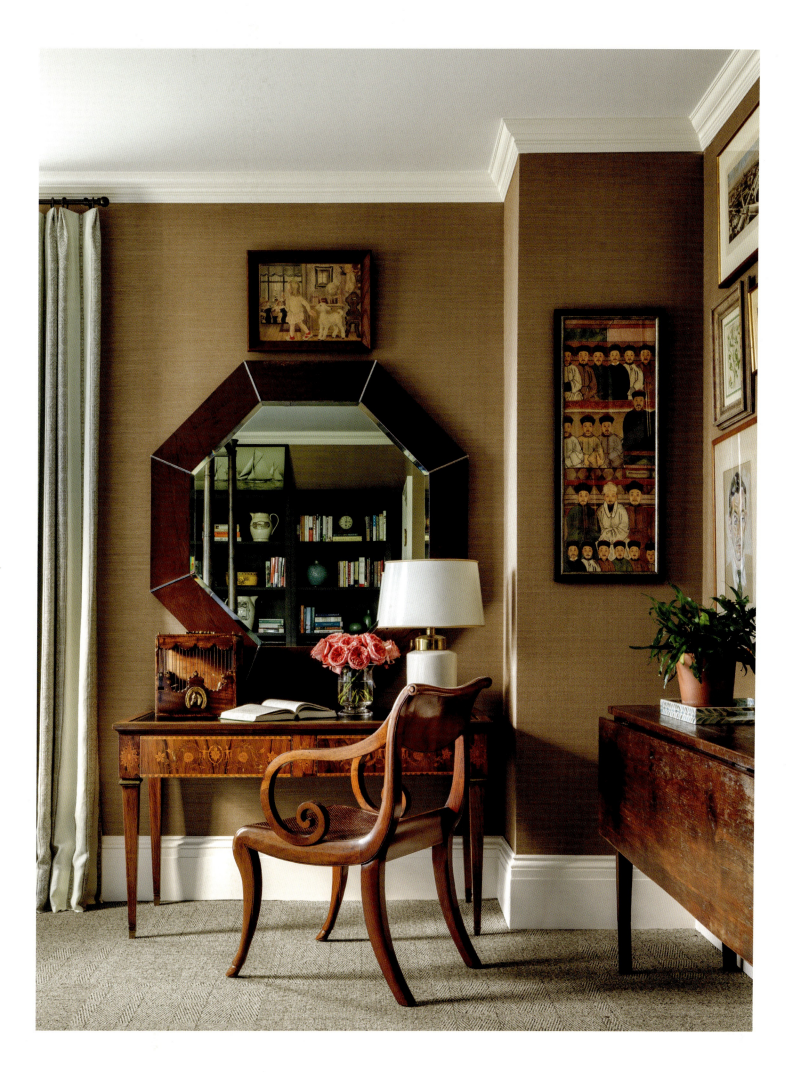

PRECEDING SPREAD, LEFT: Another guest bedroom is a bit more masculine, with cappuccino grass-cloth walls and black-painted nightstands. PRECEDING SPREAD, RIGHT: A wood-framed octagonal mirror provides a crisp contrast to the Italian marquetry desk. RIGHT: A gallery wall, with the woodcut *Caged Bird* by Walter Henry Williams as its centerpiece and Paris rooftop painting by Gabrielle Kayser at top right, pulls together disparate works from the owners' collection. Great interior design doesn't always require buying a lot of new things; sometimes it's about reimagining things you already own to get the right look.

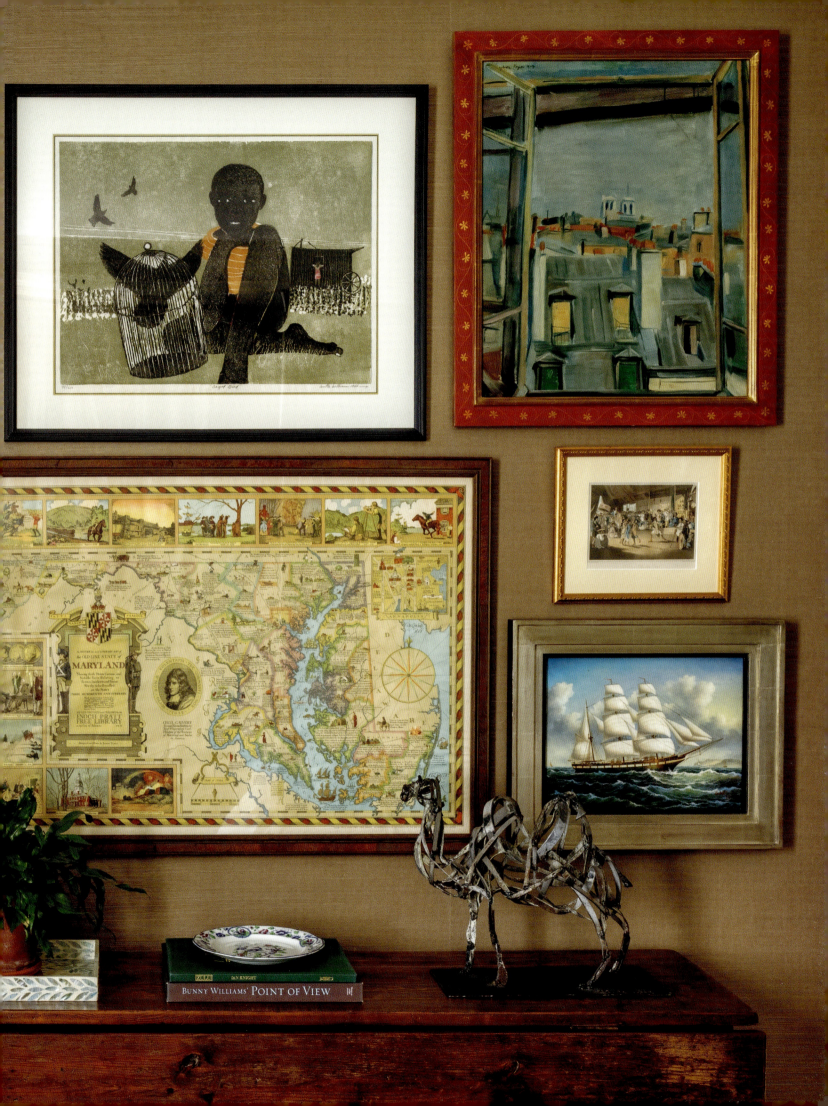

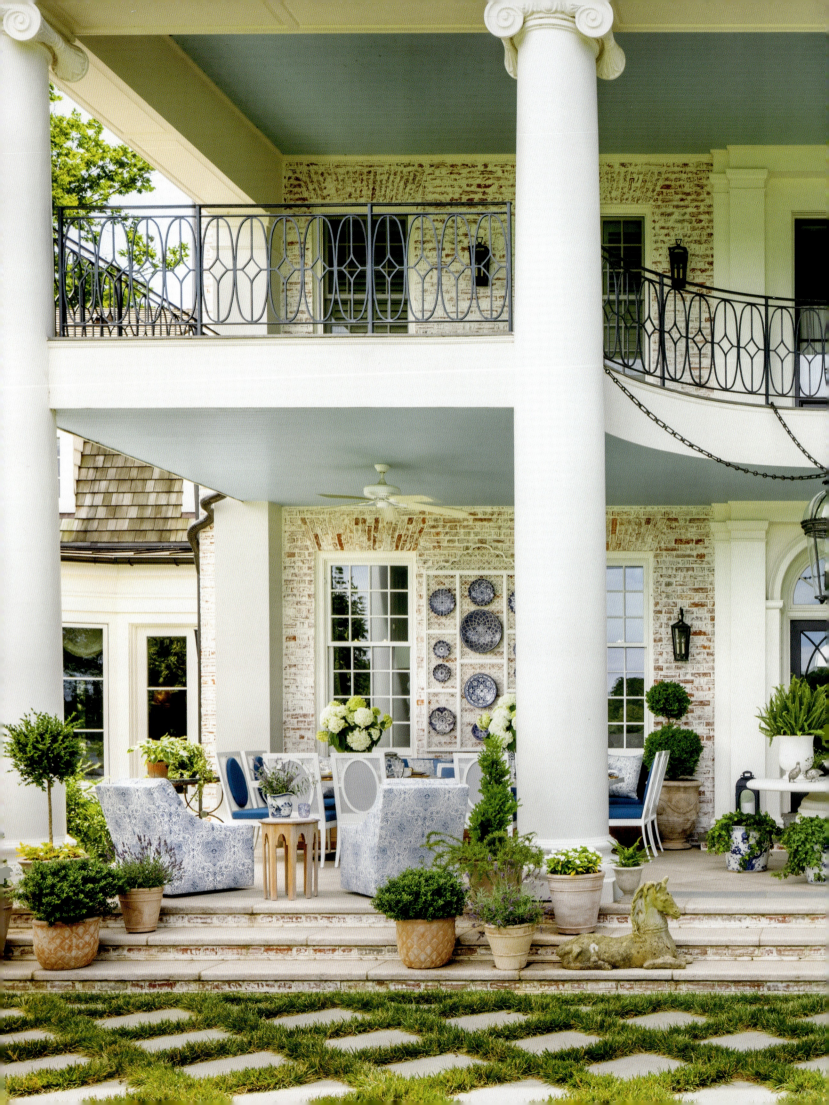

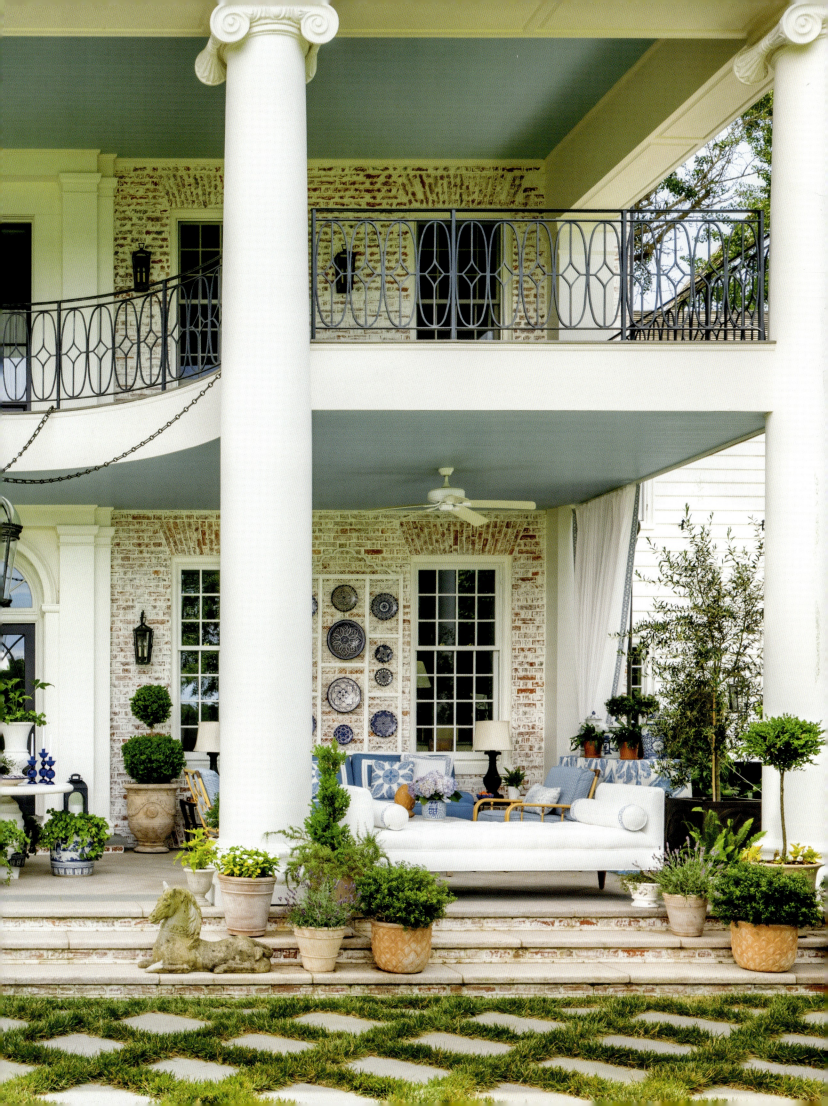

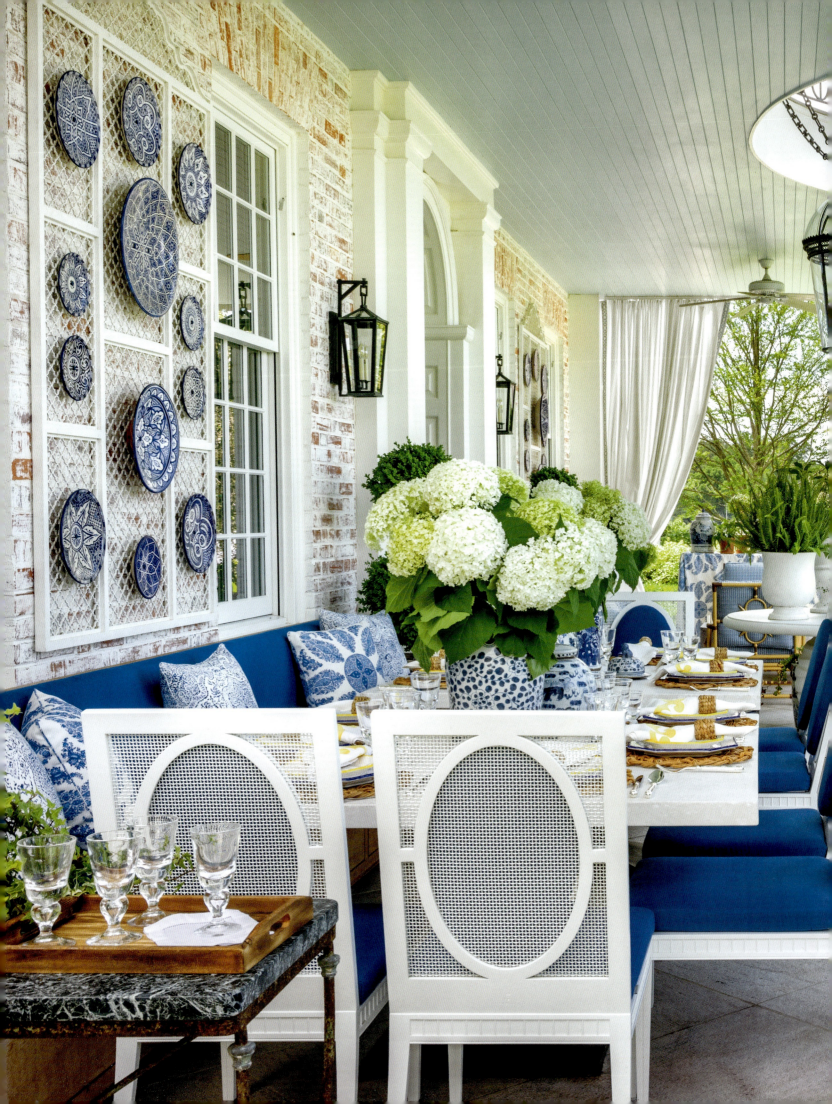

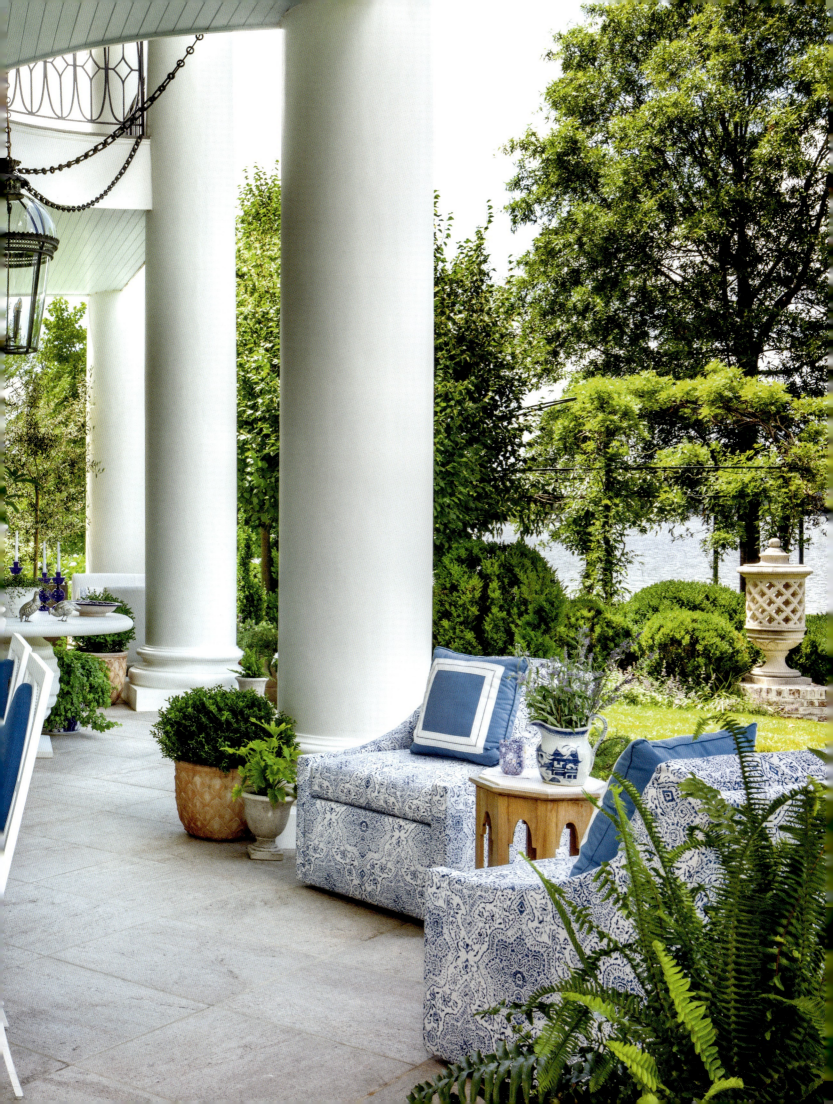

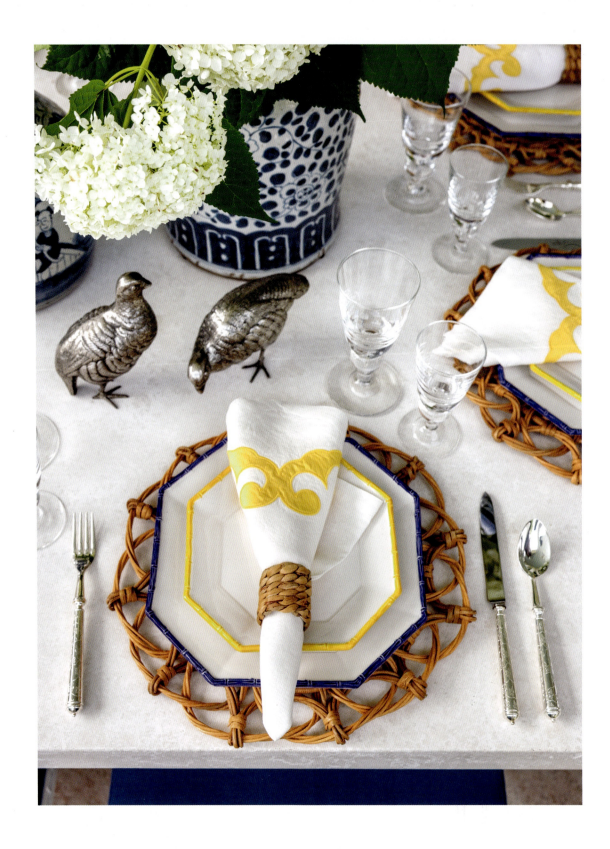

PAGES 260–61 AND PRECEDING SPREAD: The rear of the house faces a picturesque waterway leading to Chesapeake Bay, so we treated the broad veranda as a prime venue for outdoor entertaining. ABOVE, OPPOSITE, AND FOLLOWING SPREAD: Fully equipped areas for dining and relaxation occupy opposite ends of the terrace, with everything set up to promote maximum enjoyment of the fresh air and scenery.

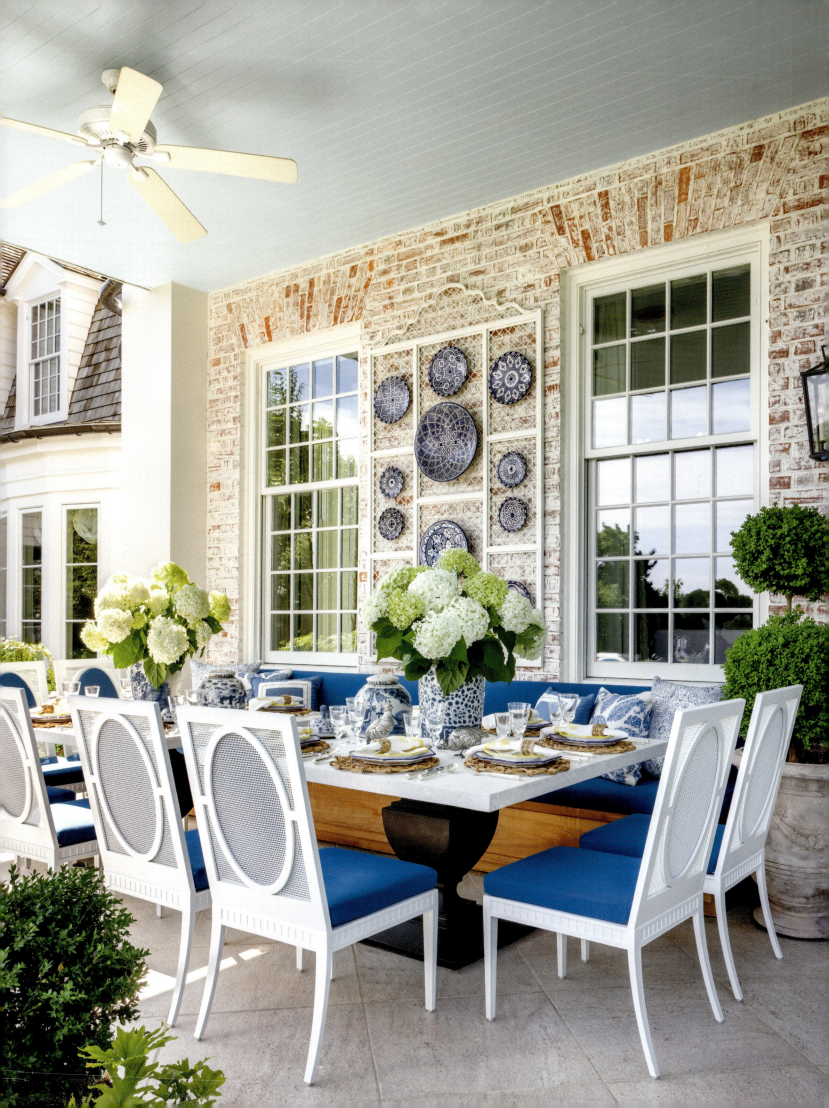

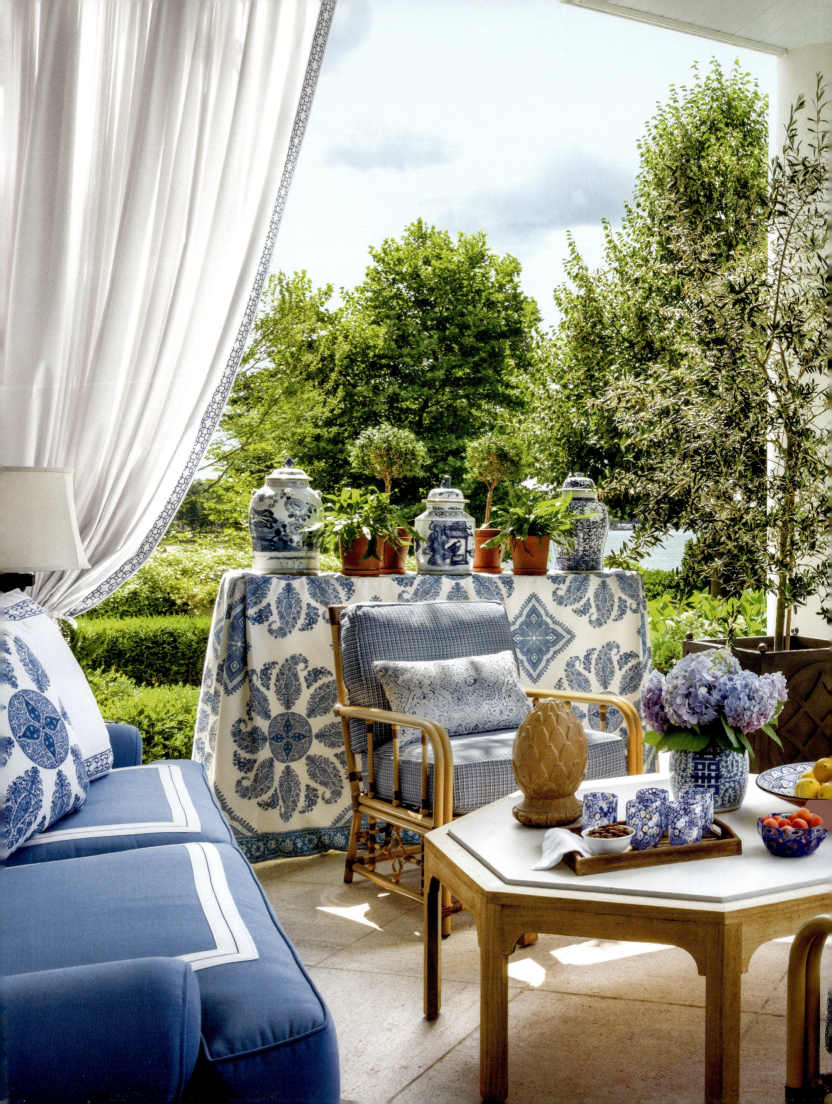

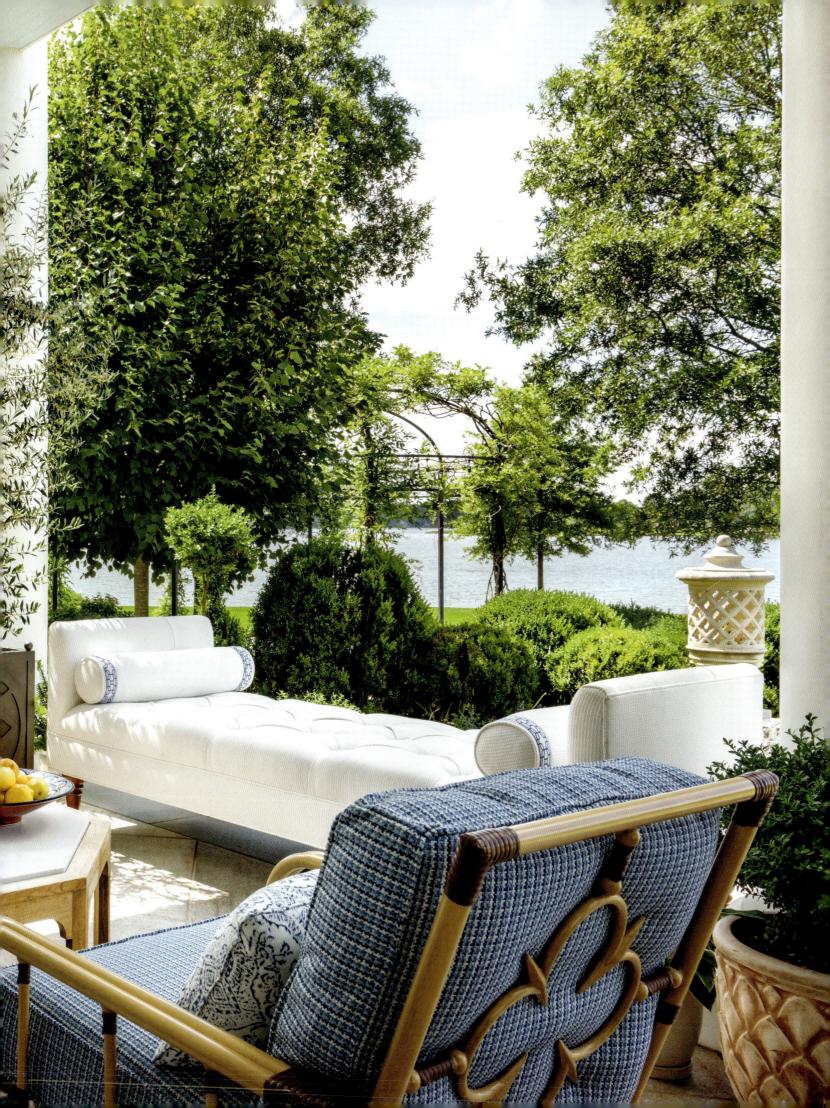

Resources

DECORATIVE LIGHTING
Arteriors: arteriorshome.com
Charles Edwards: charlesedwards.com
Christopher Spitzmiller, Inc.: christopherspitzmiller.com
Currey & Company: curreyandcompany.com
Eichholtz: eichholtz.com
Embree & Lake: embreeandlake.com
The Urban Electric Company: urbanelectric.com
Vaughn: vaughandesigns.com
Visual Comfort & Co.: visualcomfort.com

MATERIALS, FURNISHINGS & ACCESSORIES
1stDibs: 1stdibs.com
Ann Sacks: annsacks.kohler.com
Arte: arte-international.com
Artistic Tile: artistictile.com
Baker Furniture: bakerfurniture.com
Ballard Designs: ballarddesigns.com
Caldwell Snyder Gallery: caldwellsnyder.com
Cambria: cambriausa.com
Century: centuryfurniture.com
Chairish: chairish.com
de Gournay: degournay.com
Embree & Lake: embreeandlake.com
Fabricut: fabricut.com
French Finish: frenchfinish.com
Gracie: graciestudio.com
Hancock & Moore: hancockandmoore.com
Hickory Chair: hickorychair.com
Holly Hunt: hollyhunt.com
Houlès: houles.com
Iksel: iksel.com
Janus et Cie: janusetcie.com
Jonathan Adler: jonathanadler.com
John Lyle Design: johnlyledesign.com
John Rosselli & Associates: johnrosselli.com
Judy Frankel Antiques: judyfrankelantiques.com
Kallista: kallista.com
Kast: kastconcretebasins.com
Kohler: kohler.com
Kravet/Lee Jofa: kravet.com
KRB NYC: krbnyc.com
Leontine Linens: leontinclinens.com
Lisa Vandenburgh Ltd.: lisavandenburgh.com
Maitland-Smith: maitland-smith.com
Matouk: matouk.com
Mecox: mecox.com
Merritt Gallery: merrittgallery.com
Nick Brock Antiques: nickbrockantiques.com
Patterson Flynn: pattersonflynn.com
Peace & Plenty: peaceandplentyantiques.com
Phillip Jeffries: phillipjeffries.com
Samuel & Sons: samuelandsons.com
Sanderson: sandersondesigngroup.com
Savel: savelinc.com
Schumacher: schumacher.com
Scully & Scully: scullyandscully.com
Sotheby's: sothebys.com
Stark: starkcarpet.com
Theodore Alexander: theodorealexander.com
Voltz Clarke Gallery: voltzclarke.com

ARCHITECTS, CONTRACTORS & WORKROOMS
Abbondanza Painting & Contracting: brunoabbondanza@gmail.com
BarnesVanze Architects, Inc: barnesvanze.com
NBS Custom Builders: nbscustombuilders@live.com
Eva's Design & Decorating: evasdecoratingwhiteplains.com
Ferguson & Shamamian Architects: fergusonshamamian.com
French Finish: frenchfinish.com
Horizon HouseWorks: horizonhouseworks.com
Potomac Draperies: mike@potomacdraperies.com
Roberta Marovelli Studio: robertamarovellistudio.com
The Shade Store: theshadestore.com

A sitting parlor we designed using pieces from my Hancock & Moore and Maitland-Smith furniture collections has an unabashedly Palm Beach–coastal vibe despite its unexpected mixture of casual and formal elements.

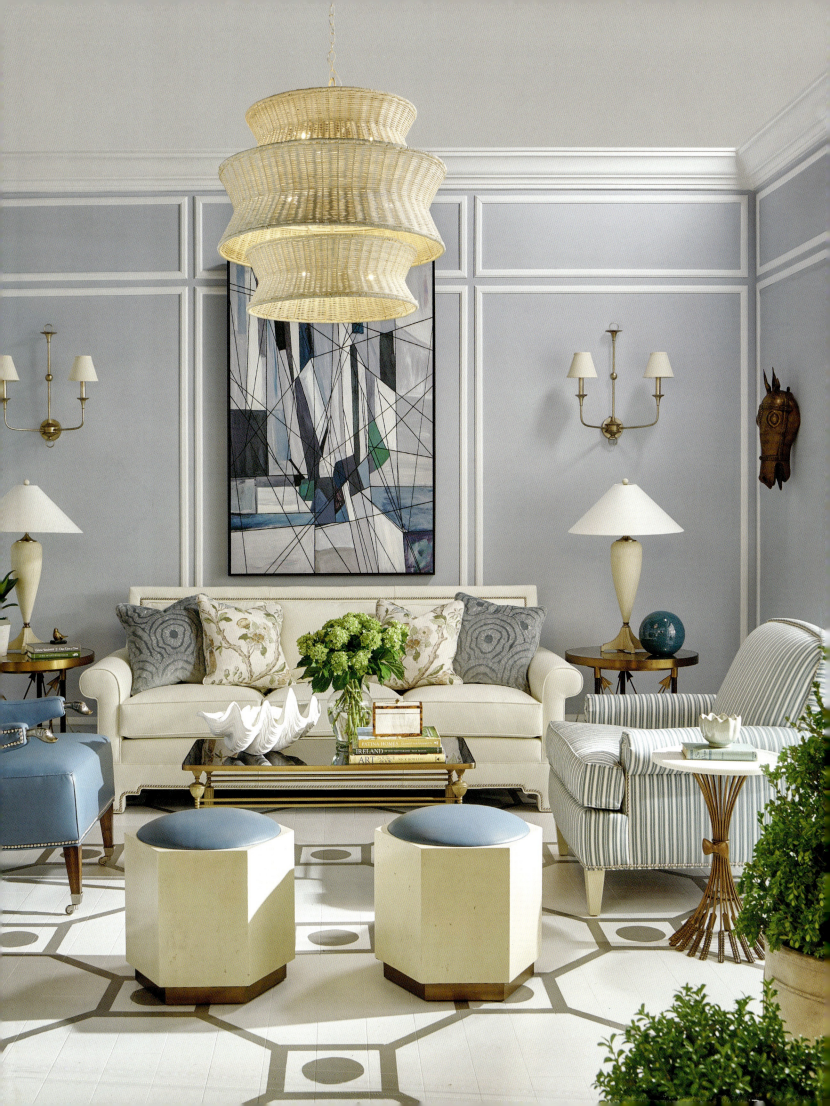

Acknowledgments

Design Reimagined was made possible through the immense generosity of some special human beings. First, to our beloved clients, thank you for graciously opening your homes to our readers. Our firm cherishes our partnerships with you, and we appreciate the trust you've placed in us.

To my wonderful staff at CDJA: I couldn't get this done without you "*gawwgeous dahlings*"! Thank you for your talents, upbeat spirits, and for making our atelier such a joyful haven for creativity.

Charles Miers, Kathleen Jayes, and Jessica Napp: Being a member of Rizzoli's family of authors is such a tremendous honor. Thank you for believing in me!

Amy Astley, your lovely words take my breath away, and I am so thankful for you. Detroit hustles harder—*always!*

Doug Turshen and Steve Turner: Gentlemen, you are truly visionaries. Every page in this tome sings your praises.

Kyle Hoepner, what a brilliant wordsmith you are. It was a joy to collaborate with you.

Andrew Frasz, you have such a commitment to excellence. Your gifted eye has framed our work so beautifully.

To the indomitable Jill Cohen, thank you for your treasured guidance.

Brian Bieder, Michael Clifford, Dorcia Kelly, David Duncan Livingston, Charlotte Safavi, Nathan Schroeder, and Sarah Winchester, thank you for your talented eyes.

Dara Caponigro, Michael Diaz-Griffith, Tony Freund, Wendy Goodman, Hadley Keller, Steele Marcoux, Stephen Orr, Kaitlin Peterson, Robert Rufino, Joanna Saltz, Carisha Swanson, Margot Shaw, Kate Kelly Smith, Asad Syrkett, Stellene Volandes, and Jill Waage: I am deeply grateful for all of you. Long live print!

Special thanks to Alison Levasseur for everything you do. To the entire team at *Architectural Digest*, we appreciate your support and kindness. And Michael Shome, thank you for talking me off that ledge!

Huge thanks to our incredible partners: Ann Sacks, Arteriors, Delta Airlines, Eichholtz, Gracie, Kohler, Goodbye Pictures, Hancock & Moore, Jenn-Air, Kravet, Leftbank Art, Lincoln Motor Company, Maitland-Smith, MasterClass, and Stearns & Foster.

Jim Druckman, you are a *mensch* and such a force for good—much love to you and Nancy. Jamie Drake, Nazira Handel, Daniel Quintero, and my fellow Board of Trustees at the Kips Bay Boys & Girls Club of New York: May God continue to bless the work we're doing for our kids.

To our favorite architects, workrooms, and general contractors: all ships rise in the tide—thank you.

To Alesa Knox: You're more than an aunt, you're my lifelong best friend. Thank you for standing with me when it mattered most.

My dear friend Alexa Hampton once told me "There is biological family, and then there is your *logical* family." To my father-in-law, Art, and the extended Wasserman family, thank you for welcoming me with open arms. And to my pantheon of proverbial brothers and sisters who keep me grounded: Bruno Abbondanza, Gloria Blaylock, Patti Carpenter, Rashaad Clark, Wendy Estela, Karen Finckenor, Dionne Gadsden, Elissa Grayer, Katie Harvey, Beth Holman, Jennifer Jacob, Derek Jech, Izzy Jimenez, Jason Kraner, Brian Lane, Steven Lyon, and Keita Turner—there isn't enough paper and ink in the world to express how deeply you all are adored.

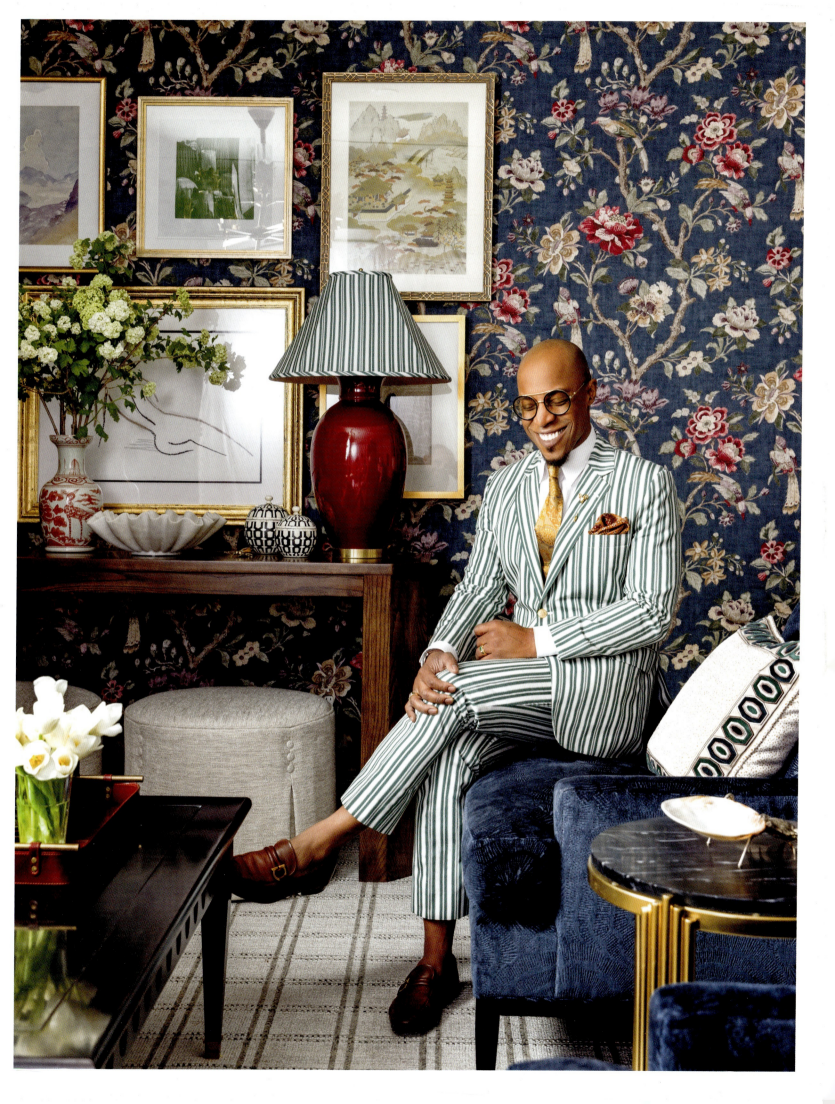

First published in the United States of America in 2025 by
Rizzoli International Publications, Inc.
49 West 27th Street
New York, NY 10001
www.rizzoliusa.com

Copyright © 2025 Corey Damen Jenkins
Foreword: Amy Astley
Text: Corey Damen Jenkins with Kyle Hoepner

Photography:
All photography by Andrew Frasz except:

Brian Bieder: 198-199, 269

Michael P.H. Clifford: reverse of front endpaper

David Duncan Livingston: Pages 158-175

Nathan Schroeder: Pages 9, 218, 219

Art Credits
Page 114: Thierry Noir, I am hungry, I hurry towards the cafeteria © 2025 Artists Rights Society (ARS), New York / VG Bild-Kunst, Bonn

Pages 116-17: Richard Diebenkorn "Blue" © 2025 Richard Diebenkorn Foundation / Artists Rights Society (ARS), New York

Page 196: Hunt Slonem, Snowdon, Offspring, 2 Hop from the series "Bunnies" © 2025 Hunt Slonem / Artists Rights Society (ARS), New York

All rights reserved. No part of this publication may be reproduced, stored in a retrieval system, or transmitted in any form or by any means, electronic, mechanical, photocopying, recording, or otherwise, without prior consent of the publishers.

Publisher: Charles Miers
Senior Editor: Kathleen Jayes
Production Manager: Alyn Evans
Managing Editor: Lynn Scrabis

Designed by Doug Turshen with Steve Turner

ISBN: 978-0-8478-7446-0
Library of Congress Control Number: 2025934188

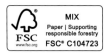

Printed in China
2025 2026 2027 2028 / 10 9 8 7 6 5 4 3 2 1

The authorized representative in the EU for product safety and compliance is
Mondadori Libri S.p.A., via Gian Battista Vico 42, Milan, Italy, 20123,
www.mondadori.it

Visit us online:
Instagram.com/RizzoliBooks
Facebook.com/RizzoliNewYork
Youtube.com/user/RizzoliNY